EARLY PRAISE FOR
BASEBALL, ART, AND DREAMS

Dreams are very special. For many boys, becoming a baseball player is a dream. As I was growing up in Cuba, I imagined myself a catcher for my beloved team, Cienfuegos, in the Cuban leagues.

Scott Christopher was just such a boy, forging ahead despite obstacles and extreme physical challenges to realize his dream of becoming a professional baseball champion and record holder. This heartfelt book tells the story of how he achieved his dream as an artist in the body of an athlete.

From his days as a professional player and prowess as an artist, Scott demonstrated compassion and empathy. He has generously shared his talents and philosophy with countless aspiring baseball players, athletes, fans, and artists in the United States, Cuba, and over thirty other countries.

Anyone with an interest in baseball, sports, and the creative mind of an artist will be fascinated by the stories told here. From his rise as an amateur, to his stardom as a professional baseball player, Scott Christopher inspires us with this truly American story.

—Stuart Ashman, lifelong baseball aficionado,
former Cabinet Secretary of the New Mexico
Department of Cultural Affairs, owner-operator of
Artes de Cuba

Obviously Scott Christopher was blessed with incredible talent. But the work, relentless positivity, and heart are the real revelations and the keys to his amazing career. I am so impressed by the writing, and I loved Scott's passion to overcome adversity.

—Dr. Michael Whiting, thirty-four years in
emergency medicine and lifelong baseball fan

I dearly loved reading Baseball, Art, and Dreams. *This book is GREAT and an inspiring story—not only by the physical limitations Christopher overcame, but also for his HUGE generosity of spirit, back then, now, and going forward!*

—Craig Joyce, Kurth Professor of Law and Founding
Faculty Director, Institute of Intellectual Property &
Information Law, Univ. of Houston, Texas

I have had to step back and let this book penetrate my deepest reaches after reading "Red Threads" and turning to the ninth inning. The at-bat of a lifetime, as described in the eighth inning is the "soul speech" that all who feel deeply long to write. It is Beowulf against Grendel, life against death, Hector against Achilles—and as written by Christopher, beautiful, "soul stretching" prose. Then to punctuate it with Red Threads . . . only poetry comes close to describing the indescribable. Perfect.

—Larry "Never Quit" Bertram, English scholar,
published writer and poet, award-winning college
football quarterback and baseball infielder,
Hampden-Sydney College

In life we meet many people, but some, by the way they live their life, shape ours. And that's why I will always be indebted to, and never forget, Scotty Christopher. Tougher than nails, faster than lightning, where no problem is too big and no mountain too high--and yet the memory he leaves me with is "Love," which pours out of him like water.... He could cover so much ground, so fast, so effortlessly, seemingly floating across the field. I used to quietly think to myself: How does he do that?

—Rob "Cat" Whitfield, three-time teammate, seven-season
pro ball player, two-time champion, and gifted musician

Baseball
Art and Dreams

An American Baseball Memoir

Baseball
Art and Dreams

An American Baseball Memoir

Scott Christopher

"Dream Big, Dream On!"

SOARING
PRESS

Santa Fe, New Mexico

Published by: Soaring Press
Santa Fe, New Mexico
SoaringPress.com

Names: Christopher, Scott Douglass, 1954- author. | Malone, Michael S. (Michael Shawn), 1954- writer of foreword.

Title: Baseball art and dreams : an American baseball memoir / Scott Christopher ; foreword by Michael S. Malone.

Description: Santa Fe, New Mexico : Soaring Press, [2023] | "Dream big, dream on!"--Title page. | Includes index.

Identifiers: ISBN: 978-0-9988157-1-8 (paperback) | 978-0-9988157-0-1 (hardback) | 978-0-9988157-2-5 (ebook) | LCCN: 2023912012

Subjects: LCSH: Christopher, Scott Douglass, 1954- | Baseball players--United States--Biography. | Baseball players with disabilities--United States--Biography. | Athletes with disabilities--United States--Biography. | Athletes--United States--Biography. | Baltimore Orioles (American Association : Baseball team)--Biography. | Major League Baseball (Organization)--Biography. | Minor league baseball--Biography. | National Collegiate Athletic Association--Biography. | Sports--Biography. | Athletes--Biography. | Sports photographers--Biography. | Photography of sports--Biography. | Self-actualization (Psychology)--Biography. | Spiritual biography. | LCGFT: Sports writing. | Autobiography. | BISAC: SPORTS & RECREATION / Baseball / Essays and Writings. | BIOGRAPHY & AUTOBIOGRAPHY / Sports. | PHOTOGRAPHY / Sports. | SPORTS & RECREATION / Baseball / History. | SPORTS & RECREATION / Baseball / Statistics.

Classification: LCC: GV865.C4347 C57 2023 | DDC: 796.357/092--dc23

Cover art by Scott Christopher, "Mosaic Lovers" ©1998

Cover design and logo by Leslie Waltzer, Crowfoot Design

Editing and interior design by Mary Neighbour, MediaNeighbours

Printed in the United States of America

Disclaimer: This book is a memoir. It reflects the author's present recollections of experiences over time, written from his perspective. Some names and characteristics have been changed, certain events have been compressed or expanded upon, and occasionally dialogue has been recreated.

A HEARTFELT THANK YOU to EHC
• • • • "WING" • • • •

Love, passion, and belief are the pillars to *DREAM BIG*.

You cannot possibly ACHIEVE your dreams unless
you truly BELIEVE they are possible
and your vision to PERCEIVE them is crystal clear.

LOVE for all that WAS, IS, and WILL BE,
lays the greatest of paths for our human experience,
our solitary and collective footprints all along this
great journey we call LIFE.

Together we SHARE, together we ADVANCE,

To INHALE, LIVE IT ALL, and *DREAM ON!*

Contents

FOREWORD

MICHAEL S. MALONE

Sunnyvale, California

It is not often that you are in attendance when a friend experiences a life-changing event. It is rarer still when you both are children—and you are still there six decades later to track the consequences of that moment.

In the first few pages of this extraordinary book by Scott Christopher, you will encounter that event. Indeed, I was part of it. I might even have been a victim if only Scott hadn't been faster than me—honestly, faster than anyone I've ever met. It happened over a matter of seconds; I was only a few feet away and I didn't understand what I was seeing . . . until I saw the blood and heard Scott's scream. I supported my friend until his father swooped him up and rushed off. Then the shocked silence of the small crowd at the Little League game.

The moment echoes through the entire story that follows. It is easy to see it as a tragedy, one that changed the trajectory of Scott's life, denying him his dream of becoming a major league baseball player. Certainly, that's how I saw it at the time and for years thereafter. It seemed so deeply unfair that a young man of such unbelievable athletic talent could be denied the brass ring because of an old injury that wasn't even noticeable unless you focused on his right hand. Yet when I was

nineteen years old, I watched him run down and catch a fly ball over his head and return a rocket throw to second base *with his so-called bad hand and arm.*

But now, all of these years later, with the benefit of a long life, I see it differently: as a triumph. That day, at the Little League baseball diamond, the accident may have ultimately closed one door on Scott's future . . . but, unexpectedly, miraculously, it opened another one. Scott woke up that warm Virginia morning one of the most athletically gifted young men of his generation; he went to bed that night, in the hospital, on a path that would test every bit of his tenacity, his courage, and his character.

To that day, it had all come easy to Scott. I know: I spent every daylight hour of every day with him, marveling at his superhuman gift. He took it for granted, as any six-year-old would. Afterwards, it would all be different. Sure, he would still remain a sports prodigy, celebrated by *Sports Illustrated* at the young age of twelve. But everything had changed.

It began in the days after the accident. Scott was burned badly at age five but had never really been injured like this before. Now he faced months, even years, of therapy with little hope of ever regaining what he'd lost. Rather than surrendering, Scott dug down deeply into himself . . . and found something he didn't know was there: grit. Imagine a little boy, barely four feet tall, obsessively and painfully squeezing a rubber ball—without being reminded, even when no one was watching. Imagine that boy, eighteen months after his accident, shivering in the snow, swinging a baseball bat a hundred times, then begging to play catch for the fourth time that day. That kind of discipline and dedication is impressive in an adult; in a child it is awe-inspiring.

It was that battle-hardened character that enabled Scott Christopher to return to his dream and accomplish more in his sport than anyone before him or since. To attempt things that made his more famous peers look on in disbelief. To consistently show a courage that few of the rest of us will ever know. And most of all, it enabled him finally to walk away from his dream. I remember his letter telling me about his last game in organized ball; and his final dash for the plate that seemed like a metaphor for his entire career. It broke my heart because I knew how much was bound up in Scott's decision.

I call this story triumphant not just because of Scott's early life, but because of what he has accomplished *after* his baseball career. The media carries stories of retired athletes who find themselves lost, broke, or in legal trouble, the path of their lives losing the trail in the wilderness of adult life. How many launched on an utterly new career trajectory that ultimately eclipses everything that came before? Scott Christopher's finest achievement is that he did just that. Great sports stories ultimately are great people stories, and Scott's is one of the best.

Scott, even as a young man, was wired differently. His approach to life was always slightly orthogonal to the rest of us. Perhaps that's not surprising. His baseball aptitude no doubt partly derived from his father's family tree, which includes the Hall of Fame manager Wilbert "Uncle Robbie" Robinson. But it is also crucial to know that Scott's father was a famous photographer. The combination of the two, propelled by his own unbounded curiosity, helps explain how Scott was the most artistic of professional athletes—and how he was able to make such a stunning transition to successful photographer, artist, filmmaker, writer, and philanthropist . . . and now, author.

In the pages that follow, you will encounter a remarkable man. One perhaps like no other you've ever encountered. I envy you meeting Scott for the first time. Life, as it does to all of us, has thrown a lot of curves at Scott Christopher. What makes each of our lives different, and ultimately a success or a failure, is how we respond to those challenges. And that response ultimately depends upon our character. At a shockingly young age, Scott was tested in a way that, thankfully, few of us were. He responded by making himself a stronger, better person; one who would never surrender no matter the adversity. Incredibly, through everything, he also maintained a sincerity and an openness to experiences that still characterize him today.

What I saw that spring afternoon sixty-three years ago was a tragedy. But it also was a miracle. It is a story that should give us all hope.

INTRODUCTION

SCOTT CHRISTOPHER

Having landed on the edge of bleeding to death, my throwing hand was severely injured, gushing blood; all seven tendons, ulnar nerve, and both arteries were severed. Russell Bertram, a WWII veteran pilot, and my father saved my life that day in May of 1960. The lightning actions of my best friend Mike Malone were also of great valor. I had ten minutes to live before I would have drifted away from blood loss. They also preserved the possibility of achieving my childhood dream: becoming a professional baseball player. As the doctors discussed amputation, my dad pleaded with them to stitch together what they could and let the future dictate my fate. Many years later, a distinguished and experienced general surgeon told me that what I accomplished on a baseball field, given my extreme handicap, was close to one in a million.

It is inevitable that we all will suffer in various capacities as part of living life. How we address those physical, psychological, and emotional challenges will vary for each of us. Passion, purpose, intention, hard work, persistence, having confidence in yourself, and most importantly, believing your dreams are yours to cultivate and live—these are the paving stones of a solid path forward that illuminate the essence of your being and will inspire others to stand strong.

As you read the story of my eighteen-year baseball odyssey, you will learn that it is possible to "Dream Big, Dream On!" The power of the mind's unlimited potential will become ingrained in your psyche as

you step onto the fields with me, season after season. When it comes to living your dreams, time does not exist. You can lock into a dream at any point in your life. Belief, courage, and inspiration will be yours to grasp when you finish reading this book.

Imagine a little boy at age six who was told he may never be able to play baseball again. My parents and the Malone family lovingly devoted their time over many years to help rehabilitate my crippled hand and arm. By age twelve, I was featured in the August 1966 issue of *Sports Illustrated*. Competing and giving athletics 110 percent was embedded in my DNA, which is good, because my life's trajectory delivered one challenging misfortune after another.

Suffering through the worst varsity baseball season of any high school junior in the country, batting four times with three strikeouts, and hitting .000 only fueled my determination to become a professional champion. By the end of my senior year, I led the team in hitting at .371 and was awarded the coveted Most Valuable Player trophy.

I worked tirelessly to becoming a star player, hitting .380 at Mercersburg Academy and swatting .375 at Ferrum Junior College. These stellar springs of 1972 and 1973 set the stage for me to deservedly earn a full-ride, out-of-state scholarship to play shortstop for the University of Maryland's storied baseball program. There, I became a two-time MVP, team captain, made the all Atlantic Coast Conference team, won the Boze Berger Award, led the ACC in steals and the nation in stolen base percentage, along with many other notable accomplishments.

Every setback I experienced did not lessen my dream of hitting a ninth-inning home run, in the final ring game, to become a professional baseball champion. I just did not know when or where that would happen. After playing in Korea during the summer of '76 and hitting .384, the Baltimore Orioles signed me as a free agent in January 1977. Although I was rock bottom on the Orioles depth chart at the beginning of spring training, I knew I would excel to make the roster. At the end of my second pro season, I had become a bona fide big league prospect, setting the all-time Orioles organization records for stolen base percentage, taking 41/42 in the 1978 campaign, .977, and stealing 66 out of my first 70 attempts, .943. Both records still stand today. And at the plate I landed as the 17th and 9th top hitter in the league with 300 or more official at-bats. Joyfully, my dreams did materialize.

With my two exceptional seasons behind me, I was a very rare, non-drafted invitee by the O's to attend the elite major league prospects Florida Instructional League, where I continued to advance my skills and excel, earning respect for my hard work and dedication to be the best ball player I could be.

I had many other highlights over my career, including being nominated for the Rawlings Silver Glove award in 1979, leading all of professional baseball in fielding percentage at every position, with 104 or more games played, making only one error, .995. Additionally, I set a very difficult record in the world of professional baseball. This extraordinary feat is that I am the only player to have ever hit two triples, from different sides of the plate, in the same game, twice in one season. My three-time teammate, world champion, Hall of Famer, one of the top-fifty baseball players ever, and the greatest shortstop of all time, Cal Ripken Jr., played in both of those games. The "Great One's" first home run derby was he and I hitting against another baseball immortal, top-fifty player, ace pitcher, and HOFer, Bullet Bob Feller. Cal and I won the derby. I truly was living the dream! And to think nine years earlier, my batting average was zero as a junior in high school—Wow!

Writing stories and making art from a very early age, I completed my first book, a fully illustrated, futuristic, science fiction novel, *The Tales of the Roving Mobileans*, while playing for the O's. It was highlighted in a *Miami News* sports page feature article in June 1978, written by the renowned and two-time sports writer of the year, Tom Archdeacon. He flatly stated my novel ". . . puts *Star Wars* to shame." Also I published my hitting book in 1980, titled, *Baseball Offensive Batting Sheets*. This successful manual focused on using the power of the mind to process recorded offensive analytical data, providing hitters statistical information to excel in the batter's box.

In April 2014, Thom Loverro, a senior sports writer for the *Washington Times*, as well as a highly established author, wrote an article titled, "Injured Hand Does Not Keep Scott Christopher from a Life of Baseball and Art." Many people contacted me, hoping that I would write my inspirational story. Six months later, I walked into the Barnes & Nobel bookstore next to Union Square, New York City, sat in the windowsill of the cafe, and started writing my American Baseball Memoir. I went to that space for almost all of the next 180 nights to complete my first, engine-block book draft.

You may not find everything you need to make your dreamer's leap, if you so desire, from my book. But I can promise you that believing in and being inspired by yourself are two gifts you will receive from reading my memoir. Belief and inspiration are major cornerstones of living out your dreams. Against all odds, I was presented one opportunity after the other. And this all was possible and happened because I clearly visualized each and every one of my baseball dreams before they actually crystallized. I use my life in athletics and overcoming many major obstacles as metaphors for you to know that YES, in fact, all that you desire is attainable and entirely possible to live.

To this day, I am unable to pick up a baseball to throw it. Since age eight, when I was given permission to play on a baseball team by my doctor, I have had to push the ball into my right hand that has very little feeling; when one finger moves, they all move; it is much smaller and weaker than my left; and my thumb is unable to wrap around a bat. Given all that, how did I become a professional athlete? I never, ever gave up on myself or my dreams. Likewise, I want to share with you that you are your own architect, your own engineer, and your own visionary to create all of your dreams and make them come true, regardless of the cards you are dealt, throughout your life!

Let's embark on this journey together. Every word I have written is part of a story to inspire you to give your life all that it deserves! I succeeded on a high level, I collapsed and faltered to a high degree, I struck out many times, and I earned the opportunity to hit my ring home run in an effort to become a professional champion along with my teammates. In the end, I know in my heart I gave my dreams 110 percent, and that is the Grand Slam I am most proud of. I truly want you to hit the granddaddy of all home runs for yourself. You can do it, you will do it, and I am very happy knowing you are courageous enough to give your dreams the 110 percent vision and attention they deserve!

My book is a work of art for me, where every word is a brushstroke, creating a colorful mural of inspiration, belief, vision, hope, and the reality of possibility. I joyfully and excitedly present my literary painting to you, my friends. Let's "DREAM BIG, DREAM ON!"

1ST INNING

THE DREAM AND THE REALITY

Summer 1957

Running as fast as any three-year-old could, I rounded first base with a deep tilt toward the earth. It all felt so natural. I wanted to keep racing, grazing the inside corners of the ripped canvas bags filled with straw, accelerating faster as I touched each one, streaking toward the black rim of the scarred white plate. By the time I scored my run, I had wings.

Over and over I charged those sacks, in my clam diggers, rope belt, scarlet-red tee shirt, and worn-out tennis shoes. Riding the bench in the dugout sat my beaten-up baseball with those beautiful red threads stitched into two figure eights and my splintered, wooden bat that I loved to hit pebbles with.

No teams competed in the dust of the diamond, no scores racked up on the board, no fans cheered and jeered from the bleachers—I played at Tyler Park that hot and sticky July day with just Dad and my best friend, Mike. He and I tossed pitches to each other; whoever was batting sprinted to the bases after hitting the ball, while the pitcher chased it down and then attempted to run down the batter to tag him out before he scored. Well matched, we excelled at having fun and generated endless variations on playing our improvised games.

That afternoon had little to do with baseball, though. I motored 'round the horn, playing my part in a pretend world created by my father, who snapped photo after photo, roll after roll, answering his calling as a historic and award-winning professional photographer—just as I pursued my dream of becoming a baseball player. My "work" that day was my greatest joy.

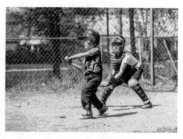

Taking batting practice as the four-year-old mascot for the Little League Panthers.

My father eventually slung his Zeiss camera over his shoulder, the pocket of his white, button-down shirt bulging with Kodachrome 200 film canisters. He called for Mike and me to leave the field, and we raced to Dad's ragtop Cadillac, always loving to ride in Big Baby-Blue. Dad turned the key and fired up that hog of an engine, and off we went: top down, classical music on the radio, in the boat of all boats, a gas-guzzling whale, clocking in at ten miles a gallon.

WINNERS

When I was five, my father again wanted to create one or two exhibition photographs of me on the diamond. This would be a much more artistic effort than our previous attempts. I wore a pair of overlarge, whipped and ripped jeans—he wanted the pants' cuffs rolled up at least four inches. My black tennis shoes with the white trim and holes in them added an athletic character to my look. Completing the picture, I sported a worn-out Panthers jersey and an oversized ball cap, set with a boyish tilt.

Dad staged our shoot at Lee Graham Field—by far the best Little League complex in the area, with its backstop, dugouts, and stands. None of us knew, although my father hoped, that we would be creating photographic history that day.

Mike, as my pitcher, followed detailed instructions on every aspect of my dad's well-honed artistic vision. From the height of the pitch to where I stood in the batter's box to how he positioned the boys playing around in the stands, Dad arranged every element to enhance his artful

imagery. Each shot reflected his preparation and practice, so that even at this young age, I understood that my father *made* photographs, he didn't just *take* them.

Witnessing this, his work ethic soaked into me, and I began to adopt it in regards to my own dream of being a baseball star. Born with a burning desire to dig down and win, I was a rugged kid with an unshakeable passion for the game. I played it all the time with Mike and other friends. But you had to be eight years old to qualify for Little League, and nine to play in the majors. At five years old, organized ball seemed a lifetime away.

As president of the Kiwanis Little League, one of my father's primary objectives was to fully integrate all the kids from the community, regardless of their race or creed, who wanted to join in the league. His vision succeeded, and if a player's family couldn't afford the proper equipment to play on a team, he personally financed the purchase of that youngster's gear. Of course, he encouraged my baseball aspirations as well. He brought me with him to different ballparks and games. How I loved taking swings and playing the infield.

On the day of this shoot, I swung for the fences. In between snaps, Dad called, "No chopping wood, keep your bat level, throw your bat at the ball, hit a home run." Again and again I heard, "Give me your best swing, give me your best swing, the bases are loaded." As a five-year-old, being cheered on by your father is a special gift.

In Dad's first series of shots, I purposely missed the ball and stretched out my stride. My father positioned Mike way off the pitcher's rubber, closer to me, so he could exercise more control over his pitches. Dad burned up a bundle of Kodachrome film as he stationed himself between the first and third base lines. This was risky business. If I dug into the batter's box and smoked one, it could have dented my father pretty good. But of course, the photo angle and his artistic results took precedence.

Whenever we went out on a shoot, Dad always said, "Let's go make a winner," which meant one photograph from our day's work would consistently score at least a five or higher in the international salon competitions. Such photographs returned home with ribbons or medals, and prestigious exhibition catalogues published them. Over my father's lifetime, he became one of America's most celebrated salon photographers. He stopped counting at 1,000 acceptances, many of

which earned medals, ribbons, or trophies. Over my father's life, he received numerous honors from the Photographic Society of America.

That August dog-day, as we knocked around home plate, I asked Dad if he wanted me to make a funny face when I took my swings. "Good idea," he said, and squatted along the first base line to burn up another roll. Mike pitched the ball, arcing toward the ground as it came across the platter, so it would look like I had taken a hefty swing yet missed by a mile. "Strike Three" became a winner, going on to win or place in

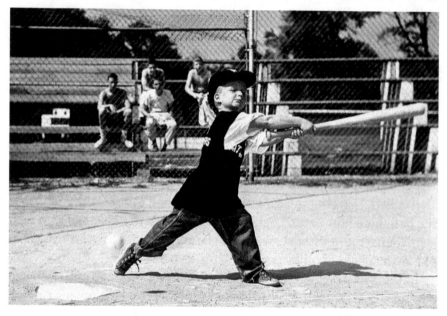

"Strike Three" (August 3, 1959).

at least 50 international salons spread across the globe over the next 30 years. In the highly competitive *Life Magazine* competition, "Final Frame," which published the winning entry on the issue's last page, it earned a runner-up award.

As the thick heat of August shifted, Dad allowed me to smack the ball hard. We only had two baseballs, so after I belted the second one, Mike and I sprinted into the outfield to retrieve them—the first one to return to the pitcher's mound won. Another wonderful and powerful image my father made that afternoon, titled "It's a Hit," also went on to pull in its share of salon awards. We all felt like winners that day.

After the three of us packed up our gear, we headed over to pick up a custard cone at the malt shop. Big Baby-Blue was cooking that day, and life was good. In the backseat, Mike and I rocked out like Elvis, even though Peter Tchaikovsky's Piano Concerto No.1 in B-flat Minor rang out from the radio.

Through the neighborhoods we cruised streets as tidy as a Monopoly board, except instead of green plastic, these homes were red brick, with white window frames. Towering oaks and pine trees shaded trimmed yards. Pets ran free, and every kid owned a bike to ride into their next adventure. Lowering sunbeams burnished drowsy clouds, and we smelled the smoking grills filled with small, red-hot charcoal pillows cooking steaks, hamburgers, and hotdogs.

We reached Pine Spring, one of the most contemporary communities in northern Virginia, with 142 mid-century houses designed by the noted modernist architect Arthur Keyes. When I was two months old, my parents settled into a two-level home that was mostly glass, situated on the best sledding hill in the neighborhood.

Mike lived three doors down, and we always—I mean *always*—palled around. A contrast of sorts, we also complemented each other. I loved to create and build things, and Mike loved to read and analyze books. He would draw grand, three-masted barque ships, and I would make small models of them using scrap wood and white pillowcase rags for sails. Through Mike, I learned early what real friendship means. The best friend I could have ever imagined, he has always, even to this day, remained one of my life's most brilliant brush strokes. I will always treasure Mike Malone and the childhood we shared.

My father parked Big Baby-Blue in our driveway, house number 423. He put the Caddy's black top up, and I waved goodbye to Mike and watched him walk home. At our front door, my mother waited to swallow me up with a big, warm hug. Mom had the ocean in her soul and wonder filled her sapphire eyes. A free spirit with a huge capacity to love, she would have single-handedly fought a pride of lions to protect her family.

Dad went into his office to type a letter to a friend, Norman Cousins, the editor-in-chief of the *Saturday Review*. They regularly corresponded on a variety of philosophical and global issues. As a freelance photographer and journalist, my father often typed editorials and articles to support and expand his humanitarian ideals for the world.

The Vice President of the United States, Hubert Humphrey, valued his opinions, and I remember letters from the White House delivered to our door. Embossed in the upper left-hand corner was "The White House," with "1600 Pennsylvania Avenue" in brilliant blue under it. Many noted people sought Dad's advice. A respected academic on politics, social concerns, and humanitarian issues, who was published frequently. He also collected and sold photographic art from across the globe.

My father devoted his life to improving the world, and I am proud to say he accomplished his aims. As a youngster, I experienced one man making a positive difference for humanity, and this has shone as one of the brightest guiding lights throughout my entire life.

The phone rang as I dug into a stack of Oreos. My mother said, "Mike," and handed me the receiver. We jawed for a bit before I yelled, "Bye, Mom!" and ran out the door.

I loved going to Mike's house, and our parents let us bounce back and forth between houses because each was "home." Mike's mother and father treated me as a second son; to me, they were a second set of parents. I think I intrigued Mr. Malone, an Air Force Intelligence officer, because I seemed so different from Mike, at least when we were boys. Pat Malone took the time to explain things well and asked thoughtful questions of me. He listened attentively, even though my answers tended to meander. Academics and intellectual curiosity formed his cornerstones, with a bent toward inventiveness. Mike inherited these qualities—a beautiful gift between father and son. Nadine Malone brought love to their home and many cherished memories to my life.

Mike and I attended Glen Carlyn, a private school that offered kindergarten and first grade. We entered at a younger age than most, however, and none of us realized the consequences. All my developmental skills were compromised, and it confused me at times. Academically, I lagged behind my peers by an entire year of mental development; emotionally, my growing-up cycles never synced with my grades; physically, I was smaller than my classmates; and core abilities, like communication and social interpretations, trailed behind. The challenges compounded with every new grade, becoming particularly evident through organized sports.

Of course, this impacts each child differently. Though a proficient student, I found myself on physical battlefields where I lost the struggle by not having that extra year—and sometimes two years, if one of my

competitors failed a grade. In athletics, your competition holds a substantial advantage over you with an additional year or two of mental and bodily development. Mike and I navigated this choppy current together; although he was academically far beyond students our age, it made the bond we shared even stronger.

Despite the drawbacks, I loved Glen Carlyn. One of our teachers, Mrs. Mary Martin, lived a few doors away from us, so we rode with her to school. She made learning a joy and also promoted creativity with coloring, papier-mâché, sculpting clay, acting in plays—I even learned to "fly" in her kindergarten class.

At the playground, a rope swing hung from a high limb of an ancient oak tree. Sitting on the wooden seat, I went so far up that I would fall back through the air with a jolt as the ropes became taut again. And when I decided to launch myself out of that swing and fly, I began to believe anything was possible.

The first time I flew, Mike cheered me on. I swung so high the seat hit two o'clock on the upswing and ten o'clock on the backswing. Mike stood way out in front, calling, "Higher, higher!"

I pulled the rope into my ribs with my arms, angled way back, and executed arduous leg pumps, one after the other, reaching the heavens. As the physics of it all maxed out, I released my hands at the same time, and my momentum shot me even higher, heading into the clouds. I soared like a hawk gliding on a thermal current, arms outstretched, creating a wide wingspan. At that moment, I owned my universe. I created it. And when I flew, I felt free, and that freedom felt effortless. The ruffling autumn wind spread my smile even broader; nothing beyond that moment mattered. I never thought about breaking an arm or leg, and to be quite honest, if I had, it would not have made a difference. I was learning that liberation comes as a gift—possibly with a substantial price tag attached.

I met the ground with a thud and rolled over and over until I lay on my back, looking into the beautiful, blue-bird Virginia fall sky. Mike stood over me, laughing wildly. We laughed together for a long time.

I had inhaled the fire of freedom, where passion and possibility are limitless. And from then on, after my first release from that swing, way up to the ether, into nowhere, I have carried that feeling with me every step of the way—all the way through playing baseball, creating art, and living my life.

Hundreds of times over my two years at Glen Carlyn, I cannonballed from that swing, landing in dirt, leaves, snow, and mud, and I never sustained an injury to be concerned about. Mary Martin scolded me, but to no avail—I *had* to fly. And when she ordered me to sit on the wooden stool in the back corner of the classroom for being a "bad egg," I just closed my eyes and flew through the air, as free as free could be.

One of my first-grade paintings (1959), demonstrating balanced composition. I have always loved creating art. Being a creative is in my DNA. My teacher, Ms. Cora Worth, wrote in the "Remarks" section on my report card: "Scott is a good worker and interested in everything."

BLOOD

By May 1960, Mike and I had both turned six, and we returned to the baseball field with my dad. May is a mysterious month to me, representing the future and its inherent possibilities. Everything that slept under winter's snow dances to life. The flora and fauna have survived once again and are ready to bust out and paint the landscape. Boys take the tied string off their rolled-up gloves that have been soaked in linseed oil for months, with a baseball placed dead center in the pocket to keep it deep, and they start playing catch.

Just being at a ballpark was my favorite way to spend the day. Still too young to play in a league, I would retrieve foul balls and try to dig

out grounders and snag pop-ups when I could work my way onto the field. By the time I qualified for Little League, I intended to feel right at home on the diamond.

My father, Mike, and I were at Tyler Park to watch my brother, Frank, a 12-year-old on the Foxes team, play a game. We weren't alone. Virginians are generous, solid fans, and they support baseball players wholeheartedly. Their enthusiasm radiated through the overcast Saturday afternoon, as the sun's rays hopped across the grass through dappled clouds.

The field was rocky and neglected. Bats poked through the holes in the chain-link fence next to the team benches, making it easier for a hitter to pick his bat before going up to the plate to take his swings. Worn-out batting-practice balls spilled from canvas bags, and helmets, gloves, hats, and equipment littered the dugout.

Operations at the concession stand—made of wooden two-by-fours and plywood painted white, with a flat roof that kept the rain out— were a bit more shipshape. Here the mothers and sisters of the players worked hard to help finance the league by selling candy, soda, hotdogs, potato chips, Bazooka gum with comics, salted Virginia peanuts, and Cracker Jacks. All the parks used rectangular tin tubs with the branded-for-life, red-and-white Pepsi logo painted on both sides, where blocks of ice melted imperceptibly. Pepsi and Dr. Pepper bottles that had sunk into the top of the ice always refreshed better than the "floaters."

Sugared up and raring to go, Mike and I played catch, swung bats, and ran around the park and its noisy, boisterous bleachers. We walked over to the concession stand and each bought a red-hot with mustard and onions, a bag of chips, and a Pepsi. I scooped up the day's bent bottle caps, as I liked to collect them. The mothers were busy serving, wearing their 1960s sleeveless cotton dresses cinched at the waist by wide belts and big buckles, hair up in hairsprayed, bee's-nest *dos*, and colorful tennis sneakers to complete their stylish outfits.

As the last inning was wrapping up, we sat next to the concession stand on beaten-up stools, finished our chips, and took the last swigs of soda. My father, who worked every day, including weekends, stood near third base in his wingtip shoes and white, button-down shirt. He signaled it was time to head home. Mike and I pushed our stools back and raced to retrieve our gloves. Mine was by the players bench on the left side of the field. As I turned the corner of the concession stand, headed toward the chain-link backstop behind home plate, I pivoted

left to run toward the outfield. But as I planted my right foot into the dirt, my sneaker caught a stone. Tripping, I fell through the air.

Countless times I had fallen; this seemed like it would be no different. I'd hit the ground, maybe skin a knee or an elbow, brush myself off, and get back up, running. Not this time. Right before I landed, I saw the afternoon light reflecting off thick pieces of broken soda bottles scattered in front of me, particularly the base of a Pepsi bottle. Half remained buried in the dirt, and the other half, shaped like a three-inch pyramid, stuck straight up toward the clouds. With no time to adjust, my right arm came full-throttle downward to brace my fall. The glass reflected a small ray of light right before the tip of the pyramid punctured my wrist. Only the hardness of the earth ended Act 1 of my nightmare.

When I pulled my arm up, the bloodied bottle fragment remained floating in a pool of my blood. My hand flapped backward toward my elbow. The cut was thick and gaping, stretching from side to side, gushing burgundy-red. The sight was dreadful. Mike yelled, "Mr. Christopher, Mr. Christopher—Help!"

I tried to run to my father as he ran to me. Dizzy from losing so much blood and in shock, I wobbled, zigzagged, and stumbled. My eyesight faltered; my father became blurry. Distantly I heard people shouting. Mike grabbed me under my left arm, with my blood seeping into the dirt, turning it black.

Dad swooped me away from Mike like a bird of prey and pressed my hand back over the gaping gash, driving it into my chest to stem the bleeding. I was turning pale and losing consciousness. I had left a lot of blood on that baseball field. I could not think, but I remember feeling safe in my father's arms. While we didn't know it at the time, both my ulnar and radial arteries had been severed; had my father not stemmed the gushing blood from my wrist correctly, I could have died in ten minutes or less.

With no time to wait for an ambulance, another player's father, Mr. Russell Bertram, ran from the stands and unflinchingly assisted my Dad in carrying me up the hill to his car. He flung open the back door, and my father hurriedly positioned himself and me into the backseat. Dad continued to hold me tight, real tight. His white shirt and wingtip shoes were soaked with my red blood.

Mr. Bertram powered up his 1958 Rambler Ambassador, with its power-packed 327-cubic-inch engine, and we jetted off to the hospital

like a cobra strike. With all the blood loss, he knew every second was critical. Our makeshift ambulance stopped for nothing and nobody as this World War II veteran Army pilot put his foot through the 4-barrel carburetor, blowing his horn all the way to the hospital.

I slid in and out of semi-consciousness, and the trees and my dad's face looked smeary, like a Claude Monet-inspired dream. But I was about as far from a dream as I could be. Shock and pain made me delirious. We pulled right up to the emergency entrance, where a padded stainless-steel gurney and medical staff awaited me. Blood continued to spill as my father and Mr. Bertram carried me, my severed wrist still pressed against my chest, and handed me over, limp and disoriented. Laying me out on the colorless metal bed, they wrapped my hand, wrist, and arm in gauze, covered it all with a heavy, white towel, and laid my wounded wrist up across my heart.

Just before they wheeled me away, Dad gave me a loving hug—the one and only time in my life my father hugged me. Sadness poured from his eyes instead of tears. I could see the pain in my father. Oddly, as the gurney began to move down the hallway, I remember trying to mimic the sounds of my favorite cartoon character, Woody Woodpecker, pecking rapidly on a tree.

Although my mother did not arrive at the hospital until the operation was underway, I felt connected to her unwavering love and knew she was sending me every ounce of love in her being.

I needed an immediate transfusion, and they whisked me into a glaring and lonely

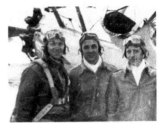

Russell Bertram (R) and a Boeing-Stearman Kaydet plane (1943).

I will never forget the valor Mr. Bertram extended to me that tragic day. He will always be one of my heroes. I have since realized that Russell Bertram, an Army Second Lieutenant Air-Corps pilot who served during World War II, revived his military training as a warrior on that fateful day in May 1960. Every action he performed was as if he were in a life-threatening battle, saving one of his men's lives. He shaved minutes off our trip to the hospital, rescuing me not only from the fate of dying from blood loss but also the less tragic scenario of the doctors needing to amputate my hand. Thank you from my heart of hearts, Mr. Russell Bertram. You saved my hand and my life.

operating room. Everything in my wrist was exposed: seven severed tendons, my median nerve cut in half, and both arteries dangled outside of my skin. My hand remained attached to my arm only by the ulna and radius bones, mangled sinew and muscle, and the skin on the top of my hand and wrist. One of the hospital's top surgeons, Dr. Allen Hall, was fortunately on duty that day. The sooner he started stitching my sliced tendons, ulnar nerve, and radial artery back together, the better the odds that my right hand would not be amputated. My ulnar artery was so damaged it could not be reattached. Over the course of a three-hour operation, Dr. Hall saved my right hand, but it was severely ravaged.

When I opened my eyes in the recovery room, I was looking straight into my mother's sad, blue eyes. Mom held my left hand and instantly bent down to kiss my forehead. She said, "I love you, Plucky."

Dr. Hall came into the room and pulled my parents aside. When he finished talking to them, I saw tears on my mother's cheeks. Many years later I asked Mom why she cried that day, and she told me he had said that my right hand would be extremely handicapped the rest of my life.

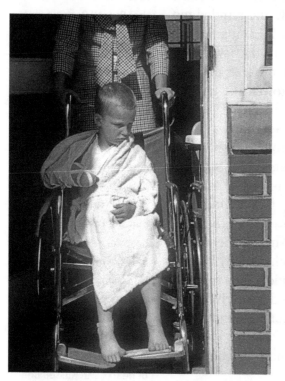

Mom wheeling me out of the hospital, four days after my accident.

In the weeks following my surgery, one consistently conscious thought came through crystal clear: I could never play baseball again with one hand. Bringing back my right hand would be up to me, no matter how long it took, how hard I had to work, or how much pain I would have to endure.

My resolve came from a previous trauma, at age five. The newspaper

headline read, "Scout Acts Fast when Flames Strike Brother." The article stated, "Frank rolled Scott away from the burning dead grass and smothered the blaze on Scott's flannel trouser leg with his jacket."

The burn scar on my right leg, running from ankle to knee, was nothing compared to the psychological injury inflicted by the trauma of seeing my skin melting away and exposing bone. Whenever I think about being burned so badly, it still hurts. But not only did I make it through, that initiation to pain set the bar so high that I learned to tolerate and accept pain as a part of my life. Consequently, I intuitively knew I could overcome my fateful wrist injury as well. While most regarded my accident as life-changing—something that would end my baseball dreams—my parents, Mike, his parents, and I refused to accept that outlook.

This time, however, rehabilitation would require a monumental team effort and years of dedication and focus. My father and mother led the way, giving me tremendous love and support. The Malone family stood right with us, especially Mike. Miss Diane Tinkelman, my favorite elementary schoolteacher and a fervent educator, also joined my lineup. As to what could be done and to what capacity, a coordinated and systematic program began so as not to push my hand and arm rehabilitation too quickly or too far.

My mother and Mrs. Malone taught me how to write with my left hand, which was no small task.

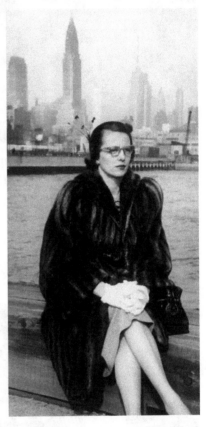

My mother, Ann, visiting New York City with my father in April 1942. She was an amazing person who taught me at a very early age, through her unconditional love, that anything was possible. I am beyond honored to be the son of such an extraordinary mother.

Injury Nips Young Diamond Star's Career

I spent all summer watching games with my arm in a sling and heavily bandaged.

Plucky Rookie Vows 'Comeback' at Age 6

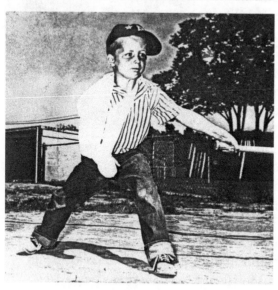

Taking one-armed batting practice, three months after my crippling injury (1960).

They showed me patience, and over time my handwriting became legible, although printing came more easily than cursive.

After I finished my writing and spelling work each day, the fun began. Mike took over from our mothers, and he helped me draw, color, and make small forms out of wire and wood. He poured out finishing nails on his father's workshop bench for me to pick up, one at a time, and put back in the Gerber's baby-food jar. Hammer, wire cutter, saw, screwdriver—at first, I used everything with my left hand only. Whether for the short term or the long haul, I would need to become ambidextrous.

When we heard my dad whistle, it meant our daily sports camp would begin: punting and place kicking the football; fielding grounders and flipping the baseball to Mike, who tossed it back to

my father; dribbling the basketball with my left hand; racing around our cul-de-sac or flat-out, straight-line sprinting. Dad also took me to the YMCA to swim, and that turned out to be a primary exercise that enabled me to move forward and become a baseball player again. Pulling my right hand through the water strengthened my entire hand, wrist, and arm.

Developing dexterity in my left hand for the easiest of tasks proved incredibly difficult. But it was my left hand or no hands, because even after the removal of my cast, dressing, and stitches, my right hand remained unable to master the simplest things, like tying my shoelaces or holding a fork or glass. I had taken for granted everything my right hand *used* to do. Rehabbing that hand and arm would take years of hard work. Doctor Hall had tied together all seven severed tendons, so when I pulled one finger in toward my palm, all my fingers came in as one. And with my median nerve cut in two, the feeling in my hand and fingers was severely compromised.

Worst of all, both arteries being severed resulted in diminished blood flow and circulation to my hand. This would restrict my muscle, hand growth, and bone density considerably. I would never again be able to pick up a baseball and throw it properly. I could only *push* the ball into my human claw. That's how it would be, for the rest of my life.

I knew—I hoped—the time would come when these challenges would be reworked and adapted to improve my eye-hand motor skills for *both* hands. But the rehab efforts were tedious and frustrating most of the time, in particular because it meant not playing baseball. Nevertheless, it was necessary, and I understood that. I repaid the dedication of these dear people with all the determination I could muster. And when I succeeded in one arena of mastery and moved on to the next, we *all* cheered.

Twelve long months dragged on before Dr. Hall gave my parents the green light, signaling that I could begin using my right hand to hold a baseball again. I immediately called Mike and asked him to meet me in the middle of the cul-de-sac with his bat and glove. I cradled the ball in my mitt as my right hand could not properly grasp it to make a throw.

We split up, and I tossed underhanded. Mike shook his head and said nope and came over to me. We examined my hand, and Mike immediately assessed that the only way I could set the baseball correctly to initiate a throw was to push the ball into my fingers. This would enable me to grip it with a very unorthodox claw-like configuration. Sadly, this would be

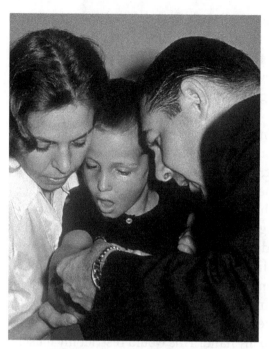

Dr. Hall and his nurse, show me my wound for the first time, in his office, one month after the accident. I cried, seeing my wrist so mangled.

how I had to throw a baseball my entire life.

Mike put the ball in my right hand and raised it above my shoulder, saying, "Now throw it." He did this repeatedly, even though I was going through the motions, pushing the ball into the air instead of throwing it. Two weeks later we started playing what resembled a normal kind of catch. Hitting, however, sent a seismic shock wave into my hand and up my arm, so I took lazy swings in the beginning, barely making contact. It took me months before I could find the strength to take a marginal swipe at a pitch.

None of these limitations mattered. My best friend and I were playing ball. Not knowing if I would ever be able to throw or hit again *by far* had been the saddest aspect of my injury and rehabilitation—and here I stood, a year later, *playing my favorite sport of all*—a happier kid could not be found! Mike helped me practice batting, and I kept the pain to myself, concentrating solely on being able to play again. If I did not strengthen my wrist and arm, I would end up a fan in the stands *watching* games instead of being a player.

Worse than the physical agony was the fear my skin would separate and my wrist would be dangling and start bleeding again. I eventually expressed my fears to Mike, and he would examine my wound, which looked like a chainsaw had hacked through my wrist, and he'd say, "It's okay. It's gonna hold, one day it will be as good as ever." I always believed Mike; he never once lied to me.

During this time, my mother started to take me duckpin bowling three or four times a week at the local Falls Church alley. She also

introduced me to pinball machines in the amusement hall there. Oddly enough, this wonderfully complemented my rehab, working both sides of my brain in tandem, developing the quick, eye-hand motor skills essential for hitting and throwing a baseball.

As my right hand gained dexterity and strength, and we reintroduced additional focused tasks, I became more determined to prevail. I mastered pinball, especially playing the game called "Cowboy." The lights were a-flashin', with bells and whistles going off, as my fingers pressed magic into those flippers. I really enjoyed sending the silver ball all over the table, working the bumpers, and racking up free replays. I truly reveled in the chaos of pinball machines. At a dime a game, I could stay in that amusement hall for two hours and spend no more than 50 cents.

While I played on, my mother would sit there in the bright-red, molded fiberglass, retro cafe chairs, usually knitting argyle socks, scarves, and mittens or crocheting large throw blankets. Her artful creations combined bright colors and striking geometric patterns. Every now and then she might challenge me to a match, or we would work one flipper each, playing the same game. She always showed me patience and caring, although the time would come when Mom said, "It's time for us to go home, Plucky."

Because of my accident, I needed to relearn countless functions that previously seemed automatic. My brain's circuitry rewired its processes of thinking, input, and recall, entirely re-engineering the mind-body connection. It forced me to become a visual learner, and I believe this is why I am so curious. I used the right side of my brain more, which seemed to guide me into excavating and exploring my creative self. Over the years, this enhancement in consciousness has taken me deeper into understanding myself, loved ones, those around me, the universe, and our human experience. For me, as complicated and confusing as my journey has been at times, I would not alter a moment, a step—or a fall—along my path. In a surprising way, the bloodied earth of the Tyler Park diamond became a launchpad for my creativity and my life's trajectory.

ORGANIZED BALL

Age eight is a transition year for many boys interested in athletics. And for those like me who yearned to play on a baseball team, the proving

ground was the Little League field. Eight- to twelve-year-olds competed on the AAA and AA leagues; later, only the most talented players, aged nine to twelve, vied for spots in the "majors."

I turned eight in 1962, and I marked off the days on the kitchen calendar, ticking down to tryouts. I had practiced hard with my father and Mike for two years, pushing the rehabilitation of my right hand, wrist, and arm so I could compete for a spot on a triple-A team. Mike and I did not want to play in the AA league. This audition would be my comeback, even though I had never played organized ball.

The skill levels of the players and their mental approach to the game, at such a young age, were noticeably weaker in AAA and AA than the majors. For many, making the grade was more about playing to have fun, to be on a team, and to be with friends. Yet even on this level of organized baseball, the skills to be evaluated are the same as in the big leagues: fielding, throwing, hitting, hitting power, and running speed. Coaches assessed a boy's talents by assigning a rank from one to five for each "tool." The total score pretty accurately reflected the player's overall athleticism. Then coaches filled their team rosters, and the players practiced for three weeks before starting their season.

College recruiters and major league scouts have used this same process for decades, except the evaluations become more detailed using a range from two (poor) to eight (excellent) to assess players. As a coach builds a team, he must be keenly aware of the strengths and weaknesses of each player, particularly the pitchers. The general consensus among baseball minds says that the hurlers on the hill dictate about 80 percent of the outcome of a game. If your teammate on the mound is painting the black rim around the dish and finding his spots in the strike zone, there's a strong chance of being victorious.

However, the five skills previously mentioned do not evaluate your intense quest for competition, a desire to be the best player you can be, how much you love to win, and how you are affected when you fail or if your team loses. Do you turn into a spaghetti noodle at home plate when the pressure is on for a big hit? Can you throw that strike when the bases are loaded, the count is full, and your team is leading by one run? Does the ball pass through your legs when you have to field a grounder, with two outs and the game is on the line?

All the way through college and playing professionally, the fundamental questions remain the same. And a shrewd coach knows his

accurate evaluations can make all the difference in building a winning team. By then, of course, you carry a reputation for the intensity with which you play and whether you have big-game potential. Baseball is one of the most multidimensional and complex sports in the world. You can be a hero and a goat in the same game—heck, in the same inning.

These are some of the lessons I began to learn when my first try-out Saturday finally arrived—a big day not only because it would be the measure of my rehabbed hand, but also because this was "home plate" for all my baseball dreams. Many times over the course of my rehabilitation, I assured my father that one day I would swat the "Big Home Run" in the final inning of the final game to win the championship—and that my right hand would contribute to that big swing. He would ask me, "How far are you going to hit it?" and I would always say, "Way over the fence, Dad."

I proved myself that day; my handicapped throwing arm was not a withered twig and my legs were not croquet wickets. Though I didn't know my score, by Sunday I was on my first baseball team, the AAA Coyotes, and on the path to fulfilling my dream.

My father, proud of my hard work and determination to rehabilitate my hand and arm, put together a surprise for me. After tryouts, he revealed it, though he would have delivered his gift whether I made a team or not. On our drive home, I saw an envelope leaning up against the windshield, emblazoned with the Baltimore Orioles logo.

"What's that?" I asked, my eyes wide.

Dad handed it to me, and I pulled out an official letter from the Baltimore Orioles: a personal invitation to visit and work out with them before a doubleheader against the Cleveland Indians on May 30, 1962. I nearly exploded. "Are you kidding? Is this for real? Am I really going to get to play baseball with the Orioles *on their field*?"

My favorite team was the Baltimore Orioles, partly because my parents were Baltimore natives. But also, a lot of Orioles history flowed through our family, including my great-great-uncle Wilbert Robinson, who managed the Orioles in 1902. In 1903 the Orioles moved north to eventually become the New York Yankees. And in 1945, Uncle Robbie became an elected member of baseball's most sacred shrine, the Hall of Fame. I was an Orioles fan by the ancestry of my DNA.

Dad said the Orioles heard about my hand injury through a friend of our family, and they wanted me to play ball in Memorial Stadium

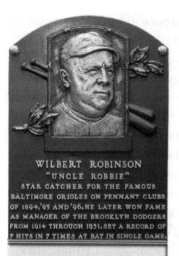

WILBERT ROBINSON
"UNCLE ROBBIE"
STAR CATCHER FOR THE FAMOUS
BALTIMORE ORIOLES ON PENNANT CLUBS
OF 1894,'95 AND '96, HE LATER WON FAME
AS MANAGER OF THE BROOKLYN DODGERS
FROM 1914 THROUGH 1931. SET A RECORD OF
7 HITS IN 7 TIMES AT BAT IN SINGLE GAME.

Uncle Robbie was a former Oriole star catcher, who played for the O's when they won three straight titles, 1894-1896.

• He managed in the big leagues for 19 years: 1 year with the Baltimore Orioles and 18 seasons guiding the Brooklyn Dodgers.

• Uncle Robbie holds an overall record of 1,399 wins against 1,398 losses

• Two of his teams played in the World Series (1916 and 1920).

• For 83 years he was the only big leaguer who had 7 hits in 7 at-bats in a 9-inning game. Uncle Robbie also had 11 RBIs in that contest on June 10, 1892.

• He was featured on the August 25, 1930, cover of *Time Magazine*.

on 33rd Street, sit in the dugout with the players, warm up on the field, and be a "Big Leaguer for a Day." This was beyond SUPER! Unable to contain my excitement, I ran into the house to show my mother the letter. Next I zoomed over to Mike's house to share my great news with him, also a fan of the Orioles. Mike and I both liked that they started their reign in Baltimore in 1954, our birth year.

Thrilled, we pulled the Orioles cards we had collected to research and learn about the players I would meet. Avid baseball card collectors, Mike and I studied each player's history on the backs of the cards and traded them among our friends after school. Another Hall of Famer, "Say Hey Kid" Willie Mays, number 24, was my favorite player, then the center fielder for the San Francisco Giants. I traded hotly to own his card, and I possessed a stack of them. Now, though, as I began swapping for as many new Orioles cards as I could get my hands on, my Willie Mays batch dwindled rapidly.

You could build your collection through four ways. One: pay cash. *I will give you 15 cents for your Frank Robinson.* Two: trade. *I will give you my St. Louis Cardinals 1959 team card for your 1962 Orioles Brooks Robinson issue.* Three: draw a line for everyone to stand behind. Next, holding the card horizontally between your thumb and index finger, you flick it, and it would roll through the air like a tumbling box kite. When a player's card landed on another's, even with the smallest measure of

contact, the dominant player scooped up all the cards and they were his. The fourth way, which netted you the most but also carried the highest risk, was to hold the corner of the card and fling it out like a Frisbee. Cards would twist and turn, sometimes landing 15 feet away, and the outcome was mostly up to fate. Like method number three, if yours landed on another's, all the cards went into the winner's shoebox.

As my collection of Orioles cards grew, Mike and I rehearsed for my visit. We picked a player, and Mike would impersonate him when we were playing catch, so I would be ready for my big day in Memorial Stadium.

May 30, 1962, a Wednesday, delivered a perfect spring day. My father picked me up early from school to drive to Baltimore. The red-brick stadium felt *meant-to-be*, like I belonged there. Far from being ordinary spectators, Dad and I were guests of the Orioles, which meant we parked in the players lot and would make our way onto the field through the team dugout. We went to will-call and were escorted to the locker room entrance. I carried my glove and proudly wore my Coyotes hat.

Being in the Orioles clubhouse was a jaw-dropper. My favorite Orioles players and their wooden lockers surrounded me. The O's seemed familiar because of the cards I collected. A stool near each locker allowed the players to sit down and put their spikes on, amid the big league gear scattered about. And then there were the players, dressed in uniforms with *Orioles* written in black and orange script on the jerseys. Theirs, unlike my Coyotes team rayon tee shirt, were 100 percent wool.

The team manager was number 45, Billy Hitchcock. He had played in the big leagues as an infielder for nine years and, at this point, managed for two. His final record guiding the Orioles tallied 163 wins to 161 losses.

Some of the players were out on the field, as batting practice got underway. Frozen around the question of what I should be doing, I watched a gigantic player walk toward Dad and me. The sound he made snapped me out of it. I had never heard spikes walking on concrete before; it's a bit like driving six nails with six hammers through tin at the same time, then six more, each step six more nails. Players must keep their six spikes flat on the slippery flooring, so they walk slowly.

I recognized him from one of my baseball cards: Jim "Diamond Jim" Gentile. I pulled my eight-year-old shoulders back a bit and looked up

in reverence at this super-Oriole. He stood six feet, four inches and carried 215 pounds of pure muscle. In 1960 he made the All-Star team, and in 1961 Diamond Jim tied Roger Maris of the New York Yankees with the most runs batted in for the season—141—and ended up third in the American League's ranking for the Most Valuable Player award, behind New York Yankee greats Mickey Mantle and Roger Maris. He paused right in front of me.

"Hi, Scotty, my name is Jim Gentile, and I play first base. We're gonna be starting our game in a bit. Do you think you could help me warm up out on the field?"

He extended his right hand, and I hesitantly put my right hand out in reply, because it still hurt to shake hands. I also felt sensitive to the way my scar looked. The team had been briefed about my injury, so Jim showed no surprise or awkwardness. He next shook hands with my father. Still in his three-quarter-length baseball sleeves shirt, Jim went to put his number 4 jersey on.

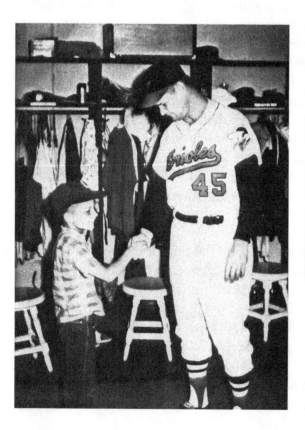

Billy Hitchcock went on to manage two years for the Atlanta Braves. His career record as a manager in the "bigs" ended with 274 wins against 261 losses. In professional baseball, if your record is above .500, you are considered successful. Billy had a 13-game buffer after 535 games at the helm.

Billy Hitchcock and I meet in the locker room. You can see my right hand and arm were very frail and weak at this age.

Right before we started out to the field, Billy Hitchcock stopped us. "I've got something for you, Scotty," he said, and handed me a brand new baseball all the players had signed. What a way to head out to play, with my own Baltimore Orioles, autographed ball in my pocket. Wow!

Clink, clink, clink sounded as Jim led the way, holding his lobster-claw first baseman's mitt. In the runway, closing the gap between concrete and earth, the dugout steps emerged and I saw the field from the third base side, thrilled to enter my first big league stadium, and from the Orioles dugout no less!

Jim asked if I wanted to play catch. I said *sure* and climbed the steps to the lip, where I paused for a moment, wide-eyed, absorbing how gigantic the park seemed: the fans, the vendors, the press box, pure-white bases, players warming up their legs, pushing off the foul lines and running toward center field, the balls thumping into their mitts. This was it, the big leagues. Crystal clear, I saw My Dream material-ize: *I would play ball for the Orioles one day, and I would jack my ninth-inning moonshot to clinch the championship.*

My first steps onto the dirt and grass were the beginning of my dream and toward becoming a young man. What a *heck* of a stride to take. We played catch, and Jim started to roll me grounders. I fielded them and threw the ball back. My father, too, enjoyed himself—snapping pictures, composing his photographs, and watching me embrace such a special day.

When the time came for the players to begin batting practice, the fun and games wound down; this is true everywhere in baseball, no more so than in the big leagues. Billy Hitchcock asked me to sit with him and the others on the bench. I still wore my glove. He asked how my hand was feeling.

I said, "It feels okay," and I flipped my palm upward so he could see my scar.

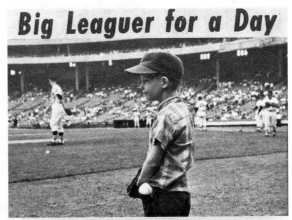

Big Leaguer for a Day

HIS PRECIOUS AUTOGRAPHED ball peeking from his pocket, 8 - year - old Scottie Christopher, of Pine Springs, surveys the field before his new found friends, the Baltimore Orioles, go into ac-tion.

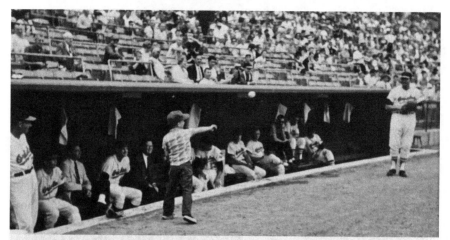

THEN, APPARENTLY SATISFIED with the work of
the groundkeepers, he lends a hand by warming
up first-baseman Jim Gentile in front of the Bal-
timore dugout.

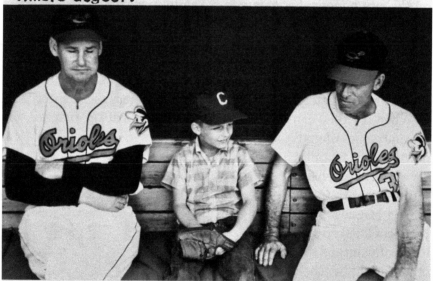

FINALLY, IT'S TIME FOR A pre-game discussion
of strategy with shortstop Ron Hansen, while
Oriole manager Billy Hitchcock quietly listens
in. The Orioles, incidentally, have an option on
Scottie's service at a slightly future date.

(Photos by Frank Christopher)

I kept looking out toward the field, as I did not want to see his expression; I hadn't gotten used to people grimacing, faced by such an appalling sight.

"What do you like best about baseball?" Billy asked.

"Just about everything—except I don't like striking out."

He took that in. "Not many ballplayers do. You won't be playing ball for long if you strike out a lot. But what do you like best?"

"Scoring runs, and I really like to hit and field. But I just love to run fast. The faster I run, the more I score, the better chance my team has of winning. And when I touch home, it makes me happy."

Billy didn't reply; he merely nodded his head. He asked, "You think you are fast enough to race one of my players?"

I thought about it. "I don't know," I said, "but a foot race sounds good to me."

Jerry Adair, who signed with the Orioles in 1958, had finished his rips, and he came back to the bench for his glove, to field some grounders at second. Billy said, "Jerry, this is Scotty, and he likes to run. You think you can give him a race?"

Jerry answered, "Sure, Billy," and we headed out toward left field, in foul territory.

Home plate looked a mile away from where we paused, and Jerry scraped a line in the dirt with his spikes. Then we walked 30 yards farther to our starting point. He told me to count to three and we would take off. *One, two, three*, and we launched out. My black Converse high-top tennis shoes were firing. Jerry made sure he stayed a step behind me so I would win.

When Jerry trotted out to second base, my father and I returned to the dugout. While watching batting practice, Dad asked, "You're having quite a day out here with the Orioles, aren't you?"

"This has been so much fun. Look at all the people in the stands—will they come to watch me when I get bigger and I'm an Oriole?"

"Sure they will." But his voice hitched when he answered. Dad knew, more than I could fathom at the time, how my hand would challenge his son's dream and his life.

Jerry was an exceptional defensive second baseman. He once held the major league record for fewest number of errors in a season played at second (5), as well as 89 consecutive games and 458 consecutive chances without a misfire.

When I went to the bench and picked up my ball and glove, Billy Hitchcock asked me how I did in my race. I told him, "I am very fast." My father and I thanked Billy, and he said, "Keep scoring runs, Scotty."

Finding our seats behind home plate, Dad and I watched the games, and I cheered loudly when Diamond Jim came to bat. The speed on the ball and the way the hitters smashed it just amazed me. The Orioles split the twin bill that day, losing their first game 7-0 and winning the second by the exact same score.

On our way out of the park, with my weekly allowance and chore money I had saved, I bought myself an Orioles pennant, a bobble-head Orioles baseball player, and two small, wooden bats with *Baltimore Orioles* printed in small block letters, painted in gold. One of these would be Mike's.

Two local papers wrote accounts about my visit to Memorial Stadium, and the *Fairfax County Sun Echo* published "Big Leaguer for a Day," with the three photographs on pages 23-24. What a great day to spend with my father. And this was an extremely kind gesture from the Baltimore Orioles to an eight-year-old ballplayer who had left a lot of his blood on a baseball diamond.

My moments with these big leaguers ignited a fire in me that burned intensely for many years. I would "Dream Big, Dream On" about becoming a professional baseball player for the Baltimore Orioles, battling through all the emotional and physical pain I would suffer, through the blood I would leave on the field and on my bat handles, and through endless practices and games before I landed there. I etched these vivid and grand big league memories deep into my baseball being.

FIRST TROPHY

The Coyotes won the 1962 AAA League Championship—my first team and championship on the journey toward my dream. As I played on various clubs over the years, I never forgot how wondrous it felt to receive a trophy at the annual awards ceremony. The credit that year chiefly belonged to a ringer named Timmy Arnold, a 12-year-old who could have played in the majors, but he devoted more time and focus to mastering golf with his best friend, Peter Oakley. They both were my friends and neighbors in Pine Spring. Timmy could *smoke* a baseball, and he took us to the crown.

Mike was on the Foxes, and we had a fun summer playing ball together and against each other, testing our talents at different positions, and swinging for the fences. Mike was lanky, with big hands. I am sure he would have made an ace hitter or pitcher if he wanted to. Smart hitters and pitchers go a long way in baseball, and Mike has always been an academic all-star.

I developed my own smarts that first season of organized ball, and I began to gravitate toward the way batters can change the course of a game. But my injured hand remained small and incapacitated. My damaged right thumb never became able to bend properly around a bat, in part because of the way the tendons healed and knit together. Also, there was very limited blood flow, which restricted growth dramatically. Consequently, I gripped the wood with four normal fingers, four crippled fingers, one fully operational thumb, and one almost-nonexistent thumb.

In batting, your bottom hand (for right-handers, this is the left hand) is the guide hand, moving your bat to the correct horizontal plane to make direct contact to drive the baseball. Your bottom hand also pulls the bat through your swing. *Driving* a baseball, however, is hitting the ball square on the nose. Done properly, the ball will find the holes in the infield for base hits, because it takes at least a step away from the infielder's range to his left or right. And if you drive the pitch into the alleys between the outfielders and it scoots beyond them, you will be standing on second or third with an extra-base hit.

Your top hand, the driver, delivers the clout because the handle lies in the palm of your hand, which drives the wood through the baseball when your bat makes contact. The most power for a hitter comes at the moment when his top hand turns the bat over. That split-second jerk of the wood colliding with a baseball coming in at 80-plus miles an hour, hit with optimum contact, will send the horsehide sphere flying all over and occasionally out of the ballpark.

Bat speed, a power palm, and a strong set of hands and wrists are essential for a top-notch hitter. My right hand's power and grip never returned to being remotely close to standard. I wonder sometimes how much better I might have been without such a serious injury. If I

> Peter Oakley later went on to win the 1999 PGA Senior Club Pro Championship and the Senior British Open Title in 2004. His older brother David, also a pro golfer, qualified for the US Open in 1973.

Taking "Big Swings" always added an immensely fun dimension to playing baseball. As this photograph shows, I started swinging for the fences at age eight, playing for the Coyotes in 1962. My mother, who loved to come to my games and cheer me on, very rarely missed one. One of my life's greatest treasures is seated in the center of the backstop wearing a white blouse.

could have used my top thumb and a regular hand, would I have been a natural hitter, who turned a baseball into sawdust when I mashed it? Conversely, did all the sports and rehab over the years make me a stronger, more resilient player? And without all that intense work, would I have become less of an athlete?

Truthfully, I don't think I would have been as gifted a sportsman, overall, without the years of rehabilitating my wrist and arm. The compensation of having to use my left arm so much turned my forearm into a jackhammer. My balance and athleticism also received above-average development, and these are essentials on a baseball field if you want to be a shortstop and a superior hitter—as I did.

Still, I estimate my hitting never exceeded 80 percent of what it would have been without my hand injury, and my throwing never topped 85 percent of its potential. Because there is no webbing between my thumb and index finger, I needed to choke the baseball, which does not allow it to roll off the fingers. So I counteracted this by training hard

as a runner and developing my speed into the top one percent of the competition. When I put a ball in play, the pressure was always intense on the defense, because the slightest bobble or hesitation with a throw, and I arrived safely on first. Over my many seasons as a baseball player, I scored runs—lots and lots of runs.

I am talking with George Depalma, my dedicated Coyotes coach before our game (summer 1962).

To be number one burns inside a competitor, regardless of the odds. Among my male friends and classmates, validation was quantified by how well you performed in sports, in the classroom, and in extracurricular activities. Being the best on the squad or being tops academically drove our efforts. Boys held back a grade felt less of themselves. If you did not make a team or see-sawed back and forth as a first- and second-stringer, that too created a sense of "less than." If you quit, then of course you might not reach your highest level of accomplishment in your quest, though you might excel in other personal pursuits. There are many pathways in the maze to becoming a man. Excelling in competitive arenas remained front and center for me. I genuinely loved competing. Beyond pushing myself hard to reach my highest potential, I truly had fun going head to head against my opponents.

The challenge of going into fourth grade as an eight-year-old was tinged by my apprehension about a new sports event that would test my athleticism: a competition, engineered by the Ford Motor Company, called Punt, Pass, and Kick (PP&K). Ages eight to thirteen could participate, and Mike and I champed at the bit to see how well we would fare against a rather large pool of competitors from our northern Virginia district. Mike had the throwing arm and I had the punting leg and kicking foot. Again, my hand injury made it impossible to properly grasp and throw a football.

Mike and I designed all kinds of games that made it fun to perfect these three skills. My father would take us over to our elementary school to practice on the playground fields. We liked to go head to head. The top score won. I know for myself, and feel comfortable speaking for Mike, that we never competed jealously; we never wanted to *be* the other. We just were the best of best friends I could imagine. We reveled in each other's accomplishments, then and today.

When the Saturday of the Ford PP&K competition arrived, Mike and I arrived at the football field early in the morning to compete. Leaves crunched under our feet and the still air carried a crisp chill—a perfect fall day. Lots of boys turned out for the different age groups. Our parents were there, along with all the other moms and dads, Ford officials, and judges.

A centerline was drawn down the hash marks of the field, and each boy had one punt, one pass, and one kick from behind the starting line. Judges used long tape measures to calculate the distances covered and added up all the points, one point for every foot advanced, and one point deducted for every foot the football veered off the center line. The top three scorers received awards.

Judges called names in alphabetical order, so I went before Mike. Punting, the first test of the competition, was my strongest skill. Even at eight, I could put a spiral on my punt. When the round finished, I led my group.

Passing came next, by far my weakest football ability. Because of my handicap, I had to throw in an unorthodox manner. When I sent my pass into the air, it wobbled and sank my total score toward the bottom of the competition. Mike launched his a long way and right down the gut. After two rounds, he remained in the mix to win it all.

Finally, place kicking wrapped up the event. As I took my turn, I remember it as the first time when my focus as an athlete became so clear that I was in an isolated vortex of concentration on what had to be done to succeed. The more your mind is able to master the "Vortex of Concentration," the greater success you will have living your dreams. The key was to strike the football right in the center, a bit low, with a square toe, making contact at the correct angle. Nothing else occupied my mind. Tomorrow did not exist—the outcome of winning an award in this competition rested solely on this kick. It was game time.

I nailed it—I was a *gamer*! Gamers love being called on in pressure situations. Gamers strive to be in the position to win. Gamers feel ill when they let down their team and themselves.

Kicking a winner placed me third in the competition, and Mike took second place. At the awards ceremony. he received a Washington Redskins (today, Washington Commanders) helmet, and I accepted an autographed team football. It took less than a month for that pigskin to look like it had been butchered. We passed, punted, and kicked it until not one autograph was legible, and the black inner tube popped out through its side.

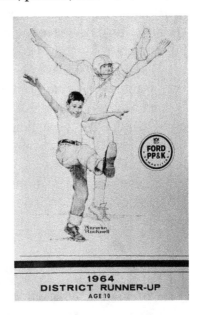

1964
DISTRICT RUNNER-UP
AGE 10

I went on to win or place in the next five PP&K competitions, up until the cut-off at age, 13. In 1964, I qualified for the district finals and placed second there. My compromised passing kept me from winning this competition. Had I won it, I would have competed during halftime, on the 50-yard line of a Washington Redskins (today, Washington Commanders) game, with that winner then competing at a later date for the PP&K national championship.

BLOOD BROTHERS

Mike and I enjoyed the best birthdays—they always ranked a fun factor times ten+++! Since he was born 13 days before me, there was just a large enough span of time that our families celebrated with a party for each of us and all our friends. At my parties, up until I turned six, boys arrived in bow ties and the girls in taffeta dresses with black-and-white saddle shoes. Of course, I received many packs of new baseball cards as gifts. My parents would give me sports gear, art supplies, or games and puzzles from the local hobby shop. The loving smiles my mother and Mrs. Malone always sported during our parties, the joy they showed in creating elaborately decorated, multi-level cakes—I'm pretty sure they relished our birthdays more than their own.

Books were regular birthday gifts too. I enjoyed adventure stories, and I liked reading about and seeing pictures of the Wild West. Sometime in the spring of 1963, a particular tale captivated me, about how the Native Americans became blood brothers to establish alliances among the tribal members. I discussed this with Mike and he agreed: we were best friends, but being blood-brother best friends would be even better.

We chose Mike's house for the ritual. After sharpening my pearl-handled penknife on Mr. Malone's whetstone, we headed out to the beautiful oak tree in their front yard, which stood on a small knoll bordered by a flagstone walkway adjacent to Mrs. Malone's azalea garden. There, we bared our wrists. For me it had to be my left, as I never, ever, wanted to see blood come from my right wrist again.

I cut Mike's first: a small incision just below his palm. Blood oozed out. I handed Mike my penknife and he did the same for me. With both wrists oozing, I put my wrist on top of his and we pressed them together: blood brothers, friends for life.

Oh, and we fed great ambitions! Finally eligible nine-year-olds, we tried out for the Little League majors. To make the majors at

Mike (left) and I, having fun at my house (1961).

age nine was big—really big—and that's where we set our sights. Mike and I would have to be exceptionally good to take the slot of an older player.

When the snow and ice melted for the last time in 1963, my blood brother and I played a lot of baseball in the street, throwing to each other and hitting balls out of the cul-de-sac into our neighbors' yards. When the baseball's horsehide cover began to flap, we peeled it off, which left a mass of gray-and-white, wound cotton yarn to unravel until we came to the small center of cork encased in two thin layers of rubber. We bounced these on the road, swatting them on their way back down. They traveled quite a distance.

Before long, the time came to pull that new, beautiful, white baseball, wrapped in onion paper, out of the Rawlings box, check the red threads, spit on it, grind it into our palms, and start playing catch again.

That spring we rode our bikes and did lots of things together, like always, but something was shifting. Looking back, I can see Mike spent more time reading and didn't come to the baseball field with my father and me as much as he used to. He seemed sad. I learned later he had been instructed not to tell me the secret, but inevitably the day would come, the minute would come, and the second would come when I would understand.

The day arrived: Mike and I were riding our bikes. We rode up to his house and let our bikes fall onto the grass, like so many times before. Mr. Malone opened the screen door and called us inside. I walked into the living room and saw my parents and Mrs. Malone seated on the couch. All four parents, fearing the news would crush me, gathered to support Mike and me. Mike looked helpless, sadder than ever, as sad for me as for himself. I knew this was it, but I wasn't sure I wanted to know their secret.

The minute came: Mr. Malone's thick eyebrows lifted a bit toward the pine-board ceiling. As an eye-to-eye type of man, this was uncharacteristic. He inhaled a deep breath and exhaled like a silent whistle. "Scott, you and Mike are best friends, right?"

"Yep."

"And you and Mike will always be best friends."

A brief pause ensued, and then the second arrived: he said, "I want to tell you I have a new job in California, and we are going to be moving in early June."

Now my eyebrows shot up to the ceiling, and I cautiously asked Mr. Malone, "You won't be here anymore?"

"That's right, we are going to be selling our house."

Unable to fully absorb this disclosure, I turned to my blood brother, who seemed frozen in place. I looked at our mothers and fathers, all still seated but leaning forward. I could see everyone felt wretched for Mike and me. Both mothers stood, hugged us, and left the room.

Two fathers and two sons remained. We did not cry. Blood pounded in my ears, and suddenly the news became an emotional harpoon that pierced my heart. My best friend, who shared almost every day with me, was leaving—moving far, far away. I could not imagine a day without Mike. My greatest friendship was coming to an abrupt halt.

The dads talked about how we would be able to write, call on the phone, and visit each other. *Think about how much fun it will be to go to California!* None of that made it through my polar ice freeze. Never before had I experienced such a wounded heart.

Mike asked if I wanted to play catch. I said no. Then my mother and Mrs. Malone returned. It was time for me to go outside in the warm, sunlit fresh air and just keep breathing.

The bowling alley with my mother once again became my refuge. We bowled, and then she would sit and read while I worked the pinball machines for an hour or more. I wanted to be alone, thinking about Mike moving all the way to California, 2,500 miles away. As May drew closer to June, Mike and I still played ball and kept seeking adventures, but the boxes in his house kept piling up as those dreadful days slowly ticked off.

With photographic winners always on my father's mind, he brought Mike and me with him while he drove around, exploring rural Virginia scenes, to find an artful, exhibition-worthy composition. Churning up dust on a dirt road, he finally spotted the setting. My father had instructed Mike and me to wear red for impact. The three of us walked through the field to a magnificent, zigzagging farm fence that stretched up a hill. After posing us on the top rail of the fence that afternoon, he patiently bracketed many compositions, creating an image that became a salon winner, "On The Farm." This was one of the last things we did together. And for my entire life, that image has remained one of my favorite photographs.

Too soon, I was helping Mike pack. Sad to be leaving, Mike also felt excited about his family's new adventure. If he were living a century earlier, when pioneers forged new frontiers, heading west, he would have been leading the wagon train.

Our time together wound down. During our sleepovers, we watched a lot of late-night television, especially Johnny Carson's *The Tonight Show* on NBC. When the black, white, and gray dartboard showed up and that mosquito-buzzing-in-your-ear noise filled the living room, we would go to bed.

June 10, 1963, arrived. I had slept over at Mike's the night before. The early morning sun woke me up, and I walked home. I waited, watching from my bedroom window the activities of those final moments at the Malone house. Their belongings gradually filled up the moving van in the driveway.

The Malones loved everything about adventure, and I knew they felt joyful to be packing up their covered wagon. My second family was more than ready to push those big metal horses under the hood all the way across the country to face the unknowns that make life, and a lot of America, what it is: a nation of pioneers, families of adventurers, warriors of the unknown, and individuals who pursue and treasure freedom.

I trudged up our hill, past Mike's oak tree, and stood at their open front door. The first person I saw was Mrs. Malone, a woman who had touched my heart and helped shape my character. She gave me a tight, loving hug. Mike came into the kitchen holding a brown paper bag. He opened it to show me the gifts: all his Orioles baseball cards, stacked and rubber-banded, and the "phones" we made out of Campbell's Soup cans and string, which we had stretched from our bedroom windows, almost 225 feet apart—that actually worked. I told Mike I would let our snapping turtle go. We had been raising "Snapper" in my downstairs bathtub. Mr. Malone entered the kitchen and shook my hand. My blood brother and I sadly said goodbye. We hugged each other and I did not want to let go, but the time had come for life to split us in two.

I walked home alone, my idyllic childhood finished. I lay on my bed, staring out at Mike's house. The Malones came out onto their walkway, carrying luggage. Mike's father had a mover take a picture of his family standing in the middle of their yard, house in the background. Mike, wearing his Foxes baseball hat, stood in front of his parents. When

they put their suitcases in the trunk of their Thunderbird, my eyes started to well up.

As the car rolled past the for-sale sign and crept around the cul-de-sac, it reached my house. Leaning forward in the backseat, Mike looked up at me. From his window to mine, we exchanged one last wave. Tears crashed on my pillow. Mike was never coming home.

That afternoon I sat under Mike's oak tree, holding the brown paper bag full of baseball cards, watching the movers bolt the van doors shut. They rumbled away, leaving a stone-still shell of a house. I felt sick, like I was sitting in a cemetery, and memories created the headstones. My sadness knew no measure; it was very, very, deep.

When my tears dried, I examined the stack of cards from Mike. The Orioles, I knew, were struggling and losing games, but they would rally. I was certain. And then I remembered it was time for me to make the majors. I would work hard and dream that one day I would become a Baltimore Oriole and smash my championship home run in the ninth inning of the final game.

I kept in touch with Mrs. Malone for almost 50 years. I never saw her again, but always around the Christmas holidays she would send me photographs, clippings, and updates on Mike and her family. I enjoyed sending her news as well. I saw Mr. Malone one more time in my life—a rock of a man and a significant influence in my life—when he visited Washington, DC, in 1987. Soon thereafter Mr. Malone, one stellar father and man, passed away at his home in California.

As for Mike, once you love someone and they are in your heart, they never leave that sacred home, regardless of the miles separating you or the amount of time marching across the great frontier we call life. Thankfully, Mike and I would see each other again along the trail.

For better or worse, my days would never be the same following that afternoon. Over the course of our boyhood friendship together, Mike had given me the greatest gifts a best friend, a blood brother, could. It is impossible, as boys evolve into men, not to take those gut punches hard. They knock every bit of wind out of you—and more. But then again, life is about change, and change in life is among those constants that can always be expected. In difficult times it will drop you on the tracks, and if you don't get up, well, that life-train keeps chugging and moving forward. It stops for nothing and no one.

This winner, titled "On the Farm," was made by my father.
It would be the last exhibition photo taken of Mike (left) and
me before my best friend moved to California.
Chantilly, Virginia, May 1963.

Tears, Gems, LOVE

When your tears crash hard into the floor,
when the moment is somehow right,
whenever that may be,
LOVE will turn them into gems
that eventually sparkle forever and ever,
bringing beauty to your life that is LOVE.

2ND

INNING

OF TEAMS AND COACHES

Little League Majors, 1963

Having worked doggedly with my parents and Mike over the previous three years, I faced major league tryouts with confidence. I needed every ounce of resolve I could muster: my skills would be tested against many players who had been in AAA for the past several seasons; the competition would be stiff. I only weighed 65 pounds—far below the average weight for the majors. And my throwing hand and arm remained another serious challenge.

The majors offered a better training ground than AAA. But in baseball, as in most sports and life in general, you are only as good as your last at-bat. Hit a homer and then have an extended slump at the plate, and you will be a second-stringer with calluses on your buttocks from riding the bench.

During tryouts, neither age nor alphabetical grouping separated us—we all mingled in one broad pool, demonstrating our baseball talents, one player at a time, one skill a time. With so many of us, it took several hours from start to finish to complete the process. The coaches carried clipboards to take notes and make their evaluations. Each time the whistles shrilled, I moved to another position on the infield, where I performed well.

As expected, my throwing arm was weak. I made consistent contact when hitting, but I did not deliver much power. With running, though, I excelled. Being one of the fastest there gave me an advantage, because coaches like players who can put the ball in play and speed to the bases. This pressures the opponents' defense and forces the fielding and mental errors that put runners on base and moves them up to score runs and wins games.

I waited by the phone after the tryouts, hopeful that one of the coaches would call. It did not matter which—I only needed one. Late in the afternoon, the phone did ring, and sure enough: the coach of the Elks Lodge Braves, Mr. Bob Fitzsimmons, invited me to the majors!

Coach Fitzsimmons giving our Braves team a pep talk before the game; I am at far right.

Left: my infield teacher, valued friend, and teammate, Larry "Never Quit" Bertram. He has always been a great inspiration to me and others—1963 Braves.

Considering that three years before the doctors had deliberated amputating my throwing hand—Wow! I felt proud of myself for two reasons. I knew what it took for me to bring a badly flawed hand and arm back to life, despite being so young; and I was aware, at least to a degree, that I enjoyed a blessed life.

I had grown up seeing both breathtaking and horrifying photographic art from around the world. These striking images—whether from my father's work, photography magazines and salon catalogues, slides projected on our white living room walls, or prints sent to my

dad to be circulated in exhibition venues in major cities, both in the US and abroad—impacted me my entire life. Seeing this 180-degree perspective of humanity left beautiful and tough impressions to process.

I also absorbed from my extensive exposure to the arts that dreaming added a great deal of significance to my life. Now, one of my dreams had come true: I would play on a baseball team with and against my friends in the majors. My parents were very proud of me. We celebrated that Sunday by going out to lunch at the International Town and Country Club.

My dad taught me about baseball, but I still had much to learn from coach Fitzsimmons. He was a broad-shouldered man who always wore a white coach's tee shirt, with "Western American" printed on the front. Coach turned out to be a very commendable man, who instilled in me solid fundamentals that served me well throughout the years.

My excitement doubled to be issued my first wool uniform, just like the Orioles wore. I've always enjoyed wearing a uniform. But playing in wool, on the dog days of July and August, you would have thought you fell in a river by the ninth inning. With a twin bill, you may as well have gone swimming in the hot and heavy fabric. Nevertheless, thicker

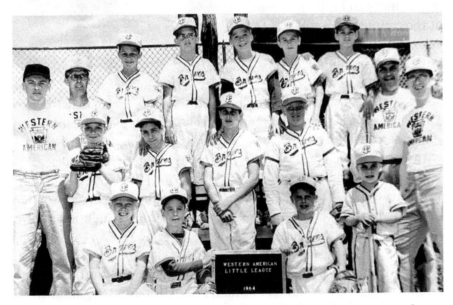

Winning championships takes teams of devoted athletes and coaches. Top row, left: I'm the first player and Larry "Never Quit" is the third—1964 Braves.

material kept you from getting as many raspberries on your thigh when you slid, and it helped block the spikes from cutting you turning double plays. In the mid-1970s, when uniforms began to be made of rayon—a much lighter fabric—I missed the wool, but it seemed I ran faster in rayon, and I loved to run fast.

Coach drove a white pickup truck with utility bays, locked panel doors, ladders, and copper pipes tied to the steel rack above the bays. Out of the bed of that truck for the next four seasons, I helped load and unload our team's army-issue, green canvas equipment bags holding the bats, helmets, and catcher's gear, along with the white-and-red cooler of ice-cold water, ready to fill Dixie Cups. I liked carrying the bat bag best of all—the sooner I could start swinging, the better.

Off the playing field, I remained determined to build my strength and increase my weight. Swinging a golf club helped develop my grip on a baseball bat, but I discovered an unexpected and excellent opportunity to bulk up at the country club golf course, where my parents were members. I used to like to sit on the steps of the clubhouse kitchen, leaning against the screen door, talking with Charles, the chef. I will never forget the

Rounding first, going for an extra-base hit. I was the smallest player on almost every team I played on, from age eight to when I graduated from college.

summer day I sat on those steps, looking at the weathered wooden barn where the golf carts were stored, and Charles mentioned how much he loved to eat fried bullfrog legs.

I thought about it and walked down to the eighth hole. For whatever reason, the bullfrogs at the pond of number eight were the biggest and fattest, requiring two hands to catch. I had to come straight down on them, a bit toward the front, so they would leap right into my grasp. A bullfrog can jump six feet. I caught Charles a meaty, seven-inch-long, one-pounder and carried it back to the kitchen.

Through the smoke from the steaks on the kitchen's wide, sizzling, flat-top steel grill, Charles's white chef's hat gleamed; he wielded a long silver fork in his hand. His eyes almost popped out of his head when he saw that jumbo bullfrog. I presented it to him as a gift. He took it and pushed it down on a cutting board, squeezing the two back legs together with his broad hand, and with his other hand he went to work with a razor-sharp knife. Before long he held up his frog, skinned from the shoulders down. The legs were two long strips of pink meat wrapped around the bones.

"You want a hamburger?"

I said yes, and Charles told me to wait on the steps. When the screen door opened, he presented me with a monumental, sizzling burger on a sesame-seed roll, and a plate crowded with extra pickle wedges, tomato slices, fresh lettuce, onions, and club fries.

Even better, Charles told me bullfrog meat had helped him grow and get stronger when he was a boy. His words struck a chord. If I grew taller and more muscled, I would drive a baseball harder and far-

Hitting balls from the driving range and playing rounds of golf helped build my grip.

This frog would have been too small for Charles to cook, but it was fun to catch.

ther. I would hit home runs. We agreed that if I brought him bullfrogs, he would cook them up for both of us. Charles also served me fresh Chesapeake Bay oysters over the holidays. He could shuck two dozen plumps and have them on ice in minutes—and I learned how to work an artful oyster knife in the process.

I caught lots of bullfrogs over the years for Charles, usually in the afternoons when I had finished playing nine holes. Then I would walk down to number eight to catch my bounty. The stately chef would send me home on my bike, with the sun at my back, and a wide smile on my face. Charles was a generous, honorable, and wise man.

In my fourth season with the Braves, I finally tagged my first official home run at age 12, on a day of several favorable omens. I smacked it against the Orioles—named after the same big league team I dreamed of playing for—and standing in the same batter's box where my father created his famous exhibition

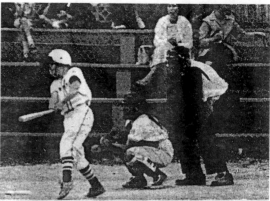

SCOTT CHRISTOPHER hits a homerun in a recent Little League game giving his team, the Braves, a win over the Orioles.

photograph, "Strike Three," seven years earlier. My long-fly four-bagger made it into my life's "beautiful memories" library. I took a hefty, calculated swing on a fastball right down the chute, and the contact felt effortless. Starting my first-ever, official, game-winning home-run trot, I watched in amazement as that splendid, white pearl cleared the fence in left-center field. Years of hard work and dining on bullfrogs, hamburgers, and oysters with Charles had finally paid dividends for me.

At each level of talent and age, players learn their shortcomings, and many eventually choose to play their final game of baseball. Those in Little League majors were fewer than those in AAA. Members of the high-school varsity team numbered even fewer still. And so on. Fortunately, I would not accept any limitations that would have led me to hang up my spikes. In fact, I believe my wrist injury aided, in varying degrees, my baseball skills. Being forced to develop left-handedness created keen left-to-right processing in my brain. Moreover, I had a true bent for "seeing" the ball well; I quickly recognized what type of pitch was cutting through the air on its short journey to the plate. I did not strike out often. If I heard an umpire call, "Strike three," my stomach churned, and I waited impatiently for my next at-bat to even the score.

The pitches in the majors challenged me quite a bit more than in AAA, where I saw mostly flat fastballs. I learned to pick up the release point of the ball coming out of the pitcher's hand. From the moment the horsehide separates from the hand, there will be a rotation on the

baseball that, over time, your brain deciphers and prepares your body and mind to either swing the bat or take the pitch.

The tighter the spin, the more a dot appears in the center of the ball, and that translates into a breaking pitch. A fastball cuts through the air on more of an angular, horizontal plane, sometimes rising or dipping, veering off to the right or left, depending on the pitcher's flick of the wrist on the release. It always rolls off the fingertips: with a four-seam fastball, the fingers are positioned across the seams; with a two-seamer, they are directly on top of the narrow seams. And when one of these comes at you, it looks like it is coming straight out of a cannon.

As you advance in baseball, so does the pitcher's repertoire, and your brain must be able to compute the ranges of new rotations and velocities in hundredths of a second. Failure to develop this skill is one of the most prominent reasons players leave the game and why few Little Leaguers ever make it to their high-school varsity team. They don't calculate swiftly enough the necessary information to smack the ball with authority. Batting practice, and lots of it, will hone this skill.

Another critical part of the equation, however, is having enough physical power to drive the ball and be a hitter at the higher levels. Here, my wrist injury proved a significant detriment. Similarly, my throwing arm was not strong enough to play shortstop, so I played as a second or third baseman on the Braves. Frequently, though, in pick-up games with my friends or when my father took me over to the field to hit me grounders, I played shortstop. It became my favorite position, and I hoped one day my arm would be strong enough to fire the baseball from deep in the hole at short, across the infield, to make the bang-bang play at first for the out.

Yet my right hand adapted slowly, not growing like my other and remaining weaker, as was noticeable when I occasionally ended my swings holding the bat with my left hand only, because it was stronger and pulled the wood out of my right one. My stunted thumb was extremely handicapped; there was no pocket between it and my index finger. Golf, swimming, pinball, horseshoes, wrestling, boxing, and basketball were developing my athletic skills and helping my compromised hand considerably, but it remained unable to drive hits through the infield or make the long throws.

Dad understood my frustration. One day he gave me a pair of green hand-grippers. A piece of steel came out one side of the plastic handle,

rose up a few inches, wound around, and spiraled back down into the other side. The more coils and the thicker the steel, the more difficult they were to squeeze. Bingo—I had the missing link needed to bring the strength back to my right hand and arm. I carried them everywhere and squeezed them until my hands and forearms were worn out. Because my seven tendons were fused together in my right hand, a sizable lump would bubble up across the scar on my wrist, looking like a ravioli, and then partially level out as I released the grip.

I devised a fun game by putting a quarter between the handles of the grips and squeezing them, one grip in each hand, until the coin dropped to the ground. A stopwatch timed how long each hand could hold the quarter. With consistent practice, I narrowed the performance gap between my two hands, although the best I ever managed was to keep the coin in my right hand, half as long as with my left.

Qualifying as a first-stringer had taken a lot of training time with my teammates and my father. I turned in a stellar 1965 Little League season for the Braves, my third year as a starter at second and third base. My defense improved constantly. That is one of the wonderful aspects of being a ballplayer: the more games and the more practices you rack up, the better you become, while also developing critical mind-muscle memories.

Those real-life game situations built my confidence and developed in me the instincts to move against my competition. Instincts—like when to stretch a single into a two-bagger, when to advance a runner by bunting to put him in scoring position, whether to go for the close, force out at second base or the sure out at first—continually need to be perfected. Players must learn to convert their judgments from a cognitive process into a physical reflex, bypassing thinking, for instantaneous results. Baseball is truly a game of inches, which shrink more and more as you develop your baseball intelligence to act on your instincts so you can make the plays quickly and with precision.

I always understood that games are lost, not won—the team making the most mental and physical errors loses. For instance, when a hitter takes one over the outfield wall, usually the pitcher has made a mistake with his pitch selection and location.

In 1966, my fourth and final year on the Braves, I performed on the field in a gigantic way: I hit .458 that summer and attained a reputation as a fearless batter with a sharp eye. My hand, although permanently

handicapped, grew stronger, and I made bona fide contact with the baseball. I also learned how to be aggressive on the base paths and turn a fielding gem every now and then.

A highlight of this super-fun season came when coach Fitzsimmons approached me in the dugout after my only Little League home-run swat and said, "Good homer, Scotty," and gave me a pat on my back.

I earned a spot on the postseason all-star team, and my mother sewed two white felt stars on my Braves cap. All my sweat and diligent work was paying off. After the all-stars, my next peak to crest was Babe Ruth baseball, for players 13 to 15 years old. I vowed to practice nonstop to make their majors. I did not want to play in their B league.

At the end of that summer, another honor materialized: *Sports Illustrated* selected me to be one of America's six featured athletes in their August 29, 1966, issue. The future football great, four-time Super-Bowl champion quarterback for the Pittsburgh Steelers, Terry Bradshaw, was in that year's selection of athletes as well. The "Faces in the Crowd" section of the magazine listed my sports accomplishments for the year, including my .458 batting average and winning four gold medals in five events at a regional junior track meet. Even today, being featured in this section of *Sports Illustrated* is considered a high-level athletic achievement.

John G. Whittier Junior High School

1965 – 1967

Seventh grade begins "middle school" for most educational systems, and that's fitting because you're between two worlds. It's a special time, similar to when the sun is rising and light fills the sky and lifts your soul. For these two intermediate years, students who have built a sturdy foundation get busy building academic, social, and athletic bridges—subtle positionings that most everyone in the school responds to—which become cemented by the time of twelfth-grade graduation and will pave the way toward adulthood.

I established myself in athletics, participating in as many sports as I could. I had been in Boys Club football the prior two years. My first team, for 65-pounders and under, was named the Ankle Biters. I played multiple positions on both offense and defense, as well as the

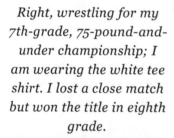

Left, taking a long jump shot, shooting for two points.

Right, wrestling for my 7th-grade, 75-pound-and-under championship; I am wearing the white tee shirt. I lost a close match but won the title in eighth grade.

Playing defensive end, I went airborne in an attempt to block a punt on 4th down and long, for my Boys Club football team. I was also the starting tailback on offense.

place-kicker and punter in this demanding sport. I excelled at it and enjoyed scoring, tackling, intercepting passes, and returning punts and kickoffs with my star teammate Cornell "General" Patton. The General and I scored bunches of touchdowns, season after season. But I faced a familiar dilemma: my body weight kept me on the 75-pound team. As an 11-year-old and the smallest boy in the seventh grade, this continually frustrated me and made my steep vertical climb even tougher.

In wrestling, my weight class was 75 pounds and under. I became the runner-up for the school wrestling championship in 1965, and also played starting guard on a talented basketball squad in a league outside of Whittier. Yet by eighth grade, I remained the smallest boy, weighing in at a distressing 75 pounds, just squeaking past that minimum weight marker for various sports teams.

Bob Addie was a prominent sports journalist for the *Washington Post*. He and other newsmen there wrote many articles about me over a span of 14 years. They and the newspaper understood my story was an inspiration for others to embrace. On August 20, 1966, Bob kindly wrote about me. Highlights from his article include:

- *There is nothing he can't do well*
- *He recently won four gold medals at the Falls Church Invitational Junior Track Meet*
- *He batted .458 for his Little League baseball team*
- *The first time he ever played football, he ran 50 yards for a touchdown*
- *He is one of the finest wrestlers and boxers for his age*
- *A month ago he won three events in a swimming meet*

I enjoyed my WFAX radio interview and proudly accepted the prestigious silver bowl award from Sports Illustrated *(October 1966).*

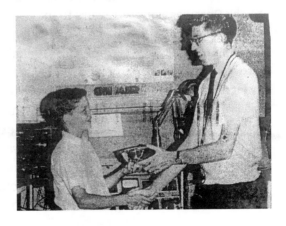

Still, I experienced a super year, with lots of friends and terrific courses; math and art were my favorites. Artistically, I had enjoyed an exceptional opportunity in 1964 and '65, when my father was Director of Photographic Operations for the World's Fair in New York City. Once the summer season concluded, I traveled up to the Big Apple with my mother to be with him. He had access to every exhibit in the Flushing Meadows-Corona Park. His company, Photo-Lab, manufactured circular disks with small, color photographic squares to be seen in View Master Stereoscopes. Dad photographed the images for those reels, exclusively for each pavilion, creating a broad overview of the fair, which tourists from across the globe then took home as souvenirs.

I enjoyed photography with my father. He had different cameras, but his two-and-a-quarter became my favorite because I could activate the shutter with the cable cord in my left hand. I've never been able to feel the shutter button on a camera with my right trigger finger. We snapped everything from a 12-story, stainless-steel model of the earth, called "The Unisphere" at night, to the world's most famous clown, Emmett Kelly Jr., the spokesperson at the Kodak Pavilion, where my father had an exhibition of his prints, including "On the Farm" and "Strike Three." I learned a great deal about perspective and negative space with my dad, especially when we rode the Futuristic Monorail or took the elevator up to the New York State Pavilion Observatory Towers to make striking aerial shots.

My father, Frank Christopher, was the Director of Photographic Operations for the New York World's Fair in 1964 and 1965. After '65, he combined a wide range of international artistic efforts and is credited with the beginning of the cultural thaw between the United States and the Soviet Union in 1960.

One night he took me with him to photograph the "Pietà," in the Vatican Pavilion. I helped Dad set up his tripod and equipment in front of the sculpture as he moved about. I held the light meter and relayed the readings back to him as he experimented with the flash. A vibrant-blue drape hung behind one of the world's most famous sculptures, created in 1499 by 24-year-old Michelangelo, among the greatest artists to have ever lived.

With his large-format and 35mm cameras, my father clicked away from different angles, locations, and heights. He even let me pop off a few frames that night. My efforts amounted to treasured memories; my father, however, created one of the most famous photographs ever made of the Pietà. This winner was published multiple times over the years, and he loved to give it away as a gift all through his life.

Dad and I enjoyed many special moments at the World's Fair, and I mark it as when I began to take my art seriously. I asked numerous questions and gained an understanding of how to *make* a photograph, as opposed to *taking* one. Sometimes we would drive around New York City in his delivery van, searching for winning photo compositions.

Due to these adventurous, creative experiences, art in middle school was a pure joy. English and comprehension, on the other hand, were my Achilles heel. Even at this young age, though, I knew that part of the beauty of life comes from blending the gifts we possess with those of our challenges.

One of my crowning achievements, literally, happened when fellow students voted me King for the spring dance. My classmate Cathi, the elected Queen, was always kind and nice to me, dating back to our first class together in seventh grade. Because I was too shy to ask a girl to a dance, especially her, being the King and having Cathi as the Queen worked out ideally. We danced together, with our elaborate crowns and red velvet robes wrapped around us. Off the floor, we sat on ornately decorated thrones, mounted on a raised podium. At the night's end, we hugged each other. When I walked home, I felt like a King, having shared an enchanted night with my Queen.

Friday, May 27, 1966

KING AND QUEEN of Whittier Junior High School's Spring Dance, Cathy Rudacille and Scott Christopher, presided over the event which was held recently in the school gym.

Like a steel chain, a team is only as strong as its weakest player—competently, physically, and mentally—and no one wants to consistently be the weak link responsible for their squad losing. So most boys who are

small bow out of sports because they are constantly unable to compete effectively. Not me. My determination would not allow anything or anyone to blur my dream. My size, my being a year or two younger than my competitors, my half of a hand, and coaches I rubbed the wrong way or who favored other players over me—nothing would keep me from wearing an Orioles uniform. Nothing!

I persisted in strengthening my hand and arm. I would get "big enough" one day and balance the scales competitively. Until that day, I had no choice but to compete with the taller, heftier boys as best I could. I played football for the 75-pound team in the fall and wrestled my way to the eighth-grade school championship. I was my country club's golf champion for 13- and 14-year-olds.

With each season came a different sport, but spring and summer— baseball time—were by far my favorite seasons. Everything I did athletically throughout the year led up to playing baseball again. I practiced in the gym, taking swings with weighted bats; finding a partner for catch; playing wall ball; and hitting off-the-cliff, curveball pitches in whiffle ball that made a whistling sound as they spun through the air—no easy feat!

BABE RUTH BASEBALL, 1967

At long last the Babe Ruth tryouts loomed right around the corner. The small confines of a Little League field would be left behind. Sixty-foot base paths now extended to 90; 46-foot pitches now stretched to 60 feet, 6 inches. I would be playing on the same-sized diamond as the Orioles played on, and for me, it would take a lot to make the Babe Ruth majors.

Tryouts started with a noticeable advancement of talent: players with strong arms, who hit the ball out of the bigger parks, ran faster, fielded better, and possessed much keener instincts. Pitchers were starting to "bring it" and showed improved command of their pitches and locations. They pounded a weakness at the plate until you compensated for it as a hitter, making the appropriate adjustments to drive the ball and get hits. As a runner, you were up against catchers whose arms were stronger and more accurate with their throws on stolen-base attempts.

I felt excited to be among the better players competing for the majors. The coaches had me try out for second base, and I fared well on

the larger field. My 60-yard dash time surprised them all. They used stopwatches that timed us down to a tenth of a second.

When the tryouts ended late one Saturday, my dad and I drove home in his new gas-hogging Chrysler Newport, with burgundy leather seats. We expected the phone to ring that night but it didn't, until Sunday afternoon. I was one of the last players picked in the draft, but that didn't slow me down. For me, the opportunity to play and improve my skills at the highest level of baseball in the area for my age was paramount. In my mind, this was another of many stepping stones I had to bridge before becoming a Baltimore Oriole.

The Babe Ruth league required a learning curve on many levels, both on and off the field. I had been an astute student of a very complex game. I qualified for three summer seasons, and each one brought in a different coach. Like players, coaches come and go for many of the same reasons people drift in and out of your life.

I started at second base my first year in Babe Ruth and handled it adequately, hitting plenty of singles as the leadoff hitter. I needed to get on base, advance into scoring position, and score runs—so that's what I did. The season lasted for two months in the summer, and I loved playing, whether a game or practice, even in the blistering heat. I knew I had accomplished a lot, given I was the smallest player in the league, with a withered throwing arm and hand. Even as a challenged athlete, I noticed after this season, and others before it, that I continued to improve against my competition, which ultimately earned me an invitation to play on the tough-to-make 13-year-old All-Star team. That kind of understanding kept the "Be-the-best-I-can-be" fires in me red hot, burning to work harder and harder to meet my competition head on.

Validation fans a person's competitive flames, and I blazed that fuel constantly. If I didn't have a scheduled game or practice, my father would hit grounders to me in the late afternoon. I scattered pebbles on the skin of the infield in front of me to develop my reflexes. Handling bad hops required mastering a quicker glove. I learned over many years, and beyond the bruises, to pick those sizzling darts and pick 'em good.

"Anybody can field the easy ones," Dad used to say, hitting his grounders wide, left and right, to increase my range. When I was older, we would wire a crab net to a trashcan, to act as the first baseman. It made a crackerjack target, and we both yelled, "You're out!" when I put a strike in the web.

Dad hit grounders to me for years on the Falls Church High School field. The tougher the ground balls, the better I liked to field them. Anyone can handle the easy hops.

In the infield, when a grounder comes your way, you stay low and square up to the ball, laying your glove flat and open in the dirt. As it rises, you come up with it to field the ball cleanly, or it will bounce off your chest. This way, the bullet is always in front of you if it's not handled smoothly, to grab and give it your best throw for the out. If you come down to the grounder, you may as well be playing croquet. That fast-moving sphere will find the wickets—the gap between your legs—and the outfielder behind you will ultimately scoop it up.

I loathed errors; all baseball players do. Not surprisingly, they are a major contributor to losing games.

In my third year of Babe Ruth, the new coach moved me off the infield into right field, and this did not sit well with me. I had been an infielder since my first season with the Coyotes. So my father advised me to "bite the bullet" and take a step back: it would be best for me to switch to the Babe Ruth B league so I could play every inning of every game at shortstop. I joyfully agreed. I wanted to put the work in at short, to hone and advance my skills.

My decision proved to be a smart one. I enjoyed a super-fun summer playing for my team, and I was honored by being chosen the captain of our league's all-star club. We performed like champs, and by the end of the tournament we were crowned the District VII champions. I fielded a crackerjack shortstop for my age, and most importantly, my hand, wrist, and arm grew stronger.

My favorite coaches settled for nothing less than championships. Their fiery desire to win and win and win influenced us all. Winning and losing are equally contagious. When you become used to winning, losing poisons your psyche, leaving you to question why you would play

such an exacting game as baseball and give up so much to do so. As a coach builds a winning team, he has a sixth sense to find core athletes who are proven champions. If he stacks his roster with skilled, consistent pitchers who are always around the strike zone, and four or five talented position players, the coach will fortify his team's chances of battling for a championship.

I loved being part of a contender team, because the better the squad, the better your own performance. You will be taking quality swings, scoring more runs, and playing to your utmost potential. Opposing pitchers cannot afford to pitch around you and hand you first base with a walk, because the power hitters following you in the order can bring you around the horn with one solid swat. This dynamic forces them to come at you and not work the corners. The bottom line is: you do not get cheated at the plate with the pitches that come your way.

Having gifted defensive players in the field also pumps the game up multiple levels. Fielders love to see their teammates make those big league stabs. I relished those short-hop, top-spin bullets; I handled them with a laser-beam throw to first that beat the runner by a step, for an out. In the course of a game, these types of moments, combined collectively as a team on both offense and defense, lead to victory. This is why baseball is one of the ultimate team sports: the one are many, and the many are one.

14 Thursday, September 4, 1969

Sports Career Inspired By Crippling Accident

I am safely hook-sliding into third base on a close play in the District VII Championship game, which we won.

Falls Church High School

Heading into high school infused me with a strong sense of independence, boosted by earning money. I did not like to ask my parents for much along the way, so I took on odd jobs, like mowing lawns and doing manual chores for neighbors. I also developed a brisk business in golf-ball sales at the country club. For a boy, I made a lot of dough.

The two club golf pros worked out a deal with me whereby I could retrieve lost golf balls by trolling the ponds, combing the woods, and walking the roughs when the course was closed on Mondays. They took half my haul for sale at the pro shop; I kept the other half. From the blue tee box on number three, I sold ten shag balls with cat faces on them for $2.50. Titleists and Maxflis went for $1.00 each. Many days, after I brought Charles a bullfrog and dined like royalty, I rode my bike home with $20 or more in my pocket.

Snapping turtles, snakes, leeches, and stagnant water with thick patches of algae made it risky work, but it was lucrative. The fifth hole had the best pond for finding golf balls, but it also contained the most leeches. One Monday night I rode my bike up to the course and went golf-ball hunting under the brightness of a full moon, emerging with a banner haul. For some reason, the leeches were thick, and many latched on to my body. After I plucked them off under the moonlight, the trickles of blood from each of those suckers left my body looking like it had been peppered with 50 birdshot pellets fired from a shotgun.

My mother did not like this business at all. First, because of the hazards, and second, I used her washing machine to clean 300 golf balls at a time. When the spin cycle reached top speed, the sound was far from melodious. What she did encourage, however, was my industriousness, entrepreneurship, and sense of adventure.

Even though a young teenager, I was living semi-independently at this point because of the peculiar dynamics at home. At the beginning of ninth grade, I confronted my father's increasing eccentricity. Today he would be recognized as a compulsive hoarder, and this, together with his typing from early in the morning to late in the evening, made it difficult to function inside the house for both my mother and me.

Mom coped by claiming territory where she prohibited my father from storing any of his letters, documents, prints, slides, negatives,

books, or magazines. She kept her "mental and operational safe zones" neat and orderly. I opted to build a tree house in the far corner of our backyard. First I sketched different designs in one of my notebooks—the final result looked like a huge wedge of cheese attached to three trees. Nevertheless, it was satisfyingly functional, with an entry door and a hatch in the roof to give me access and to use it as a small observatory with my hobby-shop telescope.

I have always loved the stars, space, planets, moons, and everything the universe represents. It is vast, unexplainable, expanding, illuminated, daunting, limitless, and amazing—like our minds. I once spent an evening with the Apollo 11 astronaut, Buzz Aldrin, the second human ever to walk on the moon, following his mission commander, Neil Armstrong, on July 21, 1969. I asked Buzz about his moon walk. "I don't know of a word to describe it," he replied. That said it all to me.

Inside my tree house, I arranged my chemistry set and microscope and lined the bookshelf with my favorite books, baseball cards, art supplies, colored pencils, and notebooks. I found a large, black-and-white TV a neighbor had put in the garbage and rolled it "home" in a wheelbarrow. I removed every vacuum tube, walked up to the hardware store to test them, and then replaced the burned-out ones. I reinstalled each one into those dark-black, plastic circles with small holes in them. The glass tubes with their metal configurations were like miniature sculptures to me, and when they burned out, they made super BB-gun targets to shoot at.

Not only the TV but a space heater and a bare light bulb hanging from the center of the ceiling required juice, so electricity traveled from the main house through multiple extension cords. Everything worked. I watched *Gilligan's Island* on Friday nights, and I kept warm throughout the fall and winter. I was at home in my tree house—my first, major-scale installation "work of art"! Sleeping in the trees, under the stars, being part of our universe's grand design, I learned to love the magnificence of Mother Nature, all of it: the winds, snow, hail, heat, rain, thunder, lightning, silence, solitude, stillness, loneliness, and independence.

As odd as family life seemed at times, we shared quite a special run, enjoying dinners together. Often in the evenings my father and I would finish editing slides and mounting them behind glass for his competitions. After giving Clifford, my pet beagle of 13 years, a hug, I

said good night to my mother, walked out the back door, and entered my own reality. A beautiful world away from the mental chaos. The wind rustling the leaves has always been poetry to my ears.

In retrospect, I know my parents gave me the most precious gift of all: unconditional love and taking their time to share it with me.

Running onto the field (at center) with my teammates, shortly before our game started, October 1967. I was not inserted for one play the entire season.

Falls Church High School, known for developing top athletes, inspired me to be one of them. My father always told me the more sports I played, the better baseball player I would be—I'd say he was right. I made the freshman football team, though I was never installed into a game. My coach, Dale Larsen, saw me as a tough kid who worked hard, but he could not risk letting me get beaten up as an 88-pound tailback or safety. However, coach learned early that I was fast, so he used me in practice the entire season to simulate the running backs of our upcoming opponents. He did this so the defensive players would be better prepared. I got nicked up quite a bit, but my teammates knew how far to take it when they tackled me so I would not sustain an injury. The more I was exposed to athletes competing and winning, the better.

Coach Norman is at right (back row), and I am #10, on the Arlington Cubs in the fall of 1968.

With coach Larsen's help in my sophomore year, I got on a competitive, 120-pound club football team, even though I only weighed 95 pounds. I played both offense and defense, returned punts and kickoffs, and was the punter. We won the league championship. My coach for that team, the Arlington Cubs, was Russell Norman, a steel pit bull with hot lead running through his veins, who chewed dirt instead of tobacco. He made you afraid to lose. I was one of his star players because I gave him 100-plus percent—anything less brought you nose to nose with him, taking a verbal onslaught that would have frozen a lightning bolt in midair, and his eyes never left yours—like a rooster in a cockfight.

I also wrestled in high school, all four years. This unique sport has a lot in common with the game of chess, which I started learning when I was young. I have always enjoyed it, and I applied the concepts of chess to many of the athletic events I participated in, from age 13 onward. You lose many battles in a game of chess, but you learn from all the strategies and nuances developed during a match: it's not about the independent conflicts, but rather laying down your opponent's king on the road to victory and declaring *checkmate*.

In Virginia, high-school wrestling is a serious undertaking. Your knocks, to begin opening the door to manhood, are observed and critiqued on the mat. For six minutes, you wrestle in a small, white, spotlit circle, with hundreds, sometimes thousands, of fans watching

Learning on a wrestling mat—and also on a chess board—that you alone determine victory or defeat. Here (on left) at a home match, I am preparing to counter the move of my opponent.

Coach Dick also guided the varsity football team for many seasons. His 1977 squad is considered the greatest football team in FCHS history, compiling a 12-2 record. This team clawed its way to play for the Virginia State Championship against the Bethel Bruins. A noted athlete during his college years at the College of William & Mary in Williamsburg, Virginia, Jim Dick worked very hard to be a consistent winner as a person, athlete, and coach. I benefited greatly having him lead me through four rugged seasons of Virginia wrestling.

* * *

Assistant coach Mike Weaver was a skilled and important coach in my evolution as an athlete; he expected wrestlers to be mentally and physically tough on every front. At all times, he relied on two report cards: one was your win-loss record, the other was breathing wrestling twenty-four/seven.

Wrestling made me a better athlete and baseball player on multiple levels. It is a very challenging sport and also the oldest competitive sport in the world, dating back as far as 3000 BCE. Ancient cave drawings of wrestlers have been found in Lascaux, France. The Greeks developed wrestling as a way to train their soldiers to fight in hand-to-hand combat. The sport was introduced into the ancient Greek Olympics in 708 BCE.

and waiting for the referee to raise your right arm, signifying victory. I wrestled junior varsity my first year and on varsity the next three, never missing a competition. I was a 95-pounder in ninth and tenth grades, a 98-pounder in eleventh, and a 112-pounder in twelfth grade. The various weight classes in this sport go all the way up to "unlimited," which is anything above 185 pounds. Almost every week there are eliminations in your weight class, and the winner represents your school on the varsity team in Friday or Saturday night's match.

Coach Jim Dick was a fierce and smart competitor, who trained you to be nothing less than a winner. Losing was not in his vocabulary. We became a wrestling power in our region, winning multiple district titles. In my senior year, our team placed fourth in the Virginia State Championships.

If you didn't have a record in dual meets of seven wins and three losses or better, you were mush. I was a .500 wrestler, which did not sit well with coach Dick as the years went by. Having a right hand unable to fully grasp and hold an opponent, maturing at a late age, and being a year or two younger than

Coach Dick (far right) cheers me on in the 112-pound class as I complete an arm-drag takedown on my opponent, for two points, in the 1971 regional tournament. He was an excellent coach, a proven winner, and an outstanding mentor to athletes on his wrestling and football teams.

most of my competition put me at a major disadvantage. Some of the guys I faced as a 14-year-old had mustaches and were 18 years old. Nevertheless, coach Dick never found anyone in the school who could conquer me at my weight.

It didn't help that I always practiced baseball in gym class. No other wrestlers did that; they practiced wrestling during the day, when time outside the classroom allowed. One afternoon coach Dick interrupted my wall ball and asked, "Scott, is it wrestling or baseball?"

I never hesitated. "Baseball." After my reply, tungsten would have melted on his forehead.

He and assistant coach Mike Weaver retaliated by doubling up on me occasionally, having me wrestle two elimination matches in the same practice, saving the best prospect to defeat me for the last one. I don't recall coach Dick ever doubling up on another wrestler. Still, I never lost an elimination match in my three years as a varsity wrestler. I gave my first one just enough gas to win and always emerged victorious in the second. Occasionally, a match went into overtime, and my margin of victory narrowed. I had to play three-dimensional competitive chess on the mat in that small, white circle.

The competition and heating thermostats in the wrestling practice room were always set on high, figuratively and literally. Known as the "corrective gym," it was a rough place. It lacked any windows, and all

four walls were white cinder-block. Retired wrestling mats covered the floor, and a single, heavy metal door marked each end of the rectangle. Wrestling hour after hour there felt like being inside one of those Jiffy Pop stove-top pans for cooking popcorn, which turned into a silver hot-air balloon right in front of your eyes as you shook the pan and the kernels of corn burst.

Over the four years, I won six medals and took the United States Wrestling Federation gold for an intense "takedown" tournament in 1971. In a particularly heated match, I wrestled a Virginia State medal winner in the finals. When I picked him up and smashed him down onto the mat, our heads collided, and his front tooth cracked in half while cutting open my scalp. The trainer cleaned up the blood, and when the competition ended, I took home the hard-won gold. Two of my medals were for third place finishes in tough Amateur Athletic Union (AAU) meets.

I qualified for the Virginia State Tournament as a 14-year-old, 95-pound sophomore—a major accomplishment. My opponent in the regionals underestimated me. He had a legitimate shot at winning the state championship as the top seed in our bracket. I was one of the lowest seeds of 16 wrestlers, so we met in the first round. One minute in, I was ahead five points to none. I pulled a slick fireman's carry move and slammed him to the mat on his back. He was unable to recover and panicked the rest of the contest. My adversary left that lonely, small, white circle devastated. The 2,000-plus fans at Hayfield High School were stunned—but I knew I could win that match. *Checkmate!*

Along with other varsity wrestlers, I attended summer wrestling camp with coaches Dick and Weaver at William & Mary College in Williamsburg, Virginia, for two years and at the Granby School of Wrestling camp for one. These intensive trainings left me feeling like a golf ball in my mother's washing machine. You either whopped butt or had your butt whopped, and we wrestled all day long, day after day—no arts, crafts, tennis, sailing, canoeing, horseback riding, or hiking at these camps. That is how Virginia wrestling works. The coaches work their wrestlers hard to develop individual champions who, collectively, win their school's postseason team titles.

My father started me boxing in Washington, DC, as a 12-year-old, and I learned in the ring how to deliver a solid punch. I also discovered

firsthand how to take stinging shots. I demonstrated a keen skill working a punching bag, and I trained constantly on one bolted into a brick wall at home. This sport built my confidence and taught me balance on my feet, which would significantly benefit me later, especially when I turned double plays as a middle infielder.

Of course, it also made me skilled in a fistfight. When a scrap stared me in the face, I held my own. Bad blood flowed between me and a high-school bully named Slick, a gristly, strong kid with coal-black hair greased back, who always hung out with his three or four thorny friends. He had harassed me on multiple occasions and wanted a piece of me. His opportunity arrived one Saturday afternoon outside the school where neighborhood teams played pick-up football games.

Slick's gang boxed me in so I wouldn't run away. But nothing could have been further from my mind. I disliked this roughneck bully and seized the moment. There was no ring, no ropes, no rounds, and no referee—just me versus Slick and his posse of ruffians cheering him on to drop me like a bad habit. They all came from a prickly part of town where winning fights established the pecking order.

Slick had his reputation, and I had my experiences, in and out of the ring. As I brought my hands up to square off with him, a painful memory flashed through my mind: being beaten to a pulp once by a deaf-mute tough guy who was bigger, older, and mentally unstable. He jumped me at a small, muddy pond in the woods when I was alone looking for frogs, snakes, and box turtles to catch after a summer rain. No way would I undergo another thrashing. Slick and his bullies were in for a surprise.

We began feeling each other out and throwing short jabs. The bully had broad shoulders but was flat-footed. A brawler, his only strategy rested on being aggressive. I played offensively and defensively. As I ducked, danced, and blocked his punches, I noticed if I faked with my left, he brought both of his hands up high, leaving his midsection open. I bided my time to land a blow that Slick would buckle .

He landed a hard straight jab to my cheekbone, which stung me and elevated the intensity of our fight. Game time! I danced and blocked his next volley, faked a left jab, and Slick took the bait. I stepped in and delivered an explosive uppercut to his gut with my right fist that went up under his ribs, knocking the wind out of him.

He was all mine now, and we both knew it. His hands dropped down to his shoulders and his eyes looked glassy. I brought a power-packed

left hook to his head that put him on his knees in the dirt. With my right arm cocked to take him out, I ended the fight. I spared Slick the final blow, and he never bullied me again. I forced that gang to respect me.

In life, without respect, you can expect to be confused, used, and abused. For a baseball player, respect is essential. It is one of the core components leading to success. All the averages, statistics, and comparative data accrue toward earning the high regard of your teammates and coaches. Teams will test opposing players in establishing a respect watermark. Once the levels are set, they mysteriously travel through the league over the course of the season—as the pitchers, players, and coaches prepare themselves to compete with you on the field.

For example, if your team operates on the diamond without respect from your opponents, you better have a super trainer, a large medical kit, and lots of ice, because your hitters will be spun around and hit by pitches at the plate. Your second baseman and shortstop will be airborne turning double plays from the runner coming in to punish you. And your catcher will be sent into orbit by bang-bang plays at home.

Baseball seasons span many games, and the sooner a team establishes its unwritten respect level, the better. A true team player would rather strike out five times in a game or get shelled on the mound than be disrespected on a baseball field. Most coaches with players 16 years old and up, who know you would not be in the middle of a brouhaha for your team, whether justified or unjustified, do not want you around, and they will figure a way for you to carry your bat and glove out of the dugout and down the road. Respect, on all fronts, is a very important and colorful brush stroke in your daily painting and your own life's masterpiece. Physically, I was very small until I started to sprout up at age seventeen. I experienced disrespect on a grand level, both verbally and bodily, and it was mentally and physically very painful. Words are like punches; they can hurt profoundly, bruising and sometimes even scarring your psyche for many years, especially when you're younger.

Reality checks

In the spring of 1968, as baseball season—with all its excitement—approached, I zeroed in on trying out for the junior varsity squad. I knew many of the players who were expected to make the team, and I anticipated being one of them. A deep pool of infielders would be competing.

The coach, Jim Warren, had seen me practicing in the gym over the course of my freshman year. He was a competitive person, but basketball claimed his passion. The tryouts extended over multiple afternoons, and I did as well as might be expected for the smallest and youngest candidate on the field. But I worried that coach Warren would not be impressed, being used to larger and more mature athletes from his basketball teams.

When he posted the players roster on the gym wall, I eagerly scanned it for my name among all the JV talent. I saw I had made the squad, and I was so excited to have qualified for my spot with the highest-level team I ever competed for!

Ultimately, however, I only played in six live games. Of the 20 players on the squad, I was dead last to see any action on the field. Regardless, my self-confidence never wavered. That spring and summer my sights were set on becoming the best ballplayer possible, yet sometimes when I walked home alone through the woods after practice, and I heard the balls coming off the wooden bats of the varsity players, it rattled my spine. How could I make it to the next level, or ever be a Baltimore Oriole, when I barely played in any JV games? My chessboard was unsteady, but my king stood firm. I had a year to practice baseball before my next move.

I golfed, swam, boxed, wrestled, played football and summer baseball, ran sprints at the track, and worked with my father on hitting and fielding grounders, fielding grounders and hitting, and then *more* hitting and fielding grounders.

Tenth grade rolled up, and coach Warren had another year to observe me practicing baseball in the gym, but he took little notice. Multiple, select athletes from his varsity-level basketball teams were receiving college scholarships. Falls Church High School competed in a premier competitive bracket in the state of Virginia. As a top, Division-AAA school, it attracted talent from all across northern Virginia.

I may not have impressed coach Warren, but coach Larsen—who guided the varsity team—took note of how tirelessly I practiced, and he understood my unquenchable desire to play top-tier baseball. He believed if a player worked hard enough, he shouldn't get cut. I had earned his respect, and he let coach Warren know that he wanted him to keep me, if not as a starter, at least practicing and developing my skills.

When the spring baseball tryouts came around, despite being a year older, I was almost the same size as in my freshman year—which made

me smaller than small. Even with this high hurdle to clear, I made the JV once again, though playing as a distant spot sub the entire season, with limited infield action. I had scattered at-bats, but ended with a you're-lucky-to-be-on-the-team, below .200 batting average. The best part for me was being on the club and loving everything about the game, including practicing hard and becoming a better player alongside my friends and many accomplished baseball players at that age.

In September 1969, the *Falls Church Globe* wrote an article about me, and the last paragraph stated, "Where will young Scott be in another nine years? It's anybody's guess, but it is safe to bet, wherever he is, he'll still be fighting the 'comeback' he started at age six."

I knew where I dreamed of being in 1978: playing for the Baltimore Orioles and hitting the home run to win the crown and my professional baseball championship ring.

Against Madison HS, I am ahead of their runner at the one-mile marker.

In the fall of 1969, my junior year, I tried out for the cross-country team. Long-distance running was a new sport for me. I liked the idea of using a different set of leg muscles, with the stretched-out strides and slower pace necessary to run the 2.2-mile competitive courses. It also would help me enter wrestling season in super shape, enhance my mental toughness, and allow me to enjoy outdoor running, especially along the diverse trails through the nearby woods.

I made the junior varsity team and ran cross-country my last two years in high school. I learned to admire long-distance runners; in body and mind, they are strong-willed athletes. The gifted ones seemed to run with such ease. Our seasoned veteran coach, Major Wells, pushed us hard in this demanding sport. I was possibly the worst cross-country runner he ever coached, almost always pulling up the rear as I reached the two-mile marker. But he and the other coaches let me run junior varsity as a senior, even though I would never be in a position to score any points for our team. Coach Wells called me his "rabbit." In practice he always wanted me to sprint until I practically jogged, because he knew

it would push his stronger runners to better their times in his team's competitive races.

In meets, too, coach Wells would ask me to give him the fastest 880 yards I could, right out of the chute. In this case, he wanted the competition to chase me and be gasping for air at the end of the race when they needed to find that extra wind to place for points. Sometimes it worked, a win-win for each of us.

Tryouts for the 1970 varsity baseball team approached with the spring. Coach Larsen stood in my court, but you can only have so many players on the roster, and his team was stacked with talent. They were the defending northern district champions who had battled their way to the regional championship semi-final game. I was 16 years old and weighed a bit over 100 pounds when the tryouts began in early March.

This tryout was doubly important, because if I failed, it would dramatically decrease my chances to earn a spot on a Senior Babe Ruth team in the summer. This league consisted of the most talented 16-year-old players in Northern Virginia. Many baseball dreams ended right there, as it was a highly competitive atmosphere that required an advanced range of abilities to make a roster. My long-term baseball expectations were grand and big—Baltimore Orioles BIG.

The tryouts proceeded, and sophomores who lacked the skill set were pointed back to JV or sent home. I hung in there for the final cut on the last day. I had proven myself, but was it enough to contribute to a team projected to be in the hunt for both the regional and state championships?

While I swung the leaded bat, coach Larsen came over and explained it was more important for me to be playing than to be on the varsity team and not improving my abilities from live game situations. He sent me over to the junior varsity field, where the first-year JV coach was hitting grounders to the infielders.

Though quite disappointed, I agreed: I'd rather be playing junior varsity than riding the pine on varsity. When I explained to the JV coach what coach Larsen had said, he replied, "I don't have room for you. There are twenty-five players on the field right now, and none of them are juniors. Sorry!"

Looking him in the eye, I turned and walked away, without a word. I continually touted myself, but I never begged a coach to play on any

team. I had too much respect for myself as a person and for my skills as an athlete. I plodded to the football field with my glove and bat, where Major Wells coached track. I could make his varsity team as a sprinter, but it was baseball I loved. I settled on practicing with my father and friends all spring to be ready for Senior Babe Ruth tryouts at the end of May. I simply had no other choices.

Along with athletic rejection comes a reality check that rocks a deep place in any competitor worth their salt. In the eyes of others and in your sense of self, the harsh truth remains: your skills don't make the grade. All your hard work did not pay off. You feel you should have worked harder; you were not good enough; you fell short, way short. A coach can have that kind of impact on your psyche when you are cut. I had missed the mark. It was a harrowing experience.

Accustomed to challenges, however, I prepared myself to come to grips with this one. I wished I had a stretching machine to make me as tall as my friends. I barely topped five feet and weighed 40 pounds less than the next lightest player trying out. But I would have my growth spurt—soon, I hoped—and I set my sights on next year. I would play varsity and play it in a significant way.

I walked alone, going straight down the center of the football field from one goal line to the other. In another 25 yards, I would have been standing in the outfield of the varsity baseball field once again, but I veered off to walk along the fence, heading home, feeling empty, dejected, lost, and misunderstood as a baseball player. I had been cut from the varsity and rejected from the junior varsity in less than 20 minutes.

Coach Larsen spotted me and called out my name, waving me over. He asked me where I was going. I told him the JV coach did not want me. Running his right hand down the side of his face, coach Larsen thought for a moment. His expression never changed. He just said, "Scotty, put your bat in the dugout and go on out to second base."

I had made the varsity team! I would wear a varsity uniform with the number 1 on it. Beyond happy, I vowed to practice day and night so I would earn my chance to play and excel. I planned to make coach Larsen proud for betting on me, and I resolved to prove to him he made the right call.

Cut, rejected, and added to the varsity roster all in one afternoon. Wow! I was going to be a player on one of the top-three, most-talented baseball teams in my high school's history.

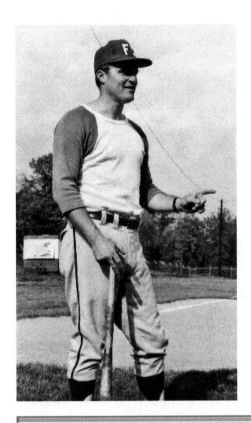

Falls Church High School Varsity Baseball Coach Dale Larsen. In life there are a handful of people who will change your future dramatically by giving you a chance to move your dreams forward. Coach Larsen was one of those people. By living my passion to play baseball, coach gave me a shot at playing varsity baseball. I always felt very valued to be a player on his team. He was an excellent coach and taught you the skills necessary to play the Great Game on a high level (Spring 1970).

I once watched coach Larsen fight an orangutan in a department store marketing gimmick. If you stayed in the fight cage long enough, you won a cash prize. He was one of the few people to (a) walk out vertically and in one piece and (b) win the cash. Most men came out of that cage bent like pretzels before their time was up, suffering from a good, old-fashioned, orangutan butt whoppin'. An orangutan is about seven times stronger than a human, and to beat the clock against this animal, as he did, was quite a feat. Coach outsmarted our distant relative that shares 97 percent of our human DNA.

This particular FCHS varsity team was exceptional. Wall-to-wall athletic winners, not just on a baseball field, but also in football and basketball. At season's end, we were three wins and seven runs shy of a 20-0 season. If we had made it to the playoffs, with this team of talent, we would have been serious contenders to win the state championship.

Our superior pitcher, Dean "BB" Boger, was drafted in round 28 of the June 1970 MLB draft by the Chicago Cubs. BB elected to attend the baseball powerhouse, High Point College, in North Carolina. After

VARSITY BASEBALL: *Front Row:* Bill Anderson, Larry Bertram, Roger Chapman, Ken Utterback, Mike Crum, Scott Christopher, Dan Rudacille, Bruce Ruddle; *Second:* Mr. Larsen, Mike Cothran, George Turner, Dean Boger, Ed Duffy, Larry Gerber, Joe Anderson, Alan Kendall.

Falls Church High School Varsity Baseball Team (1970).
This may have been the finest baseball team in the school's 78-
year history. Unlike me, every one of my teammates had excelled
as a high school athlete leading up to this remarkable 17-3 season.
Having an .850 season winning percentage is truly exceptional.

his 1974 season, Dean signed with the Oakland Athletics and pitched one summer of pro ball.

Top-notch infielder and football wide receiver, hotshot Billy Anderson would earn a scholarship to play baseball for the University of Maryland, where I dreamed of playing my college ball. He became a player on Maryland's 1971 Atlantic Coast Conference Championship team, and saw playing time in the NCAA regional tournament. Having my friend and teammate become a member of the Terrapin team felt like a gift. Billy was living my dream, making my trajectory to becoming an Oriole much more than a possibility—it made it tangible. I wasn't just going to play baseball for Maryland, I was going to be a dazzling player and work the infield with Billy.

Coaches aim for a lineup of nine Billy-Anderson-caliber players, knowing this level of athleticism will fill the school's display cases with championship trophies. Billy came to the field to practice hard, work hard, play hard, and do what he had to do at all times to win ball games. Winning requires a deep commitment from every player on the

team to give their all. I studied Billy and other winners, and I became a better baseball player, equally committed to excellence. I applied what I learned from these athletes, and I moved closer to becoming a winner myself. Mirroring how champions win is very important. This is true for all sportsmen who desire to compete at their highest level.

Also on this FCHS team: Senior Larry "Never Quit" Bertram, son of Russell Bertram, whose fast thinking and driving had helped save my hand and, possibly, my life. Larry contributed mightily to varsity baseball *and* football, for three seasons. He was a praiseworthy infielder and hitter in baseball but excelled in football.

Bruce "Bulldozer" Ruddle, a member of the 1969 Virginia All-State and All-Met Football teams as a fullback, played as our outfielder and catcher. A big-time gamer, Bruce had that way about him, as some athletes do: when pressure-packed situations develop, they all the more want to be right in the middle of it all, emerging triumphant.

As a sophomore, Bulldozer was diagnosed with Osgood-Schlatter disease (OSD), a condition where the cartilage in the knees does not grow properly. He developed OSD as a consequence of being a catcher, constantly squatting up and down for many baseball seasons. This put him out of sports for the entire year.

Larry Bertram was a member of the 1969 Northern District Championship football team and made the all-district team as a defensive back. He attended Hampden-Sydney College in Virginia. Larry played both football and baseball there. Never Quit was a freshman football team walk-on and won the starting quarterback job. This earned him an athletic scholarship starting his sophomore year. He was the varsity backup quarterback for his first three seasons, and then in his senior year, guided his team to the Mason-Dixon Conference Championship, earning honors on the Virginia Athletic Association and All Mason-Dixon Conference first teams. Larry's teams played in two Knute Rockne Bowls, competing in the NCAA D3 National Championship quarterfinals. Never Quit never quit. As a sophomore he completed one pass in three attempts, with two interceptions, for a total of 3 offensive yards. Then in his remarkable senior season, Larry passed the football for over 1,000 yards and was presented the Slater Most Improved Trophy. A distinguished academic with a degree in English, he is a published writer and poet. Larry is on the, "Dream Big, Dream On!" all-star team.

When Bruce returned to the gridiron to play his junior year in football, he was certainly out of shape, since he hadn't been allowed to exercise. He began in a pool of linebackers and gradually moved up to be the second-string fullback. As the coaches worked Bulldozer back into shape, he earned the starting fullback slot. Bruce worked with so much desire, passion, and heart that he went from being a depth-chart question mark to being honored in his senior season as one of the best running backs in all of Virginia. Bulldozer chewed up the yards scoring hard-fought touchdowns on Friday nights, earning him standing ovations from his loyal Jaguar fans.

A coach referenced Bulldozer during the season in a motivational talk to the team. He told the players Bruce had reported to his first varsity practice looking like a tub of lard but had worked so damn hard, to be an outstanding fullback, that he became a sensation. Having such a consummate athlete as a teammate brings a competitive boost, because they will get you that much closer to becoming a champion and receiving postseason honors yourself.

Bruce wrote a note to me, recounting a memory of us playing against each other, when he caught for the Little League Dodgers and pitcher Dean Boger, the king of the hill. He wrote:

> Almost everyone was a little scared to bat against him [Dean]. When I say almost, you were the exception. You were a small guy back then, but you would come to bat and you'd crowd the darn plate! It was unreal. You had no fear. I think you got more hits off Dean than anyone else. We hated to see you come to bat.

With thousands of at-bats in my baseball career, I never once feared a pitcher—or their pitches. *Fear* is one word an athlete cannot allow into their vocabulary. Real and substantial opportunities in life come few and far between, and you have to be prepared in body, mind, and heart for the moment when that illuminated ray of light appears. This is the stuff dreams are made of, and I believed not only in dreaming but in working relentlessly, to *make* my dreams come true.

The bright light that shone on the final day of tryouts never reappeared the entire season. I hit a whopping .000. Only up to bat four times, I struck out three of them. My total offensive and defensive prowess constricted to spot appearances in three, yes three, games the entire season.

I batted and played the field in the late innings of two of those three games, when we had a solid lead. At those times, playing second base, I was not throwing into a crab net at first base, as with my father when we practiced together. Our first baseman, Alan Kendall, our school's basketball leader, was six feet, seven inches tall, with arms that stretched out like windmill blades. He made for a broad target during practices and a rare game throw.

Top athlete Alan Kendall and I having a bit of photo-op fun before our game.

My third varsity moment came on May 2nd, when coach installed me as a pinch runner. Bruce "Bulldozer" Ruddle was given the steal sign. We were taught a first-move steal on left-handers, meaning you took off to steal second base on the pitcher's first movement, forcing a pickoff throw. As you close in on the base, you track the shortstop taking the throw from first, and then line yourself up between him and the thrown ball. By doing this, you will either be hit or you will block his field of vision, hoping the ball will end up in left field.

Bruce was using this base-running skill, when at the last moment he realized that second base was off to his left. He shifted his weight, like he was making a cutting move on the football field, and jumped at the bag. His metal cleats stuck to the side of it. Bruce went airborne. The shortstop dropped the ball. Bulldozer, now on all fours, looked back at second base and his left foot was lying sideways on it. Tragically, he had dislocated his ankle and broken his leg in three places.

When I arrived at second base to pinch run, Bruce was unable to move, given the extent of his harrowing injury. Seeing the high school's all-state fullback, with his left foot facing the wrong way was tough. I felt very sad for Bulldozer. An ambulance from the Jefferson Village Firehouse was summoned. The red-and-white hospital wagon came up to the football field and wound around the outfield fence. It pulled up right behind second base. The medics loaded Bruce—his foot a total, detached mess—onto a stretcher and off they went. Tailgating the ambulance to Fairfax Hospital were Bulldozer's mom and dad. As the sixth inning unfolded, I happily planted my spikes into home plate to score Bruce's run for him. Even though Dean Boger threw a one hitter,

Bruce coached first base the rest of the season, in a cast and on crutches.

coach Larsen appeared visibly shaken the rest of the game. He visited Bulldozer at the hospital after we claimed victory.

The doctor set Bruce in a cast that he slung around for thirteen weeks, seven of those on crutches. Bulldozer reported to Randolph-Macon College on August 18, for their twice-a-day football practices. He pulled far into his guts, but Bruce's ankle could not withstand the compression and force that comes from playing football or baseball. Catastrophically, his promising athletic career ended the day he stole second base.

Anything in life that you do passionately is beautiful, but with those heart-driven experiences can come mental, emotional, and physical consequences. Regardless, I say: Run, and run hard, chasing your dreams. Live them in their entirety, because not going after at least one of your dreams that you love fully will have you saying to yourself for the rest of your life, "Gosh, I wish I had--." Give yourself one of the greatest gifts you can in your human experience, at any age: to pursue something, anything, at your own 110 percent. Become your **Dream**!

I hated being a fixture on the pine. I had so many splinters in my buttocks, I could have opened a toothpick factory. For me, sitting on the bench was like being in a cage without bars. I paced up and down the dugout like a chained animal. *How in the world would I play for the Baltimore Orioles?* I made a promise to myself at the end of that season: I would become such a crackerjack ballplayer that I would never, ever, ride the pine again; and I never, ever, did.

Most likely there was not a junior in the country who had a worse varsity season than I had. I vowed anew to turn it around my senior year. I just had to! Amazingly, my own dream never dimmed during my junior year. Clearly, I needed to improve every element of my game, so I worked harder than ever. Coach Larsen taught me important fielding and hitting skills. I practiced them the rest of my playing days in high school. For hand, wrist, and arm strength, a physical component critical to being an elite hitter, he roped a tire to a light pole. I would hit and drive my bat all the way through the thick rubber that had been

cut in half with a saw, to complete my swing. It was a real wrist and forearm builder. Mission accomplished, as this exercise added raw strength from the top of my shoulders, down my arms, and through my wrists and hands.

Recreating that at home, I hung a tire from a rafter in my basement. For every 100 rips, I drove a nail into a piece of plywood. Coach Larsen came over one day, and I showed him my rigged-up tire station. He asked me what the nails meant. When I explained, he shook his head and said, "Wow! That is one hell of a lot of swings."

SENIOR BABE RUTH - MARTZ BASEBALL TEAM, SUMMER 1970

Playing varsity baseball meant I would have a better chance at making one of the Senior Babe Ruth teams. Despite my awful spring campaign, I needed to compete that summer—participating in games as much as possible. I had set my sights on not only being a starter on next year's varsity team, but also becoming a premier player. With a super senior season behind me, I next hoped to earn an invitation to play on one of the areas most celebrated teams, American Legion Post 130, coached by Harry "Jake the Snake" Jacobs—the top manager any local player with higher-level talent and aspirations wanted to play for.

Snagging a high throw, playing third base during a summer game on the Falls Church High School field.

I would push my muscle memory to the highest level possible, and beyond. The more games I played, the more baseball I practiced, the more I studied the fundamentals of how to execute the skills necessary to be a star, the better my chances were to continue pursuing my baseball dreams. The biggest of these was to become a Baltimore Oriole and crush my ninth-inning homer to win a professional championship.

The fact that I had just completed such a disastrous season had no impact on my self-confidence. My mind saw that bomb of a home run as clear as day, and one day I was going to lock in on a pitch and mash it a long way over the outfield fence for the Ring. I had learned at a young age the power of positive thinking, which was deeply rooted in my strong belief in mastering visualization.

The first step of my strategy began the summer of '70. And what a summer! I got my driver's license on my birthday in February, which changed my life immediately, enabling me to cover ground all over the Washington metro area, and occasionally beyond. Driving was like flying through the air, but on four wheels. And because of the unlimited flight destinations available to me, nobody could have played more baseball than I did. I excelled in my Senior Babe Ruth tryouts, drafted to a team that dropped me right into being their starting third baseman. Although I did not have the arm to play shortstop at the high-school level, and it was noticeably compromised, my throws from third were acceptable for this league.

With three games each week, I kept digging down as far as possible to improve my skills in every contest and practice. As summer progressed, I began to drive pitches. Although most were singles, my drives demonstrated a significant improvement over my painful varsity season of '70, when I had real trouble putting a dent into the ball. My range, fielding ability, and arm continued getting stronger, one game at a time.

This vertical trajectory was no accident. First, I worked with extreme focus; and second, I had been introduced to the Washington area's most passionate baseball coach, Edsel "B for Baseball" Martz. None of his peers and colleagues had spent more time guiding players on a baseball field than B for Baseball. He was a coaching fixture with a notorious reputation for pushing players to their limits.

Edsel worked a bullhorn from the dugout to berate opposing teams, coaches, umpires, and even his own players if he thought they were

dogging it. B for Baseball sensed I was a competitive wildfire that wanted to become a top ballplayer, and even though I was only 16, he allowed me to practice with his ace metro team of 18- and 19-year-olds. Underneath his tough, former marine hide beat a heart longing to inspire players right into professional baseball. With his keen coaching skills and love for the Great Game, he did just that—at least with me.

Winning games, playing third base, practicing with Edsel's team of top-notch players, and having my dad fill in by hitting me grounders all summer long, these months were when I started to knowingly "bleed" baseball and push myself **to become a better player than I could be**. If you drive yourself hard enough, pursuing any dream, then that statement will make sense to you. My passion paid dividends toward the end of the summer, when Edsel's team won the All American Amateur Baseball Association Regional Championship for players 19 years old and under. With this, our team qualified to participate in the 16-team, 26th Annual AAABA Tournament, which has been held in Johnstown, Pennsylvania, since 1946. This noted competition draws both college and professional scouts. Edsel added me to his team to be the pinch runner, knowing I could steal bases and score runs. Though never installed into a game in Johnstown, I became one heck of a batting practice pitcher.

When I joined the team, I quit my summer job working in an expansive plumbing warehouse. As the 18-wheelers rolled in, sometimes filled with boxed, white porcelain toilets, I unloaded and stacked them, one at a time, hour after hour. I smiled when I went up to my boss, named Fang, and turned in my time card. "I'm going to play baseball," I said.

Our force of a club made it to the championship game with a 4-1 record. The first pitch was scheduled for 7:30 p.m. in Johnstown's historic Point Stadium, built in 1926. At 5:00 p.m., Edsel had us in the hallowed locker room for his bone-rattling but highly effective verbal exhaust. As unusual as he was at times, he was one thick-skinned marine, and in his own way, he truly loved the game of baseball. Edsel believed and taught us the only way to play it was to win every game. Losing was for bums.

Winding up his memorable, Vince Lombardi-esque talk, he started pounding his right fist into his left palm, and his last words before we hit the field to prepare for the title game were, "I want to be buried in my uniform, a national champion." We all wanted to be AAABA champions, and we possessed the firepower to do it. Jimmy "Riggs" Riggleman—a

Jimmy managed 1,630 games in the big leagues. Riggs spent 48 years in pro baseball as a player, coach, manager, and advisor. In 2022, Jimmy was named manager of the Billings (Montana) Mustangs, an independent team in the Pioneer League.

fourth-round pick by the LA Dodgers in 1974 and future big league manager for the Padres, Cubs, Mariners, Nationals, and Reds—anchored the infield. Center fielder, Charles "Pickles" Smith was said to have once hit a homerun that traveled 500 feet. Our pitcher was a ringer, and this team was stacked from foul line to foul line with talent.

We faced Oakland Tool, from Detroit, Michigan, and thousands of fans packed the stadium. Oakland Tool entered this contest at 5-0, outscoring their competition by 44 runs. The stage was set early for a dramatic championship game. By the end of the top of the fourth inning, we knotted the score at 3-3. Then Detroit opened the flood gates, sending nine men to the plate, scoring four runs in the bottom half.

Watching the runs mounting up, challenging his dream, Edsel exploded. He emerged from the dugout like an aggressive mako shark, ready to attack its prey. B for Baseball darted to the mound to pull the pitcher. The former marine dogged him, screaming expletives all the way into the dugout. He forced him against the bricks. We all thought B for Baseball might fire off a frustration, you-a-bum punch. Hollering, "You just gave up four runs!" Edsel instead pulled him away from the wall and cornered him by the bat rack. Next he ran him into the locker room, calling him a broad range of spicy words. The pitcher remained emotionally imprisoned with his own feelings the rest of the game. I am not sure if Edsel ever said another word to him.

No team could extinguish Edsel's fire with five innings to play for the title. In the top of the eighth, future Maryland star third baseman, Vince "Vinny" Bateman, started a four-run rally with a single to left. Our offensive burst tied this seesaw game at 7-7. Edsel tasted victory and slammed a fistful of Red Man loose-leaf tobacco in his mouth to chew on. I never saw anyone spit more tobacco juice during a game. His plugs were the size of hard-boiled eggs. In the bottom half, two walks proved to be fatal, as the first one to left fielder, Wham Ballard, resulted in a run. Edsel grabbed a bat and started to grind the barrel with his hands. The incensed volcano of a man was going to erupt and turn Point Stadium into a molten-hot lava flow.

Down one run in the top of the ninth was too much for our team to surmount. Detroit's right-hander, Woody Mills, went the distance, picking up his second tourney win. This heartbreaker of a loss devastated B for Baseball and our team. We became a collection of mannequins sitting on a wooden bench, knowing we were *that* close to claiming the championship crown.

Our speechless marine general gulped down the exploding pain of his team's 8-7 loss. Few coaches ever managed an amateur club that went as far in a big tournament as Edsel did with this team. I bet he was proudly buried in his uniform as an AAABA runner-up tournament champion. I hope so, as he earned himself a great personal triumph.

B for Baseball's relentless practices and games had proved him right. He was a bold baseball coach, a fiery competitor, and a baseball champion.

Edsel gave me unparalleled advice on how to become a high-average hitter: build my own batting cage. The force of his idea resonated on a deep level. A batting cage in my own backyard. Wow! I had come to the conclusion that if I became an exceptional hitter and scored a lot of runs, I could be an outstanding starter for my senior year in high school.

However, I had to strengthen my right hand and arm to consistently drive the ball into the outfield and have a batting average of .350 or higher, which I surely thought would earn me a college scholarship. The only way to achieve this was to hit and hit and hit, spit into the dirt and grind it into the bloody blisters on my hands, and hit some more.

I decided to move forward with my plan. It seemed like a far-fetched idea, but nonetheless, I drew out my plan: I would dismantle my tree house to reuse the two-by-fours and other materials. Also, it would clear up the sky above home plate. Let's face it: what hitter wants to take his rips, standing in the batter's box under a tree fort? From the local schools and parks, I would collect soon-to-be-trashed tennis nets. And if I bought rolls of chicken wire and installed lights, I would have the batting cage I desperately needed. My great tree house, where my imagination was forever ignited over many years of joyful occupation, slowly was dismantled, one board at a time.

I framed in a long, rectangular box that looked less like a batting cage and more like a contemporary art installation on exhibit at the Museum of Modern Art in New York City. A wall of wire ran ten feet out, parallel to home plate, with a four- by three-foot open rectangle in

it for the pitches to go through. My grand design stopped most of the hit baseballs, unless you drilled a line drive up the middle.

I built a portable, L-shaped structure that flipped either way to accommodate a right- or left-handed pitcher to hide behind once he delivered the pitch. I cut a jumbo bleach bottle in half, lengthwise and nailed to a tree with a ramp attached that led into a dirt gully. Hitters would collect the baseballs on the ground in the hitter's wire cage and put them into the jug. They would roll back to the pitcher and end up in a hole in the ground by the pitcher's mound. In theory and on paper it seemed like it should work, and in reality it exceeded my design expectations.

I hit day and night. I hit so many baseballs my bat handles turned red. My hands bled and calluses formed on top of the blisters. The insides of my hands became so leathery I could have blowtorched them and not felt the flame. And only once did I need to be stitched up at the hospital from hitting in my cage: I took a pitch in the mouth that drove my upper lip into my teeth.

Oddly, this occasioned my second visit to the hospital emergency room in the same day. That morning, while taking the compacted trash bag out for my mother, a piece of glass stuck through the plastic and sliced a deep gash across the burn scar on my leg. Dr. Leidelmyer, a friend of my parents, who my mother worked with in the ER for many years, stitched me up both times. When he saw me sitting on a bed with an extremely swollen and bloody top lip, the doctor asked, "What the hell are you doing back here again?"

I mumbled my "how it happened" account, and Doc shook his head from side to side as he threaded the small rainbow-shaped, shiny stainless-steel needle with cat gut string to suture up my wound. He asked how my mother was handling my multi-visit day. I told him she was not home for part two, and would see the stitches in my lip later. My morning laceration, of course, had not stopped me from taking batting practice in the afternoon.

My father, a left-handed thrower, pitched to me at night and on weekends. Soon my teammates and players from other teams began coming over to take hitting practice in my cage. It became a destination, and a fun one. We would crank up rock-n-roll classics, drink iced sodas from my cooler, and hit away. Boom! Boom! and Boom! Some fine hitters came through my batting cage over the years. I most certainly became one of them.

Backyard Batting Aide

*This photograph, one of three from a newspaper article in the
Northern Virginia Sun, dated May 19, 1971, shows me taking rips
in my batting cage with Edsel "B for Baseball" at the far left. He
is giving me hitting instructions that contributed in my ascent to
become a top, .300+ hitter, season after season.*

*What can you do as a person to become a champion? (1) You
must have total confidence and belief in yourself. (2) Always
desire to be put into a position to win it all. Pressure situations
build character, and character builds champions. (3) Visualize
becoming the champion you dream of being. (4) Honor your
coaches and teammates; your team cannot win without them.
(5) Know in your heart you gave your dreams 110 percent. (6)
Pursue your dreams; they are great gifts to present to yourself
and others.*

YOU MUST PERCEIVE IT AND BELIEVE IT TO ACHIEVE IT!

Being a Champion

Becoming a champion is a great gift to give
yourself, teammates, coaches, fans, and others.
You will always be that champion.
Your competitive wounds and injuries will,
over the seasons of life, heal and fade away,
leaving you with something of great value, being a
champion.

3RD INNING

PERCEIVE IT, ACHIEVE IT

Senior Year, 1970 – 1971

My long-awaited growth spurt began with spring 1971, when I reached 120 pounds, which thrilled me. Though I remained, by far, the smallest player trying out for the team, I was also the fastest. And I made a lot of noise, demonstrating my range and fielding at second and third base to be better than average. With my new weight and improved hand and arm strength, I placed a hit in the alley now and then, for a stand-up double. Two days before tryouts ended, coach Larsen came up to me after batting practice and told me I would be his starting second baseman on opening day. I felt I deserved it and said, "Thanks, coach. I will hit .300-plus." I picked up my glove and jogged out to my position. Second base was mine—and just one year ago, the JV coach had rejected me and turned me away to make that lonely walk down the center of the football field.

Being a starter and playing varsity baseball, *serious* baseball, charged me like a solar flare on the sun's surface. Competition was intense, pitching more potent. Jay Franklin, one of the greatest pitchers in the history of high-school baseball, pitched for neighboring Madison High School.

Every aspect of our Falls Church 1971 season proved sound. We had a good team that

In his high-school varsity career, Jay went 28-1, with 15 shutouts and 363 strikeouts. Following his (continued on p. 84)

senior year, Jay pitched in the big leagues—at age 18. He was the second player picked in the June 1971, MLB draft by the San Diego Padres. During his three weeks in the Bigs, Hank Aaron got a hold of one of his pitches and hit his 638th career homer. Very sadly, Jay injured his pitching arm and would never see the big leagues again.

played well together, and I was in every inning of every game. I did not need a pair of tweezers for any splinters, and I surely did not feel like a caged animal. The grand season I experienced would earn me a starting position to play for Snake's American Legion Post 130 team. Being able to continue climbing baseball's competitive ladder to showcase my talents was exhilarating.

At-bat, I only slugged one extra-base hit, a double, all season. I put up solid defense at second, and my throws turning double plays showed real zip. I stole bases and played outstanding ball on this more challenging stage. Having been on B for Baseball's team of mostly 18- and 19-year-old players, one game away from winning the AAABA Championship, dramatically raised my own expectations.

Going into the last game of our season, I was battling for the chance to lead our team in

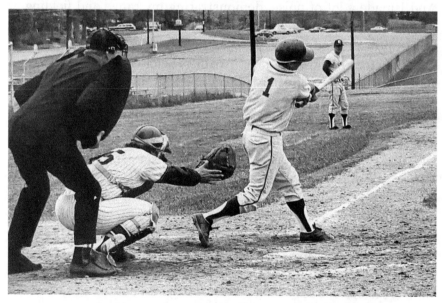

In a 5-4 win over Woodson High, I ripped out a base hit to drive home a run. Coach Larsen is standing in the third base coaching box.

hitting. Eddie "Bear" Duffy, the team captain and cleanup hitter, and I had played together on multiple teams, and we both spent a lot of time hitting in my batting cage.

My batting average led the team as my good friend stepped up for his last at-bat that might earn him the batting crown. Bear could downright hit. He possessed strong hands, exceptional wrists, and a quick bat. He also was a difficult out. Every pitch he aimed for, Bear took a home-run swing on it, and when he tagged one, it went a long, long way. A barrel-chested Irishman, he was a superior defensive catcher and first baseman, who also played center on the varsity football team. Bear took his athletics seriously, and I learned a good deal from him as a teammate. In any match, the stronger the team and the fiercer the pitcher, the deeper Bear dug into the batter's box. Had his bat been an axe, some of his rips would have buried that steel blade far into the trunk of a tree. Eddie's love for the Great Game eventually earned him a scholarship to play for the Virginia Wesleyan Marlins.

In his last at-bat, Bear lined out—and I owned the batting crown. I had gone from the lowest batting average possible, .000, the season

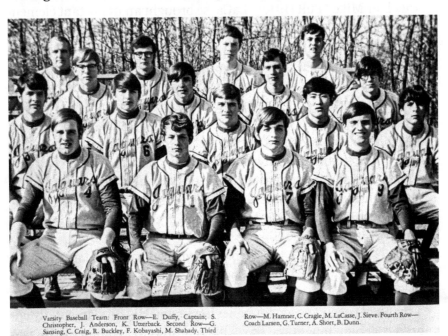

Varsity Baseball Team: Front Row—E. Duffy, Captain; S. Christopher, J. Anderson, K. Utterback. Second Row—G. Sansing, C. Craig, R. Buckley, F. Kobayashi, M. Shahady. Third Row—M. Hamner, C. Cragle, M. LaCasse, J. Sieve. Fourth Row—Coach Larsen, G. Turner, A. Short, B. Dunn.

The 1971 Falls Church High School
varsity baseball team.

before, to leading the varsity baseball team in runs scored, hits, stolen bases, and a team-leading batting average of .371. What an incredible personal and athletic accomplishment! This season was the launchpad for my 110-percent conviction in the power of visualization, dedication, diligence, and belief.

Our team displayed a mix of proficient players. Shortstop Joe "Mercury" Anderson, younger brother of Billy, was a mountain of sports talent. I studied his adept skills playing short, knowing that one day, when my arm was stronger, I would be transitioning over to play in the six spot. Joe spent many hours hitting in my batting cage with Bear and me. Before any home game, you would find the three of us ripping baseballs in my backyard. Since our school did not have a batting cage, we sometimes missed seventh period to use my rectangular, chicken-wire hitting complex. We wanted to be game-ready to crush pitches.

Catcher and basketball guard Kenny "Admiral" Utterback was always a welcome teammate, on any team, because of his intense competitive nature and the drive he exhibited to always advance his athletic skills. Admiral later attended Bridgewater College in Virginia.

Infielder Mike "Pull Hitter" LaCasse brought an important element to our team. His presence tightened up our club. Pull Hitter showed a quick bat that drove the pitch hard, especially down the third base line for stand-up doubles. His glove, the way he threw, his game instincts, all of it and more made Mike a player that fans, teammates, and I studied throughout a game. Everyone could see that Pull Hitter would have a noteworthy scrapbook when his baseball career ended, and we were right. Mike made baseball a joy for me. He had a sense of humor that rattled my ribs from laughing so much, season after season.

Coach Larsen was very proud of my sensational spring performance. I was stunned when presented with the Most Valuable Player trophy that had been voted on by my teammates. I accepted it to loud applause at the awards ceremony.

Athletes from all the spring sports teams had witnessed my commitment to improve, with a handicapped hand and my king being one move away from checkmate the year before. I had to pull through, and I did.

I thanked coach Larsen for believing in me. His fundamentally advanced coaching taught me the skills required to be an MVP. He was an admirable man who loved to teach health and physical education, fight an orangutan, and coach football and baseball. As I walked back

Joe Anderson was voted the top male athlete at FCHS in 1971, starring in both baseball and football. Mercury earned many awards, most notably receiving an All-Metropolitan Honorable Mention as a defensive back, though he also quarterbacked.

Focusing on baseball at George Mason University, Joe played both the infield and outfield, where he earned a spot on the All Mason-Dixon Conference Team multiple seasons. Also, he was awarded a position on the All Washington Metro College and All Virginia Small College Teams. As a junior, Joe ripped the cover off the baseball, swatting a red-hot .433, which ended up the sixth-best batting average in the nation for NAIA Division II. Mercury and his brother Billy built a very successful business together, Anderson Mechanical.

Kenny Utterback was always clawing away and improving his mind and body to become the best athlete he could be. Admiral played all four years on the baseball team for Bridgewater College and his first three years as a guard on their basketball team. He made the All Virginia College Athletic Association team as a catcher his last three seasons.

Kenny accomplished something that is extremely rare in the Great Game. He did not have one strikeout or one passed ball as a catcher, in both his junior and senior years. That is a major baseball feat at any level. And Kenny dug deep in the batter's box his senior year, cranking out a splendid .429 average.

Admiral had a distinguished law enforcement career in northern Va., retiring from the force with the rank of Master Police Officer.

Mike LaCasse attended James Madison Univ. in Harrisonburg, Virginia, compiling a grand, four-year baseball résumé there. The interest generated from his outstanding seasons brought in the major league scouts, and Pull Hitter was drafted by the Orioles in the 18th round of the 1977 draft. In his 1978 pro season, Mike's teammate was future baseball great, Cal Ripken Jr. Pull Hitter played 140 games and had 465 at-bats over three pro seasons. He played every position except catcher.

His teammate at Madison College was a hot prospect, infielder Billy Sample. In 1976 he was drafted in the 10th round by the Texas Rangers. Billy played in 826 games over nine big league seasons, hitting .272 in 2,516 at-bats, with 98 stolen bases. One season he played for the New York Yankees.

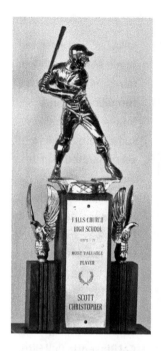

to sit with my parents, I paused for a moment to scan the crowd, holding my MVP trophy close to my heart. Dad was overjoyed by this achievement. I handed him the trophy, grateful for all his support and the many years he devoted to helping me become a first-rate ballplayer—and Mom's deep, loving hug completed this perfect night for us all.

AMERICAN LEGION BASEBALL

If ever there was a Popeye look-a-like in a human body, it was coach "Snake" Jacobs. One of his memorable axioms was, "Baseball is a man's game, second only to war." In war, you would want Snake right next to you in a foxhole, as he would lead the charge and take a bullet for his men. And for me, from a very young age, when I stepped over those brilliant-white, chalked foul lines to begin the game, it was battle time.

A dedicated coach and an industrial-strength man, Snake smoked fat, half-a-dollar cigars until they became short enough to burn his lips. He excelled as a coach, being one heck of a competitor and one hell of a fighter. When he held his tryouts, I sensed an immediate advantage: though I was a scrappy baseball player, Snake similarly was a scrappy coach. He may have weighed 135 pounds soaking wet. Also, with my exceptional varsity season behind me, I was locked in to be Post 130's starting second baseman.

Snake's teenage son, Joey, a great kid who required assistance due to a cognitive challenge, always showed up with his father and enjoyed being around baseball. Snake did an exemplary job helping Joey have special life experiences, and being in various ball parks brought Joey happiness. He was a fixture in the dugout. When Snake told us from the third base coach's box to have a quick bat—which he conveyed multiple times to every hitter all throughout a game, the entire season—Joey would then yell out, "Quick bat, quick bat." This father-and-son duet paid off, as a quick bat drives a baseball through the holes and into the alleys, which ultimately leads to putting men on base to score more runs, and runs win ball games.

I lapped up one terrific summer playing for the one-and-only Jake the Snake. He worked me hard, but every drop of my sweat left on the baseball diamonds was worth it. I felt honored to play on his team, even though, at the end of the season, we lost in the "tune-a-ment," as he called it.

Competition wasn't all on the field. For decades, Snake and my former coach, Edsel B for Baseball Martz, stoked a legendary, simmering feud. At one night game we squared up against Edsel. It was Popeye versus Brutus: Snake, a warrior who believed baseball was a battlefield stood in one dugout, and Edsel, the former marine who drilled his troops almost every day of the year, whether in practice or in a game—holidays, vacations, birthdays, and inclement weather meant nothing to him—stood in the opposing dugout.

Lots of fans showed up, as interested in following the coaches' jousting as they were in watching us play ball. When angry, Edsel hollered through his bullhorn. If he thought a player did not hustle during a game, he yelled through the mic, "You a bum. Quit baseball, you bum. Go pump some gas, you bum."

This particular hot and muggy August night, Edsel's philosophy prevailed, though it was a close match. His team worked harder, and they walked off the field, victorious. Our wool uniforms were plastered to our bodies with sweat. When the umpire called the final out of the game, Edsel's bullhorn blared as he started walking toward our dugout: "You a bum, Snake. You should be coaching a girl's softball team. Your team plays like a bunch of sandlot bums in dresses!"

Edsel had crossed the line. Snake grabbed the chain-link fence and squeezed the links with his iron hands. He spit out his cigar and ground it into the dirt with his fine leather shoes. This is what the fans had been waiting for.

As Edsel came toward our dugout, Snake erupted like Mount Vesuvius had in 79 BCE. He headed right at the man who berated him and his players. I followed close behind Jake with my teammate, Mike "Pull Hitter" LaCasse. Along the way, Snake snapped up the scorekeeper's aluminum folding chair. Everyone else—fans, players, and umpires—froze in anticipation. Snake raised the chair and smashed it over Edsel's head, bending the chair.

Edsel took a looping swing at Snake, which he ducked under, and then Snake fired a jab that grazed Edsel's jaw. As a 220-pound block

of a man, Edsel carried 85 pounds more than Snake. As solid as Jake was, he was going to get his butt stomped, and Pull Hitter and I knew it.

From behind, I put Snake in a bear hug and swung him around so Edsel wouldn't take his head off with the marine artillery-shell punch about to be unleashed. It caught Snake on the back of his head, but I had already started to move Snake away from the punch, which softened the blow. Pull Hitter got into position to block any additional missiles Edsel might launch.

The fans hooted and jeered. Some favored Snake and some hoped Edsel would drop him to the ground like a bad habit. Always hot and spicy, this time the stew boiled over. Baseball can do that sometimes.

Snake kicked his legs and flailed his arms. I buried my head deep into his back—a wrestling hold—so his elbows would not end up in my eye sockets.

A group of players had built a human wall to block Edsel, a former boxer. He wanted to damage Snake and send him falling hard to the ground. You don't smash a chair over a marine's head, take a swing at him, and get away without some form of hurt.

We put Snake in the chain-link dugout and blocked the opening so he couldn't escape back to fight. There were fifteen of Snake's players stacked up to take Edsel on if his hot temper boiled over. Pull Hitter and I were the first ones in the pack that would have squared off with the marine, and we were ready. My left fist was clenched and I had planted my spikes into a boxer's position. Yeah, Edsel would have most likely knocked a lot of us for a loop, but to get to Snake he would have had to go through our entire team first.

Coaches earn this type of loyalty from their players. It is not a given. We all deeply respected Snake and believed he would have charged a fully manned battalion alone, suffering the consequences, to protect each and every one of us from any harm. Edsel finally withdrew, but what came out of that bullhorn from the parking lot didn't sound pretty: *bum* this and *bum* that. And finally there was silence.

Other players and I escorted Snake to his red, weather-beaten, vintage Dodge Dart. We loaded up his trunk with the canvas bat bag and catcher's gear. Snake lit up a fresh cigar, and as he started to drive away he spouted, "I'll get that sum-bitch next game we play 'em."

This was one grand summer of baseball. Pull Hitter and I shared many memorable times playing for "Jake the Snake." I was happy when

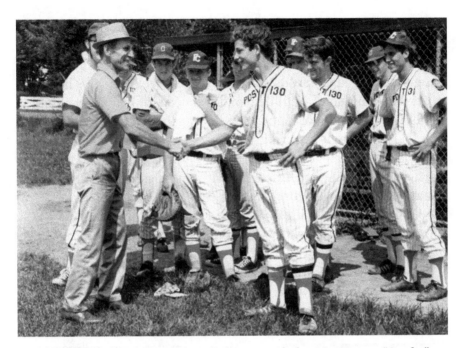

*All the players chipped in to buy a watch for Mr. Harry "Snake"
Jacobs. As captain of Post 130's 1971 summer team, I presented it
to our coach at the end of a rollicking season. My teammate Mike
"Pull Hitter" LaCasse is in the far right of this photo.*

our season ended, because I had busted my gut from laughing so hard,
so many times, that I thought I might damage one of my internal or-
gans. Snake brought a love, a passion, and a must-win philosophy for
the Great Game, which I carried with me on every diamond I played,
season after season. Snake was 135 pounds of pure man, a fighter for
his players, and one exceptional coach.

COLLEGE-BOUND

If you truly perceive it, you can achieve it. I have believed this my whole
life. I ask myself sometimes where this bold statement came from
and how did I learn it? For me, it comes with searching both inside
and outside the human experience as a person, artist, and athlete.
Disappointments and gut punches only get you that much closer to
your dreams coming true. Surrendering to the darkness will drop you
on the canvas, with "life" counting to ten for the knockout.

After my fateful injury, I used everything within me to claw my way back, even with most of the cards stacked against me. The strongest card I possessed was the Love that my parents, Mike Malone, and his parents showered on me, day after day. My baseball dreams had been frozen in a dark place. Yet I drilled down deep into my determination vault to ensure that I would play baseball again. I *had* to, and I learned that if I didn't create inspiration each day—by seeing myself swinging a bat, running the bases, scoring runs, fielding grounders and catching fly balls, making throws, being with my teammates, and winning games—I would never stand in the batter's box ever again. I needed to perceive all of these things, or my dreams would drift away, and the thought of that made me very sad as a young boy.

When I was included in *Sports Illustrated* at age twelve as one of the top young athletes in America, that branded a deep imprint in my soul that, Yes, I could achieve my dream of becoming a Baltimore Oriole. I visualized it vividly: the white, spinning pearl headed directly into my wheelhouse; I would freeze the red threads and swing for the fences.

A former pitcher from Falls Church High School, Tom Bradley, had been a star pitcher at U-MD for two years before being drafted in the seventh round by the 1968 California Angels. The dominating right-hander still holds the ACC career record for the lowest ERA, at 1.33. He went on to a successful big league campaign over seven seasons, compiling a career record of 55 wins against 61 losses—3.72 ERA—691K. Highly intelligent, Tom earned his degree in Latin with a minor in Greek. He and Billy Anderson inspired me: if *they* played for FCHS and starred at Maryland, so could *I*.

My interim step required me to play for the premier baseball program at the University of Maryland. As my last season of high-school baseball wound down, I sent a letter to Elton Jackson, the coach at U-MD, expressing my desire to be on his Terrapin team. I enclosed articles and other information about me. I highlighted that one of his infielders, Billy Anderson, and I were FCHS teammates the year before. And because coach had offered Billy his scholarship after attending the American Legion state finals—where Billy, as always, excelled—I invited coach Jackson to come see me play summer ball for the same American Legion Post 130 team.

Hundreds of high-school and junior-college ballplayers also knocked on his door. Players, coaches, parents, and bird dogs from all over the country

esteemed coach Jackson as an ace baseball coach who had guided his teams to multiple Atlantic Coast Conference championships and postseason NCAA appearances. He developed many players who went on to successful careers as coaches and players in professional ball, including the big leagues.

Coach Jackson kindly scheduled a meeting with me in his office, located in Byrd Stadium, the home of Maryland's 1951 and 1953 undefeated NCAA Championship football teams. When I walked through his door, I stood five feet, five inches tall and weighed 135 pounds. I found myself in a shrine honoring the championship teams and professional players of Maryland baseball. We both sat down and talked baseball. Through the window I viewed the Terrapin's diamond, Shipley Field.

Coach Jackson had a curious mind, and he was a straight shooter. As a mentor to many young men, he carried that responsibility honorably. He understood the competitive road I traveled. Coach himself had received no free lunches along the way. Playing pro ball as an infielder in the Philadelphia Athletic's organization for four seasons, 397 games, and 1,286 at-bats, he once got beaned in the head badly, which put him out of baseball for a month.

He spoke with me for 15 minutes, validating I was an important player; I meant something to him. I saw his appreciation of my tenacity to be a Terrapin. But, ultimately, he didn't need another infielder, especially one from out of state. Coach shook my hand firmly. I left and walked slowly over to the baseball field.

The familiar, red Baltimore bricks of the stands, the layout of the infield, the dugouts—it all seemed like I should be a Terrapin. I saw myself at shortstop, in uniform, on this proving ground for advancing to the next phase of my dream with the Orioles. But coach Jackson had just sent me down a desolate road, and I felt he didn't understand the depth of my dream or the range of my talents.

The thought of *not* becoming a Oriole never entered my mind. I had to be patient, power out, and continue to study the game. As much as I wanted to play at a higher classification of baseball, it didn't make me taller, heavier, stronger, or older. With my parents' support, I continued researching other schools with reputable sports teams. Baseball remained the cornerstone of my life. The invitation I had extended for coach Jackson to watch one of my Post 130 summer games vanished into thin air. At this time, he and I were in different galaxies with

regards to me playing on his Maryland team. I had spent most of my life climbing uphill, and I knew in my heart that one day I would be back in front of coach Jackson—I just didn't know when.

One afternoon, B for Baseball stopped by my house while my friends and I took our rips in the batting cage. He asked me about my plans for college. I told him I might go to the local junior college, as a last resort—they lacked a baseball program.

"Let's talk with your dad," he said.

Edsel told us about Mercersburg Academy, a prep school in Pennsylvania, where he had contacts. "They have a strong athletics program," he said.

My parents had been advised that I might not be ready for a college experience, and I was not enthusiastic about any of my college options. So a post-graduate year at Mercersburg sounded like a viable option to all of us. The next day Edsel made a call on my behalf to Mr. Ed Staley, the director of student admissions. The following day, my father called Mr. Staley to schedule an appointment to visit with him.

One of the finest prep schools in the country, Mercersburg conducts a highly selective admissions program. Though it was past the deadline for student applications, I held an ace of diamonds in my back pocket: I played football, wrestled, ran fast, hit .300-plus, and would score runs on any baseball team I played on.

The interview with Mr. Staley went better than expected. Afterward, he gave me a grand tour of the campus, athletic complexes, sports fields, and art department—my excitement was exponentially visible. Next he put quite a bright-orange, large carrot on my plate, offering me a partial scholarship to attend Mercersburg, which sealed the deal.

My summer job took me back to the plumbing warehouse and hauling toilets, copper pipes, fixtures, faucets, and everything connected to supplying water to a home or commercial building. Two weeks before packing up to go to school, I again went to Fang to say I was heading off to pursue my education and be an athlete. My career as a water-closet-unloading-and-stacking specialist had concluded—forever!

When my parents dropped me off in August to begin my post-graduate year, I immediately suited up in a "Blue Storm" football uniform and joined my new teammates on the practice field. My parents lingered by their car, parked near the field, finding it hard to drive away. I walked over to say goodbye to my father and next went around the car to give

my mother a hug. Tears brimmed in her eyes, and I held her close. "I love you, Mom," I said, and she replied, "I love you, Scotty."

Though I had a lot of experience at being independent, that day I took my first real step toward becoming a self-determined man. My life, world, destiny, adventures, dreams, failures, and successes were all inside my bedazzled ringmaster's top hat.

An insistent whistle blared from the field, signaling the time had come to run drills. As I finished a 40-yard dash, I slowed down and jogged back to our offensive coordinator, who was positioned on the starting line for our sprints. I glanced over to where my parents had been parked. They were gone. I pictured them at the dinner table that night, just the two of them. Sadness and excitement played a tug-of-war in my chest, as my heart pumped the future in and the past out.

BRAIN DAMAGE

Mercersburg Academy, founded in 1836, is located on 300 acres of beautiful, rural Pennsylvania land, 90 miles northwest of Washington, DC. My room was situated on the fifth and top floor of Main Hall, constructed in 1837. The famous movie actor Jimmy Stewart ('28) lived on this floor as a student. Benicio del Toro ('85), another Academy Award-winning actor, is also an alumnus. One of my favorite photographers of all time, Walker Evans, attended Mercersburg in 1921. And 54 Olympians walked the same halls I walked. My opportunities there were filled with an abundance of potential.

All the perseverance and sacrifices I had made since I began rehabilitating my hand and arm in 1960 now paid dividends through Mercersburg's academic, athletic, and art offerings. Pushing your mind and your body never gets old; they operate in tandem and advance together. What succeeds for you as an individual is, and will always be, up to the chief architect of your life—**You**!

I learned this wisdom from the headmaster, Mr. William Fowl. He and I became friends, walking together every now and then at dusk. Mr. Fowl ambled—he was a contemplator—but I slowed my pace and listened intently when he talked to me about my future. I told him about my dream to play for the Baltimore Orioles. An accomplished athlete himself, he encouraged students to make their dreams a reality. He taught me that once you learned something in the classroom or in your

life experiences, that knowledge builds your castle, and your castle is where you will live and thrive throughout your journey.

Though still small for a varsity football team, I practiced with that extra as a punt and kickoff return specialist, a second-string tailback, strong safety, and punter. Cutting, feinting left and shooting right, slowing down, accelerating, following my blockers, and zigzagging around defensive players as they zeroed in on me—it all came naturally. I pulled off some long touchdown runs in practice. I saw limited playing time, but on the gridiron, at whatever position, I played rugged football. My aim then, as on prior teams, was to bust through the defense when a lane opened up, activate my afterburners, sprint down the sidelines with the fans cheering, holding the pigskin tightly, and the defense trying to tackle me as I cut back across the field and closed in on the goal line to score—now *that's* electrifying.

Scott Christopher, a graduate of Falls Church High School, is now playing football at Mercersburg (Pa.) Academy. Christopher, 5-6, 140 pounds, is a kicking specialist for the team.

But it's also risky. The impact point of a tackle usually happens from the waist down, but occasionally it comes higher up. A helmet-to-helmet mash-up is rare, and because it causes serious injuries, the NFL now prohibits it. Nevertheless, three games into the season, during a contact drill, I took a direct shot to my head in a collision that would have stopped an oncoming train. We charged into each other full tilt, neither backing off. After colliding, I remember a moment of pure nothingness. I fell to the ground, enclosed in a vault of blackness. It took ten seconds for the lights to come back on fully, and when the confusion lifted, I continued giving it my all in the remaining drills and the rest of practice.

Early the next afternoon, I went for my mail, and when I opened a letter from my mother, her words were blurry. She always wrote on

lavender stationery, but this paper seemed white, except for a few faint lines, way in the distance. Within hours, I thought I was going blind, and I checked in at the campus infirmary to see Dr. John Prevost.

Alarmed by my symptoms, he began a battery of tests. Using a small pinpoint flashlight, he shined the beam into both pupils, clicking the light on and off. They did not dilate. After an EKG, Dr. Prevost pronounced I had suffered a major concussion. Deep bruising to the brain and pressure from the swelling inside my skull caused the temporary loss of vision.

With such an injury, the only choice is to ride out the severe headaches. I would get through them, but healing required the elimination of any and all possibilities for another blow to my head. The prescription: no more football, ever. And in the short term, no more wrestling, and even baseball hung in the balance. In the spring, I would be retested to determine whether I could play. If the damage to my brain normalized over the next four months, I would be cleared to step into the batter's box.

The prospect of being benched weighed heavily on me, and I struggled to stay positive. Dr. Prevost monitored me daily for the first two weeks. My vision noticeably improved. The pounding headaches continued to be painful, but as my bruised brain healed over several months, the throbbing jackhammers in the front of my skull eventually quieted.

In October 1971, an article I penned was published in the school paper. I wrote about my experience, titled "Consequences of Injuries." Writing assuaged, at least to a small degree, my impatience to be playing sports. Another boost came in late November, when I received a handwritten letter of encouragement from one of the greatest NFL players in the history of professional football, the Baltimore Colts Hall of Famer, Super Bowl Champion, Johnny "Golden Arm" Unitas. Johnny U concluded by writing, "So take your time, heal properly, hit the books, and before you know it, you will be right back in there. Best of luck, and I will be rooting for you. Sincerely, Johnny Unitas." Number 19 was my favorite football player, and I took his words to heart. I read his letter many times during my recovery, determined to make the sensational quarterback's prediction a reality. It was kind of Mr. Unitas, the reigning Superbowl V champ QB, to write to me after learning of my severe head injury through a friend of my parents.

The silver lining to my concussion, to being prohibited from competing, was that I created my own focused training program, entirely

See the Golden Arm's transcript of his letter to me below.

Nov. 29, 1971

Dear Scott,

Just thought I would drop you a line to see how you were getting along at the Academy. I heard about your injury but I know your life has been full of these types of things and that you have not let it get you down.

Sometimes injuries happen for the best. They tend to make us stop a little and take a good look at ourselves. I know that sports mean a great deal to you, as they do me, but rushing back into the game is just as bad as getting injured all over again. So take your time, heal properly, hit the books, and before you know it you'll be right back in there.

Best of luck to you. I will be rooting for you.

Sincerely,
Johnny Unitas

devoted to baseball, to be in the best shape possible when practice started in February. I installed a tire in the woods, similar to the setup in my basement at home, and pounded it almost every day. I pumped steel and practiced a variety of agility skills. I ran sprints on the track and also on the indoor basketball court, working on getting quick breaks on my leads, as if I was going to steal a base. Wall ball strengthened my throwing arm. Swimming in the early mornings built up my wrists and hands. Since Dr. Prevost banned me from diving into the pool, due to the impact it would have on my bruised brain, I was instructed to use the pool ladder to climb into the water.

In addition, I renewed my commitment to academics. Going to the library became a highlight of my day, to study and catch up on the reading that had been riding the pine while I ran the bases, charged toward goal lines, and pinned opponents to the mat in my earlier years. I joined the Archaeology Club, guided by one of my favorite teachers of all time, Mr. Tim Rockwell, who was my student advisor as well. He relentlessly stressed the importance of balancing academics and athletics and spurred a curiosity in my mind for the love of learning that has never been extinguished.

I also became a member of the Caducean and Varsity Clubs. I lived in Main Hall, where I made colorful abstract drawings and large sculptural candles in my room. I sold these creations at local church bazaars. My roomie, Bill "Ace" Levegood, the number-one ranked player on the tennis team, must have thought he was living with an avant-garde artist in the Marais, near the Centre Pompidou Museum, in the magnificent city of lights, Paris.

Paintings, photographs, sculptures, poetry, literature, music—all convey a life force that is filled with passionate meteors crashing into my soul. My father introduced me at a young age to art on an extreme level. And I had created lots of art myself, but from a position as a lover of the arts, as an observer, and as the son of an artist. Now, Mercersburg opened up this splendorous learning hemisphere. The history of art and the lives of artists like Van Gogh, Chagall, Michelangelo, Escher, Walker Evans, and one of my favorites, Amedeo Modigliani, added to my

"Peace to All"
I made this photograph in September 1971, from the roof of Main Hall, where I lived. Many of my photographic compositions, from an early age to the present, have been created having a geometric focus to the image, with negative space being as evident and essential as the subject itself. Abstraction, the beauty of the moment, and life experiences are very important languages for all of my artistic creations.

passion. I found the most interesting academic content I had ever consumed in those months. Expectedly, I consistently achieved honors in my studio art classes, with report-card comments highlighting my exceptional imagination.

Three good friends at Mercersburg included Ace, George Cabell "GC" Williams III, and Tom "Knight" Atkins, whose dorm room sat next to mine. Knight crossed swords on the fencing team, and he possessed all the equipment necessary for us to spar regularly. I found it to be a challenging sport that required varied skills and techniques. The footwork and timing of your lunges seemed to be the most important factor in prevailing against your adversary, which I did not do too often against Tom. Our bouts were mostly using saber swords. Knight and I also took day-long bike rides, destinations unknown, having adventures and looking for interesting photographic compositions, of which there were many in beautiful, rural Pennsylvania.

Cabell focused on scholastics and cultivated a large-screen vision of his future. He valued knowledge, and everything he did academically, no matter how hard he had to work, seemed easy for him. He mixed two half-full glasses into each and every day. I don't think GC knew what a half-empty glass was. His eagerness to learn new things helped forge our friendship. We were both storytellers, and since Cabell lived right across the hall from me, we told a lot of them to one another. And together we melded stories along the way. Cabell excelled in his business career, which was no surprise. He continues to visit Mercersburg to mentor and share his life's valuable perspectives with students.

GC has a vivid memory of me winning two gold medals in a track meet. I had finished practicing on the baseball field and walked over to the gym to change into my track uniform. Then I jogged over to the track to compete in a championship, four-school invitational meet. I proceeded to win the triple jump competition. Cabell was right next to the sand pit when I landed my longest jump. I popped up and said, "Hey, GC," and he replied, "What's next?"

"I'm the anchor for the 880-yard relay team—I'll see you at the finish line." In the final turn of that relay, I was neck and neck with another runner. At 80 yards out, my legs were fired up and pushing long strides. As I closed in on completing the race, I could see GC cheering me on. He clapped and smiled as I crossed the finish line. My relay mates and I won the first-place gold medal.

As the snows melted and baseball practice neared, Dr. Prevost gave me the all-clear to play ball. Now pushing five feet, six inches and tipping the scales at 140 pounds, I champed at the bit to be with my teammates, to dig into the batter's box and swing away, steal bases, score runs, lots of runs, and win games.

Coach Wayne Duncan, a tall man who could downright launch a baseball, liked to mix in with the players at batting practice and take his swings. I studied how he could crush a pitch and send it into "**Wow**" territory. Conventional and methodical in nature, he coached the same way: here is the baseball field; there is the opposing team. The pitcher throws a round ball covered in horsehide that he is trying to place over the 17-inch-wide plate for a strike. You hold a long, rounded piece of wood with a knob on the end of the bat handle, and you time your swing to hit the ball far and away. Come to the field and give 110 percent. Play within the rules. Score more runs than the other team. Win the game. Oh, and by the way: do not forget your opponents are working in unison to get you out, embarrass you, and send you off the diamond a loser. Period. Conventional and methodical was a skillful approach to coaching our team; we won more than we lost.

At this level my arm still lacked the strength to play shortstop, so I played third and second. First baseman Tom "Lobster" Hadzor worked his glove like a large lobster claw. He went straight into a short hop throw and pulled it right out of the dirt. Lobster took hefty swings and consistently put a charge in the ball. He wrote to me once that I "had a wicked strong arm." I appreciated his confirmation, but I still strove to be able to wing it from shots way in the hole at short.

During practices, I spent quite a bit of time fielding grounders at short, certain that one day, on another team, shortstop would be my full-time position. I had better-than-average range, with a smooth

Tom Hadzor came from Pittsburgh, Pa., and attended Mercersburg on a Newspaper Boy Scholarship. After graduating from Mercersburg, Lobster hung up his baseball spikes and dusted off his golf clubs, playing four years for the Muhlenberg College Mules in Allentown, Pennsylvania. Continuing his academic ascent, Tom earned his graduate degree in education from Michigan State. He retired in 2022, after a 27-year fundraising career at Duke University working for the Cancer Center, the Law School, and the Library. Lobster will become president of Mercersburg Academy's Board of Regents on July 1, 2023.

double-play pivot and turn at the bag. Joe "Tough as Nails" Imler, a stalwart second baseman, outfielder, and hitter, was instrumental in helping me zero in on my double-play throws to second base. Tough as Nails never flinched on bang-bang turning two plays. Joe would be welded to the bag like a steel girder. And he would fire off his throw to first base, dismissing the physical consequences he might endure to get the out. Championship teams are built around players like Tough as Nails. That zone, a bullseye right in the middle of the chest that I perfected with Joe, stayed with me no matter if my throws came from shortstop, second, or third base. As an infielder, every ball hit my way presented an opportunity to make an out and move my team closer to victory. *Losing* was not in my lexicon.

Joe wrote to me saying, "You elevated our team the way you played the game, hard-nosed but clean. Always forcing the other team's hand with your speed and knowledge of the game. You were not given anything, you made it happen with intense desire, and you would not take no for an answer. No matter what cards you were presented with, you played

Joe Imler was my favorite kind of teammate. He played the game with one objective, which was that his team would be victorious. Tough as Nails felt tremendous joy when his teammates excelled. He played the game to win at all costs, to be the best he could be, and that inspired me. Joe and I would hit each other grounders after practice. He would drill them far to my left and right at shortstop. Tough as Nails knew that the more challenging he could work me, the more I liked it. I stressed to him I did not want to field fluffy pieces of cake.

Joe was dealt a tough hand at age two, when his father passed away. His mother, Margaret, raised two sons and a daughter, working on the production line in a business forms factory, lifting heavy boxes all day long. She would take her family on a one-day outing, once a year, to Idlewild Park in Ligonier, Pa. Margaret is a first-vote member of the "Mothers Hall of Fame." Tough as Nails told me, "We didn't have anything, but had everything."

After graduating from Duquesne University in Pittsburgh, Pa., with a degree in finance, Joe became a very successful businessman. He spearheaded a $200,000 fundraising campaign to completely upgrade the Mercersburg baseball field. In 2005, Joe's vision became a reality when the first game was played on the newly renovated, beautifully designed, baseball complex. This generous gift to the baseball program was done in honor of Mercersburg's class of '62 ace hurler, Bruce Eckert, who went on to pitch for the Yale Bulldogs in New Haven, Conn.

to win, regardless of the circumstances. Someone had to "do it" and it was going to be you. You truly raised the bar for our team. To be able to play with you was an honor and joy." Joe believed, as I did, that when you really push yourself in anything you are trying to master, you improve your chances of reaching the summit of your dreams.

I was now among a team of proficient players and talented athletes. On opening day, ace power pitcher Kris Pigman, a gritty competitor who attacked hitters with his four-seam heaters, went the distance, notching a 6-5 victory with eight Ks (strikeouts). I spanked three of our team's five hits. Not only did the whole club play well together over the season, we made practices fun, and expected ourselves to win, which

Taking a healthy swing in my spring season at Mercersburg Academy (1972). Coach Duncan is standing in the third base coaching box. America's great minimalist artist from New Mexico, Agnes Martin, who is famous for her lined grid pieces, drawn in pencil over light pastel washes, would have loved our baseball field. It had the least amount of traditional baseball fixtures a complex could possibly have. There were no dugouts, only a row of wooden benches that each team's 15 players and coaches could sit on. The groundskeeper kept the field in tip-top shape. For me, the vast green grass, white foul lines and bases, brown dirt, and openness were picturesque. I felt very privileged to play baseball on Mercersburg's team and field.

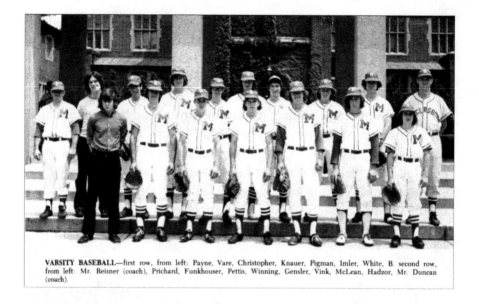

VARSITY BASEBALL—first row, from left: Payne, Vare, Christopher, Knauer, Pigman, Imler, White, B. second row, from left: Mr. Reisner (coach), Prichard, Funkhouser, Pettis, Winning, Gensler, Vink, McLean, Hadzor, Mr. Duncan (coach).

we did. Playing every inning of every game, I led in several offensive categories, including hitting, with a sizzling .380 average.

I also continued to compete on the track team when our season ended. I excelled in the sprints, long jumps, and anchoring the relays, winning six medals in meets along the way. When the students voted for the school's top male athlete, they honored me with the runner-up award, behind future PGA golfer John Ferrebee III.

The passing years are not counted by accumulated heartbeats. They are determined by memories, moments, your health, experiences, accomplishments, happiness, sadness, setbacks, successes, and other contributing factors. For me, it all revolved around baseball and its seasons. Mercersburg provided me with a dream of a year I have always cherished. To this day, it is considered one of the exemplary educational and athletic prep schools in the United States. When I graduated on June 3, I set my sights on visiting coach Jackson again to talk about my baseball future at the University of Maryland.

A CHAMPIONSHIP SUMMER

There always comes a time as a ballplayer, if you desire to accept the challenge, when you have to step into the batter's box to see what you are made of, facing the next level of competition. The moment arrived

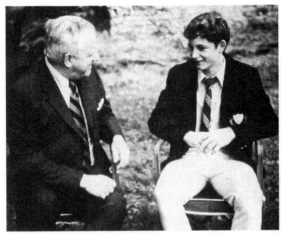

Dad and I talking on
graduation day.

My Mercersburg
senior class portrait.

for me playing ball in the summer of 1972. Manager Woody Harris and coach Will Crouch, of the Maryland Industrial League's perennial powerhouse team, Fairfax Furniture, invited me to be their starting shortstop. Three of my former teammates and friends, Eddie "Bear" Duffy, Joe "Mercury" Anderson, and Billy "Always" Anderson, were on this team. Four Falls Church High School stars would play together again, in the most talent-rich competitive arena across the Washington Metro area, because there was no age limit. Baseball players on every team had to be adept.

I would be the youngest and smallest player in the league, but I pursued my upward trajectory, and nothing was going to stop me from living my dreams. This opportunity gave me a barometer of where I stood playing against many previous and current college ballplayers and a sprinkling of former pros. I was eighteen, and I wholeheartedly accepted this challenge, confident I could perform on this level. At shortstop, I paired up with Billy Anderson, the Maryland infielder who would play second base; together we would be a dynamic double-play duo.

As the summer played out, I kept improving, and I needed to. A handful of pitchers chewed me up and spit me out every time I faced them. If they could command a tight spinning inside slider or fastball, with some gas that would bite your bat handle, my right hand and arm were not strong enough to push the bat head into the pitch. It was very frustrating, but it also educated me on what I needed as a hitter

to dominate the competition. I bought a set of hand grips and a pair of dumbbells to build raw strength. If I did not strengthen my hand, grip, and arm, my baseball dreams would be coming to an abrupt halt.

Fairfax Furniture lived up to its reputation. We made it to the championship game in the Unlimited Division of the Maryland State Baseball Association. If you play baseball long enough, players get used to the anomalies that the Great Game presents. Of all the teams we could have been facing, we ended up pitted against none other than B for Baseball's club, Martz Insurance, for the title. Edsel was only satisfied with championship trophies. That, combined with his intense nature and unfiltered commentary at times, brought the best out of the teams he competed against. We loved to see Edsel fire up his bullhorn when losing and yell out one verbal exhaust after another.

Victory would not come wrapped in a bow—Edsel's starting pitcher on the hump was the very successful, former big league relief pitcher, Bill "Oil Rig" Dailey. Oil Rig pitched in 119 games over four seasons (1961-1964), hurling for the Cleveland Indians and Minnesota Twins, going 10-7, 22 saves, with an exceptional 2.76 earned run average. I was beyond excited to bat against my first pitcher who had been in the Show. His battery mate, catcher Chris Hudson, earned the reputation as one of the toughest catchers in the metro area, a defensive bulldog. Chris immediately assessed a hitter's weaknesses and called for pitches to capitalize on those flaws. And he came equipped with a good arm that put the ball on the money when a runner attempted a steal. Their cleanup hitter, masher Darrel Corradini, was known for his tape-measure homers and getting pressure hits when they were needed most. This team deserved to be playing in one of Maryland's premier amateur championship games.

With all of Bill's baseball wisdom, talent, and experience, we knew the longer he was pitching, the better he would become. So we implemented the strategy to be very aggressive in the batter's box against him, to send him to the showers. Our game plan worked to a "T." We hammered Oil Rig inning after inning, thanks to our first six hitters: me; Mercury; Bear; Wilton "Ribs" Crouch Jr., who played first base for Memphis University and led the Maryland Industrial League in RBIs with 50 in 115 at-bats; Billy "Always" Anderson; and catcher Bill "Sheriff" Harris, who played his college ball for William & Mary and pounded out hits for us all season.

By the fifth inning, B for Baseball relieved Oil Rig and sent him back to the bullpen, dumbfounded by the hitting barrage we unleashed.

Our lead proved insurmountable for Edsel's team. Of course, the next time we faced Oil Rig, he may well have pitched a shutout against us. He remained a big leaguer, who had a rough day. It happens in baseball on every level. But hardened ballplayers have very few rough games—and those are spread far apart. The Great Game itself has no conscience.

At trophy night, the Maryland State Comptroller, the Honorable Louis Goldstein, presented our manager, Woody Harris, the state flag, to honor our victory. This was my first high-level baseball championship, and to win it against a former big league pitcher made me feel like a very worthy shortstop when I was presented my player's trophy.

FERRUM JUNIOR COLLEGE

September 1972 – December 1973

I approached my second meeting at Maryland University with confidence, bolstered by two solid years and the stats to prove it. The Maryland Terrapins held a strong two-season record themselves, posting 18-10 in '72, and the year before winning the Atlantic Coast Championship title. Many considered coach Jackson's program the best throughout the Mid-Atlantic states.

Once again, I met coach Jackson in his Byrd Stadium office. He noticed my extra inches, but my stature remained too small to generate any bona fide interest from him. I said, "Coach, I'm a ballplayer on the move and can be an asset to your program." Once again my words and my stats fell on deaf ears. Though I beat my own drum loudly, I was the only one hearing it, which was frustrating. I had to be patient and strategic.

I left the athletic complex and drove home in my French Renault I recently had purchased for $400 and 1,000 golf balls—leftovers from my high-school days as a golf-ball-recovery specialist. "Renauldo" and I would cover a lot of miles together—I just hoped many of them would involve driving to baseball fields and a college campus that would provide me the opportunity to become a Baltimore Oriole.

I delivered the dismal news to my parents, and we immediately went to the bookstore and bought the thick, dark-green college and university

admissions directory for the entire United States. Researching intensively the schools that would give me the academic and athletic platforms I needed to advance, I angled my line—baited with biographical information and season statistics—out to baseball coaches at four-year colleges and universities. My self-promotion hooked no interest, not even a nibble. I did not receive one follow-up inquiry. I was the lead singer in a rock band without a single fan.

This reality never shook me in any way. A ballplayer senses when his talents have peaked because they are unable to compete at the next level. Baseball statistics never lie. I was nowhere near plateauing, as I kept excelling at every tier I competed in, season after season. I felt in my heart and visualized in my mind that one day I would be such a solid player, a big-name college coach would be offering me a scholarship to play on their team. I could *see* myself in the lineup. My teammates and I would be representing the University of Maryland.

The day finally arrived when my bobber did go deep. I hooked an inquiry from a junior college located 35 miles northeast of Roanoke, Virginia. Ferrum Junior College offered a wide range of academic options, maintained a fine art department, had earned nationally recognized athletic honors, and two NJCAA national football championships, in 1965 and 1968. The baseball program, too, ranked above average for a junior college. I arranged a campus visit with coach Jerry Little. My father and I sliced Virginia in two, driving south on Route 81, stopping along the way at farms and one-horse towns to make photographs. Once we passed Roanoke, we drove the back roads. The majestic Blue Ridge Mountains dipped and rose like stormy ocean swells.

Arriving on the Ferrum campus, we explored their 700 acres of contemplative, rolling hills before we parked at the field house to meet coach Little. The baseball diamond, positioned next to the football complex, was a pasture of a field with the skin of the infield cut deeply, which would allow more fielding range to my left and right, gloving grounders, and having to make longer throws, building up strength in my throwing arm.

We walked past showcases overflowing with championship trophies. Coach Little emerged from his office with the presence of a Brahma bull. He was a part of the Ferrum football legacy as an assistant coach, an accomplished athlete, and the 1966 MVP for both football and baseball. In 1965, as starting fullback and co-captain of the football squad,

he led the Panthers to the national champi-
onship. Winning made him win more, and
losing made him angry, like an irate, bucking
rodeo bull reared up tall on his two hind legs.

I could tell he liked what he was seeing in
me. My solid academic record and my base-
ball statistics over the past two seasons spoke
for themselves. Hitting a torrid .371 and .380
at the plate were in the bank, and he knew
investing in a speedster who could hit, steal,
and score, with a quick glove at shortstop,
would fatten his team's win column.

Coach Little laid out the baseball program
to me, outlining his vision for the future,
with the returning players and new recruits.

*Coach Jerry Little
(1973).*

I learned I would be among those rookies when he said he had contacted
coach Jim West from the University of Virginia about me, and coach
West said if I excelled at Ferrum as an athlete and met the academic
requirements, I'd have a solid chance of being recruited as the short-
stop on his U-VA team, on scholarship, for my final two college years.
What an affirmation! I had swung for the fences and swatted a very
long homer: a potential slot at a major university, the winner of the
Atlantic Coast Conference Baseball Championship in 1972, possibly a
full scholarship, and playing as their first-string shortstop!

The University of Maryland remained my number-one choice, but coach
Jackson had already sent me down a lonely road with his firm handshake,
twice. If all went well at Ferrum, and coach West pursued me, I painfully
anticipated having coach Jackson watch me round the bases and haunt
his Terrapins. My baseball dreams banked on a major Division-I program.

I did not need to weigh my options; no others existed. So my decision
remained quite simple: Ferrum or no Ferrum. I informed coach Little I
was excited to become a Panther. I also alerted him about my teammate,
Eddie "Bear" Duffy. Bear, with his superior batting, had brought me
around the horn to score a heap of runs on past teams. Coach Little did
his homework and recruited Bear. Both of us received the news gladly,
and Eddie enthusiastically accepted his deserving offer.

Together we stirred up some mischief, beginning with our drive
down to school. We stopped in the mountains to fish for rainbow trout,

and by the time we arrived on campus, freshman orientation was over. Two days later, I resumed my passion for flying, leaping from a 30-foot-high bridge into a river, over and over. Fun, fun, and more fun! I hit the cold water and plunged straight down like a piece of stone. I stayed underwater as long as I could, only to pop up like a cork downriver. As the afternoon inched forward and I climbed onto the sun-drenched riverbank after jumping off the bridge, I looked up and faced a uniformed ranger waiting for me: coach Little, doing a summer stint as a deputy. We walked together up the hill to the road, and he issued me a warning ticket for trespassing. This proved to be coach's credo as well: his way or the highway! That day it was both.

I went into fall ball as the first-string shortstop on coach Little's players chart. We played in the "hollars" of Virginia, where chewing tobacco seemed culturally mandated. You twisted a sizable plug of Red Man, pushed it into the back of your cheek, worked it up, and played ball. Tobacco spit turned out to be good for the pocket of your glove, too—it softened the leather.

I incorporated a new item of equipment into my game: batting gloves. They gave my handicapped right hand an improved grip and became essential in assisting me to make better contact with the ball. I eagerly accepted anything and everything that advanced my abilities as a hitter. Pine tar mixed with tobacco juice, dirt, and hitting gloves produced the best grip possible.

One of the problematic challenges I faced was the power stroke, because my top-hand thumb couldn't deliver what it needed to: drive the bottom half of the hand through the bat handle—this pushes the baseball and is the most important force for any batter to employ. I would never master that, no matter how tight a grip I developed. Falling on that jagged, broken glass at age six cost me a ton of extra-base hits and home runs.

When the season commenced in the spring, I was the starting shortstop. Bear had given me the nickname "Hawk" over the summer, because of my aggressive play and focus on winning. Our team was well balanced, both on offense and defense, expertly managed, and we took lots of chances, forcing our opponents to make mistakes. These Panthers played skillfully sound, consistent, winning baseball.

Coach Little, appropriately known as "Bull" to the team, drove us to be our best. In his philosophy, when your butt is in a sling and the

make-or-break moment is at hand, you will always prevail if you have worked harder than your adversaries, especially the pitcher. I had been using this psychology for years: incorporating discipline, dedication, intention, cognitive training, and passion to give myself a necessary mental edge.

Bull used a two-mile mountain road, with a steep grade and numerous switchbacks, to condition us. He made us run up and down the mountain at the end of practices and checked off your name when you reached the top. If a player cut the mountain short, the whole team would have to run the course again. That never happened.

Bull also enforced rules for our behavior; we were not allowed to cuss. During one practice, coach Little had set up behind me at shortstop, though I didn't know it. The batter hit a short-hop, top-spinning rocket that jumped up and rang my bells. Taking a shot down under bends you over, with both hands on your knees, as you take deep breaths, searching for oxygen, in an effort to stop the clanging. You need a minute to recover and begin fielding again.

When I stood back up, I directed two cuss words toward the sky. Bull said, "Hawk," and when I turned around, he held the baseball in his hand. "Give me two round-trippers up the mountain." Bull knew I could do it, Bull knew I would do it, and I did do it. Coach made an example of me. He wanted his shortstop to be one of the leaders on his club.

In the season of 1973, a bizarre event occurred. An underwater spring bubbled up on our diamond. With no way to cap it, center field turned into a swamp to become inhabited by frogs. So we played our home games on Muse's field. Mr. Muse, a farmer who raised cattle and grew corn, had built a beautiful diamond on his farm. He loved the game of baseball and kept the infield all skin with no grass, and he raked out every pebble. Mr. Muse put thick, gray clay in the batter's box, giving hitters a firm and welcomed stage to hit from. And this park was no bandbox. It stretched 320 feet down the foul lines, 370 feet in the alleys, and 390 feet to straight-away center field. You had to seize hold of a pitch to take it deep and out of the park. He carefully thought out everything and kept it well maintained. Deservedly, Mr. Muse was proud of it.

I preferred it to our campus field, because the infield was truer on the grounders. Also, the more dense dirt gave me a better jump to steal

bases. The only problem we encountered were the cows that occasionally closed in on the third base foul line during a game.

Playing every inning of every game at short, I basked in a banner season. I stung the opposing pitchers for a blistering average of .375, also leading the team in home runs. A special tater I swatted took place on my father's birthday, with him cheering me on from the stands. Before this season, I never had any fence-clearing swats on a regulation diamond, and the experience was exhilarating—I always longed for another. Riding one out of the park and circling the bases, I flew all the way to the plate, my wings flapping as I touched 'em all.

Pitchers and batters are always at war with each other. It is one of the epic battles in the world of sports. Pitchers love to send you back to the dugout, holding the end of your bat, yapping up a storm; and hitters love to see a pitcher slam the rosin bag into the dirt behind the pitcher's rubber. That puff of pure white rosin rising from the ground made me a very happy hitter, knowing I had prevailed.

In my last three spring seasons—at Falls Church High School, Mercersburg Academy, and Ferrum Junior College—I never sat out an inning, hitting close to .400 in each season. And over the whole course, I was only thrown out stealing bases five times.

This garnered some attention and respect for me as a baseball player. On June 19, 1973, the *Washington Post* ran a full-length feature article in their sports section with a photograph of me swinging away, highlighting my baseball talents as well as my rehabilitation after a crippling injury. I felt humbled and amazed that my comeback story would be read all across our country and the world, to inspire others, especially people with handicaps, to "Dream Big, Dream On!"

Up until this point, my dream was just that: mine. But now, validation came from the *Washington Post* and its readers, who were strangers I'd probably never meet. I asked myself: *Will I really pop my ninth-inning homer for the Ring?* I had never doubted that I would, but knowing other people were now rooting for me was a sensational affirmation of my **Yes**!

With our stellar seasons behind us, Bear and I made calls to noted, collegiate summer league teams. Our only opportunity came from a league that played in Long Island, NY. Bear and I traveled north for tryouts, to be conducted by the St. John's University baseball coach on a field located in Queens, a borough of New York City. My brother-in-law,

(the) iron blade

"Read By The Decision Makers"

| Vol. 18, No. 16 | FERRUM COLLEGE, Ferrum, Virginia 24088 | May 9, 1973 |

Hensley and Christopher Raise Panthers from Doldrums with Two-run Homers against Chowan

May 1973: I am swinging for the fences on this rip. My father had driven to Ferrum for a doubleheader to celebrate his birthday. This photograph shows in detail how compromised my top right hand was, especially in the batter's box. As you can see, my thumb could not grip the bat, which at times, depending on the pitch, allowed my hand to only function at or below 50 percent capacity. I never mentioned or talked about how difficult it made playing the Great Game. Why would I? Every one of us has our own personal challenges, and how we respond to them will impact the quality of our lives, especially when you are pursuing your dreams. I have always felt blessed to have a right hand and my life, to experience this amazing journey.

JUNE 19, 1973

CHRISTOPHER TURNS CRIPPLING
INJURY INTO .375 MARK

Washington Post excerpt: "I hope
this story does not look like a lot
of 'Scott Christopher did this' or
'Scott Christopher did that,'" he
said, suggesting that perhaps
it will emphasize overcoming
disabilities. "Maybe," said the
somewhat shy Christopher,
"somebody else might be in a
similar situation and take heart
in knowing the difficulties can be
surmounted," as he once learned
when a friend got polio at age
13. "He helped me along a lot,"
Christopher said, referring to the
friend. "He'd play catch with me.
I saw (in him) someone else who
was worse off. But he never let
that affect him negatively."

Bruce, a former stand-out college soccer player at Virginia Tech, arranged for us to stay in his parents' basement in Oceanside, a small town in the southern part of Nassau County. Bud and Ethel were family and made their home our home.

In the competition, I performed strongly at shortstop. My hitting eye was sharp. But I had developed a hitch in my swing, which resulted in pop-up fly balls, instead of driving the baseball. This mechanical flaw destined me for the bench as the tenth man in a nine-player lineup. I needed to ratchet up my skills to compete on this high level of college talent.

Bear proved himself a worthy starter at first base, turning the coach's head with his power at the plate. But if we were not going to be working the infield together, then we would implement plan "B" on our fifth day: Bear and I, in his Kelly-green, souped-up 1970 Oldsmobile Cutlass coupe, would head south on I-95, back to Falls Church, listening to Elvis and talking baseball.

Before Bear's engine cooled, I was heating things up in the batting cage to correct my swing, with my father and Bear pitching. One week later, I was back, driving the baseball consistently: no more weak fly balls. The hitch was vanquished! Lunkers Bait & Tackle added me to their roster immediately. The core of my strategy remained intact: to play as many games as possible and advance beyond my competition vying for a full-ride, U-MD, Division-1 scholarship offer as their shortstop.

CLARK GRIFFITH LEAGUE

The summer of '73 demonstrated why baseball is one of the greatest games ever invented: our 19-year-old team in the Clark Griffith League romped

and rollicked. Our fans loved us, we delivered super-competitive games—winning many—and for the most part, we were left to our own devices.

The Lunkers comprised a mix of above-average ballplayers and mediocre talent, and our coach, at times, went AWOL. An employee of the bait and tackle shop sponsoring us, he drank a lot. When he did show up, he made managerial moves that other coaches used, to teach their players what *not* to do. If he was coming off a bender or halfway into one, a far-away smile lit up his face while he dreamily gazed across the field with blood-shot eyes. He would hand a player the lineup card before the game and ask him to fill it out. Never did he discuss or dispute anything with the umpires. We, the players, held the game's fate in our hands, taking turns being the designated coach all summer long.

Our uniforms fit some of us but on others looked like potato sacks with a head, legs, and spikes. Sometimes we played games with only 12 young men suited up. This meant one player stayed in the dugout and a player and pitcher sat down in the bullpen. They juggled three or more baseballs at a time, shot the bull, mimicked teammates and rivals, put up Dixie Cups and bowled with baseballs, played baseball putt-putt golf, and joked around, melting through the summer heat and humidity, waiting to be inserted into the game.

If the pitcher in the pen was a better hitter than the other two players, we might use him as a pinch hitter, limiting our options for using a relief pitcher. The player who wanted to pitch the most on the team ended up on the hill. Then we had nine players discussing our strategy near second base, until the umpire would come in and break up our conference. Eight players would fan out to their positions and the lucky one of us would head to the mound.

For one game we all played a different position except for catcher. In another, I manned first base and batted eighth. In the truest sense of the word, we were a team: all for one and WON for all. We tracked only games won and lost, without keeping any statistical records. For all the fun on the field that summer, we were, underneath it all, a team of 19-year-old competitors who did not expect or like to lose.

Lewis "Country Mile" Lastik, our clean-up hitter, had been one of the outstanding high-school football players portrayed in the 2000 blockbuster movie characterizing the events that took place during a time when racial integration in athletics was in its infancy—*Remember the Titans*—starring nine-time Academy Award nominated and two-time

winner, the great actor, Denzel Washington. In real life, Lewis's 1971 T. C. Williams HS football team went undefeated and claimed the Virginia State Football Championship.

I encouraged Country Mile to attend Ferrum, which he did, and he starred as a football player and javelin thrower on the track team for two years. Following junior college, he attended Austin Peay State University in Clarksville, Tennessee, where he played out his football career. A true asset on any team he competed on, the larger-than-life Country Mile could downright MASH a baseball.

The season should not have unfolded as it did. The Lunkers stunned other coaches, teams, and fans across the league when we kept winning and made it to the league championship game. Who wasn't surprised? Twelve psyched-up players and one coach who consumed too much alcohol at times. The victors of our championship would advance to the regional playoffs, with the winner of that tournament going to Johnstown, Pennsylvania, to compete for the AAABA championship. Ever since playing for Edsel's team that lost in the finals, I longed to return to Point Stadium. I hoped our summer team of '73 would give us all the opportunity. Special baseball memories stay with you as a player or fan for a lifetime.

Beyond being selected a dark horse to be in the finals, our team would not even have been considered a horse. We were overwhelmingly the least-funded squad in the league. Strobe's Mobile Gas Station, squaring off against us, was by far the most-financed, with a full complement of top-notch players handpicked by coach Doug Coughlan. They wore uniforms of the highest quality, which actually fit and all matched. Bats, balls, catcher's equipment, gloves, spikes, and everything that was needed to play baseball was top-shelf.

Fans packed the stands for two reasons. First, they were eager to see the championship match of a keenly competitive league. Second, one of the top-two pitchers in northern Virginia, Kurt "Flamethrower" Christl, took the mound for Strobe's Mobile. Kurt, a left-handed fireballer, delivered a fastball in the mid-nineties that loved to bite your bat handle and crack it up the grain, a nasty screwball that slid sideways and fell off a cliff the last ten feet before the plate, and a change-up that crossed up the best hitters in the league. Kurt had lost only a handful of games all spring and summer, and with a stretch of 19 consecutive no-hit innings, he likely still holds the Virginia high-school state record.

His father, Max, was a major in the US Army during WWII. As the commanding officer of a train station located in Mourmelon, France, Max coordinated troops, weapons, and supplies being sent into Belgium as the Battle of the Bulge raged. In one attack on the station from the air, Max's building was strafed by German Messerschmitt planes with 20mm machine gun cannons mounted in the wings. The bullets pierced and destroyed whole sections of the walls, exploding and sending shrapnel into the air. Major Christl had to be dug out from the rubble after the strike by his men.

During one game, Kurt's father watched from behind the outfield fence as his son pitched. Every time the Flamethrower notched a strikeout, Max put a small stone in his pocket. Kurt's team won that twelve-inning game, 1-0. The Flamethrower threw smoke the first eleven scoreless frames before being relieved to pitch the twelfth. Afterward, Kurt and his father stood by their car, and Max asked Kurt, "How many strikeouts did you have?" Kurt didn't know, and his father started placing the rocks on the hood. When they counted them one by one, there were 20. Kurt's father acted as his practice catcher for years, and his body paid a dear price from the Flamethrower's pitches that got the better of him, leaving bruises. Max clearly loved his gifted son and was beyond proud of him.

On the competitor meter, Kurt rated a ten on a ten: smart, talented, tall, strong, and built to go deep into a game. He lived to win and had not lost enough games to know what losing meant; the Flamethrower's 110-percent intensity never wavered. Relishing the pressure-cooker games, he loved even more to intimidate batters and strike them out. Hitters left the batter's box wondering whether a baseball or a bazooka shell had just mowed them down.

As often happens with the excitement of a championship game in August, smart coaches will come out to study prize recruits' performances. They want the player to feel supported, and they need to assess how a rookie handles the pressure.

I was unaware on that hot and still summer night of championship baseball that the University of Maryland's coach, Elton "Jack" Jackson, sat in the stands to observe Kurt. Had I known, it wouldn't have made a difference. I revved up to fourth gear for the win.

Being the leadoff batter on the visiting team in a championship game is important. The momentum generated from this at-bat can set the

tone for your team's offense over the next nine innings. If you hit a homer, your teammates believe they can follow your tater trot around the bases themselves. A strong at-bat or a weak one starts the game off for both the offense and defense in similar ways—one for the better and one for the worse. I carried this responsibility as I warmed up as our team's first hitter.

With a doughnut on my bat, I made figure eights, took looping swings, and chopped wood. The weighted bat loosens up your wrists and helps generate more velocity in your swing once it is removed. I readied myself in the on-deck circle, studying Kurt as he prepared for his first victim. Flamethrower tried staring me down. For seconds neither one of us flinched, until Blue hollered, "Play ball!" The home crowd savored watching such a talented arm on the mound, and his teammates in the field and dugout braced for an onslaught.

I only knew of Kurt through his reputation, though I had faced many ace pitchers over the years. I felt psyched to take my swings against him, particularly in the championship game. Walking around the catcher, I spat into my batting glove and ground fresh pine tar into my bat handle. Next I grabbed a small amount of dirt to mix with the tar, to make it thicker. I stepped into the box, ready to extinguish the Flamethrower, the crowd, and his blistering array of pitches.

He stared me down again to see if I wanted to pull a white flag out of my back pocket. I spat in the dirt. I guessed fastball, and that's exactly what he delivered. Yet I

had never faced a faster pitch. As I pulled the trigger, the catcher's glove popped like a firecracker had gone off in it.

I stepped out of the box. Recalculating, I figured if I choked up on the bat I would have a more compact swing, which would compensate for Kurt's brawny arm. He threw me a dancing screwball that dipped away and dropped off a cliff toward first. I fished for it, and the count clicked to 0-2. I decided to attempt a drag bunt, which I never tried before with two strikes, because if you foul the pitch on a third strike bunt, it's a strikeout. But if I were successful, it would be considered a gutsy move. To my chagrin, I fouled it and struck out.

Scuffing dirt on my way back to the dugout, I carried more than my bat. Kurt had handed my buttocks to me. He knew it, my teammates and his witnessed it, and the crowd loved it.

Kurt throwing the "FLAME" *(Fort Hunt High School, 1973).*

Weak at-bats don't end at the plate when the umpire yells "strike three." They torment you. I would have to make a major adjustment. I replayed Kurt's rhythm on the mound, how deep I stood in the box, my stance, the position of my hands, and even the weight of my bat. I studied how he worked the next eight batters. When Flamethrower finished a pitch, he landed his right spikes hard into the ground—a pure power pitcher. Kurt continued mowing us down like blades of grass. No laughs came from the dugout. We wanted to win, and we had to figure out how to generate runs, despite our coach, who had arrived for the championship game in high spirits and half-tanked.

As I stepped into the batter's box for my second at-bat, I steeled myself to settle my butt whopping. I decided I would take a strike unless I guessed everything right about the pitch as it entered my wheelhouse. Flamethrower threw his heater on the first pitch, and ump called it a ball.

His next would, of course, be a fastball, since the count was 1-0 and he had chewed me up and spit me out with his heaters during my last at-bat. Ump called it a strike.

I now had seen four fastballs, and I branded the rotation of those red threads in my mind. If it spun any differently, it would be an off-speed pitch. His screwball displayed a counter-clockwise, ten-to-four spin, much different than his two- or four-seamed fastballs.

With the count 1-1 and the game scoreless, our personal match was on. It was Kurt's move. He chose to throw me a sharp screwball with lots of spin. I picked up its gyration at the perfect point of his delivery, the instant the baseball separated from his hand. Hitters only get a split second to make critical adjustments. This pitch sped off the table and would be tailing away and breaking downward. I needed to keep my left shoulder and head right on the ball, because if I opened up my hips too quickly, I would lose most of the potency in my swing.

My move now: I latched onto those orbiting red threads, which resembled the rings around Saturn. I started my swing with my back foot anchored deep in the batter's box to drive the ball. Only screwballs and low outside pitches minimized my hand-wrist handicap, because the bat handle lay firmly in my hand and my palm could drive the ball. When my wrists turned over from the bat's momentum, the power delivered to the pitch had already been generated by my palm.

My bat struck the ball. Wood to horsehide, I drove the Flamethrower's pitch hard, and I watched it create a majestic arc between the two light poles into right center field, easily clearing the fence for a 375-foot, leaving-the-yard long fly! After rounding the horn, I planted my spikes deeply into home plate. A lot of baseball remained to be played, but my team now led, 1-0. My tater silenced the crowd and evened the playing field. I had hit a homer off the Flamethrower, and now my teammates knew the king of the hill was hittable, a pitching phenom with feet of clay. It was quite evident the Lunkers were capable of an upset victory.

Strobes Mobile would be leading the game 2-1 before my third at-bat—chin-music time for the Flamethrower. He took a hit off him as an insult, and a home run was like a personal assault. After he worked me inside with a fastball that would have cracked a rib or two, I drilled a liner up the middle, stole second, advanced to third on a bunt, and scored on a grounder to the second baseman, to knot the score at 2-2.

I grounded out my fourth and final at-bat. Strobes Mobile went on to win the game 3-2 and qualify for the regional tournament. The Flamethrower notched another victory on his "King of the Hill" belt.

As we put away our equipment, one of the Strobes Mobile players came over and asked me to speak with coach Coughlan by the third base line. Coach told me he could pick one player from the league to join his team to play in the AAABA Regional Tournament and asked if I would like to play center field for him. If Strobe's Mobile won the regionals, they would travel to Johnstown. I grabbed my chance to play in Point Stadium again. "Sure, I'd love to be on your team." Elated, I had no idea the best was yet to come.

While talking with coach Coughlan, I was surprised to notice coach Jackson congratulating the Flamethrower on his stellar pitching performance. I later learned he asked Kurt, "What do you think about their shortstop, Christopher?"

Kurt replied, "I couldn't keep him off the bases. The homer he hit off me was the best pitch I threw all night. I don't know how he tagged it."

Shortly after that disclosure, coach Jackson came to say hello and congratulate me on playing an excellent game. He asked, "The pitch you drove out of the park was a tough one—how did you hit that home run?"

"I picked up the rotation on the ball early, screwed my left shoulder into the plate, got on it good, and pulverized it." Coach liked my answer and was impressed by the way I played baseball. He sensed my will to be a winner, love for the game, longing to play for Maryland—and my middle name was "fearless." Right there, steps away from the batter's box where I crushed my homer, my life changed forever: coach Jackson offered me a full-ride, out-of-state baseball scholarship to begin playing at U-MD in the spring of 1974! I wanted to put my future coach in a bear hug, lift him into the air, and run around the bases trumpeting my dream-come-true news.

Of course, and in a state-of-happiness shock, I instantly accepted. We shook hands, and coach patted me on my back. A handshake for both of us sufficed—it was as binding as any written legal contract.

I walked back to our dugout and told my teammates what had just happened. Outfielder Joe "Chimp" Hensley and Country Mile came over and gave me high fives. Then Chimp yelled out, "Hell yeah, Hawk, *Congratulations*! Let's hear it for the Hawk," and the dugout turned into a rockin' celebration, even though we just lost a hard-fought championship game. And this is why our club made it as far as we did. We played all summer as a team and celebrated every time a player did something worthy. I slammed my glove into the bench and was in a total state of euphoria, almost breathless, realizing what had just taken place.

That timeless swing of the bat delivered one of my greatest baseball dreams. Twice already I had swung at my chance to play for Maryland and twice denied digging into the Terrapin's batter's box—tonight's homer proved to be my third and winning swing. My persistent drumbeat on coach Jackson's office door for years, desire, dedication, determination, talent, belief, and vision had earned me the opportunity to play for the prestigious and storied U-MD baseball program.

AAABA Regional Tournament

Two days later, after practice with Strobe's Mobile, I received my uniform for the tournament. Kurt and I became immediate friends. We both were bound for U-MD, we both loved baseball, we both excelled at playing the game, and we both loathed losing. Our regional tournament started out in a bad way, however, with a 6-4 loss to the all-star team from Hagerstown, Maryland. All six of their runs were scored in the second, disastrous inning. Unless we won our next three games in a row, we would not make it to Johnstown.

The pressure was on, and I welcomed it. In our next game, I racked up four hits in five at-bats to pace the offense, and we won 7-3. The following day served up a double-dip against a resilient and proven Prince Georges, Maryland, championship team, flush with talent.

Our ace, Kurt, reigned on the mound, and he pitched this must-win contest like a big league playoff game, rolling over the Prince Georges Eagles hitters, flattening them like a steamroller. His superb work on the hill took us into the top of the ninth inning leading 3-2, and I ramped up our hitters by scoring the first of six runs. We went on to stomp them handily, 9-2.

The second, winner-take-all game unfolded quite differently. This nail-biter brought us to the bottom half of the ninth inning. I had aggressively scored three of our team's six runs. Prince Georges trailed by two runs when slugger Darrel "Dini" Corradini, their leadoff batter, stepped up. He got a hold of a curveball and jacked a moonshot tater way out of the park. Prince Georges went on to score another run and tied the game.

All cards were on the table now, as we went into extra innings. The tenth ended scoreless. In the eleventh, we scored three runs, leaving us in a great position to start packing our gear for Johnstown. But as the great Yogi Berra, once said, "It ain't over till it's over." Prince Georges,

mirroring Yogi's words, miraculously scored three runs on five hits in the bottom of the frame, and we moved into the twelfth inning.

In this tug-of-war, Bob "Still Going" Sellers, who could powder a pitch, scored our second and final run with two outs. That pushed our never-give-up team score to 11-9. Their first hitter sent a long fly ball to me in left center field. I ran at full tilt, all the way to the warning track to flag down an almost-homer and make the first out. Their second hitter struck out swinging on the third pitch. We thought this game was all but etched into the win column. As far as baseball statistics go, the probability of our opponents tying this game was infinitesimal.

With two outs, feared power slugger Dini stung a double off the left field fence. Now their crankin' cleanup hitter, league leader in home runs, first baseman "Big Mike" Thaxton, lashed a stinger of a grounder to our second baseman, who made an error, allowing Corradini to score. Prince Georges desperately needed one more run to tie the game.

When the 1973 NY Mets were in last place for the pennant, their manager, Hall of Famer Lawrence Peter "Yogi" Berra said, "It ain't over till it's over." His very famous quote meant he and his Mets would rally to come back and win the National League East Division title, which they did. Yogi played 18 seasons as the catcher for the NY Yankees. He was an 18-time all-star and 10-time World Series Champion. This was an elite baseball player at his best. WOW!

Bob "Still Going" Sellers was drafted in the 31st round of the MLB draft by the Kansas City Royals in 1973. Still Going pursued advancing his education by accepting a baseball scholarship to attend Univ. of Virginia, where he excelled both on the field and in the classroom, earning a B.A. in Government and Public Affairs.

After playing three seasons for the Cavaliers, baseball lost a great player when Bob suffered a career-ending injury to his left foot that required six surgeries and the installation of a 4-inch titanium plate with three screws in it at the base of his big toe.

Still Going credits his persistent nature and keeping a never-too-high or too-low daily approach in life, to having been a baseball player. Bob is an Emmy-winning broadcast journalist and very respected media personality. His exceptional career includes being a news anchor on CNBC, Fox News, NewsMax "American Agenda," and other noted stations. Still Going also reported live from the Iraq war in 2003.

After a walk, Prince Georges' Jimmy Blackwell stood on first base, Big Mike held second. When Rick Greenspan drilled a single through the infield, our right fielder, Tom "Torch" Wilson, came up throwing and fired a strike to Still Going, who was in perfect position with his shoulders parallel to the first base foul line and his glove in front of his body toward Torch to receive his relay throw, pivot, and send a clothesline rope to the catcher—a perfect, pressure-packed throw.

Big Mike intended to force the play. He rounded third with one mission: to score the tying run. Dirt flew from his spikes as the gap narrowed between him and the plate. A bang-banger was two strides away, and fortune favored our side after Big Mike drove his cleats into home base. When the chaotic play quieted, the umpire threw his right hand above his head and yelled: "You're out!"

The opportunity coach Coughlan gave me to play on his squad made me ecstatic. I validated his choice by hitting .470 in the tournament and scoring three runs in the final game to help us advance to Johnstown. One heck of a team effort made this title a reality. It also made my dream—hitting a homer in the ninth inning of the final playoff game, to win a professional championship for the Baltimore Orioles—seem more possible and real.

Blue's call at home plate was hotly contested, angering the Prince Georges Eagles coach. He was unwilling to accept the runners-up trophy. For him and his team to give up two playoff games that Sunday settled like hot bubbling lead in their guts. Dini represented the Eagles and was presented their award. Baseball coaches suffer just like the players do when they drop a game, no less a championship match. To this day, Big Mike swears he beat the tag and was safe—and he may have been.

Umpires bring stability and consistency to the diamond. Without Blue calling the plays from behind the plate and on the field, there would be an uncontrollable frenzy, from both inside and outside the foul lines, because of disputed calls throughout the game. However, umps, like players, are at times imperfect. One missed call can initiate a drama that turns a stadium into mass hysteria. Overall, umpires are an inherently respectful and honorable breed of professionals, responsible for making baseball a very human, emotionally charged, and in-the-moment game. They are an integral component entrusted to enforce the rules of the complex baseball mosaic.

The play-by-play scorebook of our final, winner-take-all game against the Prince Georges Eagles championship team.

AAABA CHAMPIONSHIP TOURNAMENT & A REUNION

After winning the AAABA Regional Tournament with Strobes Mobile, another wonderful surprise awaited, one which I had longed for since 1963. My boyhood best friend and blood brother, Mike "Explorer" Malone, planned to visit me at my house in Pine Spring and then drive up to Johnstown to see my team compete in the championship tournament.

I had not seen Mike for ten years, but his cobalt-blue eyes remained vivid in my mind. My heart was awash with many, clear-as-day memories. Impatiently I waited for Explorer to arrive in his gold-metal-flake dune buggy. He had spent quite a bit of time modifying and beautifying VWs and Porsches as a teenager, and he and his father built this zinger of a machine. Now Mike drove it 2,500 miles from California, solo, to participate in the 1973 National Scout Jamboree in Pennsylvania and to see me. Explorer crossed the country over four days in this roofless, quasi-hotrod, cracking off 1,500 miles the final day to zigzag his way into camp as something of a scouting celebrity. The other Boy Scouts must have wondered what in the world the western winds had blown into their Jamboree.

Scouting runs in Mike's blood. An Eagle Scout at the young age of 13, he also received their highest honor of NESA Distinguished Eagle Scout. Explorer went on to write one of the most informative and important books on scouting ever written, *Four Percent – The Extraordinary Story of Exceptional American Youth*. And Mike's two sons, Tad and Tim, both earned Eagle honors.

Mike's 1964 school photo, when he was ten years old, had found a home in my wallet or on the shelf in my bedroom for many years, ever since his mother sent it to me that year. She inscribed the back of it: "To Scotty, from Mike." I still have that wallet-sized photograph in my art studio. It never fails to elicit a smile and an extra-special heartbeat.

Our reunion day arrived. I waited with my iced tea, remembering that summer day, ten years before, when Mike and his family headed west in their new 1962 Ford Thunderbird. Memories of happier times surfaced, like when we sledded down the hill in my yard until we became so dog-tired we just lay in the snow, making snow angels, staring into the late afternoon sky. We created many such moments that have contributed to my spirit throughout life. Those early formative days branded a freedom in my soul that has never dulled, and it continues to drive my adventures and curiosity, to propel my life and creative process forward every day since.

Finally, I heard the buggy's engine rumblin' down Woodberry Lane, sounding like exploding Black Cat firecrackers. When Explorer took the right turn heading into our cul-de-sac, I walked into the circle where we once spent so much time together. As Mike pulled the parking brake up and stepped over the side wall of his dune buggy, I stood at a loss for words. Mike was *home* once again.

Our silent embrace spoke volumes. We were children and men in the same moment. A part of Mike had slipped away from me when he moved to California, and the pain of that separation now completely dissolved. Mike stood before me, six feet, one inch tall, and livin' the *California vibe*. Laughter accompanied us into his dune buggy, and we fishtailed wildly on the off-roads where we used to construct forts and catch frogs, snakes, and crawfish. We exchanged story after story his entire visit, as though we were inside and outside our personal forests of memories.

Mike and I laughed a lot, reminiscing about our childhood and telling stories relating to the past ten years we had spent on different sides of the country.

I always admired that Mike never underestimated himself or his potential. This has led him along a path of one superior accomplishment after another. He is known as the "Sage of Silicon Valley" for writing numerous historic technology books, hosting shows on PBS, and being a journalist for several publications, including the *Wall Street Journal* and *New York Times*, and editor of *Forbes ASAP* magazine. Two of his books received Business Book of the Year awards. Mike has been nominated for the Pulitzer Prize twice. Explorer has focused primarily on the tech wonderland, its history, the evolution of computers, and the human innovators pushing the high-tech boundaries. As a founding shareholder of eBay, Siebel Systems (acquired by Oracle), and Qik (acquired by Skype), Mike has also held business interests in several other successful tech companies. In 2004, Oxford University named him a Distinguished Friend. Explorer is also a former fellow of Oxford's Saïd Business School. Currently, Mike serves as the Dean's Executive Professor at Santa Clara University.

When the time came, I drove up to Johnstown for the start of serious baseball. Mike and I made plans to meet at Point Stadium. I was fired up and ready. I always loved tournaments, especially those that carried lots of weight and history. The AAABA is one of the premier championship series in all of amateur baseball.

This was a double-elimination tournament, and sadly, we dropped our first game 5-1 to the Zanesville, Ohio, Pioneers. Their pitcher, Jeff Bennett, slammed the door on us. I went 1-3, with the lone RBI in the game. Our ace, the Flamethrower, took the ball to be the starting pitcher against the Pioneers. Kurt piled up five strikeouts after five innings, only giving up one earned run. Strangely, he was pulled for a relief pitcher to start the sixth inning. Our fresh arm quickly gave up three runs.

Managing a team requires coaches to make quick, strategic decisions. They never explain them to their players. When you win, they all make sense. When you lose, ballplayers are quite forgiving because they know questioning their manager leads to defeats. The manager must be the only general guiding your team's destiny on the field.

On August 16, we played the host tournament team from Johnstown in their sold-out, historic Point Stadium. Mike being in the stands to watch me play brought my exhilaration to a pinnacle. We fared well and eliminated the hometown team 5-1. I was 2-4 with a double that I drilled into the left field alley. Our pitcher, future University of Virginia Cavalier ace, Harry "K Factory" Thomas, silenced the Johnstown Junior League champions' offense, throwing a must-win three hitter. K Factory set down 13 batters with his masterful array of pitches, especially his fastball heaters that found their spots and would attack the strike zone like a baited rattlesnake. I readily awaited our third game on Friday. The team seemed to be gaining momentum when we needed it most. Winning every game from here on out was a must, or we would be eliminated.

I played sound ball in my first two games, hitting .429. The local *Tribune-Democrat* ran an article on August 17th, "Scott Christopher Wipes Out Obstacle," about playing at this high level of amateur ball with such a handicapped throwing hand and arm. "Many athletes are remembered for the obstacles they overcome, rather than by records they may have broken. Scott Christopher, a nineteen-year-old outfielder, is a classic example." Further in the article the writer said, "Thirteen

years ago doctors predicted Christopher would never be able to use his right hand after severing seven tendons and a nerve in his wrist."

Friday's game at Point Stadium represented a sort of reconciliation for me, since my team lost the 1970 championship game to Detroit in this same ballpark. As always, I gave it 110 percent and locked up a memorable play in center field, a great catch that looked super-spectacular because I had made a tactical error. When the ball came off the bat, I took my first step at an incorrect angle, and I had to adjust for the misstep with every bit of speed I possessed. Steaming toward the right center field wall, I caught the ball over my head with my back still to home plate, my glove fully stretched out. As they say in baseball, "I chased it down." Then I drove my right spikes firmly into the ground to halt my momentum, pivoted 180 degrees, and fired a one-hop strike to second. My strong throw kept the runner on first base from advancing into scoring position. It was an outstanding play.

In the scorebook it went down as an F-8, which is all that mattered. It is not *how* you send a hitter or runner back to the dugout, it is whether or not you remove their ability to score.

Making a super play in the field was always a blast for me, because the opportunity to make stellar defensive plays presented themselves in unexpected ways, and they do not happen often. To pull off a major league web-gem required supreme athletic abilities and baseball skills. Mike congratulated me on my catch after the game, which made it even more momentous.

Strobe's Mobile was eliminated from the tournament after losing our third game—a letdown, on top of the fact Mike would soon be leaving. But we were 19 years old and busting loose at the seams to experience all we could in life. Our dreams lay in different directions, but they hovered right there before us, to be mapped out, strategized, pursued, believed in, and realized.

Mike fired up the topless dune buggy, with his close friend, Craig Windmueller, riding shotgun, and the firecrackers popped loudly. My blood brother revved that back-door engine and dropped it into first gear, waving goodbye. Explorer and his dune buggy quickly became a dot, heading west, back into his world of open skies, mountains, the Pacific Ocean, new adventures, and dreams to pursue and be fulfilled.

When the dot disappeared, I opened a piece of paper Mike had handed me, right before he turned the key in the ignition. It looked like

a flattened snowcone and turned out to be his hotdog and chips paper plate from my game at the Point, folded over three times. He had written a poem with no title that I have saved all these years. Through his own perceptions, at the young age of 19, Mike crafted a poetic and mighty poem, a pillar of wisdom, his personal gift to the Great Game. It read:

The pitcher holds the ball
As though it were some woman
To be caressed—then cast off
With a viper's arm
At the enemy
A bullet for his heart
In a place six inches before his chest
The batter falls forward with a step
Like stepping into a grave
Uncoils, like a cloth-wrapped spring
And drives bat into ball
With an artillery's crack
A meteor returning skyward
The ball buries itself into the sun
Not a fly but a universe
Not a ball but a world
A lifetime and its death
Dependent upon a swing of the bat.

– Michael S. Malone (Untitled, August 1973)

Mike and his co-host, Emmy Award-winning reporter for NBC Bay Area, Scott Budman, currently anchor a podcast, *The Silicon Insider.* They broadcast their shows on air every Friday. Given Mike and Scott's legendary history in Silicon Valley, *The Silicon Insider* has grown into a global tech MUST listen.

I have never seen Mike again after that August day in 1973. His visit meant the world to me, as I was flooded with fond childhood memories and one important fact: if Mike and his mother and father had not shared their love with me in rehabilitating my hand and arm, I might not ever have been able to play baseball again in my life.

I do follow Mike's career and publications. We also have updated each other

through emails over the years. On January 14, 2011, Mike wrote a heartfelt article, "The Photograph," about our childhood. Published in *Forbes Online Magazine*, his essay also highlighted two of my father's award-winning exhibition photographs that toured the world for nearly forty years—the image of Mike and me in 1963, titled "On the Farm" (p. 37) and also "Strike Three" (p. 4).

This was as fun a baseball game as I could have played. Mike was in the stands, the stadium was electric with fans rooting for their Johnstown team, I was picking up the pitches well, taking big cuts at the plate, smacking baseballs all over the park, and there were lots of college coaches and major league scouts positioned across the stadium. I made a great catch in center field and showed the scouts my throwing arm was getting stronger. And we WON!

COACH ELTON "JACK" JACKSON, A MAN OF HIS WORD

I floated on cloud nine when I drove 265 miles to Ferrum to begin the fall semester. My return to earth occurred when I told coach Little I accepted a full-ride baseball scholarship to attend Maryland University. However, when we sat down in his office, he expressed his support of me moving forward into a highly noted Division-1 baseball program. As much as he prized winning ball games, he loved seeing his players earn scholarships to advance their dreams and careers.

Bull even contacted coach West at the University of Virginia and ascertained that the Virginia Cavaliers remained interested in me; I had options. My heart, I explained, remained set on playing for

Maryland, to be within striking distance of a Baltimore Orioles scout, to draft and sign me. My home-run and player dreams sparkled closer than ever.

First, however, I faced a demanding hurdle. To qualify for an athletic scholarship to a D-1 university, I needed an academic "victory" in biology class. I enjoyed the subject, but it stretched my brain's gray matter. The professor's tests left my king tilting on the board. Whether I would be academically eligible for my scholarship rested on the outcome of the final exam and my knowledge of living organisms. Admittedly, during the semester I had been working on specific baseball skills and building my strength in the weight room, at the expense of being prepared for my biology class. Now almost five feet, ten inches tall, I weighed a rock-solid 165 pounds and was continuing to sprout.

With the biology exam two days away, in early December 1973, I felt prepared for the test. I had rigorously applied myself to studying. My teammates and friends at Ferrum knew I would be leaving to play baseball for Maryland. They held a going-away party for me, which started in the afternoon after my philosophy exam. When dinnertime approached, we walked over to the dining hall.

I had been dating Harriet, a girl who loved the natural world and quiet contemplation. She could not come to my party, so we planned on having dinner together. During our conversation, I asked Harriet if she would like to take a drive to a hiking cabin up in the mountains. The farewell gathering brought home to me that I would soon leave campus, the beautiful Blue Ridge Mountains and Ferrum's enchanting surroundings. I wanted to soak up the crisp mountain air, identify star constellations in the sky, listen to the Beatles' *Abbey Road* album on my 8-track tape player in Renauldo, spend a few hours bathed in nature, and share a kiss or two with an exceptional gal. Harriet joyfully said yes and we drove off, with four friends leaving a half hour later to join us at the cabin.

The still, winter night shimmered with stars. As we gradually gained altitude, winding through the mountains, it began to snow lightly. The flakes dancing and drifting into the headlights seemed romantic. Harriet and I sang along with the Beatles as we climbed, neither of us concerned about the bright-white, light carpet of snow outside, which reflected a dreamy glow onto the gray boulders and trees. As the road started to wind back into the mountain, we hit a patch of black ice.

Renauldo slid toward the edge of the road, where there was no guard-rail, only a steep, vertical drop, straight down for a long way.

Surreally, with the Beatles singing, "You Never Give Me Your Money," and counting from one to seven, rhyming with the last word in the lyric, *heaven*, I lost total control of Renauldo. The black ice held the steering and braking functions prisoners. Expecting the worst, and with only my left hand holding the steering wheel, I covered Harriet with the top half of my body.

The drop beyond the verge loomed. Two more seconds and over the mountain we would topple. The Beatles continued counting, as they sung that same line seven times in a row, to finish their song.

A higher power blessed us that night as Renauldo caught a patch of dry pavement. I yanked the steering wheel to the left and punched the gas. My reflex maneuver catapulted Renauldo into a boulder across the blacktop as the Beatles were finishing their verse. I heard "heaven" as Renauldo crashed into the large granite stone.

Harriet's head smashed my arm into the windshield and then forced it down abruptly against the dashboard. My arm ended up between her forehead and two knobs of the radio, which was mounted on top of the dash. The collision was extreme. My effort to protect Harriet's head from sustaining a major impact wound from the windshield succeeded, but in the accident, I sustained multiple injuries to my arm.

The crash demolished Renauldo's front end, but spared the rear-mounted engine, which thankfully kept the heater going. Harriet bled from a cut on her forehead, and we both were rattled from dodging an almost-certain fatal wreck. While I comforted her, my arm swelled rapidly. Stranded, we could only hope our friends would soon catch up to rescue us. We were hurting, and it was very cold outside.

Fortunately they did. We piled in their car to drive to the nearest hospital, two hours away. By the time I was admitted, my forearm had ballooned to the size of a late-summer butternut squash. The doctor read my x-rays and set my arm in a cast from hand to mid-bicep. As they applied the plaster, I dreaded the difficult phone call ahead: telling coach Jackson I had broken my throwing arm and dislocated my wrist. I worried he might want to reevaluate my scholarship.

But coach Jackson has always been a man of his word. In every sense, his handshake was firm and binding. He said my scholarship for the spring semester of 1974 remained unchanged. Whether or not

I would be an asset to the team was secondary to our handshake. What a man!

I completed my biology exam alone in the lecture hall, my arm throbbing with pain. The day after I received word I passed it, with a sliver of wiggle room, I waved goodbye to Ferrum Junior College, coach Jerry "Brahma Bull" Little, my teammates and friends, lovely Harriet, and southern Virginia. Since Renauldo was temporarily out of commission for six weeks, I loaded up my gear in Bear's car, and we traveled north on Route 81. Now nothing stood between me and my dream but the miles I needed to chalk off the highways to reach my future destination: U-MD's baseball complex, Shipley Field.

A noted physician in Washington, DC, Dr. George Resta, oversaw my healing process. Renowned for putting athletes back on the field, he had worked with many NFL Washington Redskins (today, the Washington Commanders) players and other professional sportspersons. Of course, my childhood injury complicated rehabilitation, but Dr. Resta told me the reconstruction of my wrist by Dr. Hall had been a monumental medical feat, which was encouraging. I was in the best medical hands, with opening day for the Terrapins just two and half months away.

In mid-January I walked into coach Jackson's office, the same spot I had visited in 1971 and 1972, and the location where the mailman had delivered my letters self-proclaiming, "I will be an asset to your program if you just give me a

Dr. Resta reading my x-rays in February 1974. He kept the cast on my arm for almost two months. It felt like half a year. I had to be patient and mentally tough. Dr. Resta was holding my baseball future in his hands.

chance!" The hallowed baseball program at Maryland, which began in 1893, was about to commence its 81st season. Standing there, with my throwing arm an injured mess, was not the way I wanted to begin my next chapter of life at U-MD. I shook my head, wishing it was different.

Coach showed me a couple of options for living quarters, and I decided on a run-down, decrepit storage room, dripping with potential. Despite a clutter of used furniture and spider webs, its location was unbeatable. One wall, made of brick, was the end of the U-shaped football stadium bleachers. When I opened my front door, I looked straight down the football field's goal line, 35 yards away.

Though extremely narrow, I envisioned a swanky college dorm room once I built a loft, dropped in the used, red, weight-room rubber tiles for a floor that were stacked along the wall, and set up an aquarium filled with angelfish and colored coral for atmosphere.

I had to wait to implement my architectural vision. Coach Jackson planted a bunk bed and a roommate for the spring semester—a first-rate senior veteran pitcher, the Baltimore Stopper, Ty "Hunt Machine" Hunt. I named our room "the nest." This piece of valued real estate was all about location, and Hunt Machine was all about having his final season, pitching for Maryland, end on a high note, which he joyfully and successfully accomplished.

Coach Jackson was a Korean War veteran. His duties took him into fierce fighting as the Supply Sergeant in the Army's 103rd Field Artillery Battalion. He told me that when a battle was raging, the thought of dying never occurred to him. Coach asked, "Hawk, when you were up to bat, were you ever scared or think you were going to get hit by the pitch?"

I said, "Never."

Coach then stated that was how he felt fighting the war. His toughest battle was on the front lines of Heartbreak Ridge in a thirty-two-day conflict where the big artillery guns almost ran out of shells after launching hundreds of thousands of rounds at the enemy. The Second Division Commander was given permission to fire "all the ammunition necessary to take the positions," and he did just that, with coach Jackson and his men supplying the artillery shells.

Allowing You to Inhale Love

An athlete's dream involves many:
Coaches, teammates, family, friends, competitors, and leagues.
All of it built a launchpad,
to know that it was in fact possible.
I was very lucky, as I took my failures seriously,
they taught me well,
constantly processing, making necessary adjustments.
I never wanted to be the same person or player the next day.
Sculpting your passions and dreams is work,
and if you pay your dues, whatever that cost may be,
dreams will prevail and you will live inside them,
with the failures and successes creating bright brush strokes,
allowing you to inhale the passion, your dream,
and the beauty of LOVE.

4TH

INNING

PURSUING THE DREAM

Coach Jackson cared about his players' academic progress as much as their improvement on the field, and that made me feel wholly supported. He had an interesting mind and was a reflective contemplator. My aesthetic nature seemed to intrigue him. Over the years of seasons and teams, I had experienced that some of my coaches were jolted by my creative pursuits and outlook on life. The conflict usually worked its way out, and when it didn't, I moved on to play for another team, as I did at age 15, moving down a talent level to play for Joe Gas. I have never stopped creating art in various forms. Being creative resides in my DNA; my intuitive and abstract expressions flow naturally.

I loved being a student-athlete at the U-MD. I had attended basketball games, wrestling matches, and track meets at this campus over the years, so I was familiar with its grand scale. In late January, our spring-season training began inside Cole Field House. I suited up as half a ballplayer; Dr. Resta wouldn't remove my cast for weeks yet. Meanwhile, I became acquainted with my teammates and positioned myself with as much of a competitive edge as possible.

I participated in most of the conditioning exercises and many of the fundamental skill practices: running sprints, fielding grounders, and swinging bats, though I swung them with only one arm. In addition, that year we all had to get used to hitting with aluminum bats, and the transition took a while. The sound of a baseball meeting aluminum

Although I had another uphill challenge to conquer, I saw myself as a star player for the Maryland Terps and Baltimore Orioles. Taking swings in my basement on my rigged-up tire, with one arm, was better than taking no rips at all (December 1973).

is markedly different than when it makes contact with wood. Instead of a deep-sounding crack of the bat, it rings out. Aluminum gives the offense a fresh "RUN" clout. Because the bat is hollow, it energizes the ball more than wood, giving a hitter an increased advantage to drive the ball through the holes in the infield, into the gaps, or over the fences. Baseball is a game of inches, and every inch on the field is precious.

Outdoor training began when the winter weather broke. I took my first step onto Shipley Field as a Terrapin, predestined to play on *this* diamond. The infield was perfect for true bounces, regardless of the spin on the grounders or line-drive one-hoppers. When I drove my cleats into the dirt for a long throw to first, from a shot in the hole, my spikes bit into the earth. The ground crew maintained everything in excellent condition throughout the season. They kept the grass trimmed the right height, and I would rake out shortstop myself three or four times a week to keep the bad hops to an absolute minimum. My connection to Shipley was synchronized with my baseball spirit.

I fielded with my glove hand, but due to my cast, it was impossible to make any throws. I also took my turn in the batting cage, which sometimes

sent nail-biting jolts through my dislocated wrist and fractured arm. But I had learned from an early age to block the pain from dominating my mind, my thinking, or my choices. I gave these practices 110 percent.

Coach Jackson allowed me to call my own shots now and then. One afternoon I told him I felt ready to face live pitching in an intra-squad game. Coach let me dig in at the plate and swing away, one-handed, with a cast on my right arm. When I hit a liner in the gap for a stand-up double off our ace, Bob "Wheel" Ferris, I stood on second base—looking into the dugout, where coach Jackson grinned and shook his head. Wheel was kind enough to pipe his pitches so I could make contact and put a ball in play.

Equally anxious to have my cast removed, coach Jackson and I waited impatiently for Dr. Resta to pronounce the time had come. We grew frustrated when every week he simply repeated, "Wait another seven days, we can't rush it." Then, in mid-February, the doctor finally cut off the plaster—and the sight altered my breathing. My atrophied muscles no longer looked like the limb of a college athlete. The skin hung loose, shriveled, and crêpey. My arm, wrist, and hand were a wreck. I knew rehab would require a great deal of perseverance.

Within moments, I enjoyed a sense of relief as the air began to cool my skin, and it felt wonderful not to be slinging that weighted cast around anymore. Dr. Resta ran me through a battery of tests and said my arm would return to my pre-crash skill levels, with the right exercises. He just could not—and would not—say how soon.

Coach Jackson demonstrated not only patience but total support. He put together an entire rehabilitation regime that I followed throughout the spring and summer. Coach had been studying the science of kinesiology, and from that he applied many activities for me to repeatedly work my hand and arm. Being the academic that he was, he showed me medical charts of the muscle groups and explained why these exercises were necessary. Coach himself designed some of his own creative regimens for me, and whatever he did for almost a year worked wonders. Interestingly, coach originally had his mind set on becoming a dentist when he first attended Maryland, after his time serving in the Korean War. He was well versed and interested in human anatomy and applied that knowledge to my exercise programs.

I rode the pine for a good part of the season but practiced with intensity, earning scattered innings of playing time. My first at-bat on opening

day, March 9, resulted in an anemic strikeout. I sized up the pitches well, but the bat felt like a thirty-four-inch concrete pole in my recuperating right wrist and arm. Seeing this, pitchers chewed me up and spit me out with inside fastballs, pounding pitch after pitch all season long.

Occasionally I had glimpses of hope, with a stolen base here and there, and a gem of a play in the field, but altogether it was a lost campaign. The pitching was too adept to be swinging a bat as lamely as I did. Despite doing the best I could, I remained an embarrassment at the plate. Only up to bat 40 times the entire season, my eight hits averaged an ice-cold .200.

Overall, our team struggled, beginning when our southpaw ace pitcher, Flamethrower, suffered a season-ending injury to his throwing arm. We tallied a rare, below .500 win-loss season. The Terrapins were eliminated in the first game of the Atlantic Coast Conference Tournament with a 6-0 defeat to the University of Virginia. I resolved to respond with my bat to this loss in a future season.

The support I received from my teammates shone as the bright side of my absent season. Coach had told the team he had signed a top hitter,

A doomed season. My very compromised right hand and arm could not catch up to the pitchers' fastballs. The strength I needed in my hand, wrist, and arm was just not there.

Kurt "Flamethrower" Christl unleashing a pitch to a Georgetown batter in the second inning of our season's second game, on April 3, 1974. He struck the hitter out. (Cont'd in sidebar, opposite.)

fielder, and run-scorer to play shortstop, and here I was unable to get on base and score anything, turn a tough double play, or fire a strong throw from way in the hole because of my weakened arm. I could, however, stay attentive. When I detected a chink in our adversary's armor, I was quick to alert my teammates. If I couldn't perform in the lineup, at least I could give 110 percent from the bench. You play baseball to win, and many games are won from observations players make from the dugout, and then share with teammates. And this team displayed the talent, history, and spine of Maryland baseball—by far the finest assembly of outstanding athletes I had ever competed with.

As the practices and games ticked by, it was very apparent I was part of an exceptional baseball program. Senior right fielder and four-year varsity veteran, Adrian "Rollo" Druzgala, and I became good friends. Rollo had been a formidable three-sport athlete at Baltimore's storied Mount Saint Joseph High School before Maryland discovered him. His former teammate and highly recruited pitcher, Ty Hunt, voiced to coach Jackson that Adrian would be an asset to the team if given an opportunity. Coach extended an invitation for Rollo to try out. Adrian was such a gifted athlete and ballplayer that he made the 1971 ACC Championship squad his freshman year.

His competitive fire was to lead by example, to be "all in to win," which showed with every at-bat and fundamentally spot-on plays in right field. Rollo also kept the team loose with his monotone, classic one-liners. But beyond his kidding around, he persisted as a serious and focused athlete. Rollo naturally shared his wisdom, and I learned from him to be patient at the plate. Adrian had an excellent eye and very rarely went after a low-percentage pitch. He knew he would get his .300-plus pitch at the plate, even if he gave the pitcher two hittable, but not drivable strikes in the count. Rollo executed a very strong and compact swing powered by a pair of large vise-grip hands, which always drove the ball hard, and that is what good hitters do, game after game. Frozen ropes

Tragically, as Kurt threw a slider to the next batter, his season ended when a ligament detached from his throwing elbow. The Flamethrower's arm was never the same, even though he fought back to post a 2-0 record in 1975. His glory years were over. Baseball lost a GREAT pitcher, who was destined for the Big Leagues, the day my father's photograph was made. This was an emotional injury for me to accept then, and it still is now.

Adrian picked up the very difficult sport of golf at age 22. In his career on the links, he qualified for three U.S. Amateur Championships: in '84, '89, and '91, which is a major accomplishment. In his third tournament, held at the Honors Course outside of Chattanooga, Tennessee, Rollo noticed a young teenager on the driving range who mesmerized him with his abilities. That phenom turned out to be 15-year-old Tiger Woods, who would become one of the top-three golfers in the history of golf and one of the most famous athletes to have ever lived.

One of Adrian's golf dreams was to win the Maryland State Amateur Championship. After three runner-up finishes, he finally tasted the ecstasy of victory at age forty-seven. Going into the final back nine, Rollo was down by five strokes. He birdied the 10th, 12th, 13th, and 16th holes. That put him one up with two holes left to claim the championship. At the end of the round, Adrian was holding up his dream, as the fans and his almost-always golf-caddy father, Andrew "Neck" Druzgala, applauded.

Rollo is an excellent example of what it takes to become a titleholder. Always paying the price to perfect his skills, patient, passionate, he never lost focus on seeing himself raising up his MSA Championship trophy. It took Adrian 20 years on the competitive circuit, in pursuit of the MSA crown, to finally realize his dream. Rollo never questioned his competitive motto, "Confidence is everything in sports." Adrian's steadfast perseverance and desire to win were instrumental in his quest to become the champion he became.

will take you into the elite hitters' club. Rollo added a lot of fun to my life and our team's chemistry. His single-minded approach helped shape me to become a better player.

Coach Jackson never lost faith in me as a player, and I surely never lost belief in myself. We both knew I would put my all into a mounting a gallant comeback. Like Renauldo on the black ice, I would regain traction and avoid a lights-out result. I prepared to meet head-on

Coach Jackson observing and evaluating hitters during batting practice. He coached U-MD teams on a pro baseball level.

what lay in front of me to earn the starting position at shortstop next season. I deposited my dismal stats in a spaceship and sent them on a one-way flight into orbit. Riding the pine was the only option I refused to entertain—not for one pitch.

SUMMER BRAWL

For the second summer in a row, I worked with my former teammate from Ferrum and our prior year's summer team, Joe "Chimp" Hensley. Chimp had the baseball instincts and talent to be one accomplished hitter and center fielder. He banked the entire game on risk, and that translated into more runs and more defensive outs: More Runs + More Defensive Outs = More WINS.

His father, Conley, who could scale the tallest of trees faster than a fox squirrel, owned Hensley's Tree Surgery and Logging Company. He taught me how to turn the towering giants on their stumps so they would not land on houses or buildings. You have to know how to read the weight in the top half of the tree, the angle of the trunk, where the limbs are located, how to notch it, and drive a steel wedge in at the base cut. Watching these trees twist and defy gravity fascinated me and left no room for error when felling them.

My chainsaw was a hefty Homelite 1050, with a 24-inch cutter bar. I cleared building lots, drove a log truck to the mill, and cut and split firewood, not only making good money but also developing raw strength in my arms and wrists. I purposely wanted this arduous job, as it became an important part of my arm's rehabilitation. I worked all day long, cutting down tall red oaks, poplars, and hickories; at night I was the starting shortstop for Fairfax Furniture, who assembled a blue-chip team that battled for the Maryland Industrial League State Championship all summer long and competed in the highly competitive, end-of-season, York, Pennsylvania, tournament.

The highlight of my action-packed, 1974 season was July 23, a few days shy of the fifteenth anniversary of my father's creation of "Strike Three." I rode shotgun in Chimp's mint-condition, Vincent van Gogh-sunflower-yellow, 454-cubic-inch, 1974 V8 Corvette Stingray. We burned up 250 miles of pavement on a sunny afternoon in less than four hours before parking his jewel at Three Rivers Stadium, in Pittsburgh, Pa., for the 45th annual Major League All-Star game, known as the Midsummer Classic.

Eighteen future Hall of Famers stacked the rosters: Reggie Jackson, Carl Yastrzemski, Brooks Robinson, Catfish Hunter, Hank Aaron, Al Kaline, and Johnny Bench, to name a few. I sat in the stadium enjoying this historic event, dreaming of playing with or against future Hall of Famers and one day wearing a professional championship ring that I helped win, by driving a tape-measure home run in the ninth inning of the final game. It was all possible, because my passion, desire, vision, and belief would fuse to make it become a reality. The NL prevailed 7-2, with the last out being recorded at 11:00 p.m. Chimp and I woke up in a truck stop somewhere in Pennsylvania the following morning. He missed a dental appointment, but we sure were smiling when we showed up late to work.

Due to the last 14 years of partially rehabilitating my badly damaged hand and arm, combined with fine-tuning my competitive instincts in the process—competing on baseball and football fields, wrestling mats, tracks, cross-country courses, basketball courts, boxing rings, bowling alleys, swimming pools, pinball arcades, golf courses, and even chess boards—I developed an ingrained confidence in myself. I kept improving and adding to my skills. Winning had become the norm for me and not a goal. I expected that much of myself, and there was no pressure attached to my level of certainty. I thoroughly enjoyed, embraced, and loved everything relating to sports, all the exciting settings, and the dedication it required to be a top athlete.

Enjoying a moment with my Hall of Fame beagle, Clifford, on our patio, after I had finished hitting in the batting cage. My howlin' hound dog and I spent 13 special years together.

I kept my team's records. The three shelves above my bed were filled with championship trophies and plaques, MVP awards, medals, and red Naugahyde scrapbooks that were stacking up as

I completed my long list of competitions. And having been featured in the sports section of one of the world's premier newspapers, the *Washington Post*, my self-confidence meter soared to the next level. Knowing my inspirational story would be read by a million people or more across the globe made me beyond happy, because it was going to inspire others to "Dream Big, Dream On!"

Being at that MLB All-Star game had a way of making my next weeks dreamlike. The baseball spirit in my body was so heightened that the hits, plays, pitches, and players were like a movie reel with no off switch. Many of baseball greats duked it out in one game for the win. Bravo!

Baseball teams are composed of many elements; Fairfax Furniture boasted high baseball intelligence. We methodically played a game one run at a time and made few mental or strategic errors. Our lineup proved to possess the talent needed to march forward and prevail as contenders for the title.

My arm recuperated well, and I played a vigorous shortstop, aggressively stole bases, and hit close to .350. At the six spot, I applied the rhythms of playing coach Jackson had been teaching me, stressing the importance of keeping the bag clean and protecting my second baseman. He also warned me—and it proved true—that at this level of baseball, at times players would come at me with their cleats aimed high.

One muggy Maryland July night, with the mosquitoes swarming in the lights, we played a game at Wheaton Regional Park against a team from Brandywine, Maryland. Billy Anderson, the top-notch second baseman who had played for FCHS as well as two seasons at U-MD, delivered me the ball to catch the back corner of the base and fire a smoker to first. I came across the bag with what I expected to be a textbook 4-6-3 double play.

Baseball is a demanding game. How runners conduct themselves rounding the bases is many times outside the rule book. DPs are pivotal contributors in making or breaking the outcome of a game and occasionally get super-heated. As I was about to throw the ball to first, the runner slid way out of the base line with his cleats high, headed for my right knee. Fortunately, he landed low, denting only my shinbone.

I never threw the ball to first. Still holding it in my hand when he started to get up through the dust, I turned my right shoulder in toward his face and delivered a power-packed right rear hook, cutting him keenly above his eye, drawing blood.

He staggered, and both benches cleared for a full-tilt, Southern brawl at second base. I dropped the ball and my glove, intending to square off with the wounded runner when, out of nowhere, I took a heavy right cross to my head from their first baseman that damn near sent me airborne.

I learned from my boxing days that when your thinking is scrambled from a punch, you have to protect your head to give yourself time to get your wits back and regain your footing. But this first baseman wanted more of me, and the bloodied player I slugged was enraged. He readied himself to go toe to toe.

The first baseman was feared cleanup hitter Darrel "Dini" Corradini—the same Darrel who showed a hot bat against my team in the 1973 AAABA regional tournament. He stood six foot, three inches, weighed a solid 215 pounds, and carried a fist the size of a cantaloupe. In the midst of players swinging away at each other, Dini and I were performing our own dance, and the strong star was winning.

I wanted to take a swing at my rival, but he was blurry. Dini put me on the ropes, and I prepared to become one with the infield dirt from another of his crushing blows when an umpire planted himself between us. Dini, incensed like an enraged grizzly because I had slugged his teammate, was nevertheless respectful of Blue.

After an incident like this, you can expect fans to give you an earful, but angry disciples of the home team left the bleachers and attempted to spill onto the field. As a player on the visiting squad, it was assumed I had delivered a cheap shot. I had drawn blood and the scene grew ugly.

The fog in my mind lifted, and I remained keen to square off with Dini. The umpires were doing a good job of keeping the teams safely apart. Dini and I exchanged poetic verse back and forth, adroitly as Shakespearean scholars, except for the expletives.

The umpire ejected me from the game. And even though I never threw the ball to complete the double play, the field ump called the runner at first base out, for interference—he was that far out of the base line when he planted his spikes in my shin.

Normally, the scales of justice would have been balanced. Each team received a penalty, each side delivered some solid punches, and each had retaliated. Such brawls usually end on the field—but not this time.

The fans in the stands hurled their abuses as I left the diamond. A handful of them, all men, assembled by my dugout, possibly irate

enough to start another fight. I countered by angling toward the bats lined up along the rusty chain-link fence.

One of the unwritten and sacred rules of the Great Game dictates you never use a bat to resolve any type of altercation within the confines of a baseball park. A player does not throw a bat at a pitcher, even when a pitcher intentionally drills them. I would not break that rule, but I didn't mind insinuating I might.

Nobody flinched as I walked toward the dugout. As the gap narrowed, a Maryland policeman in charge of security at the complex that night intercepted me, because he felt I might get harmed. Relieved to be with law enforcement, I knew I was safe. I assembled my gear, and then the hardened patrolman escorted me to my car. "Drive straight to Virginia and do not look back," he said.

Over the next few weeks, I thought about Dini—not because of our dustup but because of his ability to hit a baseball. He possessed a set of wrists batters dream about. Dini could drive baseballs that were halfway across the plate before he made contact, which takes one strong pair of paws. I spoke to coach Jackson about Dini, saying that I thought he would provide the power we needed in our lineup for next season if recruited. He was well aware of Dini, having scouted the slugger on two occasions. Darrel handled the pressure like a champ and pulverized the pitches, tagging one homer and a ground-rule double. Coach must have liked what he saw, as Dini received a baseball scholarship to play for the Terrapins. I was excited to have such an exceptional hitter and player, who would defend his teammates, join our team. We became close friends. Dini, the "Gifted Power Hitter," has a Big League Heart.

ELVIS "THE KING" PRESLEY

Coach Jackson wore different job hats, as most coaches do. With a degree in phys ed and a masters in education, he taught several classes and also managed the staffing at Cole Field House for Terp basketball games and musical concerts. Coach gave his players an opportunity to make extra money working as ushers at these events, and I signed up for them all. I always felt the more experiences in life, the better.

When he asked a group after practice during fall ball if anyone would like to work two nights during the Elvis Presley concert, "Chaos in

College Park," I jumped at the opportunity, having become a huge Elvis fan the last few years, palling around with Bear. If Bear was driving, you listened to the King. His impersonation was so close to the actual Elvis, I would have to hold my sides from laughing uncontrollably as he belted out the "Cool Cats" lyrics.

Coach Jackson asked me if I liked Elvis. I quickly answered in my best Memphis twang, "You Ain't Nothing but a Hound Dog, Coach." He then said he was going to make my work with the King special. I was so excited and **Wow!** Coach set that Elvis table with Tiffany's finest china. His word, "special" was an understatement. He assigned me to guide the King's limousine into the service area inside Cole Field House, usher the rock-n-roll legend to a makeshift lounge, and then clear a pathway through the fans for he and his entourage to reach the stage only minutes later. I would have direct contact!

Wearing sunglasses, I coolly waited for the King's limo at the back of the field house. A wall of fans assembled to get a glimpse of him through the car windows. Elvis had demanded the tickets for his show start at ten dollars, so the students could see him perform. Cole seated 15,000, and both shows packed the seats, with the female devotees far outweighing the males.

A line of limos approached. This was it. I was going to park the King's stretch and meet him. The fans clapped and cheered as the motorcade turned into a service entrance, but as the procession wound up—no Elvis. Many of the admirers walked away, disappointed.

A manager told me to be on the lookout for a white limo that would soon roll in. Fifteen minutes later, the King arrived. I pulled the looped, galvanized chain to raise the corrugated-steel gate. Elvis and his entourage entered the field house to the cheering of his most loyal fans.

A large man, most likely a bodyguard, stepped out first when I opened the limo's back door. He seemed upset and handed me an empty booze bottle to throw away. In honor of the King, I won't convey what he said to me, but I will say it appeared Elvis had been sipping the spirits.

I myself was intoxicated from the excitement, watching him step out onto the landing. The "Memphis Flash" wore a white jumpsuit with a wide belt, cinched tightly. Hand-sewn sequined peacocks adorned the front and back of this fashion finery. We exchanged hellos, and I guided the King to his holding room. Elvis said, "Thank ya," in his thick Southern drawl.

The next time I would see him, I'd be a human fan-plow, clearing a route to his band, who were amped up to start the King's rock-n-roll show. He was 38 years old but still had plenty of fire to turn the audience inside out. As his performance captivated the night, he threw scarves into the crowd. The fans, chiefly the women, left their seats to swarm an area in front of the stage. Elvis played one heck of a set that included "Hound Dog," "Blue Suede Shoes," "Fever," and the show-stopper: "Love Me Tender." He was a one-man gospel choir bathed in passion, who sang and performed with so much love for singing and giving his fans great shows, I was in total awe.

I had seated a group of Elvis-aged women from West Virginia in a section to the right of the stage. With their beehive hairdos, adorned in jewelry and rings on just about every finger, they were all dolled up, having the time of their lives. When the King sang "Love Me Tender," one woman grabbed me by the shirt collar and pulled me in for an up-close and personal, 30-second hug. I could barely breathe as she shook and sang along with Elvis rockin' the arena. I rode a magnitude-six human earthquake and thankfully survived to tell about it.

After he rode away in the limo that final night, I hosted a fifty-yard line, cutting-the-big-rug, post-Elvis bash in the football stadium, bringing my speakers out to the grass. I blasted "Ol' Snake-hips'" songs from my stereo tape player. This devoted Elvis family danced and sang wildly on the field, reliving the rockin' and stompin' two-night gigs he had just performed, vibrating Cole Field House. I can assure you, when I pulled the plug to call it a night at 2:00 a.m., we were "All Shook Up!" The King had given me a gift. Seeing his shows validated my belief that a passion for your dream takes you to a higher level. It was truly possible.

1974 FALL BALL – 1975 MVP SEASON

In my junior year, I enjoyed being able to design my room the way I envisioned it. Hunt Machine graduated, and it was *Architectural Digest* time. I installed a plywood loft, leaving a clearance of only a foot between the tip of my nose and ceiling, but it allowed me more floor space. I lived solo, and my dorm room became a weekend destination for those who wanted to study the five artistic disciplines—dance, media arts, music, theater, and visual arts—late into the night.

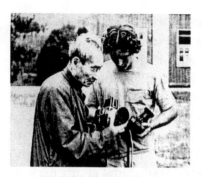

Lang Jingshan and I made sure our camera settings were spot on before we began composing "winners" with my father.

At times my father would bring one of his artist houseguests over to the Hawk's nest, so we could go out and make photographic art. In September 1974, he brought one of the greatest photographers in history, Lang Jingshan, of China, known as the father of Asian photography. The three of us had an interesting photo shoot that day, pursuing winners. Lang Jingshan lived to almost 103 years old, passing away in April 1995.

Splitting firewood and working my 1050 chainsaw all summer helped bring back my arm strength. I came off a summer championship contender season with my arm and wrist back to my pre-crash, high-bar mark, ready to deliver what coach Jackson expected: much better results. He carved out his depth chart, positioning his new recruits and returning players.

Coach left my fate as the starting shortstop in my own hands, to keep or to lose. My competition for the six spot was last season's starting shortstop, "Dougy D" Daniels, a slick defensive fielder and top-notch baseball player and teammate. In the end, Dougy D moved over to second base, and we worked well together, turning double plays, understanding each other's fielding range, knowing where to anticipate throws to the bag and importantly having fun together locking down the middle infield.

I also studied every outfielder's ability to cover ground on different types of fly balls. When a fielder gets on his horse to run down a shot in the alley, it requires a specific relay-throw fielding position. Knowing a player's arm strength will dictate how close you have to be to receive their cut-off throw. A stronger arm equates to a better result, at every position. Runners on base will dramatically alter a fielder's positioning. Fans can learn a lot about baseball by watching where the defensive players go after a ball is hit. The best are always in the right place at the right time for the ball that eludes the fielder or gets away from them because of a wayward throw.

Many other circumstances will crop up during a season, and it is not a question of *if* these variables will happen but *when*. Baseball instincts

make a huge impact on a fielder's performance. As with calculated hitting, strategic fielding translates into wins, and that is why I loved to play the Great Game: to excel as a player, winning games and championships as a team. College and pro scouts take a player's instinctual defensive positioning seriously.

Cutting the diamond in half from home plate to the center field wall, our "Gut D" defense up the middle was a pitcher's dream: Frank "Chief" Kolarek guarded the plate—one splendid receiver, who brought a big league arm. I covered shortstop, Dougy D handled second base like a pro, and Kevin "Gator" Hicks, who would be selected as a member of multiple-season, all-ACC squads, patrolled center field in an all-star way.

Championship teams always require a strong defense. Players need to know everything about their teammates' speed, arm strength, and defensive talent, as well as the opposing players' hitting abilities, instincts running the bases, and most importantly, how

After playing for Maryland, Frank Kolarek advanced through the minors as a catcher to play AAA ball for the Utah-based, Oakland Athletics affiliate, the Ogden A's in the Pacific Coast League. Frank was knocking on the door for a shot in the Bigs as a catcher and hitter with a batting average over .320, when he was sadly hit in the nose, which severely broke it, by a catcher's throw on a passed ball play at the plate. Chief's march to the Show began to reverse its course in that moment. As his playing career unraveled, he then became an assistant coach in the A's minor league system, before returning to U-MD, to team up with coach Jackson as the baseball program's assistant coach in 1982, and from 1986–1989.

In 2004, Frank founded the League of Dreams Foundation (LODF), inspired by his own quote stating, "In order to say something, I had to do something." The goal of LODF was to see that everyone, regardless of limitation or disability, has a chance to be a "player" in the great sports of baseball and softball. He currently serves as its president. In 2009, MLB and *People Magazine* selected and recognized Chief at the MLB All-Star game in St. Louis, as one of the 30 people from around the country designated as an "All-Star Among Us" for his League of Dreams Foundation. Frank has served as the Director of Baseball and Softball for the Special Olympics International, with programs in over 152 countries. Chief scouted for 15 seasons with the Baltimore Orioles. He has been an extraordinary ambassador for the Great Game and has made our world a better world.

Frank was a three-time teammate of one of the greatest baseball players ever to wear an MLB uniform: the undisputed king of stolen bases, Rickey "Man of Steal" Henderson. Rickey holds the all-time record for MLB stolen bases, with 1,406 swipes over a 25-season career. He was a 10-time all-star, two-time World Series champion, 3,081 games played—fourth all-time—1990 American League MVP, and in 2009 the Man of Steal was inducted into the MLB Hall of Fame.

Frank wrote me, "Rickey had, by far, the most God-given ability of anyone I played with. However, he never rested on his ability alone. He was one of the hardest workers I ever had on a team." Rickey earned every stolen base he notched on his spikes.

Chief also interacted on occasion with the Oakland A's manager, New York Yankee four-time World Series champion as a player, and manager of the Yanks, who guided them to one World Series crown, Billy Martin. Frank said Billy treated his young players very fairly and he wanted them to succeed. Billy was his nickname. His birth name was Alfred Manuel Martin.

Chief's son, Adam Kolarek, a U-MD star alumnus and veteran big league pitcher, won a World Series in 2020 pitching for the LA Dodgers. After a two-year stint with the Oakland A's, he pitched for the Dodgers and New York Mets in 2023, before being traded to the Atlanta Braves in August.

fast they run. We wrapped up a top-level fall season, both on offense and defense.

Having led the team in home runs, I knew I was *back*. An article written for our school paper, *The Diamondback*, on September 20, 1974, said, "Christopher has been a real find for the Terps, according to coach Jackson. 'Scott has been hitting the ball real well, including some long balls, so if he can handle the job at shortstop, he will be our starter.'"

The Great Game demands both mental and physical endurance. You need long-haul players who are not nursing injuries and are students of the game, intent on winning postseason championships. Typically, November and December become the time when you allow your body to rest and heal from all the wear and tear of spring, summer, and fall.

These two months off the field allowed my mind the freedom to enjoy my classes, study, write, create art, and have fun as a college student—right up to 11:59:59 p.m. on New Year's Eve. Right then and there I started preparing for my upcoming seasons.

I had seventeen months and two Division-1 campaigns ahead of me before the June 1976 Major League Baseball draft. At

12:00:01, January 1, I committed myself 110 percent to be a top-tier ballplayer and become a Baltimore Orioles draft pick.

Coach dropped a roomie into the nest for our spring season. Steve "Frat" Frattaroli, a thick-skinned competitor who would field a grounder with his teeth, if that's what it took to make the out. A talented and disciplined hitter, Frat loved his trips to the plate, especially with runners on base. He had earned All-State, high-school honors as a catcher in Connecticut.

Steve and I were good teammates. Many days, we would go over to the field and take two-player batting practice: just two ballplayers having fun, hitting baseballs all over and out of the park. When it came to nine-ball or eight-ball in the campus poolroom and beyond, Frat drew a crowd to see him running the table. Watching him play pool was a thing of beauty; you would have thought Fred Astaire was dancing inside the cue ball. Frat was undeniably regarded as the "emperor of the felt table" in College Park. He could and did on occasion run rack after rack.

Frat once picked up a stray dog on a busy road and brought him back to the nest. He named him Sully, after notable, 32-year Maryland wrestling coach Sully Krause. Steve and canine remained companions for 15 years. Frat also coached baseball teams in Connecticut that ranged in age and talent, for 20 years. Frat's love and passion for the Great Game resides in his being.

Like crocuses popping up through March snows, the spring baseball season suddenly appeared. I stepped into the batter's box as the lead-off hitter on March 16, 1975, to play the opener of a twin bill against Towson State. We dominated our rivals and won both games. The Terps continued to win five out of six games, with Chief batting in the third spot and Dini hitting cleanup. Gator, Mike "Hornet" DeSimone, Frat, and I powered a potent offense.

On defense, I had become an above-average shortstop. Coach Jackson taught me the finer points, like squaring up to a grounder with my shoulders; circling a ball on tight plays and using my body's momentum to fire a rocket to first, taking at least a full stride away from the runner; adjusting my position at second base on stolen-base attempts; applying the tag by gauging the catcher's throw; and perfecting my own hurls over to Dougy D on bang-bang double plays, depending on where he stood

in relation to the bag. Coach Jackson educated and taught his players to excel. I was fortunate to have such a fundamentally gifted coach sharing his baseball intelligence and life's wisdom with me. Coach was a class act on and off the field. Our assistant coach, Charlie "No Pressure" Bree, kept me on my toes too. He was an impressive motivator who expected the club to take playing baseball seriously. At times, my free-spirited nature chafed No Pressure. The wide range of personalities that made up this montage of players and coaches always intrigued me. It was a true-life, magnified reality show.

Our team ended up with a .652 winning percentage for the season. The eight games we lost were by an astounding total of a mere sixteen runs. This two-run loss average per game is the lowest in Maryland baseball history.

Though we improved our performance over the year before, our record still lacked an edge. Bob Ferris pitched eight complete contests, ending the season 7-1. He entered the ACC tournament with a sizzling 7-0 tally. We should have fared better, but it was the low-water mark of our season. Repeating our '74 showing, we were eliminated in the first round, losing to Wake Forest 1-0. Wheel only gave up two hits, but their hurler shut us down offensively, and we managed a measly three safeties. Five total hits

for two teams remains the ACC record for the fewest bingles in a tournament game, and that is one record I am not proud to be a part of at all.

I ended up excelling on defense, however, playing every inning of every game at shortstop, only making five errors the entire season. I tagged out a boatload of runners trying to steal second on Chief's cannon of an arm.

Chief, Dini, Gator, Hornet, and I each stroked a batting average over .300. My record against ACC teams, a torrid .370, led the team. I delivered at least one hit in every game during the regular season, except two. And I joyfully jacked a tater every now and then.

On offense, I was never thrown out stealing a base, and I tied for the nation's highest stolen-base percentage, at 1.000 with ten or more stolen-base attempts. Averaging 1.13 runs scored per game and one strikeout per 17.33 at-bats, I still rank among the top-ten, all-time Maryland baseball players in these two categories. For the highest batting average on the team, Dini and I were both one hit short for the Silver Bat Award, which Chief ultimately and deservedly carried back to Baltimore to place in his trophy case.

The Terps whipped up a lot of fun that season. When I received the team's Most Valuable Player award, coach Jackson presented the trophy to me at the annual fall awards banquet. The moment made us both proud. Only three years before, he had sent me back to Virginia

BOTTOM ROW: K. Hicks, S. Housley, D. Daniel, B. Niffenegger, F. Kemp, D. Kurtz, M. Brashears, S. Christopher.　SECOND ROW: R. Greenspan, F. Kolarek, J. March, K. Christl, R. McNally, M. Desimone, A. Frattaroli, J. Norris, manager T. Williams. TOP ROW: Coach E. Jackson, C. Hudson, S. Larmure, S. Riggleman, D. Corradini, R. Ferris, G. Thomas, Y. Randy.

Our crackerjack 1975 U-MD team.
I am front row, far right.

to find another school to play for, and now I was the storied program's MVP. We knew I had earned this coveted award through excelling as a dedicated player and continuing to be a devoted student of the game.

Wearing a Baltimore Orioles uniform and hitting "The Home Run" to win the championship moved closer to being reality. But I never lost my grip on the importance of improving my skills on every level. Compensating for my handicapped hand and arm was always necessary. Reaching the highest plateau of baseball intelligence and to be in peak physical condition, I needed a synchronized mind and body, more than ever.

As players move up the competitive ladder, their minds have to parallel their physical ascent. The more I played, the more I utilized my mental capabilities. I found this to be extremely beneficial, as my season statistics continually validated my mind/body theories. I strongly felt then and have always believed that the most powerful instrument in the universe, that we know of, sits comfortably between our ears: the human brain. What made this interesting for me was that baseball is the greatest sport in the world to integrate your amazing mental and physical gifts in tandem. I made science out of my theories, and the results were setting records and scoring runs to help my team win championships.

Shortstop Scott Christopher has been the Terps' leadoff man all season. The primary function of a leadoff man is to get on base and Christopher has done just that. He has hit safely in 20 of the Terps' 22 games, including all 10 Atlantic Coast Conference games. He has 32 hits, nine walks and 10 stolen bases and has scored an amazing 26 times in the 22 games. His batting average is .317.

* * * * * * * *

Christopher and left-fielder Mike DeSimone know the value of bat control. Christopher has struck out only six times in 101 official trips to the plate. DeSimone has only five Ks in 68 trips, lowest total of any Terp regulars.

* * * * * * * *

ACC competition was a delight for four Maryland regulars. Shortstop Christopher hit a robust .370 in conference play, a nifty .053 above his season batting average. Centerfielder Kevin Hicks, a two-time All-ACC selection, had the best above-season average, jumping .055 to .364. Leftfielder DeSimone went from .309 to .351, a .042 increase while catcher Frank Kolarek jumped .014 to .324.

* * * * * * * *

There wasn't any weak spot in the lineup for the Terps this season. Five players had between 12 and 17 runs batted in with Kevin Hicks and designated-hitter Steve Frattaroli each having 17. The others were Mike DeSimone with 16, first baseman Darrel Corradini with 15 and catcher Frank Kolarek with 12.

Terps baseball notes, written by Steve Sigafoose, May 1975.

VALLEY BASEBALL LEAGUE - "GATEWAY TO THE MAJORS"

Summer 1975

The Valley Baseball League, located in the Shenandoah Valley of Virginia, is a well-regarded incubator for high-level college talent. One of the premier amateur leagues in the country, it draws the attention of major league scouts and has produced over 1,100 professional baseball players since being established in 1923. Its regular season runs two months through the summer, and from 1954 onward has included a postseason tournament.

I hoped to be invited to play shortstop on one of these elite teams. Thanks to Chief, who played in the league as a catcher the previous two summers, I was. Chief and I had competed for two seasons together at Maryland, and he built the bridge with a strong recommendation to coach Jim "Mole" Moeller, of the Madison Blue Jays, who recruited me as their shortstop.

In Renauldo I cruised into Madison, Virginia. This quintessential, rural Virginia town and its generational farms, fanning out into the Shenandoah Valley like colorful patchwork quilts, embody a broad and diverse history. Absent from its legacy, however, was winning the league championship, which they lost in the 1973 finals, four games to two. Mole intended to change that by bringing the trophy home and placing it on a shelf in Rixie's Restaurant. Rixie, along with Thornton Berry, who owned a diner at the west end of town, were Madison's biggest Blue Jay fans, and they financed a hefty part of the club's expenses.

Many of the 25 players on the team roomed in an abandoned bank building made of thick, Virginia gray granite, with specks of black in them. I bunked with Chief and two other teammates in what must have been the bank president's office, because it was larger than the other rooms and was situated in the front of the building, on the second floor, with a grand window overlooking Main Street.

Quaint doesn't begin to describe Madison's downtown. Narrow streets, originally designed for horse-drawn carriages, cut right through its center. One way in and one way out. As cars replaced horses, they paved the dirt roads but could never widen the strip because of all the shops and homes that lined it from days gone by.

I enjoyed representing Madison. Blue Jay fans came from far and away to cheer us on. Whether we won or lost, they remained kind and loyal. But they had a real appetite for claiming their first championship—and we wanted to deliver. All baseball players worth their salt love to win championships, and as the season rolled on through those heavy, humid Virginia nights, we proved to be a contender.

Beyond talent, teams must demonstrate perseverance when the pressure mounts. Most of us loved those do-or-die situations, and that made being a Blue Jay fun. We were a solid team, and sure enough, the scouts showed up with their clipboards, stopwatches, and folding aluminum chairs. Sometimes they stealthily positioned themselves way down the foul lines to assess hitters. When scouting a pitcher, the salty talent judges sat to the right or left of home plate so they could evaluate velocity, pitch location, ball movement, stretch, arm and leg strength, competitiveness, instincts on the mound, and the *pop!* sound pitches made as they smacked into the catcher's mitt. Once an evaluator finds a prospect, he tracks that player to see whether his skills and baseball intelligence make the cut and to observe if he plays at a consistently high level to ultimately earn a ticket to the big leagues. Scouts trained their eyes on Chuck "Falcon" Porter, our ace and the league's king of the hill. The second-best arm on the bump that summer was my teammate from Maryland, Bob "Wheel" Ferris, who pitched for the Harrisonburg, Virginia, team.

Wheel and Falcon pitched in the big leagues. Bob threw for the California Angels, and Chuck brought it for the Milwaukee Brewers. Falcon was drafted in the seventh round of the 1976 MLB draft. He spent five years in the big leagues (1981–1985), earning a 13-13 ledger, with a 4.14 ERA. Chuck was a champion pitcher and teammate of the highest order.

Acclaimed Southern writer Pat Conroy, who had four of his books made into films, would have loved to pen this summer of baseball. Drama, atmosphere, quirky characters, and idyllic settings—we delivered it all. As the only club on the east side of the Blue Ridge Mountains, we spent a lot of time riding in a retired school bus, painted blue and converted into our own Blue Jays transport vehicle. Over the mountain we rode to our away games, and over the mountain we returned to our clubhouse.

Floyd, our driver, only listened to one song the entire summer: "I Heard It through the

Grapevine," recorded by Marvin Gaye. Everyone sang along when we crested the summit going in either direction. If Floyd rode the brakes or took a switchback a bit too fast, we designated a player in the front of our "Blue Bird" bus to keep an eye on him and ensure that his eyelids did not come down. Arriving to and from our away games was an adventure, but all in all, Floyd

My mother and I, taking a long and winding afternoon walk. We both deeply enjoyed the natural beauty of Madison. I spent most of my time that summer, off the baseball diamond, barefooted, to connect with and absorb the earth's energy.

deserved a trophy for excellent driving. He never delivered us late to a game, and he always returned us back to our field safely.

At home, our stellar fans brought their excitement to the park, and if a player had an exceptional game, they were rewarded with a variety of fresh, farm-cooked dishes, mostly from farmers' wives or daughters. My favorite was homegrown green beans from a colorful fan named Twila, who could cook up a storm. She invited me over to her father's farm every now and then, serving up Virginia salt ham, green beans, beefsteak tomatoes, and thick, dark-brown, sugar tea. Twila's delicious, farm-fresh lunches were a front-row ticket to this young man's heart. Looking out from the loft in her daddy's barn, with two wooden flap doors open to the cornfields, lying in the golden hay on the planked pine floor, talking about last night's game—well, Twila made me proud to be the shortstop on the Blue Jays.

Fabulous fans and a topnotch team made our season exciting, but Mole and I did not get along. I was too much of a free spirit, and he was a "fiver": if he said two plus two equaled five, he expected you to agree. So we clashed. But I had learned over the years a coach could not put me on the pine as long as I played at the top of my game. If Mole wanted a shot at winning the championship, play me he must.

As one of the most reliable leadoff hitters in the league, my batting average smacked .333-plus, with at least one hit in every contest.

Playing shortstop on the Madison Blue Jays field. My balance and range improved this summer. You can have an excellent glove, but just as important is how quickly your feet move through a play (July 1975).

Stealing bases, I was thrown out a handful of times. I played a pick-it shortstop and scored runs. Thinking about Mole as a coach was an afterthought. Instead, I embraced my wonderful opportunity to play at such a high level of amateur baseball on a team stacked with players that had the talent to win games and take the crown. Our club continued posting victories. We made it into the playoffs and dominated the teams necessary to make it to the finals to battle for the league championship.

Still, a coach has ways to deliver his message. One pregame, Mole batted grounders to me at shortstop, timing them against the swats of the hitter taking batting practice. Customarily, he sent me a grounder right after the hitter took his rips. That gave me time to field his ground ball and toss it back before the batter took his next swing and possibly drove the ball my way. Like the sea's waves, there was a rhythm to it.

But Mole hit me a grounder just before the batter took his swing. I fielded it cleanly, and when I looked up, a line drive from the bat of our right fielder, left-handed hitter Mike "Tiger" Mahoney, shot right off the crest of my forehead. Had the ball connected with my eye, nose, or mouth, the injury would have been severe. Mole turned away and walked back into the dugout. I was jarred when Tiger yelled from the batter's box, "You okay, Hawk?" I threw my right hand as if I were swinging a bat, signaling to Tiger to keep his BP going.

When we finished batting practice and I slowly jogged into our dugout, Mole came up to me and asked if I wanted to sit out the game. I said no and activated an ice bag from the medical supplies to press against my forehead until I took my position at short. Mole never said a word to me and showed no remorse for what he had done, which riled me up.

One of our avid and more vocal fans, Rooster, wore leather, hand-tooled, pointed roach-killer cowboy boots. He was all country, talked with a Southern drawl, and seemed to be a friend to everyone. We loved him at our games because he was a seasoned heckler. From shortstop I could hear him giving opposing hitters a good, old-fashioned ball game sniping. The worse the night was unfolding for a visiting player, the more ammunition Rooster discharged. A few of his choice lines included: "I didn't know you could use a bat made of Swiss cheese"; or "Do they play high-school baseball where you come from?"; and my favorite, reserved for right-handed hitters: "Maybe you're a left-handed hitter and don't know it."

Rooster immediately came to mind one afternoon as I worked my part-time job in Thornton Berry's diner, as a grill cook and milkshake specialist. Flipping hamburgers for a group of men who had piled out of two old farm trucks, my ears perked up when one of them said his buddy had recently cooked a fine batch of Virginia moon.

I thought, *If someone in the mountain is mashing cracked, dry, yellow field corn to make moonshine, Rooster is going to know all about it.* When he wasn't at games, Rooster cruised up and down Main Street in his early-1960s maroon Lincoln Continental, at all hours of the day and night, slowly and somewhat mysteriously, acting as if he was Madison's self-appointed mayor and one-man police force, keeping tabs on all the happenin's about town and in the hills.

That night we had a home game, and I asked Rooster about the moon. "It's the best corn-mash peach moonshine in all Virginia," he said. "It'll cost you six-fifty a quart." I explained I wanted two quarts for a party we would hold in the abandoned bank building, after our last game. He nodded and said, "It's in the bag, Hawk," and I headed out to shortstop to take infield.

Three weeks passed, and Rooster unexpectedly stopped by to see me one afternoon. He hollered up the stairs, "Hawk, you up there? It's Rooster." I had just returned to our colorful living quarters with Chief and Tiger, after relaxing and meditating in a beautiful, crystal-clear,

flowing stream I discovered at the start of our season. I would soundly meditate there, with my teammates or alone, several times a week. This was a power spot for me, where I had arranged the rocks to create an energizing pool of water to lie in. I made a pillow out of stones and let the pure, crisp water run over my body while I visualized being outstanding in my game scheduled for that night, training my mind to play flawlessly, make pure contact with my swings, steal the perfect base, love the pressure spots, and live a victory.

I came down and Rooster asked me to ride with him into the mountains to sample the corn mash. Game time was just three and a half hours away, but he assured me I would be back well before batting practice.

We wound our way up into the hills, parking his Lincoln with the engine still purring. He walked up a wooded slope, pulled some money from his pocket, laid it inside a gray, weathered hickory stump, came back down, and we drove off.

Having to kill 20 minutes, this Madison dynamic duo drove the back roads, talking and listening to country singer, Johnny Cash, on an 8-track tape player, later returning to the pickup spot. Rooster climbed back up the hill, collected four lunch bags from the stump, and returned to the car. Before reaching town, he turned off on a dirt road and parked. "We need to taste-test the moonshine before I sell it to you."

Rooster extracted a Ball jar and drinking glass from his glove box. We got out of his car and met by the hood ornament, a silver rooster crowing. He unscrewed the tin top and dipped a bottle cap into the clear hooch. With the cap half full of peach moon, he placed it on the dirt and touched a lit match to it, explaining that if the moon did not burn an ocean blue, it was tainted and could blind you. The moonshine burned just dandy, and Rooster declared it a *good'n batch*. Pouring a hefty swig into the drinking glass, he said, "Put the hammer down, Hawk."

"Uh, I've got to play a game later."

"Don't worry. You'll have a hell of a night. A belt of peach moon don't stay with you for three hours."

So I crooked my elbow and slammed the white lightning—my eyes watered, I inhaled as much oxygen as I could, and I attempted to clear my throat multiple times, still twitching but trusting the self-elected mayor. Satisfied, I pulled $13 from my handcrafted Tandy wallet. I had carved, tooled, stitched, and painted my billfold with a rural landscape scene on it. I began working with leather when I was 15 years old and

have continued through my life creating pieces using variations of these applied techniques, mostly carving, in my art.

I paid Rooster, and he dropped me off at the bank. I carried the two lunch bags upstairs and stored them under my bed. As the minutes ticked away, the time came to head to the park for pregame warm-ups—and the moon still buzzed strongly in my system. I explained my current state of affairs to Tiger and he offered to drive me to the field. He was a top-notch ballplayer from Manning, SC. Tiger played his college ball for Clemson in 1975, then went into the Navy for four years, returned to Clemson to play center field, earning All-ACC honors on the baseball team and for academics in 1981.

After observing me, Mike commented, "Hawk, you're tilted and need some substance in your gut." Tiger and I stopped at Mr. Berry's diner and doubled up on hotdogs. The red hots slightly stabilized my mental and digestive turbulence. *Slightly.*

Batting practice and pregame infield were slanted and rocky. I operated on baseball autopilot. The moonshine continued its gravitational pull on my senses, eye-hand coordination, judgment, balance, and skills.

In the first inning, a batter hit a weak grounder to me at short. I raced in, planning to glove it and make a low and quick sidearm throw to first. But as I closed in on the ball, it split into *two* slow rollers, about six feet apart. With no time to shake my head and clear my vision, I chose my best option, which was to be as close to first as possible. I scooped up the grounder to my left, and it turned out to be the actual ball. It was a chancy play to execute. Blue called the runner out.

Tiger, in right field, shouted, "Those red-hots straightened you up, Hawk!" The inning

From 1994 to 1999, Mike became the Mayor of Greeleyville, South Carolina, population 500. He hosted President Bill Clinton's visit there in 1997, riding around as his personal guide in the President's limousine for the afternoon. Then, when the President was walking up the steps to board the helicopter that had landed in the middle of the local high school football field, with his secret service corps, he spotted Tiger across the track. President Clinton immediately flipped a u-turn, came down the steps, and walked over to Mike to personally thank him for making his visit to Greeleyville so special.

ended without any damage, but as I trotted back to the bench, the fans in the stands were a bit wobbly.

How many split pitches, I wondered, would I see coming at me as the leadoff hitter? Fortunately, Rooster stood behind the fence while I took practice swings. I told him my plight, and he said to chew some Red Man. He yelled toward the dugout, "Hawk needs a plug." Chief pulled out a pouch from his back pocket and wound me a healthy one.

One minute later the umpire yelled, "Batter up." I took my time, setting myself in the batter's box, getting the plug set just right in my jaw. Rooster called, "Take two and hit one in the alley, Hawk."

Chief and me before one of our summer games. This season was all about working as a team to win the championship, improving every aspect of my game, and having too much FUN with my teammates!

Feeling like my stomach might hurl the moonshine and Red Man right on the plate, I focused on the pitcher. At least there was only one of him on the hill. Ideally, moon plus tobacco juice equaled one pitch to see and one grounder to field, not two.

We peaked at the perfect time of our season and faced the Harrisonburg "Turks" (short for Turkeys) in a best-of-seven for the title. Their ace pitcher was my friend and teammate at Maryland, Bob Ferris "Wheel." The Great Game has a way of pairing players up like this the longer you play. But once you raise your bat, it doesn't matter who is on the mound. You are in that box to hit, and the pitcher is on that mound to get you out. Baseball is about many things; one of the most important is winning championships.

"Blue Jays Win Title, Madison 'Classy Bunch,'" was the headline in Charlottesville's *The Daily Progress* on Monday, August 18, 1975. The article accurately reported: "Spurred on by a large and rambunctious home crowd, Madison broke the game open with a five-run fifth inning, sending eleven men to the plate and two Harrisonburg pitchers to the showers." We won 9-5, and the Valley League Championship Title became ours and Madison's, four games to two.

I hit .400 (10/25) in this series and scored the game-winning run three times, executed warrior "D" at shortstop, and peppered three hits in the final game to roll out the red carpet with my teammates for victory. Even better, we clinched the championship at home, which prompted loyal fans to go wild.

To give credit where credit was due, Mole made the right moves and played his lineups shrewdly, to claim the crown. When all the hoopla ended, Mole and I looked at each other walking out of the locker room, neither one of us intending to shake hands. That was fine with me. I never saw, spoke to, or thought about Mole again. This was his final season as coach of the Blue Jays.

We brought the first Valley League trophy home to Madison, for Rixie to proudly display in his restaurant. I drove through Madison 16 years later, on New Year's Day, 1991, and stopped in Rixie's for dinner. Our 1975 championship trophy and team photograph were still there on the walnut shelf, polished and shiny as the day we won it. Seeing my name there, along with my fellow teammates, was special. As it is known throughout sports, "Once a champion, always a champion."

We would be champion Blue Jays together for one more night and the following morning all fan out, back to our homes up and down the East Coast. I broke out the corn peach mash, and the bank building was vibrating as my tape player blared Ten Years After, The Moody Blues, Jimmy Hendrix, Pink Floyd, The Rolling Stones, and Elvis Presley. This team of winners was crumblin' the bank's bricks! Fans danced up a lightning storm with us. Our party was one well-earned, open-the-fun-gates championship bash.

Outside the courthouse, three blocks up the sidewalk from the bank, on a green, wooden-slat bench I shared with Twila, the farmer's daughter who could cook up a sizzling midday country feast, things were getting toasty. When the dawn sky started to turn a light-conch-shell pink, it was time to give Madison, Virginia, and Twila, one memorable "thank-you-for-a-great-summer" goodbye kiss.

I pulled Renauldo up to the curb in front of the bank, loaded up my gloves, spikes, bats, assorted gear, clothes, and then gave Chief a high-five. Back in the driver's seat, I slammed King Elvis into the 8-track, and yelled out, "We won it all," to my teammates who were still standing after our celebration. Several came to the curb, hooting and hollering as I revved the engine to max out the RPMs, popped the clutch, burned

rubber, and left a smoke trail as I jetted out of town, the shortstop for the first Madison Blue Jays Valley League Championship team.

1975 Valley Baseball League Champions

First row: Scott "Hawk" Christopher, Robbie Emerson, Rick Wade, Joe O'Malley, Larry Meekins, Mike "Tiger" Mahoney, Bat Boy.

Second row: Bat Boy, Mike "Pull Hitter" LaCasse, Ron Miles, Geoff Goff, Ken Massimini, Frank "Chief" Kolarek, Pete Anderson, Manager Jim Moeller.

Third row: Joe "Lights Out" Laniak, Jim Rollins, Chuck "Falcon" Porter, Rick Foebler, Gerry "Another Homer" Laniak, Dave Obal.

NEW RELATIONSHIPS

Coach Jackson recruited a blue-ribbon corps of players to attend Maryland in the fall of 1975, all aiming to be contenders for the ACC Championship. I would be working with a new second baseman, Franklin "Toto" Thomas, and a hot, pro-prospect first baseman and outfielder, Gary "Bish" Bishop. Both had excelled in Baltimore-area baseball programs over the years, and they brought elevated performance and experience to our team. Bish, one of the finest students of baseball I ever played with, had been drafted number one by the Minnesota Twins in the 1974 MLB June draft, secondary phase, out of Indian River Community College. Another MLB June draft (1975) was Gary "007" Spies, who would share time behind the plate with veteran catcher Chris "Cro-Mag" Hudson. Few catching duos could have filled

the Chief's vacancy, but without question, 007 and Cro-Mag more than qualified. Left-handers Mark "Coyote" Jackman and Jim "Big Cat" Raska, were both adept pitchers from Baltimore. Righty fireballer Ed "Cougar" Armstrong, Florida's high school strike-out star, rounded out our strong pitching squad. Six of these players would be drafted or signed by various teams to play pro ball.

Unfortunately, Frat—our team's co-RBI leader and third baseman from the stellar 1975 team—had to have a back operation that ended his season. This was an enormous loss, although Frank "Air" Kemp, our senior first baseman who was a free swinger, having a history of producing pivotal hits when we needed them, would fill the void of Frat's untimely departure.

Our lineup boasted speed, power, and dead-eye pitching. Coach Jackson gave me the honor of being team captain. He honed our skills, constantly giving players personal attention. On defense, one player's success relies on another's talents for a positive or negative result. Toto, Bish, and I made quite a double-play trio, and we turned a lot of them that season. From the first practice, Toto and I demonstrated a keen understanding of each other's talents and strengths. He executed a quick delivery on his throws, turning our double plays. We worked all fall on our pivots. Toto always stayed low and was second-to-none with fleetness and timing. We played the middle infield like two wizards, both dreaming of becoming pros.

Heading into October, the majority of our games registered in the win column. This club exhibited the most expertise I had ever played with, and we were uncompromising about keeping the ACC Championship within our sights. We practiced before practice, and we continued practicing after practice. A group of us *bled* baseball, and we knew the more we trained as a team, the better we would fare in our spring season.

Off the field, we socialized—teammates, through and through. Saturday nights we frequented a student rock-n-roll club on campus. One late night in November, out on the dance floor, I twirled to my own "Alligator" choreographed dance, where I kept one arm on the ground and spun around in circles like a Fourth of July pinwheel. Looking back, I may have been the world's first breakdancer. When I became dizzy, I would lie on my back and shake my arms and legs as if I had been sprayed with bug repellent.

Ed "Cougar" Armstrong is the epitome of a gallant athlete and person. His career as a pitcher only validates why coach Jackson awarded a scholarship to this Florida phenom. Dunedin High School, a perennial powerhouse in Florida, charted a 24-4 record in Ed's senior year. The region's ace had a perfect record at 10-0, with a head-turning 1.15 ERA over three varsity seasons, versus top competition. Multiple postseason honors were bestowed on Cougar.

When the sturdy and tough, 6'2", 200-pound right-handed fireballer confidently planted his spikes into the mound for Maryland's '75 fall campaign, it was evident that one of the team's future power pitching winners had arrived. Ed's heater rose and busted in on hitters at 90 MPH-plus, dominating and buckling his foes from the heat. An exceptional student of the art of pitching, he was very coachable and relished advancing his skills to win. Ed's vital do-or-die competitive core was instrumental in his victories at Maryland.

Cougar took his strong arm into summer ball to pitch the first game of a double dip. He faced future 1985 World Series champion, Steve "Bye-Bye" Balboni, pounding the power hitter with lightning fastballs, striking him out twice. Toward the end of Cougar's stint, his arm started hurting. Knowing something was wrong, Ed was diagnosed with a torn rotator cuff, tragically, never recovering. When his laser heater sadly became a memory, he gave it his best to become a finesse pitcher as a junior. That proved not to be an option, mentally or physically.

Cougar proceeded to focus on his pursuit to earn a law degree from Vanderbilt-U after graduating from U-MD. Having exceptional academic acumen, Ed became a high-profile lawyer. His reputation sparked the attention of the Tampa Bay Rays. The execs hired him in June, 2008, to join their complicated stadium funding and location efforts. That season the Rays played the Philadelphia Phillies in the World Series, losing 4 games to 1. Because of Ed's exemplary work and passion for baseball, Tampa Bay presented him with an American League Championship ring. BRAVO!

Ed's courageous nature would be tested to its limits in 2002, when both of his kidneys failed and were removed. The donated transplanted kidney only lasted eight years, then Cougar lived with the horrors attached to dialysis until 2012, when the "Courageous One" received his second transplant. Thankfully and beyond almost insurmountable odds, it has provided normal kidney functions to this day. Recently, he was selected by "America's Top Lawyers" to the 2023 Top 50 Lawyers in America list. Ed is a CHAMPION on every front, a GREAT teammate and friend who will always be a true INSPIRATION to all. Cougar is in the "Courage Hall of Fame!"

The pub boogied at full tilt. I jumped up on a table and did a mechanical and poorly executed rendition of the "Swim," with my feet doing a tight, rapid 180-degree shuffle and my arms swimming all four strokes against a swift tide. I enjoy dancing, but it can be painful—very painful—to observe me shaking it up at times!

When the lights went up, a really swell girl named Ruby said, "That was a hot table dance. You look like Paul Newman." We dated for a month. A talented art major, she made an exceptional black-ink and water color portrayal of me as a hawk with a baseball and bat in its talons. This rock-n-roller was very kind and gave it to me as a present, artist to artist.

My teammate and top-tier friend, John "Bendix" Norris, was named after actor William Bendix ,who played Babe Ruth in the 1948 movie, *The Babe Ruth Story*. John keenly resembled the former Hollywood star. He and I were visiting my artist friend's dorm room on December 13, 1975, when a co-ed student who lived on the floor walked in. Named Sharon, her presence mesmerized me from the moment our eyes met. We immediately started talking about artists, nature, writers, and New-Age philosophies. When Sharon left to go back to her room and study for her exams, I left with her. We talked for a long time, then I walked across campus back to my nest #2 in Byrd Stadium. As I moved through the stillness of the night, I felt different; Sharon presented something fresh and exceptional to my soul. A warmth that was calming, curious, and sincere.

During the holiday break, I headed west with my best friend, Ramon. He had been my first-year roommate at Ferrum, a very dominant football player who earned a scholarship as an offensive guard to play for U-Richmond. Ramon majored in history and became an educator and noted war historian. We have remained friends for my entire life. On our safari, weaving our way across the southern United States, we headed west on the country's fourth-longest interstate highway system, stretching 2,460 miles from coast to coast, I-10. On the return of our adventure, we zigzagged back east along a mismatched northern route, all in Ramon's orange Volkswagen Beetle.

This road trip was steeped in upperclassmen behavior. We partied with a major beauty pageant winner in a swanky hotel bar that overlooked El Paso. I ate a white tequila worm in Nogales, Mexico,

accompanied by a mariachi quartet we had paid to serenade us for half an hour while we polished off shots of cheap tequila, then hit the streets to admire and explore the colorful Mexican city. On New Year's Eve, Ramon and I started our celebration early at a Western bar decorated with a 12-foot, cement martini glass as its marquee sculpture.

At 11:59:59, though, I marked the end of the fun factor. When the hands of the clock struck midnight and the chimes officially ushered in 1976, my senior spring baseball season commenced. I started thinking and living baseball to bring in the new year, leaving the party behind, to be resumed at some point after the last out of our final game—hopefully as ACC champions and beyond.

I loved being out in the Wild West. The rugged landscapes, diverse cultures, art, history, animals, architecture, light, amazing ever-changing skies, and the openness have always been strong influences for feeding my soul. Heading back east, Ramon and I ran out of cash after a day of skiing in Colorado. We bartered or sold what we had in pawnshops or gas stations, for fuel, sodas, and bread-and-cracker money, to get us back to Virginia. I traded my Schrade camping knife for a tankful in Kansas. We managed; a VW Beetle goes a long way filled up at fifty-seven cents per gallon.

Back on campus, my whole focus returned to baseball. But in the middle of January, I received a phone call. When I said hello, a soft voice said, "Hi, Hawk, this is Sharon. I wanted to thank you for my postcard. How was your trip?" I had sent her a postcard of a beautiful Western landscape with red clouds rippling across the sky. Now, so glad I did, we talked and reconnected. In a matter of days we started dating.

Clueless that Sharon and I might fall in love, I found myself moving into uncharted, loving territory with her. She would stand way down the left field foul line and watch me practice and play games. Her blue eyes both relaxed and invigorated me; inside and out, Sharon's beauty shone. A born intellectual with a curious mind, she balanced her days with our dating, avid reading, poetry writing, classes, hiking with her mother, and outdoor adventures.

Sharon did not know much about the finer aspects of baseball when we met, but she took a genuine interest in the game. Her mind always wanted to know more, so this immersion into my athletic world, and baseball in particular, was wonderful for me. My exposure to Sharon's intellectual sphere similarly broadened my horizons. We would study

together and prepare one another for tests throughout the semester. Doors opened for each of us that were not only riveting but also truly magical. I had dreamed of a love like this, but for it to actually be blossoming in my heart of hearts was beyond my wildest imagination. I was almost 22 years old, and in a state of absolute bliss.

A MISSED CALL

That winter I had to relocate my living quarters from my football stadium "nest," as it did not pass a health inspection due to insufficient ventilation. So I bunked with Bendix and other teammates in two different dorms, unconcerned about where I called "home." My final year of college baseball awaited. Now almost six feet tall and weighing 175 pounds, I was in excellent shape, except for my right hand. I judged it had reached maximum strength and usability—between 40 to 90 percent of a normal hand, depending on the baseball skill being called upon. I estimated throwing at 80 to 90 percent; hitting an outside pitch, 75 to 90 percent; hitting an inside pitch, 60 to 85 percent; and fielding a slow roller on the infield grass that required a one-handed, pick-up and throw was next to impossible. My hand was what it was, and I learned to compensate. I had no other choice.

Few were aware of my disability. I never, ever talked about it with my coaches or teammates. Looking back, I realize I had mentally detached my hand from my body at quite an early age—that was necessary because it hurt at times to use. I called this appendage "it" and not "my hand"—I made my handicap an external hurdle to be overcome and conquered. I succeeded through sheer determination and dead-eye focus on my dream.

As in prior years, the team started our conditioning in Cole Field House. Some players practiced out on the diamond in the snow and cold, just to be on the field, eager to do whatever was necessary and possible. Everyone wanted to be at the top of their game, knowing our team had the fire power to be ranked in the top 20 nationally.

Winter was kind to us, and we held spot practices on Shipley Field in mid-February. Soon we were out there every day, as the weather broke and March approached. The coming of spring was beginning to paint its beautiful canvas, just like baseball does as the season approaches.

Our team built strength and skills progressively until three weeks out from opening day, when we started to train as if playing competitively. Inter-squad and practice contests with other schools' teams are essential to sharpen the abilities you need to hone. Practicing counts as one way to prepare for the season, and live-game situations are the other. They prepare you to anticipate what to expect from yourself and teammates, and to clearly identify what needs to be improved. All the drilling and coaching could not have equipped me for my next challenge.

Each February, all players were required to take a medical exam. For one of the tests, the doctor used a pin to assess the reaction of nerves in your body. The outside of my right thigh had been numb for several months, and I felt none of the pricks there. I was not concerned about it, as I attributed it to many, many years stealing bases and pounding my body into the earth when I slid. Scoring runs mattered more to me than damaged nerves in my leg. When I told the doctor a smokin' fastball had hammered the left side of my head over the summer, he frowned. Doc ordered an immediate Computed Tomography scan, which uses x-ray imagery of the different layers of your brain.

My father picked me up at school the next morning, and we drove to the hospital. A technician put me on a bed that slowly moved through a gantry while the x-ray tube rotated and made images of my brain. I felt like I was in a science-fiction movie, getting ready to be transported to another planet as the machine made switching, mechanical noises. I recalled the incident that caused all this concern. A six-foot, seven-inch, 250-pound redwood of a young man delivered the wayward missile in the Valley League. I had dug in at the plate against Redwood. Unfortunately, his inside heater rode in on me at 90-mph-plus. I didn't flinch and the ball bit me like a tiger shark, leaving a four-inch crack in my helmet. The field, known as the "snakepit" in Shenandoah, Virginia, spun like a top for 20 seconds. My mind was momentarily a shaken-up snow globe. Then, using the white foul line as my balance beam, I wobbled and zigzagged to first base.

After the inning ended and I jogged past the mound on my way to short, Falcon asked, "Hawk, you want me to drill their six spot?"

Hurting and angry, I said, "Hell yeah, sting him!"

When their shortstop took his place at the plate, Chuck's four-seam heater found a home in his ribs. He plunked him solid, and both benches cleared as an ol' fashioned brawl ensued. The rhetoric and fists went

flying in the snakepit. The fans were, "a-hootin' and a-hollerin'." Once the dust settled and the collective ire of the players had been extinguished, we all returned to our positions, and Blue tossed a baseball out to Falcon on the hill and said, "Play ball." We had left it all on the field, which is the correct way brou-ha-ha's should end. A funny thing about the Great Game is that it almost always resolves players' issues that present themselves outside the rule book, if attention to the contentious matter is deemed necessary.

I did not think much about the CT scan for several days, until coach Jackson asked me to meet him in the locker room during practice and sat me down. We were alone, and his expression made me uneasy.

"Hawk, sometimes there are brick walls you just can't climb over."

"What's wrong, Coach?" I had no idea what was coming.

"Your CT results reveal you have multiple sclerosis."

"Holy smoke! I know MS is a serious diagnosis, but what the heck does it do?"

Coach explained that MS is when the insulation covering the nerve cells in the brain are damaged. "Hawk, you are going to have to turn in your uniform."

This stinging pitch zoomed in at me. Again, I didn't flinch. "No way, Coach. My thigh has been taking a beating for years from sliding on it so much." I could accept my brain might have been scrambled—just as I accepted my handicapped hand—but neither would stop me from being part of a team slated to contend for the ACC Championship, and nothing would stop me from giving the Oriole scouts such a power-packed season they would be champing at the bit to draft me in June.

We spoke real and difficult words. Coach, truly at a loss, was the one faced by a brick wall. The discussion and his decision were both tough; he stuck to his guns, just like he did in the Korean War battles he fought, moving swiftly and doing what had to be done. As my coach trudged back to the field to prepare his team for opening day, I neatly folded my uniform and set it in my locker.

Thirty minutes later, wearing street clothes, I watched my teammates practice, imprisoned in the words my coach had delivered. I felt like I was Auguste Rodin's stone sculpture, "The Thinker," thinking my baseball future was frozen in marble and time.

No way, I told myself. My spirit was yelling out to me that the diagnosis was inaccurate. Gasping for thin air, I hounded coach for the next

several days. The results were wrong; they *must* be wrong. I said, "I am tuned in to my body, coach, and have been stealing bases since Little League. This is not MS, this is BS." He finally relented and requested to the doctor that I be retested right away.

Back to the beautiful spaceship I went, and this time, my results were evaluated immediately. The rocket that delivered me to planet MS now brought me home—a doctor had misread my first CT scan. I did *not* have multiple sclerosis. Back in uniform the next day, I was giving my training extra swings, before and after practice with my teammates. I had missed three intra-squad games and days of hitting and fielding work, but it did not affect me. I felt grand going into my senior spring campaign and moving toward our team's and my dream's bright glory.

In the batting cage I galvanized my hitting stroke. In less than ten days from when this photograph was made, I would set up, ultra-focused, in the batter's box as the leadoff hitter to begin our team's 1976 season. My teammates and I hit in the cage before and after practice. We knew we had the firepower to claim the coveted ACC Championship. I was going to have such an exceptional season, the Orioles would have to take me in the June MLB draft, and I was so psyched I carved "Hit Taters" into the trunk of the oak tree, to the right of the cage. The letter "H" is visible in the photograph.

5TH INNING

TESTS AND TOURNAMENTS

Our opening-day game, March 6, 1976, pitted our Terrapin team against the East Carolina Pirates, located in Greenville, North Carolina. On the day before, I and my four teammates—Bendix, Toto, Dini, and 007—headed south in a brand-new, university-issue, gold Ford Torino, with fewer than 100 miles on the odometer and having that clean, new-car promise. We loaded it with the team's bats, catcher's gear, and clothes to wear for a week on the road. Setting out on a clear and crisp day, we were jawing away, listening to the radio, singing like a quintet as Gary Wright's "Dream Weaver" chart-topper played. We cruised down Interstate 95, confident this season would be ours!

Bendix handed me the keys late in the afternoon, when I asked to drive, because I always enjoyed being behind the wheel when sunset approached. I took the exit onto Route 301 south, heading toward Fayetteville and Fort Bragg, to close in on our Pirate adversaries. When reaching

Being a player and captain of Maryland's baseball team were great honors for me.

Rocky Mount, I spotted a billboard advertising a steakhouse, so we decided to pull in for dinner. I needed to switch lanes to make the right-hand turn but could not see out the windows in the back because of all the equipment. I asked my co-pilot riding shotgun, "Bendix, can I get over?"

He said, "Yeah." As I was switching lanes, he added, "But hurry up!"

Too late.

A twin-stacked 18-wheeler—with a forty-eight foot flatbed, carrying twenty tons of pipe and rebar tied down with steel chains—slammed into the rear of our station wagon, turning it into a spinning golden helicopter blade. My teammates and I were smashed hard and headed right into a telephone pole. Good fortune delivered us a gift that evening, as our vehicle circled around the pole. I held the steering wheel with every ounce of strength I had in me to keep the wheels straight and locked down. As we spun around one and a half revolutions, shattered glass and baseball gear flew all around us. The left side of the car ended up against a hill with a sharp gradient, and the big rig teetered above the passenger side, threatening to overturn and possibly kill me and my teammates. Because of the heavy smell of gas fumes, we knew our tank was punctured and had spread fuel on the ground all around us.

Toto shouted, "The truck is going to crush us!" Ten more feet down the slope of the hill and that semi was tipping over. Our fate would have been a tragic and dark headline in the newspaper the next morning.

In the midst of this grisly scene, 007 yelled, "The car's gonna blow up," and we surely resembled circus clowns piling out of a miniature car. Chaos reigned. The wrecked right back meant Toto, 007, and Dini had to squeeze out through the narrow opening of the damaged door. Up front, Bendix managed to get out his door, but the embankment blocked my exit on the driver's side. My teammates, already on the grass, would not abandon me. Bendix, closest to me, grabbed both of my wrists and pulled me out of the car. What a friend and complete team member! Once I hit the ground, we all sprinted from the scene, expecting shrapnel to bite our backs. Running at least 40 yards, we huddled together, waiting for an explosion should the 18-wheeler and its load of steel pipes roll over and flatten the state vehicle. Remarkably, that gruesome scenario never happened.

Oddly, the driver of the 18-wheeler stayed up on top of the ridge behind his truck. Steam gushed from under the semi's hood, and its

right bumper was mangled. Dini's hazel eyes were wide open, in shock. There was blood on his arm.

"You okay?" I asked.

"Hawk, I got tossed around like a rag doll."

We checked ourselves and each other for injuries, and it seemed incredible that there were only three: a knot on Toto's head from an air-borne bat, Dini's cut on his arm, and my hands sustained bone bruises between my thumbs and index fingers, from being jammed into the steering wheel by such a forceful impact.

When a North Carolina state trooper arrived, he talked to us in a group and determined there was no need to call an ambulance. The officer performed his procedural duties, lining flares along the road to divert traffic. When the trooper asked who was driving, I stepped forward and gave him my license. The officer directed me to wait by his patrol car, and then he called the driver of the truck over. "Tell me what happened here," he said.

I replied, "I was making a right-hand turn to pull into the steak house, and the tractor trailer slammed into the back of our vehicle."

The commercial driver, with a heavy Georgia drawl, said, "Yeah, but he did not use his turn signal."

I acknowledged this as true.

The trooper, also speaking with a Southern accent, chatted casually with the long hauler as he processed the information. The red flares melted down on the blacktop. The semi continued to threaten to tip over onto our station wagon.

"I am going to have to write this up as a no-fault accident," the trooper said.

"That doesn't seem fair," I replied. "He mashed the hell out of our car and hit us from behind. He could've killed us all."

The trooper gave me a long look and said, "Young man, you failed to use your turn signal. An 18-wheeler can't stop on a dime."

After the big rig righted itself and the tow truck arrived to haul away our station wagon, we assembled all the gear from inside the smashed Torino and placed it next to a florescent-lit phone booth, with a glass-paneled door that opened and closed like an accordion. Our only option was to alert East Carolina's security department and have them notify coach Jackson about the crash. As the captain of the team, I placed the call and delivered the message to security that we

needed to be rescued. I gave the phone number of the pay phone that was printed across the middle of the rotary dial in black numerals.

The five of us sat on the curb and waited over an hour for the phone to ring. Famished, Dini, Toto, and 007 walked over to a mustard-yellow Waffle House to order take-out rations. They returned to our cement bench with grilled cheese sandwiches, hash brown potatoes, and sodas.

Toto told me that when the waitress came over to take the order, they made eye contact. He said he felt a bit jolted, as yet another surreal moment unfolded. "Is your name Doris?"

Surprised, she replied, "Frankie?"

Mystery solved for Toto. Doris had vanished from her row house in his Baltimore neighborhood three years prior, and he always wondered what became of her. Many of a person's enigmas are deciphered simply by living their lives.

I continued calling security, multiple times, receiving assurances that my SOS to coach Jackson had been delivered. We sat out there like five numb birds on a telephone wire, anxious and nervous because of our predicament; coach was not responding to my calls. Everyone's nerves were shot, our brains were jumbled.

I have said baseball is a game of inches—occasionally, so is your life, especially when you're inside a station wagon totaled by an 18-wheeler. A potentially fatal accident leaves an indelible impression in your mind. The impact and that clashing-thunder noise rattles you viscerally.

The pressure was on. In 19 hours the umpire would be dusting off home plate to start our season, yet we were stranded. I made another attempt to contact coach. This time when I picked up the receiver, I heard him, trying to converse. We finally connected.

"Why the hell haven't you answered the phone?" he demanded.

"It never rang, Coach." He had been trying to reach us since my first rescue call; only now we realized the pay phone did not have a ringer bell in it.

"Is anyone injured?"

"No."

"Are you able to drive the car?"

"It's scrap metal, Coach. The state police towed it." In the ensuing pause, dragon flames came through the earpiece. I needed a fire extinguisher, as my ear drums were burning.

"Hawk, who was driving?"

"I was."

Silence and a more intense, scorching-hot blaze crackled through the line, melting the multi-colored, woven insulated wires.

Fifty minutes later, we loaded everything into the back of another university-issue station wagon, driven by none other than a tight-lipped, fuming coach Jackson.

As he pulled onto the highway—passing the diner where we never did get our steak dinners—coach uttered three words, "Is anybody hurt?" A chorus of "I'm okay, I'm fine" sounded like it came from under water. Not another word was spoken by anyone the entire trip to Greenville. I was nothin' but a junkyard dog, in the dark back corner of a doghouse.

Someone lined up cots for us at the Pirates field house. I tossed through a rough night's sleep, as my body started to absorb the after-crash reality of being banged up and slung around.

Nevertheless, the next morning I was set to go, except for my bruised hands and aching psyche. I needed to clear the accident from my mind. I would take the first pitch, as the leadoff hitter, to start our season in a matter of hours. Both teams delivered stellar pitching performances; the score remained 0-0 after 11 innings. In the end, East Carolina prevailed by smashing a three-run homer in the bottom of the twelfth to earn the win. Our team was rattled, knowing the night before was that close for five Terrapins.

This dismal beginning spiraled into one loss after another. We were outplayed our next four games by scores of 3-2, 6-4, 5-3, and 8-3. Overall, our spring trip netted only 12 runs, and we gave up 29. Both players and coaches felt ill, knowing our team was better than our 0-6 record—the worst of any college baseball squad in the country through six games.

The sixth consecutive loss came at the paws of the Clemson Tigers, by a score of 6-0. My batting average sunk well below .200. Our offense lingered just shy of being declared missing in action. Coach Jackson's fury vibrated the cinder blocks in the Clemson locker room after the game. He went ballistic. Yet it turned out to be a warm-up of what was to come in half an hour.

While we loaded up our gear to return to Maryland, coach needed to check paperwork in the rental car's glove box. When he opened the door, he spotted a six-pack of Pabst Blue Ribbon on the floorboard—four full, two drained. He picked up the full cans, still in the plastic rings, and

flung them like a discus thrower across the parking lot, causing three to explode on impact. Livid, he called every player back to the locker room. When we were all seated, he resumed, right where he left off 30 minutes before, with his verbal tirade, no holds barred. A human inferno, every one of his cells erupted volcanically. Molten lava flowed out of his mouth.

As the captain of the team and one of the passengers in the car, I took the frontal assault. "Hawk, who was drinking the beer?"

I said, "No comment," and his ranting continued, ending with his same inquiry. I delivered my earlier reply. I was not going to turn the screw on a fellow Terp.

You could have fried an egg on coach's words when my teammate spoke up and said the six-pack was his, and he had drunk the two beers.

Coach gave me a stare that could bore a hole through a plate of steel. "Why did you let him, Hawk? You are the captain of this team."

"He's old enough to have fought in Vietnam, so he can make his own decisions about whether or not to drink."

Coach pounded his right fist into his left palm. "That is exactly what I expected you to say, Hawk. You are no longer captain of this team."

I accepted my coach's stance on this unfortunate development, but I was jarred. This was my fourth roundhouse punch in one week: (1) a totaled team vehicle; (2) team was 0-6; (3) I was hitting below .200; and (4) my honored captainship had been stripped away.

Back on our home field in College Park, the season started to gain momentum. After ten games, my teammates requested a meeting with coach in the locker room, which I was asked not to attend. They proposed that coach reinstate me as their captain. He complied, calling me into the locker room to inform me of his decision. Victories in three of our last four games helped calm coach down. I sensed he respected me for being true to my friends.

I wanted the Atlantic Coast Conference championship trophy more than ever now. My teammates had covered my back. Each of them knew if one or more adversaries confronted them, the Hawk would stand toe to toe with their opponents until the issue was resolved or I was knocked down for the count. With the next 24 games, we went 16 wins, seven losses, and one tie. If we had played baseball the first six games like we played from game seven on, we could have had a record of 25 wins against nine losses or better.

Dini was ripping the cover off the ball, leading the ACC in hitting with a .400-plus average. Our cleanup hitter ended the season as the 48th top batsman in the country, pulverizing pitchers for a .387 average. And what a dominant pitching staff, completing the season with the eight-lowest team ERA in the nation. Wheel led the ACC in strikeouts and ERA, with a dazzling 1.17 average. Jim Raska, who had been drafted by the California Angels in the fourth round of the MLB January draft in 1975, went a spectacular 7-1 on the hill, with control maestro Mike Brashears performing solidly when penciled in to pitch. Catchers Cro-Mag and 007 gunned down runners like falling dominoes when they attempted to swipe a base. Toto and I sewed up the

Darrel accomplished an amazing feat as a baseball player. Dini worked relentlessly, beginning as a young boy using cracked bats nailed and taped together by his father, hitting stones he threw up in the air. Making his first all-star team when he was 10 years old, he fought for every swing of the bat to become one of the finest college hitters in the country.

As a senior, after pulverizing pitchers for a .387 average at season's end, he was ranked 48th top hitter in the NCAA and second-best batsman in the ACC. This spectacular campaign earned one of the top hitters in Maryland baseball history to be chosen a member of the 1976 All-ACC team as the designated hitter. In Maryland's top-ten, all-time records, Darrel is fifth with a .451 on-base percentage and ninth in batting average at .353. Always swinging for the fences only, he holds the 11th spot for slugging percentage at .547. What a remarkable college career!

Nothing stopped Dini from chasing his dream to earn a full scholarship to play for Maryland. He would drive from Maryland to Virginia for weekend practices with "B for Baseball" Martz on a field covered with winter's freezing ice and snow. Of all the hitters I ever shared a dugout with, Darrel had one of the five best sets of hitting wrists I ever saw. When he was in the batter's box, teammates would come to the lip of the dugout just to watch him hit. And when he did crush a long home run, we would all cheer. A reputable scout told Dini he had a triple-A bat, but it was his running that kept him out of pro ball. In today's game, the MLB teams would be fighting over giving this power hitter a shot. You don't have to leg out a hit if you are driving in runs, trotting around the bases after a long fly. It truly was a thing of BEAUTY to watch #8 take his rips.

*Darrel "Dini" Corradini takes a big swing and crushes a long homer,
his second tater of the game. Assistant coach Charlie Bree is in the
third base coaching box. My father made this winner of a photograph.*

middle infield and made double plays as if trained by the great ballet
dancers Mikhail Baryshnikov and Rudolf Nureyev, flying through the
air with ease. Bish was smacking his patented line drives, chalking
up the RBIs with Dini, and Sam "Hit House" Housley was swatting
a crisp .316.

I was leading the conference in stolen bases, among the tops in
runs scored per game, and sporting a .300+ batting average. Bendix
and Dickie "Can-Do" Cann added backbone and grit to the lineup,
beefing up our offense and racking up outs patrolling the big pastures.
John had lightning bolts for legs and covered as much ground as two
outfielders. Bendix never cheated himself taking his cuts at the plate.
When he touched one, his homers had a high, majestic arc. Dicky was
a very disciplined hitter who was built for pressure at-bats. He had
one of the best jumps on a ball coming off the bat I ever saw in the
outfield. It was as if Can-Do was being shot out of a cannon. Every
cylinder on our team fired, turbo-style.

There had been tough moments for me during the spring. One in partic-
ular was very wrong. To be on the field an hour or two before afternoon
practice, to take grounders and hit in the batting cage, I scheduled

Frank "Toto" Thomas was one of my all-time favorite teammates. It was evident from his first day of fall baseball in 1975 that Frankie had the presence, talent, work ethic, and mindset to play major league baseball one day. A Baltimore star, who had earned a spot on the Baltimore City - Metro Area All-Time High School Team as a shortstop, accepted his scholarship from Maryland to advance his skills and move right into pro baseball. In Toto's freshman year, he was selected a member of the 1976 All-ACC team as a second baseman. The next two summers, playing for Baltimore's famed Johnny's team, he won two AAABA championships and was voted the tournament MVP in 1977. Frankie's accolades kept amassing at Maryland. In 1978, he was taken in the seventh round of the MLB draft by the Milwaukee Brewers. Toto won his pro baseball championship ring in 1980, playing for the AA Holyoke Millers in the Eastern League.

In 1981, playing second base for the triple-A Vancouver Canadians, Toto made only 11 errors in over 400 plays in the field. In most organizations, Frankie would have had a fine career in the Bigs, but his main competition for that coveted slot to be on the roster wound up being seven-time All-Star, Hall of Famer Paul Molitor and another Hall of Famer, two-time AL-MVP shortstop Robin Yount.

Toto had 2,633 plate appearances in seven minor league seasons, hitting a solid .268. Always a slick fielder, gloving over 3,000 chances in his career, Toto was an all-star to the Great Game—and to me as a teammate and friend. He proved himself to be one of the premier players in U-MD's storied baseball history.

my classes as early as I could. One day, out on the diamond ahead of practice with my teammates, I had to pee. Walking over to the wall by the bleachers, I left a half moon on the bricks. When coach saw it an hour into our drills, he called the entire group into the dugout. Livid, he demanded to know who had urinated on the bricks. I owned up. Coach picked up some dirt and threw it back to the ground, yelling, "Hawk, you have as much couth as the dirt on this field!" Angry, he sent me out to shortstop. I was the only player on the field, and he turned me into a case study with punishing, one-hop, top-spin liners drilled right at me. Fuming, coach issued frozen ropes from in front of the dugout, which gave me less time to react. Those darts delivered his message in a very effective way.

Skilled with a fungo bat, coach ran me to my far right and far left. He next shot bullet after bullet, some of which bounced off my chest, shoulders, shins, and thighs. When he called me back into the dugout,

I apologized. I was bruised, and that was okay. I deserved my punishment. I learned then and there, and my teammates did as well, never to disrespect a baseball field or stadium. The coaches, players, umpires, fans, vendors, announcers, the diamond, and all the construction materials used to build the great ballparks are important, worthy of the utmost respect.

In early April, we prepared for a two-game series against Duke at home. In the first match, with a man on first, Duke's hitter peppered a grounder up the middle. I fielded it cleanly and swiftly shoveled the ball to Toto to turn the DP. The runner came high and hard into Toto's leg on the play. Being behind the bag, I watched the assault unfold, despite Toto's quick hands and superb instincts. The runner hurt Toto with his spikes, shoving him to the dirt. I came in to the bag to help Frankie up. We locked eyes, and I said, "Somebody's mine, Toto."

The situation reversed on the back end of the twin bill. Toto fielded a tough grounder to his glove side, stayed low, pivoted, and threw a pea as I came across the bag. I had been waiting for my opportunity to settle the score with any Blue Devil coming into second.

As I tagged the base, I angled a sea-level, sidearm throw to Bish at first, forcing the runner down on his slide. I marked his helmet and drove my knee right into it when I landed on the ground, after completing the DP. The runner rolled in the dirt, jolted. I looked down at him and said, "Any player ever comes at Toto again, he will be ferried off this field on a stretcher." We won both of our games against Duke.

As captain of our team in 1976, I was asked to deliver and receive ground rules before games. Head coach Jim West, from U-VA, is also receiving the guidelines.

1976 MVP SEASON AND ACC TOURNAMENT

Coach Jackson's talented team was super-charged for the Atlantic Coast Conference Tournament, to be held in Chapel Hill, North Carolina, for game one. The winner would then travel to Clemson, South Carolina, to compete against the other bracket winning teams. The first round of the contest was single elimination, and then it converted to double elimination for the remaining four clubs. In the past two season tournaments, the Terps had been eliminated in both first rounds without scoring a run; we were determined to bring our offense to the field and score a trainload of tallies. As a team, our confidence to win it all couldn't have been higher.

Knowing the baseball scouts would be thick, I wanted to impress them for the upcoming June draft. The Orioles top regional scout—the one I most cared about showcasing my skills for—would be evaluating talent. I was raring to put on a show. So were my teammates.

We entered the tournament seeded number-two behind Clemson. The first team we squared off against was Duke. Highlights of this

At shortstop, I always set up for any type of fielding play that came my way. It is critical for all defensive players not to be flat-footed on any pitch. Bob just released a curveball, and 007 is catching. Bob and I had a very good baseball experience together.

Bob "Wheel" Ferris proved to be one of the top five pitchers in U-MD program history. Bob was a baseball and basketball star at West Springfield HS in Northern Virginia. At Maryland, Wheel wrote himself a grand résumé over three seasons (1974-1976). He is on the all-time, top-ten list in the following categories: #1 complete games, 20; #3 ERA, 2.46; #5 wins, 17; #14 innings pitched, 231.1. At 6'6" and 230 pounds, Bob was a scout's dream. That proved to be the case, as Wheel was chosen in the second round (#30) of the 1976 MLB draft by the California Angels. This power pitcher had two visits to the big leagues, compiling a career 4.69 ERA. Most of Wheel's amazing talent was displayed in AAA pitching for the Salt Lake Gulls, posting an overall record of 46 wins against 38 losses. I played shortstop behind Bob for three seasons. Every inning he pitched was a thrill. He owned the pitcher's mound, and watching the opposing hitters fall like dominoes was a joy for me and my teammates. A mathematics major, Wheel had the pitching mechanics to unleash his rocket fastball in the mid nineties. Combine that with the educated adjustments made for every hitter he faced, and it was PURE intimidation. Wheel was an exceptional teammate and person. Bob persevered and was destined to pitch in the Bigs. And he did!

seesaw game include center fielder Cliff "Rooster" Hill tagging a two-run homer for us in the sixth and Wheel coming into the game as a relief pitcher, shutting down the Blue Devils offense by tossing three scoreless innings. After Wheel's first two innings of work, the score remained tied, 9-9, through nine innings. In the bottom of the tenth, with two outs, I came up to bat. Third baseman, Bob "Niff" Niffenegger stood on second, eager to score. The Duke coach decided to walk the hitter before me to give his team more defensive options for a third out. If we scored a tally, Clemson would be our next field for victory.

Coach Jackson approached me from the third base box; I met him halfway down the base line. "Hawk, show this manager what a winner is made of. He made a mistake pitching to you."

"Coach, this game is over." I walked up to the plate, pulled some dirt out of the batter's box with my back spikes for better footing, and tapped the far corner of the plate with the end of my bat.

Pitching to a hitter when the slightest mistake can eliminate your team from the tournament is pressure. Driving in the game-winning run—in extra innings, with two outs—is pressure. We both felt it. The entire stadium

sensed it, including the fans, who rooted primarily for Duke. Admirers of baseball thirst for situations like this; it is one of the best real-time, as-it-unfolds dramas in all of athletics.

Niff sported a speedy pair of wheels and was a smart base runner, so I set my intention to drive the ball through the infield. I would not take a power swing for extra bases; I only needed to bring Niff across home. I adjusted my stance slightly more open than usual, and I shortened my swing to enable my bat head to come through the strike zone for solid contact to drive the ball into the outfield.

With the count at two balls, one strike, the pitcher fired a tight-spinning slider my way. Holding my bat head steady and with a strong, compact swing, I drilled a liner right up the middle, which was my intention, for the game-winning hit and a 10-9 victory.

After my teammates and I celebrated, coach came up to me and said, "Great bingle, Hawk."

I believe this stands as Maryland's only extra-inning, game-winning, walk-off hit in their postseason tournament history. It didn't exactly match my dream of hitting a homer in the ninth, but this represented a memorable hit for my team and me. My dream homer in the championship game still beckoned brightly. I could clearly see swatting it in my mind; I just did not know where or when.

The Terps advanced into the double-elimination round of four teams, scheduled to begin at Clemson the next day. We were paired up against the University of Virginia in the winner's bracket. Playing a solid game, we triumphed against the Cavaliers, 8-4.

The following day, our match against Clemson remained a considerable hurdle to clear before winning the ACC championship. If we succeeded, the stage would be set to compete in the title game against the winner of the Clemson-Virginia game. If we lost, we would play Virginia again for a shot at Clemson and the title. The two best pitchers in the ACC squared off for this match-up. Coach placed Wheel on the mound. He led the ACC in strikeouts (96), earned run average (1.17), and second in complete games (9). The Tigers countered by placing their stopper on the hill, Chuck "Falcon" Porter, my former teammate on the Madison Blue Jays, who boasted an undefeated 9-0 slate and later was honored as the ACC Player of the Year after compiling a perfect 12-0 season, still today a Clemson record.

I had never seen so many major league scouts at a game in my life. Clipboards, stop watches, and small notebooks were everywhere,

especially behind home plate. One of those dream weavers was surely scouting for the Baltimore Orioles. In a nail-biter of a game, we lost 2-1. Clemson scored two runs in the top of the ninth and took the win when Falcon handcuffed us in the bottom of the frame.

A photograph printed the next day on the front page of the *Greenville News* sports sections is one of my all-time favorites. It showed me airborne, throwing the ball to first base. I had just come across second on a double play, after Toto pivoted and threw a bullseye to the bag. The runner was shown sliding into me. An extract from the accompanying article stated, "Porter gave up the lone Terp run in the fifth on a double down the first base line by Scott Christopher and an RBI single by designated hitter Darrel Corradini, the conference's leading hitter."

With this knotty loss, we would confront Virginia the following day, at high noon. The winner would earn a berth in the championship game against Clemson four hours later; the losers would pack their gear. For one of us, this would be the end. Baseball leaves you no corner to hide in: as a player, you are totally exposed. As a team, you either savor victory or suffer defeat.

Both lineups unleashed a scoring barrage. In the fourth we were losing 4-0. Virginia perched on the brink of a potentially lethal inning. Coach summoned Ed "Cougar" Armstrong to the mound, to halt the offensive hemorrhage and keep the game tight, which he skillfully accomplished, relentlessly challenging hitters with smokin' fastballs.

Going into the sixth, still down 4-0, we were piling up outs. To close the gap and take the lead, the Terps had to put runners on base and bring them home. As the inning developed, I tamped down my impatience to drive in runs and work my way around the bases to score.

My next at-bat promised to grant my wish. With the bases loaded, I contemplated the situation and understood very well I was in a position to drive in desperately needed runs. The relief pitcher, Bill "String Puller" Harvey, had no base open for him to work the corners of the plate and tempt me to fish for a pitch outside of my zone.

My baseball DNA informed me that the opportunity I had worked so persistently for was right before me, encapsulating why I loved to play the Great Game and fulfilling both coach Jackson's and my teammates' faith in me as a player and captain. This was the proving ground for one of the most important at-bats of my baseball life.

Taking my time getting into the batter's box, I wrapped the rosin sock around the handle of my bat and shook it, slid it up and down, slapped it with the tar rag, and spit into my batting gloves, all for a better grip. Remembering vividly that Virginia had eliminated our team in the 1974 tournament, it was game time.

The pitcher had as much pressure on him as I was feeling—but did he embrace the pressure as much as I did? I glanced into the dugout and around the field for a quick survey of my teammates and number 16, coach Jackson, standing in the third base coach's box. He fixed his steel-blue eyes on me, clapped his hands, and said, "Put a charge in the ball, Hawk." My fellow Terps clapped and cheered me on. I would dent this baseball. I just had to come through.

I held an advantage as a hitter because String Puller had to throw strikes. If he walked me, it would push our base runner on third across the plate. Reducing my strike zone in my mind to a square, 12-by-12-inch chessboard, I resolved to be selective about the pitches I was going to swing at. If, however, I had two strikes on me, I would have to become a defensive hitter and expand my red zone. I did not want to put myself in that position, because the advantage would shift to the pitcher.

I had faced Bill Harvey before. He could sling a deceptive fastball that would ride in on you swiftly and saw off your bat handle. As an above-average control pitcher, String Puller could make you spin like a top at the plate if you chased pitches and he got ahead of you in the count. Bill was also a smart student of the game, with a reliable memory of a hitter's prior at-bats, even from past seasons.

I dug in at the batter's box and raised my bat. Ump called the first pitch a ball. I picked up Bill's release point, and zeroed in on the whirling red threads of a curveball clearly. With the count one ball and no strikes, I anticipated and hoped for a fastball from the reliever. I would recognize if it was a heater by the rotation of the ball, a split second after it left his fingertips. Determined not to swing for anything but a fastball, I prepared to drive the ball and drive it hard.

String Puller released his pitch—and I was wrong. He had put the brakes on his fastball. With the horsehide orb still 30 feet out, I computed he was sending me a change-up that was 8 to 15 miles per hour slower than his heater. I kept my hands back without any hitching. Most of my weight was distributed on the back half of my body, until the time came to clamp down on the trigger, if the pitch was in my zone.

As a hitter, I was in perfect position because I had not committed my swing in any way. If a candle had been perched on the end of my bat, the flame would have stayed lit.

You can tell if a pitch is going to be in your wheelhouse when it is roughly 15 feet from the plate. That is the instant when your mind commits to swing at the offering or not. This wasn't the golden sphere I had set up in my mind to rip, but since it was off speed, it gave me time to wait a tick longer. A visitor had come calling to my chessboard. I saw the ball sharply and began my swing by throwing the bat barrel right into its horizontal trajectory. My hips rotated, arms extended, and eyes focused right on the meat of the wood where bat impacts ball.

I hit Bill Harvey's pitch dead center on the barrel of my bat, somewhere between nine to 18 inches in front of the plate as it flew in waist high. I drove that horsehide a long way, 385 feet, for a grand slam over the left-center field fence. This "granny" was a colossal swing for me and our team. We punished Virginia with an offensive assault, scoring 12 runs that inning. This is the most runs ever scored by a Maryland team in one inning of postseason play.

MARYLAND	ab	r	h	bi	VIRGINIA	ab	r	h	bi
Chrstphr,ss	6	3	2	4	Emerson,cf-2b	5	3	3	2
Bishop,lf	5	1	1	1	Mawyer,2b	3	1	1	0
Kemp, 1b	6	2	2	1	Thomas,cf	2	1	1	0
Corradini,dh	3	1	1	1	Zdancenicz,ph	1	0	0	0
Housley,rf	5	1	2	3	Norwood,dh-p	4	0	0	0
Hill,cf	1	0	0	0	Berry,ph	1	0	0	0
Cann,cf	4	1	2	1	Zentgraf,3b	3	1	1	2
Kurtz,3b	1	0	0	0	Smith,1b	4	0	1	2
Nfinggr,3b	3	1	1	0	Korber,rf	2	0	1	0
Thomas,2b	1	0	0	0	Duncan,lf	4	0	1	0
Owens,2b	3	1	0	0	Sposato,ss	4	1	0	0
Hudson,c	5	3	3	0	Wilson,c	4	1	0	0
Totals	43	14	14	11	Totals	37	8	9	6

Maryland..........................000 00(12) 002—14
Virginia..............................101 202 200—8

E-Kemp 2. Owens Sposato, Mawyer, Hudson. DP-Maryland 1. 2B-Emerson, Kemp, Corradini, Smith, Cann. 3B-Housley, Hudson. HR-Christopher. SB-Emerson, Christopher. S-Norwood, Bishop. SF-Zentgraf.

	IP	H	R	ER	BB	SO
Brashears	4	5	4	4	2	3
Armstrong (W,2-0)	3	4	4	2	4	3
Jackman	2	0	0	0	1	5
H.Thomas (L,4-5)	5⅓	3	5	4	2	3
Haden	0	3	3	3	0	0
Harvey	0	5	4	3	1	0
Norwood	3⅓	5	2	0	2	3

WP-Brashears 2, Norwood, Armstrong. HBP-Emerson (by Brashears), Wilson (by Brashears), Corradini (by Norwood). Balk-Armstrong. U-Newsome, Grimsky, Herring. Daye. T-2:42. A-400.

Now the pressure clamped down on Cougar, in a serious way, to keep us on top through the next frame. He did a superior job with his pitch selections and locations, earning one of the most important victories of our season and Ed's Terrapin career on the bump.

In the two final, scoreless innings, Mark "Coyote" Jackman came to the mound to slam the door shut on the Cavaliers. He was a big-game pitcher—six-feet, four-inches and weighing 195 pounds—who loved to challenge hitters. His golden left arm sent them back to their dugout as if they were falling dominoes.

Coyote dominated the opposition and bolted the door tight, incredibly striking out five of the six batsmen he faced. We won the game 14-8 and advanced to the championship game against Clemson later in the day. This team of turtles was riding very high, anticipating winning the title.

My grand slam remains the only "granny" a Maryland player has ever hit in the history of Maryland postseason baseball. Since the ACC Tournament began in 1973, only 22 other players have swatted this "granddaddy" of all hits. I am proud to be in the record books with them all, and this bases-loaded, four-bagger boosted my confidence that the Hawk would one day hit the soaring fly of his dreams for the ring.

Six thousand two hundred and fifty rabid Tiger fans were packed into their stadium for the ACC Tournament game against Maryland. We came out of the chute at the beginning of the season with an agonizing 0-6 start, but we fought and clawed our way back to battle for the coveted championship. The crown brought with it an automatic bid to play in the NCAA Tournament.

Coach Jackson decided our team's best option was to send George "Blue Claw" Thomas to the mound; at six feet, two inches and 210 pounds, he reigned on that throne. Getting to the finals can stretch a pitching

Mark "Coyote" Jackman was destined to be a dominant left-handed pitcher. He pitched his senior year in college for Birmingham-Southern College in Alabama, tying the single-season record for strikeouts, with 128 K's, while tossing two no-hitters. Coyote was drafted in the 18th round (#451) of the 1979 MLB draft by the Chicago White Sox. Well into his third pro season in 1981, Mark was sporting a career 3.88 ERA when he felt a pain in his chest, jogging in the outfield before the game. Being a gutsy competitor who bled baseball, Mark pushed the pain to the side. He was hospitalized directly after the contest, having pitched with a collapsed lung. Sadly, the Kansas City Royals released Coyote after his successful operation. On the comeback trail in the spring of 1982, Mark harrowingly found himself fighting for his life, as a stroke paralyzed him from head to toe. Being a fighter, he responded to an extreme rehabilitation regimen and recovered, but he was unable to ever return to the pitcher's mound. With all Coyotes in your starting pitching rotation, your team would be sporting championship rings at the end of the season. It was a thrill for me to play short-stop behind such an exceptional athlete and kind person.

George possessed innate baseball DNA and wisdom in his pitching arm and mind. His father, George Sr., saw seven years of pro ball action on the hill, from 1947-1955, in the Brooklyn Dodgers system, cresting in 1950 as a triple-A pitcher for the Montreal Royals. Senior posted a very respectful 3.84 ERA that season. Two players on that 1950 team were future LA Dodgers Manager, Hall of Famer Tommy Lasorda and Chuck Conners, who became a successful Hollywood actor, playing "The Rifleman," a very popular TV show.

Senior taught George the very complex science and art of pitching. When Blue Claw arrived at Maryland, he had unfortunately suffered an arm injury in his senior year, when he pitched and won the final two games of the league championship series.

George gutted it out for four seasons and threw many outstanding contests. I was not surprised that pitchers sought out the gifted right-hander to learn more about the mechanics necessary to command certain pitches, especially the slider. Blue Claw was all-team as a teammate, and with every pitch I ever saw the big right-hander throw, George gave his offerings 110 percent-plus.

staff and players at certain positions if they are underperforming. There are no nice guys when it comes down to the second tier of the season, the playoffs.

Baseball fans love pitching duels, and they were in for a memorable matchup. Coming into this game, our potent offense had scored 34 runs in four contests. After seven innings the score was tied 2-2. Blue Claw pitched a game coaches would use in locker-room pep talks to inspire their teams. It was heroic. George showed every player and fan in the stadium what a champion was made of. He fanned seven Tigers. Each team only managed seven hits. Inning after inning, we hovered on the brink of victory. And so it remained until the bottom of the ninth. With runners on first and second base, the Clemson batter executed a perfect bunt that hugged the edge of the infield grass. Four-year letterman and talent-rich third baseman, Dave "Babe" Kurtz, made an outstanding play on the bunt. Babe attacked the ball and stayed low to make a sidearm whip throw to beat the runner by a step. Both men on base advanced. With two outs, the runner on third base was driven in by a line drive to left field, giving Clemson a hard-fought 3-2 victory.

This loss was extremely painful for each and every one of us. Our squad simply could not mount

enough of an offense to win. We showed up to give the standing-room-only crowd a title game to remember. A steadfast Clemson fan came into our dugout afterward and congratulated us for playing like champions. Claiming to be a baseball enthusiast for decades, he said he never had seen a better-played college game. Clemson easily won the NCAA Eastern Regional series, averaging 9.6 runs a game. At the eight-team NCAA finals held each year in Omaha, Nebraska, the Tigers made it to the quarter-final game, where they lost to the soon-to-be crowned National Champions, Arizona Wildcats, by a score of 10-6. Clemson averaged 5.7 runs a game. Against Maryland in the ACC tournament, the Tigers averaged 2.5 runs per game, a small consolation.

Our team had the following Maryland postseason tournament highlights:

- tied most games in a tournament—5;
- second-most runs scored in a tournament—36;
- third-highest runs per game total—7.2;

Dave "Babe Ruth" Kurtz, from Pennsylvania, was a stellar athlete who had both baseball and basketball scholarship offers his senior year in high school. Players like Babe are great to have on your team because, not only did he bring his advanced skill set to the field each and every day, his confidence bubbled out of his baseball cap, and those are the type of players you want to stack your team with.

After Maryland, Dave served as sports editor for daily newspapers in Southeastern PA, including *The Mercury* (Pottstown) and *The Times Herald* (Norristown), earning national and state writing awards. He later developed an online digital high-school sports website, pac-10sports.com, serving as editor/publisher/owner. Babe became an amateur baseball legend in his region, finally retiring at the age of 49 after a career that produced 18 championships, two batting titles, five playoff MVP awards, and 13 All-Star appearances, including one All-Star performance in which he out homered, 2-0, future baseball Hall of Famer, New York Mets star catcher, Mike Piazza. Dave kept swinging a heavy bat, and at the age of 31, Babe swatted 39 taters in 65 games. Dave's amazing accomplishments throughout his career were validated when he was inducted into the Perky League HOF in 2004, and the Tri County Chapter of PA Sports HOF in 2008. As a player, student of the game, writer, and fan, Dave has earned the distinction as a premier ambassador to the Great Game.

- third-most runs scored in a game—14;
- most runs scored in an inning—12; and
- we were the last Maryland team to make it to the championship finals (in 1976), until 2014. The Terps have competed in two NCAA regional finals (2021, 2022) and two sweet-sixteen super regional tournaments (2014, 2015). Their 2022 NCAA, #18 team finished with a close-to, best-in-the nation 48-14 record (.774).

A championship loss like this one knocks you back off the bench into the cinder blocks, staring into nowhere. I suffered, thinking I could have done more, especially when the defeat rested upon a single run, and I did not cross the plate one time.

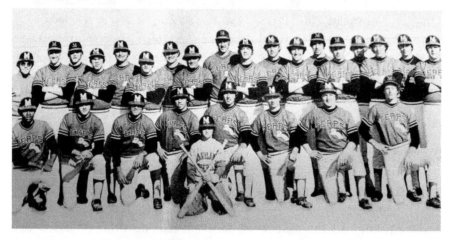

Our Outstanding 1976 Varsity ACC Runner-up Championship Team
In front of the team, batboy Jackie Jackson;
Front row, L to R: Billy Gardner, Sam Housley, Bob Niffenneger,
Dickie Cann, Jim Raska, Brian McGuire, John Norris, Scott Christopher
Back row: Team Mgr. Eric James, Mike Brashears, Billy Owens,
Frank Thomas, George Thomas, Mike Morris, Cliff Hill,
Dave Kurtz, Bob Ferris, Chris Hudson, Darrel Corradini,
Gary Bishop, Mark Jackman, Ron McNally, Frank Kemp, Brad Beyer,
Gary Spies, Asst. Coach Paul Thompson
Not pictured: Coach Elton "Jack" Jackson, Ed "Cougar" Armstrong

Moreover, seven players from this team—Frank Thomas, Bob Ferris, Chris Hudson, Gary Bishop, Mark Jackman, Gary Spies, and me—would sign professional contracts with major league clubs. Dini, Ferris Wheel, Toto, and I were all voted to the All Atlantic Coast Conference team. We enjoyed a successful run and wrapped ourselves around the winning concept: "All for one and one for all." I believe our club would be considered one of the five best teams in Maryland baseball history.

Four years had passed since coach Jackson pointed me toward the highway, heading south to find another college team. From my current vantage point, I could see we were both right—I did not have enough firepower to be a Terrapin ballplayer as a freshman, and my extra hard work to become a dominant player had ultimately made me worthy of joining his first-rate program. The positive influence coach Jackson had on my life—and hundreds of other players' lives—was remarkable. I felt extremely fortunate to be one of his shortstops over the 39 years he coached Maryland's legendary program.

A bonus that comes with playing for a blue-chip team is the attention of MLB scouts. They had attended our games all season long, sizing up players for the June draft. The Texas Rangers were giving me serious consideration, but I still hoped the Orioles would grant the significant and major evaluation I had earned—and draft me.

I was leading the Atlantic Coast Conference in stolen bases—being thrown out once—for a .941 success rate. In the country, this ranked in the top five for stolen-base percentage. I worked every inning of every game at shortstop, committing only five errors. Toto and I turned double plays that required skill, accuracy, and precision timing. I won the Boze Berger Award as the top senior player and was voted the Most Valuable Player for the second year in a row. I set the Maryland record for the highest two-year, stolen-base percentage at .963. And during my last two seasons as the leadoff hitter, I averaged over one run scored per game, which would be in the all-time, top ten. In batting, I hit above .300.

My 1976 U-MD MVP trophy.

I left that championship field optimistic about my prospects. I studied for my exams with Sharon, my most ardent baseball fan. After the semester ended, my final grade-point average qualified me for the All-ACC Academic team. In the five weeks before the MLB draft, I practiced, fell more and more in love, and prepared myself for the phone call from a major league team. I had dreamed of this one phone call since Little League—even with my handicapped hand, my withered arm, and being the smallest player on almost all of my teams. With the

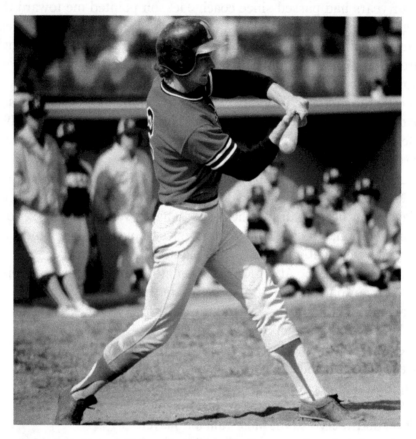

Taking a rip as a Terrapin, in my final game played at James Madison University. I had a good day at the plate, collecting two hits. I left the Dukes field excited, believing I would be selected by a team in the upcoming MLB draft. This photo highlights that my very handicapped top thumb was not able to contribute to my swing in any way, adding a considerable challenge for me to drive a pitch, from age six forward.

help of my mother and father, teammates, coaches, Mike Malone, and his parents, I had invested a large chunk of my soul, dreamed big, and beaten the odds from age eight to my last game played at Maryland. I could not conceive of being overlooked.

June–and the long-awaited, major league draft delivered a harsh reality check. The phone, like a study of a solitary Henry Moore abstract human figure sculpture lying down, asleep—NEVER rang! I felt indignant and deserted by baseball. My thoughts were crisscrossed, but my vision remained crystal clear, knowing with such clarity it was possible to blaze a path to make those dreams become reality. Every day was brand new, and reliving past disappointments wasn't for me. My scrapbooks and trophies would help bring me back to center. I fell asleep at night, dreaming of my great home run for the championship ring. Sharon and I talked at length about how unexpected setbacks lead to exciting, new doorways opening and opportunities to expand personal evolution. I have never questioned the universe, and I never will. Somehow, my passion and love for baseball would not fail me. I had to release my expectations and rebuild my reality. I believe everything happens for a reason, saying to myself, *I will prevail*!

Out but not gone: American Bicentennial team

There are no rules for how drafting decisions are made. Baseball is a magnificent sport and also a monumental business, similar to many others where substantial financial dealings are involved. Almost all investments carry a degree of risk with them; the grander the benefit from your investment, the higher the gamble. Seven hundred thirteen players were drafted in the 1976 MLB June draft, taking their validated positions in the game. I matched or bettered many of them, but the scouts and the brass determined I did not have the necessary professional skills, talent, or personal chemistry to warrant my shot at pro ball. They left me standing outside the foul lines with a very credible scrapbook and résumé–wasn't there room for me to have been just one of 713 draftees? Or #714? I knew strongly that I should have been chosen along with the other elite players.

My king tilted centimeters from the board; my dream was close to being checkmated. But I would not allow my vision of becoming a professional to be extinguished. Thousands of ballplayers around the

country know what I'm talking about. So I buckled down and returned to square one. I was 22 and ready for the fight. Bring it on!

Being underestimated in baseball was a hurdle I had surmounted many times, prevailing on every level. When my throwing hand dangled from my wrist as a boy, I became determined for a comeback. As a junior in high school, when my batting average was zero, I set my sights on being a star player in my senior year. When coach Jackson turned me away from Maryland *twice*, I knew I could excel at that level of competition—and I ended up the team's MVP, *twice*.

So, what would I do now? No question: I would continue to "Dream Big, Dream *On*."

I wasn't alone in thinking I deserved a chance in the majors. I lined up baseball contacts to write scouts, requesting that they give me a shot for an evaluation in rookie ball. None of those efforts proved fruitful, and I belatedly realized it wasn't the best tactic, because it put coaches in a no-win situation: if I didn't perform, they had extended themselves, wasted their time, and lost credibility; if I did prove myself, how would the scouts explain missing my talent boat in the draft?

I held fast to the belief my shot at pro ball lay just ahead. My one and only option remained working hard and achieving such a stunning summer I'd force the decision makers to take a chance on me next season. I had eight months before spring training started in 1977. I could do it. I had to do it.

An unexpected boost came two weeks after the MLB draft. Word spread in the local baseball community I had been overlooked, and some people were stunned, including Gus "El Greco" Pappas, President of the American Masonry Baseball Club, one of the top-three amateur teams in the Washington, DC, area.

El Greco was a successful businessman with Greek lineage who constructed large brick buildings. Gus also built winning clubs. He asked me if I would consider joining the American Bicentennial Baseball team he planned to sponsor to tour Korea, opposing the Korean National All-Stars. Our trip, stretching from July 23 to August 9 across the largest cities in Korea, was supported in part by the US State Department. I accepted on the spot, knowing this would be a baseball adventure of a lifetime, an opportunity that would tilt my king back upright, increasing my chances to try out and make the roster of a pro ball team somewhere in spring training.

American Bicentennial teammates (L to R): me, Darrel "Dini" Corradini, Gerry "Another Homer" Laniak, Bob "Snake" Madden, and Joe "Lights Out" Laniak. In front is famed Polish photographic artist Krystyna Lyczywek (1920-2021). She and her son Lech were welcome guests to our home in the summer of 1976.

Walking in front of the White House, I am giving Lech Lyczywek a photo tour of our nation's capital, Washington, DC.

Since high school, I pumped steel, using weight-lifting stations I had built at home and also the weight rooms in gyms. My challenged right arm and hand needed strength to hit and throw. One of my mantras to becoming a champion was, "No pain, no gain" (September 1976).

In the window of time between Gus's call and our departure, a sense of urgency to get away and immerse myself in art overcame me. Creating has always succeeded in untangling my confusions. I become so absorbed into the depth of my unfiltered process that I literally transcend into my unconscious when I make something that will contribute to, advance, and stimulate humanity. I feel artistic creations are noble carriers to promote my belief that intelligence, imagination, and curiosity run parallel to each other. All the elements, when I ask myself why, seem to make sense, and the world stops spinning and the mosaic puzzle pieces mysteriously find their way to fit tightly and cohesively together again.

I asked Sharon if she would like to join me, and without hesitation she said, "For sure! I would never miss this adventure with you, Hawk." At this time in our union, we were very in love.

I mapped out a 4,900-mile, multi-week, cross-country photographic safari for us, gutted the back of Renauldo, and installed a cooler and shelves for our provisions and camping gear. We rolled like tumbleweeds in the wind. Wherever Sharon and I ended up, from one day to the next, that was our itinerary. When we grew tired, we set up our small, orange L.L.Bean tent in farm fields, deserts, and campgrounds, making wishes on shooting stars. Our love spread like the grandeur of the forever horizon and night sky above us.

We enjoy a special moment shortly after returning from our cross-country photographic expedition and adventure-packed road trip.

We shared one fine slice of America and met many sensational people along the way. While driving through Kansas on I-70, I started writing my novel, *The Tales of the Roving Mobileans*, a futuristic, fully illustrated, sci-fi tale. My main character, King Fishba, and his two dozen galactic ambassadors of goodwill, addressed many universal issues, like our wronged environment, Destination Y, hunger, academic pursuits, and space research, among 19 other relevant topics.

Sharon and I traveled leisurely, talking away and learning more about each other. We both created interesting portfolios of photographic images. When we spotted the silver glow of baseball field lights shining in the distance at night, across the small towns of America, we would stop to take in the games. Love, baseball, art, and America—life is the grandest of adventures, and we were exploring the depths of the known and unknown each and every day. The summer winds filled our souls with splendor. A MAGNIFICENT Wow! This odyssey impressed and branded me with a clearer sense of our beautiful country—which I was about to represent, playing on El Greco's team of all-stars in Korea.

Halfway around the world, our plane landed in Seoul after a long flight. Head coach Venizelos "Jello" Lagos and his quick-witted assistant, Duck Lee, led a strong lineup, and we were red-hot. Being in a foreign land to play baseball excited us all. In an article highlighting our trip, the *Washington Post* quoted Jello saying, "Just think, we're one tiny dot on the map of the United States, yet we are representing the entire country. It's a great honor." In that same piece, Duck said, "In Korea, baseball games have twenty-five to thirty thousands fans at them, and tickets are scalped after a sellout."

With absolutely no idea what to expect on or off the field, only one thing was certain: baseball has its own universal language, and once we entered the impressive Korean stadiums, we would be back playing on the diamonds we called home.

My father had arranged for me to spend time with Korea's most celebrated photographic artist in history, Choi Min-shik from Busan. Choi and I met on multiple occasions, along with his interpreter, to have dinner and make photographic art. We visited a number of stunning locations. He also came to our games in Busan and created a catalog of black-and-white images with his heavily contrasted winners throughout. Choi added a wonderful and artistically important layer to my Korean adventures.

The pomp of the Korean culture enfolded us. Bleachers filled up with rambunctious fans, and we rode in parades atop the seats of US Army jeeps—like the ones you see in old WW-II movies—with American and Korean flags fluttering from the antennas. The Koreans demonstrated a strong fascination

Choi Min-shik

WELCOMING ADDRESS BY: JA CHOON KOO, MAYOR OF SEOUL, JULY 24, 1976

Today, I think it very significant to open the Korea–US Goodwill baseball games under the sponsorship of the Korea Baseball Association in commemoration of the Bicentennial Anniversary of the Independence of the United States of America, enhancing friendship and goodwill between our two countries. From the bottom of my heart, I welcome the visit to Seoul by you, members of the American team.

Baseball games played over green fields are often called an athletic event, which cheers us. Also they teach us a lesson that in baseball the swift action, resourcefulness, and courage—as well as the spirit of pioneers to overcome difficulties with endurance—bring us to the final victory. In such a way, baseball games may well be termed to have even more significance in relation to the spirit of independence of the US.

As you know well, two centuries ago those pioneers of 13 states of the US adopted the Declaration of Independence, which in part said, "All men are endowed with certain inalienable rights, that among these are liberty and the pursuit of happiness . . . And that governments are instituted among Men to secure these rights. . . ." This led to the birth of the United States of America today. Even in a relatively short history of the nation, the US has created the glorious history of the world's greatest power today.

Such a brilliant history is the product of the American citizens' deeply rooted confidence in liberty and peace, as well as their endeavors made with the progressive spirit of pioneers in a solid unity. Such a spirit, I believe, will be a valuable yardstick for us, who now strenuously endeavor to achieve economic prosperity and national unification through a sustained economic growth.

Our two countries have maintained close ties through our long history of traditional friendship, and are both allies in the cause of crushing any aggression by Communists. I sincerely wish that today's games will enhance our friendly ties even more and will close successfully as a significant event commemorating the Bicentennial Anniversary of the Independence of the US.

Wishing for the good fighting of champions of our two countries and for making the game to demonstrate a good dialogue between our two countries, I wish again to welcome your visit to Seoul.

Following the welcoming address, I was the leadoff batter. We played in the fan-packed Jamsil Baseball Stadium in Seoul. I happily brought the baseball admirers, who were clapping passionately, to their feet after I launched a towering home run my first time up.

and curiosity about our American team, and they appeared to want us to win, which was odd, since we faced their country's elite all-star players.

Koreans packed the sold-out parks and waved American flags—expressing their gratitude and thanking America for fighting in the Korean War. The fans honored the 33,652 American soldiers who had

After stealing second, I cheered on our feared power hitter, Big Darrel "Dini" Corradini, to rip a hit and bring me around the horn to score. I was excited in Korea, because I was playing excellent baseball. I knew somehow, somewhere, I would be excelling on a professional baseball team next year. I dreamed the Baltimore Orioles would sign me in the January 1977, winter draft. If I was bypassed again by every MLB team, as was the case seven weeks before our Korean tour began, I would force my shot to play pro ball. I was physically and mentally prepared to fight for my dream.

Bob "Snake" Madden was handed the ball to be the starting pitcher for our opening game. He held the Korean hitters at bay, resulting in a 2-2 tie. The big left-hander has an illustrious Maryland Baseball all-time pitching résumé: #4 ERA at 2.46; #4 complete games, 14; and #5 strikeouts per nine innings at 10.40. Snake was presented with Maryland's 1974 Boze Berger Award. Bob was a shoo-in to be chosen in the 1974 MLB draft, had his pitching elbow stayed healthy. Snake snapped the two photographs of me playing ball in Korea (pp. 202-203), along with many other moving images inside and outside the baseball stadiums across the magnificent Republic of Korea.

The Outstanding Korean National All-Star Baseball Team (July 1976).

lost their lives, from 1950-1953, when they battled side by side with their fellow South Korean soldiers.

The soupy, humid air seemed to make the days move slowly and increased the difficulty of driving a ball out of the yard. Our bus rides between cities were long, but also beautiful and content-rich. Heavily armed soldiers walked about, families worked in the fields, picturesque landscapes streamed by, and sadly, poverty abounded.

We appeared at multiple formal diplomatic affairs. During a Korean State luncheon, where we wore our requisite US Team blazers, my meal tasted quite odd. I asked the waiter what I was eating. He replied, "Dog." I glanced sideways at Dini, sitting next to me, then gagged, coughed, and gulped down my entire glass of water.

Our team suffered from various forms of food intolerance during the tour. Players hugged toilets and trash cans all over Korea. Dini and I were spared, but our teammates dropped quickly. In one game we barely had enough men to outfit a team. Our right fielder was ill, but we needed to suit him up to have a full contingent on the diamond, or our match would be forfeited. He had a blank stare the entire nine innings, and was a ghost at the plate, vomiting almost every inning.

Dini and I hit up a storm. In game one, I smacked a homer my first time up. Fans stood, clapped, and bowed as I scored. When Dini stepped into the batter's box for his third at-bat, the Korean catcher, Mr. Park, said, "No one hits the ball as long as you. I'll call a fastball next pitch. Make the people happy." In one minute from that discourse, Dini was crossing home plate, after sending the fastball 400-plus feet over the center field wall for a long jack. He caught the catcher's eye, who was in awe of the crushed home run, and said, "Thank you, Mr. Park."

My running mate in Korea was Dini. One of the local papers interviewed Darrel to write an article about his father, who fought in the Korean War.

The Koreans displayed impressive skills and talents. They were taught well and executed fundamentals on a high level. I felt from their movements

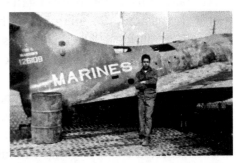

Darrel's father, Army Private Richard Corradini, fought in the Korean War. Stationed at the Suwan airfield base in South Korea, Pvt. Corradini was on duty when baseball's great Boston Red Sox outfielder and future Hall of Famer Ted Williams crash-landed. Williams, a marine combat aviator, made an emergency landing in his F-9 fighter plane, riddled with enemy bullets. Dini told me his father watched in horror as Ted's plane, engulfed in flames, skidded down the runway, out of control, for more than a mile, shredding strips of metal and on the brink of exploding. Then he saw Ted jump out of the cockpit, take off his helmet, and smash it into the tarmac. He flew 39 missions, and his plane was hit three times in combat.

Ted Williams, the "Splendid Splinter," and 19-time MLB All-Star, has been considered by many players and fans as the greatest hitter in the history of baseball. He is the last player to hit over .400 in the big leagues, with a .406 season average in 1942. The Splendid Splinter has the highest all-time on-base percentage at .482.

Top: Darrel's father photographed army buddy Paul Flores with the charred plane on the airfield, after the flames had been extinguished. The Splendid Splinter stated later he was afraid to eject from his aircraft because he thought it would shatter his kneecaps. Also he said, "I would rather have died than never to have been able to play baseball again."

Bottom: Ted Williams signed the back of this photo for Dini in 1969.

on the field that certain aspects of the game were not instinctual, occasionally showing a slight hesitation moving a play forward. That would not be the case today, as they have mastered baseball to become a global strength. To date, 26 South Koreans have seen action in the major leagues.

We played 10 action-packed games over our three-week tour. I hit a crowd-pleasing .384, highlighted by a two-homer game in Busan. Gus sent my father a letter after this junket, writing that the Korean managers had chosen me as the one player who they thought would play big league baseball.

When I left Korea, my king stood upright, and I was psyched to resume my climb toward pro ball. Back at home, I finished out the season with American Masonry. We had the best amateur squad in the Washington area, as reflected by our 16-game winning streak and a Maryland Industrial League Championship. El Greco appreciated my commitment to play tough. We won and won and won, which made Gus proud of his club.

If you proved to be the star of a game, El Greco would shake your hand and give you a set of keys to one of his Mercedes. A stellar performance earned two days of cruising around town, feeling like a celebrity. I could not have had more fun that summer. Sharon and I were totally in love. I played baseball for Gus, Jello, Duck, and one exceptional collection of ballplayers like Dini, Gerry Laniak, his brother, pitcher Joe Laniak, Sam Housley, Bob Madden, and former pros Tommy "Pick It" Smith and AAA pitcher in the Detroit Tigers organization, Ray "Gold" Blosse. Gold pitched the winning game against Cuba in the US-Pan American Games in 1967, winning it 2-1 for the gold medal. He was quoted in an article saying, "After we beat Cuba for the title, they were so distraught that several of the players defected."

Sharon and I enrolled for the fall semester at U-MD, as we needed to complete additional classes to graduate in December. Our romance blossomed. We lived together in a small apartment not far from campus. El Greco gave me a job during the summer and autumn, hauling bricks using a large, V-shaped metal brick holder with a long, wooden handle. On weekends, I became his demolition specialist, taking out walls of vacant apartments with a heavy sledgehammer. He gave me the used appliances, and lots of them, to sell. Once the condemned complexes were flattened by heavy equipment and removed, Gus would build grand, new buildings out of his own red bricks.

I started to demolish a door jamb in an abandoned complex, and a homeless man emerged from the closet and lurched at me before he ran off. The next day, Jello was packing a snub-nosed Colt .38 and said he'd bring me one. I have to shoot a pistol left-handed, as my right hand is too weak to hold a weapon. I declined his big-iron gun offer and told Jello that if I whistled, he should come running with the safety off and his .38 held high.

Gus paid me like a Greek shipping magnate. I could work for him whenever I wanted to. I carried a mountain of bricks, did handyman jobs on site, and helped his team win a Greek cargo-tanker full of games—a win-win for us both. Gus Pappas was highly respected as a builder and baseball man, my friend, and a brick building of a human.

The chemistry and unity between Sharon and I continued evolving and amazed us on every level. One late July afternoon, while we lay under a giant oak tree in the green Virginia grass, sharing our thoughts, I asked her to marry me. Sharon's *yes* surrounded us both with love and was a life-changing moment. We set our wedding date for October 23, 1976, and began planning our future together, right there on the hill.

After graduating in December, we would move into the lower level of my parents' house for two months and work as substitute teachers. I planned to cut, split, and sell firewood. When spring training started in Florida and Arizona, I expected to travel from camp to camp until somebody gave me a shot. Sharon would continue to teach and live with my parents until I had a club to suit up for. Then she would join me, somewhere out there, when I was assigned to a farm team.

With my speed, I rated among the elite 1 percent of all professional players, so I aimed to have scouts time me in the 60-yard dash. Once they checked their stopwatches, it would force them to take a meaningful look at my other skills. My amateur stolen-base record also ranked in the top 1 percent, and my batting average consistently crested the leading 10 percent. Speed + hitting + runs (would) = my pro shot.

I started my semester as an assistant baseball coach for fall ball, drilling rookies and former teammates. Since my playing days at Maryland concluded with the last out of my senior spring season, being a coach allowed me to continue working hard on my hitting and fielding skills after practice ended. Lots of players liked to keep their baseball day going with me. William H. "WHO" Owens and I would have fun fielding "tune-aments" almost every day. First one to make

an error lost, and then we would start our next round. WHO worked himself into becoming a star. In his senior year, Billy made the All-ACC team as a third baseman and won the Boze Berger Award. My formal duties mostly involved coaching the perimeter players trying out for the spring squad. Ninety vied for a spot on the 25-man varsity team. One star freshman, from Clinton, Maryland, Gordon "Hawk" Hawkins, generated a great deal of excitement. The second club squared off against community colleges and junior-varsity teams of local universities. We dazzled the competition and ended the almost-perfect season 15 wins and one loss.

The one game we dropped, in Annapolis against the Naval Academy freshman team, angered coach Jackson, and he let me know it. I sent a runner to steal second base late in the game, to put him in scoring position. He was thrown out. If I had it to do over, I would not give him the steal sign. We needed the run in the top of the ninth to tie the game, and I eliminated our only chance. Pressure forces opposing players and coaches to make mistakes, and cracks in the armor lead to victories.

Gordon "Hawk" Hawkins, an ace power pitcher, was beyond his years with velocity, pitch location, and competitive intensity. The dominator had been drafted by the Texas Rangers after a sizzling HS senior season ERA of 1.20. Sadly, he tore his rotator cuff early in college, which greatly impacted his can't-miss, promising career.

In a well-earned twist, Gordon—whose major was music—has since sung his way to become one of the greatest opera baritones in the world today. In his remarkable artistic journey on stages across the globe, he has received much praise throughout his career. Highlights include winning the Luciano Pavarotti competition and being honored as the Washington Opera "Artist of the Year" in 2006. The Hawk has performed with icons Luciano Pavarotti, Mirella Freni, and Placido Domingo. The gifted lefty kindly sang at coach Jackson's daughter's wedding.

Coach Jackson and I, strategizing shortly before our game was to begin.

With my gamble, the Navy catcher did not crack. Coach Jackson was right to zero in on me. I was wrong.

I played one more college game at shortstop. Oddly, it occurred *against* my Terp teammates, and it qualifies as one of the most important games of my life.

With three days left in fall ball, a practice game against Montgomery Junior College was scheduled. The season had gone well for our players and coaches. This team had played for the ACC championship in the spring, and several proven veterans returned. Also, the Yankees number-one pick in the winter draft, Mark "Leather" Harris, very competently filled the vacancy left by me at shortstop.

About 40 minutes before the game began on an overcast, gray, October day, coach Jackson and Montgomery's coach spoke behind home plate. I was hitting fungo grounders to the infielders when the visiting team's coach came over and asked me an unusual question. I had never heard of it being asked before, and I have never heard of it being asked since: "My shortstop has not posted for the game, Scott—do you want to play short?"

The request crossed me up—I hadn't played in a live game in six weeks—but I answered, "Sure." I loved baseball; who I played with or against registered a distant second. I grabbed my glove off the bench and joined my new squad in the visitor's dugout. Ten minutes later, I took infield. As happy as I was, confusion tinged my mood; covering shortstop against former teammates I had coached in the fall was strange. That vanished once I stepped into the batter's box. The game was on. My new team and their adopted shortstop, me, wanted to win!

Baseball is called a *game* for a reason: it is played, in part, to have fun, and this was a fun-packed afternoon. I had one heck of an outing. All of life held promise: playing ball, marrying Sharon in one week, and graduating in eight weeks. The skills

Mark's father, Gail Harris Jr., played from 1955-1960 in the big leagues, as a first baseman for the New York Giants and Detroit Tigers. Gail hit the last homer ever for the New York Giants in their stadium, the Polo Grounds, on September 21, 1957. This was the team's 75th and final season in NYC, then becoming the San Francisco Giants in 1958. A gifted lefty, Gail had 1,331 at-bats, 38 doubles, 15 triples, 51 home runs, drove in 189 runs, and hit .240 in his impressive MLB career.

I had mastered over my life were poured into this contest, and I held an added advantage: I had extensive mental recall as to the strengths and weaknesses of every player.

On the flipside, I did not know one of my teammates, the coach's signs, or even who the coach was. Despite being the most peculiar game ever, I was back playing the six spot—and feeling the joy of baseball. I made a strong statement of my abilities when I hit, ran, fielded, and threw that afternoon.

One play at short unfolded as a major league pick-and-out, from start to finish. Frat was the hitter. He defined his strike zone and consistently pulled the ball hard to the left side of the infield. Frat had many talents, but being fleet-footed was not one of them. I positioned myself two steps deeper than usual, and one step closer to the third base foul line. Sure enough, Frat stung a liner that was destined to be a single into left field. I calculated the exact angle necessary to cut it off at the pass, with a completely stretched-out backhanded stab. The ball had just touched the grass, and I showed a glove skill you do not have the opportunity to use often. When you field a one-hop liner that is on the rise, you have to start your glove close to the ground and bring it up at the same speed and hop angle as the ball. When you do it correctly, it is very fancy glove work, specifically a backhanded stab. I fielded the ball cleanly. With Frat running, I had time to set my spikes firmly in the grass.

Since this was my college field, every inch of the terrain at and around shortstop was familiar. If I threw a rocket all the way across the infield from the outfield grass, I would peg Frat for an out. I set my shoulders at the right angle for the dart, planted my cleats, and gave it everything I had. My strike beat Frat by half a step. Blue raised his right arm up, signaling him out.

Toto yelled from the Maryland dugout, "You're a traitor, Hawk!" I spit in the pocket of my glove and pounded it with my fist, then pointed my leather at Toto and retorted, "That pick was for you, Toto!"

When the game ended, I trotted back to the Maryland dugout. My teammates ribbed me good, but in the end they had enjoyed seeing me play again. Frat came up and said, "You robbed me, Hawk, big league stab and a beauty." Some of my fellow ballplayers saw it as I did: the MLB had shortchanged me in the June draft.

I shared fun moments coaching fall ball with super friends and teammates. We won, lost, had fun, battled, and advanced forward to become men together.

On my way back to the locker room, I noticed coach Jackson talking to a gentleman by the visiting team's on-deck circle. Coach called, "Hawk, come on over." I walked up in my dirty uniform, still holding my glove. "Hawk, I would like you to meet Dick Bowie, a scout for the Orioles." And coach Jackson left us alone. I knew this esteemed baseball man by name and appearance only. We had never met.

My blood pressure shot up. I stood face-to-face with the region's top scout for the Baltimore O's. The moment had finally arrived.

Mr. Bowie looked me square in the eye the whole time we talked. He complimented my game and said, "You know, Scott, I made a mistake on you. I drafted the wrong player last June."

I never thought about hearing these words, and in that instant, I experienced a mix of feelings, and they were not pleasant. I did not blink much and returned Mr. Bowie's level gaze. It hurt sharply, knowing I was that close for my shot at pro ball. But I would not let that realization beat me up. I had left every ounce of baseball in me and more, on all the ball fields I had ever played on. When you're certain that you have given it your best, in anything that you do in life, the future is just what it is from day to day, because tomorrow will come and with some fine tuning, you create another path and walk it to live your dreams. Yes, his words confirmed my talent, yet his "mistake" cost me an entire season playing professional baseball. They made an error in judgment with their pick, who failed to produce. The Orioles spat him out before the ink had dried on his contract.

Even though Mr. Bowie witnessed me delivering a stellar game, I did not put much weight on his being in the stands. Our brief interlude brought home a fresh insight: my life in baseball had been a drumbeat from an early age, and I proved every coach that did not have faith in me wrong. Whether I was a vagabond or wearing an Orioles uniform, I knew I could bat, field, and especially run at the highest levels. I was not dependent upon the system to create my opportunity. I would make the break I needed myself, as I always had done since Little League.

Having played with and against many drafted players, I had an abundance of confidence regarding my abilities to be a leader. Multiple

MVPs, championships, scholarships, national stolen-base accolades, a total of eleven errors playing every inning of every game for two seasons, captain of my college team, all-ACC shortstop, press coverage, and many other awards validated my talents and self-confidence that I could hold my own and excel at the pro level.

Still, I walked back to the locker room saddened. Damn, I had been so close to being drafted by my dream team, but the Orioles put their belief in another player, one who didn't measure up to the tough challenges of pro ball. I had spent time processing different scenarios as to why I had been clearly bypassed in the draft. *Zingo*: four conclusions became evident:

(1) I was an artist in an athlete's body, a person who was very comfortable walking and creating on the fringe of Bohemianism. To many people in and out of the baseball world, I seemed "counterculture" and quirky, which left a question mark in their minds. My artistic pursuits were exposed, displayed publicly in exhibitions, publications, and performance art.

(2) I possibly had reached my potential.

(3) My extremely handicapped hand was unable to handle the skills and talent levels you needed to play pro ball, and my throwing arm was compromised because of the way I had to grip a baseball.

(4) My wiry body was not strong enough to excel against the exceptional pitchers and players I would be facing over a five-month pro season—pitchers pounding me with 90-mph-plus fastballs night after night.

These four insights, or a combination thereof, were likely quite real in the scouts' minds, *but they meant absolutely nothing to me.* Somehow, someway, I would prove the entire pro baseball establishment wrong. I loved playing, and that love fueled my passion as a driving force to perceive and achieve my dreams. I just needed one game in a pro uniform.

Coach Jackson congratulated me in the locker room on a super game, one Dick Bowie would surely remember. That one, very complex play at shortstop convinced Mr. Bowie to make the statement he did; it set me apart in his mind. He no longer perceived me as a highly accomplished amateur college player, but as a pro prospect.

I cleaned out my locker and walked over to coach Jackson and shook his hand. He had given me one of the greatest opportunities of my life. He put his faith in me as a person and ballplayer. Coach gave me a fully paid college education and a sea of memories on and off the field that live within me today. I had become a better player than he judged I would be.

We respected each other, and coach understood me as a player, student, young man, and friend. He told me I was always a straight shooter when it came to telling him what I thought, and he respected that.

With my equipment bag loaded up, I walked out of the locker room for the last time. Turning around on the sidewalk for one final look back, I thought, *The Hawk has left the stadium for good.* I had fulfilled my dream to play ball and excel for the celebrated Maryland program. This was the end, but once I left Maryland, I started strategizing a new beginning.

Baseball was always on my mind, but something else consumed every thought as I put my gear in Renauldo. In one week, I would marry Sharon. I was so excited about our wedding and what that meant to my heart, Sharon's heart, and our lives being shared together—I was living in the depths of my own passionate dreams; they were enchanting and as real as real could be.

On October 23, 1976, I married my beloved Sharon. The ceremony took place in a nondenominational church with a vaulted ceiling and walls constructed of vast glass panels, poetically situated in the woods. Being and feeling close to the natural world was a necessity for us. Our union occurred on a perfect day, with the fall colors ablaze and the afternoon sun dripping like a light spring drizzle, on and off the fluttering, brilliant, yellow and red leaves. Sharon walked toward me in her tailored and embroidered wedding dress, holding a beautiful, all-white bouquet of roses, chrysanthemums, and baby's breath. We exchanged our handwritten vows and inhaled the magnificence of our love.

My father snapped a late afternoon wedding-day photo of the happy newlyweds.

Sharon and I enjoy the day on a ferry in the Atlantic Ocean, traveling 120 miles from Bar Harbor, Maine, to Nova Scotia, Canada, on our honeymoon (October 1976).

Our reception was held at the historic Comus Inn, located at the base of Sugarloaf Mountain in Maryland. The inn, built in 1862, has quite a history. In the Civil War, there was rear-guard military action there during the Antietam campaign.

At 10:00 p.m., Sharon and I set off on our honeymoon, zigzagging north to Bar Harbor, Maine, to then hop a ferry to Nova Scotia, Canada. We cruised at a snail's pace in our green, weather-beaten Chevy Nova. All along the way we wrote, sketched, and photographed anything that sparked our creativity. The craggy and beautiful coasts of Maine and Canada were the ideal destinations for us, offering unknown days of exploration, rugged terrain, natural sculptures, adventures, cabins with firewood for heat, candles and lanterns for light, and super, late-afternoon sunsets that drenched everything in our path.

If only my baseball landscape were filled with such album-perfect images. I was 22, newly married, and had nowhere to play baseball for the first time since 1962. Playing pro ball and hitting my home run in the ninth inning to win a championship for the Orioles remained one of my spirit's dreams. I saw it in my mind's eye, it was real, and I had to see it through. But how?

It would take just one person from the Orioles brass to gamble on me. If I was given one at-bat, I knew I would earn more and more trips to the plate, I would play as a pro for seasons, I would stroke the pressure hits when my team needed them, my teams would make the playoffs and win championships, and I would set Oriole and professional baseball records. My entire being believed this. I bled baseball, yet the draft in early January rolled up and over me like a steamroller. Again, the phone, my Henry Moore sculpture look-alike, sat silent on the small marble table.

My parents and Sharon also had faith in my 100-plus percent, but I was the only one who could step onto the baseball field. My back was against the wall as I looked ahead to spring training. Millions and millions of dollars flowed toward the players on those proving grounds in Florida, yet I was set to force the gates open into stadiums without so much as a penny behind me or an organization that backed my talents. Those two hefty undrafted strikes counted heavily against my quest and, well, I did not strike out much. I was down for the count, but I would throw my own pitches over the plate and crush them.

Sharon and I were both full-time substitute teachers. I also did tree work and sold firewood on the weekends. Every day we received assignment calls early in the morning or late in the afternoon. On a cold January day, after I had returned home from teaching, my mother called me to the phone. I picked up the receiver and said hello. A voice said, "Hi, Scott. This is Dick Bowie, scout for the Baltimore Orioles."

Dick Bowie, the same person who erased my scouting report for another player in the June draft—could this be the call I had dreamed about since I began playing baseball in Little League?

I detected excitement in Mr. Bowie's voice. He first asked how my winter was going and soon mentioned he had spoken with coach Jackson. He referenced the fall ball game where I filled in for the shortstop playing against Maryland. "Your caliber of play and hustle made quite an impression on me." Then he asked about my plans for the spring.

I explained my intent to travel from one big league camp to the other, forcing a tryout. Miami would be first, because it was the training camp for the Orioles. From there I would head to Fort Lauderdale, showing my skills to the Yankees, next to West Palm Beach and the Montreal Expos, and keep zigzagging from club to club until I was signed. If a team did not give me an opportunity in Florida, I would travel to the camps in Arizona to take my at-bats.

Mr. Bowie paused and said, "Scott, how would you like to sign a professional baseball contract with the Baltimore Orioles?"

My heart pounded! I feared it might burst out of my chest. My hand froze on the phone and my jaw tightened. These feelings and emotions were like feathers on the wings of a high-flying hawk. This call had come out of nowhere and with no forewarning. The team I always dreamed of playing for wanted to give me a serious look. Pro ball, here I come!

Mr. Bowie said he'd travel up from his Fredericksburg home in a couple of days, so we could get together on a contract. Instead I asked him if it would be okay to drive down and sign the next morning. Mr. Bowie said, "Sure, I look forward to seeing you."

Sharon was reading a poetry book by Edna St. Vincent Millay, one of her favorite poets, when I told her the news. I lifted her high into the air. Embracing, we shared the joy of our happiness. Together we went into my father's office, where he was sorting through a collection of his exhibition prints that he was mailing to France.

"Dad, the Orioles want to sign me."

Grinning from ear to ear, he asked me for every detail of the call. My father was in proud-of-his-son shock. As for me, it was nearly an out-of-body experience. Together we had devoted much of our father-son relationship chasing this dream. Sixteen and a half years ago, my severed hand left a long trail of blood on a baseball field as I ran to my father. And now the Baltimore Orioles—who kindly rolled out the orange and black carpet for me to be "Big Leaguer for a Day" at Memorial Stadium in 1962—at long last, called. He asked when I would meet with the scout to sign. I exultantly told him, "Tomorrow at breakfast." Then my father looked me in the eyes and said, "I am proud of you, Scott!"

Now the three of us trooped upstairs to tell my mother the great news. Mom was in the kitchen making a salad, listening to crooner John Gary singing on the radio. Sometimes Mom would cook in tap shoes and dance to music while preparing dinner. She set her knife next to the tomatoes on the cutting board and we rejoiced with a loving hug. She, Sharon, and I started movin' and groovin' on the linoleum floor. Everyone was euphoric! Dad made himself a dry Manhattan. In less than 18 hours, I would be a member of the Orioles organization. To celebrate, we drove to my favorite restaurant, the Peking Palace. I was so excited I could barely read my fortune cookie. It did not matter what it said; my dream was unfolding in real time. My fortune was about to become true.

On a clear winter morning, Sharon, my father, and I drove in his Chrysler Newport south on I-95 to Fredericksburg. Mr. Bowie sat at a table in the Holiday Inn. He had laid out the standard player's agreement, which consisted of multiple pages of legalese and a fill-in-the-blanks type of format, printed on canary-yellow paper. I relished this moment so much. Mr. Bowie handed me his pen, and the second I dotted the "i" in Christopher, to complete my signature, I was immediately

and formally added to the roster for the Miami Orioles in the Florida State "A+" League, two rungs away from the big league Orioles team in Memorial Stadium. As exhilarating as this was for each of us, I remained guarded to the reality attached to my future opportunity—I still had to earn my spot on a very tough lineup.

As one of the few undrafted, free-agent position players going into spring training, I needed to be at the top of my game to make the cut, to compete for a job to play *professional* baseball. The competition didn't faze me—*nobody* had worked as hard. And nobody could halt my first at-bat in the pro ranks. I would step into the batter's box, hearing the announcer say, "And now batting, Scott Christopher"—and bang out a hit.

Days after signing, the *Washington Post* ran a feature article in the sports section on January 27, 1977, titled, "Baseball Player Finds a Hard Road Leads to His Life's Goal." The sports writers at the *Post* had been fans of mine since they first reported on me in August 1966. Their stories emphasized my determination, despite my handicap, to do something important: provide inspiration for other athletes and people, at whatever capacity or level; to "Dream Big, Dream On"; and believe that with knowledge, passion, hard work, desire, and intention for the quest, your dreams will come true!

Coach Jackson was quoted in this article, and his words validated my commitment and devotion to the Great Game: "Scott did not know it, but Bowie was up in the stands, scouting some other kids that day. Scottie was spectacular, playing 110 percent, like always." The entire piece, filled with strong statistics, facts, and quotes, was inspiring, and it marched in step with my timeline to get my break—especially in the Orioles organization. If you have a dream, you have to fight relentlessly and be unconditionally disciplined to live it.

This was my Topps Chewing Gum baseball-card, Valentine's-Day check, which I received shortly after I signed my first contract with the Baltimore Orioles.

All Dreams Are Anchored in Love

Your dreams are meant to be pursued and seized,
as passions always open the gates wide
in life to boldly walk through.
You must have the courage to believe in yourself,
knowing the possibility of it ALL lives in your heart.
All dreams are anchored in LOVE.

6TH INNING

PRO BALL

Winters in the Washington, DC, area required creativity when it came to preparing for spring training. The cold and snow meant most of my conditioning and hitting centered on gyms or indoor batting cages. I had begun getting in the best physical and mental shape possible on January 1, 1977—before I learned I would be competing and drilling alongside the Orioles. I methodically built my regime week by week, syncing mind and body to be their sharpest.

Tom "Star" Brown, a distinguished alumnus of U-MD, owned a farm outside of Gaithersburg, Maryland. He covered the top floor of his barn with AstroTurf, suspended nylon-mesh netting from the beams as the batting cage, and installed a state-of-the-art pitching machine, called "Jugs," which could throw a fastball over 100 miles per hour. Jugs even threw breaking pitches to simulate curveballs and sliders.

Tom generously allowed me to use his cage twenty-four/seven. Sharon and I would

Tom is one of the few athletes in sports history who played both major league baseball (1963 Washington Senators) and in the NFL (Green Bay Packers). He played safety for legendary pro football Hall of Fame coach Vince Lombardi. Tom won three NFL championships and the first two Super Bowls in 1967 and '68. He continued to be a beacon of goodness, mentoring young athletes to become champions on the field and in life. Star currently lives in Florida.

drive to his farm, and she would feed Jugs for me while I swung away as the snow fell outside. We had fun practicing together and played games where she impersonated a pitcher trying to strike me out. Then we would drift into the rural surroundings, making photographs—leading to my second major international salon photographic award. Titled "Contemplation," it was an image of Sharon looking through a broken window with tattered curtains, in Star's barn.

"Contemplation" Photo of Sharon at Tom's hitting barn (1977), my second, major medal winner.

My medal of honor from the Musée des Beaux Arts, Bordeaux, France.

A competitive environment awaited me at spring training. As one of the few undrafted players, I was pitted against teammates the Orioles had scouted, pursued, and invested money in. If I prevailed, a drafted player would be delivered his one-way ticket home, and I would take a spot on the roster.

Shortstop in the pro's is a combative position. The infields are cut deep, allowing little room for any kind of bobble on a grounder, because runners will beat your throw. I trained arduously for total body strength, concerned primarily about my handicapped right hand and how it would fare, hitting against one professional pitcher after the next. I would either carve my dream into reality or it would become a vanishing hope, leaving me to ride off into the sunset carrying an "almost there" memory in my heart.

My exhilaration nearly constituted a health hazard. Excitement at times compromised my breathing. I now belonged to one of the most respected baseball organizations in the entire major leagues. The Orioles had battled their way to four World Series, from 1966 to 1977. In these extremely successful 11 seasons, the Orioles won two World Championship rings. I was going to be evaluated and taught by coaches and managers with decades of experience and intelligence. The anticipation of this opportunity created a thrill with almost every

breath. Wow! My dream meter was sparking and shorting out, knowing I would be playing pro ball in two months.

Dreaming about my inauguration in Florida was invigorating: baseball talent everywhere; foul-line chalk laid like thick, almost-dry oil paint; manicured infields; tamped-down clay batter's boxes; brand-new, brilliant-white, red-laced baseballs; pitching machines; batting cages; baseball games all day long; and spitting tobacco juice with big leaguers and future Hall of Famers. The Orioles ordered me bats from Louisville Slugger with CHRISTOPHER burned into the end of them. I oiled up my baseball gloves and shined and sharpened my cleats, ready to make fielding gems, turn double plays, steal bases, score runs, charge all things baseball like a locomotive, and split the seams on the baseballs, driving them in the alleys and over the fences. My enthusiasm was real, and logging a good night's sleep was elusive.

In February, the Orioles arranged a photo shoot at their big league park, Memorial Stadium. They wanted to start compiling a player's file on me, in case I made the roster. The odds of me making a team were statistically slim, but baseball odds meant nothing to me. The sooner I could start building my player's dossier, the better. My father and I drove to Baltimore five hours before the shoot, stopping for lunch at the legendary Lexington Fish Market, one of the most eclectic venues in the city, operating since 1782. Parking ourselves at Faigley's raw bar, we crafted a culinary feast—Chesapeake Bay oysters, Maryland crab cakes, shrimp, crab soup, and ice-cold Coca-Colas. Truly, this was a great way to celebrate my affiliation with the Birds. Afterward, we spent an hour chasing photographic art, and there was plentiful subject matter everywhere. Baltimore offers a smorgasbord of spectacular human interest and architectural content winners.

Soon I stood in the same locker room where I had shaken O's Manager Billy Hitchcock's hand, back on May 30, 1962. Fast-forward nearly 15 years, and my invitation letter became a signed contract to play baseball in the O's organization.

Shifting back and forth from being a handicapped eight-year-old boy to the present, I again heard the metal spikes of players walking on the cement floor, though there were no players in the locker room. When the photographer arrived, a stadium employee handed me a jersey for my public-relations shots: number 23, with *Jackson* spelled in outlined block letters across the back. I wore future World Series champion,

game 7-winning pitcher, Grant Jackson's jersey for my Orioles press kit photographs. Crab cakes, oysters, photographic winners, and the WS 7th-game winning pitcher's jersey—PRO BALL CENTRAL!

Outfielder Gerald Coleman was photographed with me that afternoon. Gerald was a third-round pick in the January 1977 draft, where I had just been overlooked once again. Did he want it as badly as I did? Had he left blood on the baseball field? Only Gerald could answer those questions. I hope he gave it his all. Even to me, my improbable history seemed like a ballplayer's fiction story at times. Gerald's career in pro ball was short-lived.

Three hours later, back home in Virginia, I pounded the tire I had installed with rope, hanging from one of the two-by-ten joists next to the refrigerator in our laundry room. In five weeks I would be walking into the Orioles spring training locker room in Miami, Florida. I'd make the team and then stand in the batter's box for our home opener, in a pro baseball stadium, on a pro baseball team, and I would swat a hit so I could get up to bat again, smack a good one, and step up to bat again to pound yet another. The thought of a one-way ticket back to Virginia made my innards quiver and shiver.

I chalked off the days I had left to train, and they zipped by quickly, until mid-March 1977, when I would drive 1,100 miles to Miami. The sooner I headed south, the better. I wanted to study my competition and the fields I would be competing on. I had fixed up Renauldo the best I knew how, with a tune-up and new tires. The morning I packed my gear, shortly before I fired up Renauldo, I hugged Sharon and we kissed. My father held my gaze and said, "Show 'em how the game of baseball is played, Scott."

Sharon and my mother stood in the driveway next to each other as I pulled away, driving straight into my dream. I glanced back at them and said, "I love you both." Sharon and my mother both had blue eyes, and those blue eyes lit up and said it all as they waved goodbye.

I would arrive to the minor league spring training complex at Biscayne College in less than 30 hours, if my car did not have any type of mechanical failure. I had my tools and spare parts in the trunk. Traveling south, I was movin' and groovin' to the Ten Years After album *Essential*, playing and replaying "I'd Love to Change the World"; carrying $200 in my wallet; Sharon and I were very in love; and I was on my way to play pro ball, living my dreams in the grandest way.

Cruising along, I kept my Konica 35mm camera close at hand. If a composition caught my eye, I would pursue it, trying to create an exhibition-worthy image. I snapped off frames along the way, and a very artistic possibility appeared in a Florida sugar cane field, where shirtless, sweating migrants labored. The cutters held the cane with one hand and sliced their sharp, metal, hook-shaped machetes through the thick stalks with their other. They never stood upright, as that took time and energy. This was their last harvest of the season. I pulled off the road and appreciated the workers. I opened a cold soda out of my cooler in the backseat and sat on top of a hill for a few minutes, sipping away. Every now and then a worker would stand and give me a stare.

Growing up, if I wasn't in an athletic arena of some kind or palling around with Mike or other friends, I was most likely immersed in a creative environment, especially the photographic arts. I began making photographs at age eight, becoming fascinated with light and the stories attached to my photographs. When I was a teenager, and even today, I study the nature and effects of light, how it can cascade through a frame, and its importance in creating artistic paintings, photographic art, sculptures, and mixed media installations.

As I stood on the slope, I adjusted my telephoto lens to compose potential shots in my viewfinder. Panning across the field, I found the moment, the light, and the man who interested me most. Cutting the cane, he worked his way down the row, advancing in my direction. His muscles and sweat played into the reflective light and shadows, forcing extreme contrasts. I planned to make my photographs a moment before his machete sliced through the cane and as the freshly cut stalks tilted toward the ground.

I fired off three frames. The worker stood and faced me. Unaware he was upset, I lifted my camera back into position when he bent back down to cut more stalks. I popped two more frames, and surprisingly, my subject rushed along the row like a charging bull. Running my way, with his machete raised over his head, he quickly covered ground. I did not think about photos anymore, knowing I had better hightail it off that ridge.

The cane cutter hit the slope and raced up the hill, now only 30 yards away. Luckily I left my key in the ignition. If Renauldo burped, I was going to be in for one heck of a fight. The gap between us closed quickly, but fortunately I was in the driver's seat.

Please start, please start, please start! I did not want one of us to resemble a beaten stalk of bagasse cane lying in the field.

As I turned the key my French crickets cranked right up. Then I slammed it into first gear and popped the clutch, casting gravel into the air, and sped away. I looked out my window, back at the man standing still, firmly holding his intimidating machete. I created one worthy image from my efforts—and I learned a lifelong lesson about being more understanding with strangers, whether working or not, when making photographs.

It was night when I rolled into camp, a fitting time since I was by far the darkest horse of any of any player in spring training. I confronted a blank canvas: I knew not one person, not one field, not one player, not one coach, not one locker, not one anything. All was 100 percent new. But I arrived loaded for success, mentally and physically up to the task, with almost three weeks to prove myself on the diamond before our home opener. I came in with one mission: no matter how intensely they drilled us, I would push and work harder than any man in camp. The thought of *not* making a team turned my stomach. I just had to, as it was the bridge to living my dream.

Each player was assigned a locker. Inside hung your uniform and above—printed in thick, black magic-marker letters on white athletic tape—was your last name. If you came in from the practice fields and the tape had been stripped from the top of your locker, you couldn't help but look down for your ticket home. Once the club released you, there was little dialogue. With each day, fewer and fewer names remained above the lockers.

Whenever I entered the locker room, my eyes darted straight to my name. Mathematically, my odds of becoming an Oriole improved as the player pool decreased, but the percentages of being sent home increased, making every game pressure-packed.

Spring training is an intensive proving ground for ballplayers. If the brass and managers make the wrong decisions, the end result is a losing team that puts their careers in jeopardy. The coaches and executives assessed talent day by day. Clipboards holding paper notes, stopwatches, and even binoculars were evaluation tools as they zipped about in a fleet of golf carts over four fields. Periodically, they converged to discuss player data and then fanned back out like spokes on a bicycle wheel.

The managers and coaches were astute professors of the game. They spotted a flaw at rapid speed and worked with that person until it was corrected. Baseball men are hard on themselves and harder on players who do not perform. They will only let the rope out so far, and then they will release it—and you with it. That is how the Great Game works.

Some athletes thought destiny lay in management's control, but I held mine in my own calloused hands. When I went to bat with the golf carts right behind the backstop, I was aware of their presence and intensity, and I stepped up to match theirs with mine. I would strike the ball like lightning, chew up the base paths like a shoal of piranhas, and field like a hawk that hunts down baseballs. I'd give my throws precision and accuracy, with as much zoom on the rock as my crippled hand and arm could unleash.

Practice days ran with smooth efficiency. We were moved like chess pieces, which suited me just fine. From day one, I performed like a starving, undrafted competitor, giving the decision makers what they wanted to see: judgment and solid contact in my at-bats, aggressive base running, surgical defensive plays in the field, and grit in pressure situations. I eagerly anticipated the start of practice games, where I would set myself apart.

If I cracked the nut, Lenny "Badger" Johnston would be my manager for spring training and the 1977 season. Encrusted in baseball salt, Badger possessed keen

Lenny played 16 years in the minors and led the International League in hitting in 1956. He played in 1,826 games, with 7,030 plate appearances, compiling a career batting average of .286. Badger was inducted into the Baltimore Orioles Hall of Fame in 2010 for his 34 years of managing and service to the Orioles organization; 2019 marked the Badger's 43rd and final season affiliated with the Orioles, concluding Lenny's remarkable career with the O's and his life surrounding professional baseball. He was the perfect managerial match for me in my rookie season.

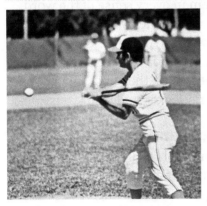

Lenny "Badger" Johnston hitting me and other infielders pregame ground balls.

coaching skills. A shrewd evaluator, he noticed everything and guided the 1976 Miami Orioles team to a regular-season, first-place finish, only to be eliminated in the playoffs. An extra bonus was that our team's pitching coach was MLB former Cuban star, Camilo "Little Potato" Pasqual. Little Potato played 18 seasons in the Bigs, registering 174 wins, ranking 68th all-time in strikeouts with 2,167, and his curveball is top-10 in MLB history. Camilo still has the record for most strikeouts on opening day, pitching for the 1960 Washington Senators, fanning 15 Red Sox in a 10-1 bruising.

Sometimes quiet, other times expressive, Badger always calculated the best-case strategies for his players, both on the field and in the batter's box, to win ball games. He had experienced baseball inside and out. From my first day forward, I understood the value of speed on his team. I stretched my singles into doubles whenever the opportunity arose, stole bases to be in scoring position as often as possible, and I ran and ran and ran, realizing that Badger and I were cut from the same uniform. Lenny had scored 780 runs in his career, so right out of the gate I demonstrated to him I would claw my way to home plate to score runs—and lots of them.

As the pressure mounted to make the club, Sharon arrived. I moved off the complex to live in a jungle-green, block hut that the landlord allowed us to rent day to day. We enjoyed the Florida scrub lizards moving about on the inside and outside walls of our spring-training palace. Tucked way back in a grove of palm trees, it lacked air conditioning. A ceiling fan kept the thick, still air circulating. Having Sharon there meant the world to me. We were a team in every sense of the word.

My name remained above my locker when the two weeks of practice games started. The hours ticked by. I was playing professional-caliber ball. After another full day of working on fundamentals and a practice game, the Baltimore execs and Badger made their final selections. I entered the locker room, looked above my locker, and read CHRISTOPHER: I made the team, and I was a pro!

Elated and proud to be in the company of pros who were some of the finest across the globe, I had earned this chance, this elusive opportunity, to become the best player and teammate I could, sore body and all. I had skinned up my right leg from sliding when I stole bases, stretched hits, and turned double plays. My strategy from day one was centered on the fact that I had to play my games like a ravenous athlete, to force Lenny and the execs to honestly evaluate me.

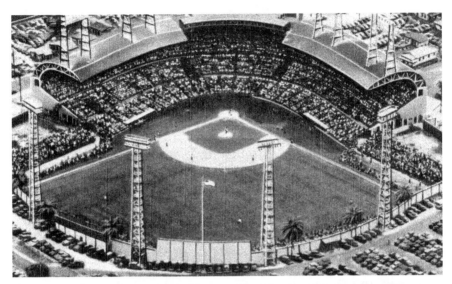

The historic Miami Stadium opened in 1949. It was my first
professional venue, steeped in baseball history. I wanted to
be a big part of that history, from game one forward. I had
forced open the door to my dreams, and now it was time to
seize them all. At the top of my list was a championship title.
A very historical 2008, 90-minute documentary film about
Miami Stadium, titled White Elephant: What Is There to Save? *is*
available to view online at vimeo.com/105767151.

What I had accomplished with my challenged throwing hand and
arm was phenomenal, and one of my dreams, playing in the Orioles or-
ganization, had come true. Impatiently, I drove back to the cinder-block
cube to share my momentous news with Sharon. When I turned onto
the dirt road, I spotted her reading and sipping from a glass of sun
tea, on a wooden bench we had set out underneath a palm tree. When
Sharon saw me, she stood up and waved. I excitedly beeped the horn,
and within twenty-seconds we were hugging and kissing each other,
celebrating my making the Miami team.

Seven years before, as a junior in high school, I had three strikeouts
in four at-bats for the season, playing in only three games. In the 82
months since then, I worked relentlessly on my skills. Through all those
seasons, I kept my promise to myself. I played every inning of every
game, other than my lost sophomore season at Maryland, when the
car crash sprained my wrist and broke my throwing arm. Also, I had

matured considerably. My handicapped hand and wrist would always compromise me on the field and in life, but physically and emotionally, I had closed the gap with my peers.

FIRST PROFESSIONAL GAME

Standing in Miami Stadium for the first time as an Oriole, a wave of accomplishment surged through my body—I had arrived. Printed in towering, red block letters above the entrance was "Home of the Orioles"—home to me, my gloves, spikes, and bats. I walked into the locker room, certain that the work ahead meant using every minute inside that stadium to become a better baseball player and champion.

Miami Stadium had been the home of the Miami Orioles since 1961, with all the dimensions of a major league arena: 330 feet down both foul lines, 400 feet to straight-away center, housing a 15-foot wall to clear for a home run. As a player who could run fast, this was an ideal ballpark to scorch the base paths and score runs.

Electricity crackled up my spine when I stood in the locker room. My uniform, with "Orioles" written across the front of my jersey and the number 15 under it, hung neatly in my locker. The moment I had dreamed of crystalized. I soaked it all up with sweet anticipation. I was beginning my career as part of a team built of topnotch coaches and teammates. These boys just downright played masterful baseball.

Our home opener against the Fort Lauderdale Yankees on April 15, 1977, delivered all the hoopla for 3,000 fans. The esteemed guest who would throw out the first pitch was Joe "Brown Bomber" Louis, of whom I was in awe. Badger slotted me in as starting second baseman, which I took as a good sign. For many reasons, this was a memorable night in my life. The Great "Brown Bomber" would watch me play my first pro ball game—what a grand honor.

Joe Louis sat right there on the rail, ten feet from me in the on-deck circle. He held his World Championship Heavyweight Crown, a record-setting 140 consecutive months, beginning in 1937. Big Joe ended his career with 66 wins—including 52 knockouts—against 3 losses. What an inspiration! The Brown Bomber lost his last fight when it was stopped in the eighth round against Rocky Marciano. The brawl was a TKO for the Rock on October 26, 1951, at Madison Square Garden in New York City.

*I visited with the great Joe Louis before our game started, and
I strode onto the field wanting nothing more than to give the
legendary boxer a game to remember, which I joyfully did. This
home opening night has always been a favorite baseball memory
of mine. I gave one of the greatest champions of any sport ever a
victorious moment to enjoy and remember.*

In March 1947, Rocky had tried out for the Chicago Cubs farm team in Fayetteville, North Carolina. Three weeks later, his tryout ended, proving that baseball is one of the toughest sports in the world to master. He returned to Brockton, Massachusetts, to begin his boxing training. What followed was one of the most commanding chapters in boxing history. Rocky Marciano went on to have a historic boxing career, never losing a professional heavyweight fight, compiling a 49-0 record with a power-packed, lights-out, 43 knock-outs. Wow!!!

When I set up in the box as the leadoff hitter and the stadium announcer belted out, "Now hitting, Scott Christopher!" I had to step back, tap the dirt out of my spikes and gasp one proud breath for all I had accomplished. I was more than ready to swing my Louisville Slugger and drive its barrel smack into the right pitch. Gripping my bat like a battle-axe, I

moved back to the plate. I was seeing the ball distinctly as the count built; then I drilled a sharp line-drive single to center field.

With five at-bats in my first pro game, I reached base safely five times. When I prepared for my last plate appearance, we were down by a run. The bases were loaded, but my team was chalking up outs. I focused on smacking the baseball dead center and powdering the pitch. It came at me on the outer half of the plate, belt-high and in my power zone. I airmailed it far into the right-center field alley. As I slid head first into third base, I narrowly beat the cut-off throw from the second baseman. I had driven in all three ducks on the pond, giving our team the game-winning runs for victory. Coach "Brahma Bull" Little taught me at Ferrum never to make the first or last out of the inning by taking third, and I never did in college or pro ball.

I called timeout, stepped off third base, and dusted the dirt from my uniform. My most ardent fan, Sharon, sat near the dugout, close to Joe Louis. I looked into their eyes, pointed at them, and popped my hands together. Sharon was smiling and clapping. The Brown Bomber balled up his famous right, cannonball fist, and pulled it up into his chest. One of the most distinguished athletes in the history of the world, Joe Louis shared the experience and sent a punch my way that knocked me out of the park. My triple and three RBIs were a gift to one of, if not *the* greatest boxing king to ever duke it out in a ring.

Washington Post reporter, Byron Rosen, wrote this on April 27, 1977, shortly after my home opening-night game. Below is an excerpt:

> Christopher collected two singles, two walks, and a bases-loaded triple for the go-ahead runs in a 14-10 victory and playing an errorless second base—a perfect night.

Celebrating with Sharon after the game in Little Havana made it a "*truly* perfect opening night."

A WINNING SEASON

Sharon and I had located an apartment in Coconut Grove, a trendy waterfront area on Biscayne Bay. Local arts and the natural harbor made this a creative haven for us, ideal for two newlyweds. We liked to sketch in the cafés dotted along the shoreline. Sharon landed a job as a waitress, right across the street, in the exclusive Coconut Grove

Hotel. If I had a home game, she would work lunches. If I was on the road, Sharon doubled up, working two shifts a day. We set our table for quite an exciting baseball season.

Little Havana was not far from where we lived. An ethnic neighborhood, it was best known for its population of Cuban expatriates. Sharon, a coffee connoisseur, made this her favorite destination for their famous *cortadito* espresso. It was cool driving along Calle Ocho, a lively road, block after block, and making street photographs of the Cuban Americans' going about their colorful and expressive lives.

We enjoyed a blast of a season, living the bohemian life in Coconut Grove. I continued penning my fully illustrated science-fiction novel, *The Tales of the Roving Mobileans*, created watercolor paintings, and searched out photographic art all across Florida, into the train yards of Miami and beyond.

Writing poetry was Sharon's favorite creative expression. She had attended the University of Aberdeen in Scotland, in part to study the

Above left: Sharon's sketch of me, sitting at an outdoor cafe table. She captured me contemplating the moment and the turquoise blanketed water of Biscayne Bay (Coconut Grove, 1977).
Above center: One of the 25 science-fiction characters I created for my futuristic novel. This one, Cyplow, was director of environmental research (1977).
Above right: "Insightful Wisdom," my first major photography award-winner, that I won exhibiting in the Kodak International Portrait Competition. I made this powerful image in the Miami rail yard (1978). Making art to share with the world inspires my soul.

revered English poet, playwright, and actor, the "Bard of Avon," William Shakespeare. I loved it when she recited poetry—hers or Shakespeare's—to me as we inhaled sunbeams, relaxing in our favorite cafés during the days of my season.

Of course, the game occupied my mind in a beautiful way. I lived in baseball heaven, managed and taught by preeminent professionals who matched and countered the competition, alongside teammates brimming with talent. The O's boasted two number-one draft choices, Dallas "The One" Williams and Randy Stein. Seven Orioles on this roster later earned spots in the Big League Show. Truly, I loved pro ball; I was right in the middle of my dream.

The One was a gifted center fielder, all-around ballplayer, and friend. Dallas and I could not look at each other without laughing. He had

Dallas was the Baltimore Orioles #1 selection (#20 overall) in the 1976 MLB draft. He was an 18-year-old phenom coming out of Brooklyn, New York. Besides his outstanding baseball talents, The One had a heart, soul, spirit, and humanness that illuminated the stadiums he played in. Dallas inspired his teammates to stay focused and play heartfelt baseball. His passion for the Great Game touched me deeply. If players or fans wanted to understand the fundamentals of how to play a big league center field, then Dallas was the fielder to emulate. He played 12 years of pro ball, earning two visits to the big leagues: his first with the Orioles in 1981, and second wearing a Cincinnati Reds uniform in 1983. A baseball DNAer for over 40 years, The One was a coach and instructor in the Chicago White Sox and Cleveland Indians organizations. He has been a first base coach for the Colorado Rockies (2000-2002) and Boston Red Sox (2003). In 1988, The One played in Japan for the Hankyu Braves and was a hitting instructor in Taiwan and Mexico for multiple seasons. In 2019 his team, Acereros de Monclova, won the Mexican League championship. Most of Dallas's stellar career was spent playing AAA baseball, where he amassed 3,561 at-bats, scored 490 runs, hit a crisp .292, earned two team MVPs, and won three American Association Championships playing center field for the Indianapolis Indians. He was a player in the longest pro game ever played, a 33-inning contest on April 19,1981, for the AAA Rochester Red Wings. The One has the most official at-bats in a game in the history of pro baseball. He recorded 13 at-bats without one strikeout. His baseball philosophy was to play each game as if it was going to be your last one. That way you would be the best baseball player you could be. Dallas is a treasure to this Great Journey we call life. He lives his life believing LOVE is the answer, and he is right.

a million-mile smile. The One is and continues to be a godsend to the game.

Richie "Conch" Bancells joined our team in early June as assistant athletic trainer. Conch hailed from Key West, and we became immediate friends. His grandfather had known Ernest "Papa" Hemingway in the Keys, and Conch shared impressive "lost generation" stories. I have read and reread many Hemingway novels, my favorite being *The Old Man and the Sea (1951)*, awarded the Pulitzer Prize in 1953. It also contributed to Hemingway being awarded the Nobel Prize in Literature in 1954.

Conch and I remained baseball friends for 40 years. I visited with him in different stadiums and at Orioles spring training games numerous times over the decades.

But some rain must fall in any season. Badger, our keenly ambitious manager, would generally find a way to win. He constantly reviewed the players lineup card taped to the dugout

Cal "The Iron Man" Ripken Jr. and Richie "Conch" Bancells. I made this photograph of my two friends in 1987.

Richie went on to start his tenure with the major league Orioles in 1984, becoming the head trainer in 1988. Almost 30 years later, after the 2017 season, Conch retired. He also was instrumental in supporting Cal Ripken Jr. toward his monumental achievement of playing in 2,632 consecutive big league baseball games, as well as becoming one of the greatest players in the history of MLB. Cal honored Conch in his Cooperstown Hall of Fame induction speech, given on July 29, 2007. I was proud to be there.

Richie was the head trainer for the Rochester Red Wings when they played the longest game in professional baseball history. He left the stadium at sun-up with Doc Edwards, the manager. When Conch returned to his hotel room, the phone never stopped ringing from newspaper and wire services wanting to know about the game. He realized then that the game was something special. In 2011, Richie was elected to the Oriole's Hall of Fame. He has been a celebrated ambassador for the Great Game of baseball. BRAVO to the fly fishing-for-bonefish KING!

wall, to see what game-winning strategic moves he might make and when it would be most advantageous, both offensively and defensively. During a night game, I was 2-4 with a double in my previous at-bat. The contest was tied; we had a runner on third with one out, and it was vital we score the run. I swung the leaded bat in the on-deck circle, ready to bring my teammate home, when Badger sent me back to the dugout. He switched me out for left-handed pinch hitter Arnulfo Camacho, a 5'8", 165-pound steel block, who had a disciplined eye at the plate and consistently hit the ball right on the sweet spot.

I understood the strategy was to keep the ball on the right side of the infield to drive the run in. But I was irked. "Lenny, if I couldn't drive the runner in from third, I should be in the stands selling hotdogs and sweeping up peanut shells."

Lenny's nickname wasn't *Badger* for nothing. He had a short fuse, and my protest ignited it. He came at me, firing off the finest of verse. I put my arms behind my back and grabbed my right wrist with my left hand—baseball's way of tying up your fists so you do not foolishly throw a hotheaded reflex punch. Badger shadowed me all the way down to the bullpen, barking the entire way. My teammate, smokin' fireballer John "High Noon" Noonan, helped defuse the contentious climate. Arnulfo drove in the run, and we won the game.

To be sure, I had learned my lesson, as Lenny clipped the Hawk's wings for the next several games. Badger never said a word to me, and I crash landed on the bench for questioning the general's move.

ROAD TRIPS

Except for being apart from Sharon, I loved the unknowns of the road. Every mile brought something new to see, connect with, wonder about, and sometimes revisit as a memory. Roadies also delivered ample opportunity for me to dream about life. Viewing the dotted, white lines from the team bus windows, it seemed they would never end.

Road trips in baseball are similar to weather patterns, invariably unpredictable, due to an abundance of factors. A busload of players, ticking off 650 miles for an away series, can only be described as live theater at its best. In today's world, they would make great television reality shows. We joked, ribbed each other, impersonated the coaches, and conducted eating contests in greasy spoons that sometimes wound

up costing me at least a step stealing a base the next day. I once ordered a salad and asked the waiter to have the cook put four heads of lettuce in it. He did. I doused it with creamy French dressing and devoured that green mountain as my wide-eyed teammates watched.

To have 25 young men captive in a single vehicle for days at a time would have made college psychology research departments jump for joy. It was a petri dish of human consciousness at a pivotal time in our psychological development. Baseball was in our DNA; we loved it, lived it, breathed it, and bled it. The PhDs' findings would have impacted behavioral science research in a variety of ways.

The more the team was winning, the fewer the rules when traveling from one city to the next. Managers know a loose squad of 25 ballplayers, all being paid to play baseball, with similar dreams of playing in the Bigs, will win games if they are having fun on and off the field. And fun we had in a big league way.

I always sat in the back of the bus, thinking baseball, reading, writing, drawing, daydreaming, and observing the real-time movie frames as they came into focus and disappeared in a flash. I often felt like I was traveling in an enormous flashlight on wheels. The way the headlights spread out, in a 180-degree arc, into the dark nights, town after town, made my soul happy. Of course, we never caught up to the light, which made every mile on the blacktop a bit of an ever-unfolding mystery.

There is no solid ground on road trips because everything changes in a short period. Like the old Kodak carousel slide projectors, our games and the towns were the images that were displayed on the screen for three or four days, and then on to the next stadium and a new set of slides. The fans, the teams, the designs of the parks, all created a cornucopia of stimuli for my five senses. Whenever I had the opportunity, I explored the cities with my camera. The South dripped in raw and storied content. If I saw an artistic composition from the bus window as we chewed up the asphalt, I would etch it into my mind and draw it from my seat or paint it later in our apartment.

Missing Sharon was by far the worst part of being on a roady. I would call her once during the day and after every game, no matter the hour, from wherever I could locate a pay phone. We would chat at length, as young lovers do. Our reunions, when the bus returned home, were treasured. I loved seeing Sharon in our green Chevy Nova under the parking lot lights of Miami Stadium, late at night, at the end of another

adventure. No more white, dotted lines as the flashlight was turned off. I was home, and my wife and I were together again.

A DREAM DEFERRED

Our team had a successful and exciting season, with a must-win finale after dropping the first game of a doubleheader. We were pitted against the Pampano Beach Cubs to earn our spot in the playoffs. I drove in two runs and our bats dominated, contributing to Worm Killer's 8-1 pitching gem triumph. With this second-place, 72-66 record in the Southern Division, we qualified as one of four teams to battle for the league championship. This was the eighth time in nine seasons Miami earned a playoff berth. We paired off against the defending champion, Lakeland Tigers. At .616, they touted the highest winning percentage, with an outstanding 85-53 record, thanks in no small part to Jim Leyland, their manager, a rock-solid baseball genius and proven winner. He was the kind of manager I loved to beat, especially in the second season.

Playoffs were to begin in Miami, but the first game was rained out, and the entire series moved to the Tiger's Joker Marchant Stadium in Lakeland. We left Miami on a Friday morning for our 7:30 p.m. opener. Hurricane storms trailed us north, and we did not play the first game until Sunday afternoon. After two rainouts in a row—and being overpowered by future MLB hurler, Mike Chris, the league's leader in victories (18-5, 2.01 ERA)—we played like the downpour had never stopped. Our

Hitters love to rip into a pitch and drive the ball a long way. In this at-bat, I did just that. From my viewpoint as an artist, this photo captures a beautiful, painterly, Edward Hopper aesthetic.

squad put a total of five singles in the box score, and we lost 5-1. I played third base and was penciled in as the number-three hitter in the lineup.

Our pitchers in the second game Monday at 1:00 p.m., starter Larry "Engineer" Jones and Bill "Elvis" Presley, pitched a jewel of a battle. Larry gave up the game's only two runs in the first inning; then he and Elvis, who relieved the big righty later in the game, slammed the vault door shut, piling up a scorebook full of goose eggs. I played the hot corner again, and Badger, who let bygones be bygones, tagged me as the cleanup batter in the number-four power slot. My first two professional playoff games, and I was hitting three, four in the lineup—Wow!

I had earned Lenny's respect as a pressure-cooker hitter because of how I proved myself coming through in the clutch. It takes months of success, in tight, must-produce situations at the plate in pro ball, for a manager to pencil the #4 hitter in the "he's the one to get it done" batting order. Especially in the playoffs, when there is no tomorrow, and the championship trophy is slipping away, one out at a time. Any ballplayer that rolled into spring training, sitting on the last rung of the entire camp's depth chart ladder, as I was in March, had the right to feel like a contender when they dug in at the plate as the #4 hitter. Every swing I took had one objective, meet the red threads head on and hammer out a **BIG** fly.

Nevertheless, you might have thought our offense played in a Florida swamp filled with gators. We lost to the Tigers 2-0, giving them the playoff bracket win. They advanced to the championship series and were victorious in defending their title. Randy "Double" Robinson was a top, all-around hitter. He led the league in doubles with 28. Three of our hitters ranked in the top-17 sluggers in the league, with 300 or more at-bats. Outfielder Marshall "Machine" Edwards, a future player in the Show, won the league's batting crown with a .334 average. Marshall's twin brother, Mike, and his younger brother, Dave, also played in the Show. Double and I were the other two Orioles in the top-17 mix.

Lenny piloted his club to the playoffs masterfully. The Baby O's, along with the major league team (97-64), were the only two teams in the O's organization with winning records. Miami fell off the cliff in the playoffs, but at least we competed in them, which was a credit to Badger and Little Potato, our level of talent, and the steadfast winning ways the team exhibited all season long.

Everyone experienced the disappointment strongly—we fell four games short of winning the ring. But in baseball, for fans and players

alike, there is always next season. I would be more than ready to win my ring—pounding my ninth-inning blast in the final game—at whatever level of ball I was playing.

Over our '77 season, I advanced every aspect of my game: playing the most games at shortstop of any infielder on our team; leading the league in stolen-base percentage with 25 or more stolen bases, at .892; second on the squad in runs scored per at-bat; hitting .287 for the season—third highest on the team. And despite all of my stellar accomplishments, the Orioles did not invite me to the winter Florida Instructional League.

It was inconceivable, even though I had experienced the back burner and overcome major setbacks many times in my baseball life. This slight, on the heels of losing the championship, chafed me. I was 23 years old, undervalued and overlooked, at a time when I needed to play as many games as possible and be taught the Orioles baseball way so I would noticeably improve as a player. The insult made me want to enter the ring with whoever shunned me and sting 'em good. My passion was rattled, and knowing the Orioles did not consider me a top, big league prospect made me think about quitting the Great Game. Fortunately, those thoughts lasted a short period. I was angry and needed to vent and process my standing with the Orioles.

Soon thereafter, the *Washington Post* published my season highlights and rattled feelings in their sports section.

Yet, as with every impediment, I resolved to continue to work like a champion and perfect my skills. My 1978 season would be so indomitable it would force the Orioles to invite me to be on their team in the Florida Instructional League as an extremely rare, undrafted free agent. I was built to "Dream Big, Dream On!" No one could, or would, rob me of that.

My dear wife Sharon wrote me a poem that bolstered my aspirations:

A Dreamer Lives for Eternity

Because all dreams come true
Hawk, I will always love you and admire you
Because you are so creative and so full of dreams
Which will some day come true

7TH

INNING

SEVENTH INNING STRETCH: SWITCH UP

The Orioles carried one of the best reputations in all of baseball for developing quality teams and minor leaguers to funnel to their big league club. I held my own in spring training on the AA Charlotte team. Then I learned the coaches wanted to convert me into a switch-hitter; this did not sit well with me at all. While it affirmed I was fast—they judged I had too much speed not to maximize on it from the left side of the plate—it portended they desired me back in A ball.

After my elevated AA competition, I continued excelling as a full-time outfielder and racking up the runs for the Miami Orioles. Learning to hit from the other side of the plate at age 24 asked a ton of athleticism from a ballplayer. I could master it, but I would need at-bats, and lots of them, from the left side. I also would have to be patient with myself, as my batting average and every other offensive category would suffer, initially, leading to fewer wins for my team.

Surprisingly, the Orioles replaced two-time ring playoff contender Lenny "Badger" Johnston. Our new manager, Jimmy Williams, liked to be called "Skip," short for skipper. A gristly man who may have played more hockey than baseball growing up in Canada, Skip nevertheless possessed a lifelong baseball history, playing at various levels in the minor leagues for the Brooklyn/Los Angeles Dodgers from 1947 to 1964. Jimmy stung the baseball for a career average of .290, with a dazzling 2,017 hits. He once shared the infield during spring training

Skip told me quite a story about playing winter ball in Cuba. While he played infield for a team based out of Havana on January 8, 1959, Fidel Castro and his revolutionaries rolled their tanks into the city and took control of the country. Jimmy heard celebratory gunfire all through that night, but the winter season never missed a beat. Fidel Castro loved baseball, and even the successful revolution he led to overthrow Cuban President Fulgencio Batista, was not going to interfere with the baseball season.

Over Skip's 40-plus years in professional baseball, he won a championship at every level, including a World Series ring in 1983. Jimmy coached first base for the Orioles, wearing number 40, when they toppled the Philadelphia Phillies over five games for the World Series Championship title. Cal "Rip" Ripken Jr. caught a line drive to his right for the last out of the series. That season Rip also received the American League's Most Valuable Player award at the young age of 23. Right behind him, in a close vote, came teammate and future Hall of Famer, first baseman Eddie "Steady Eddie" Murray.

Jimmy "Skip" Williams.
My manager on four teams and a World Series Champion coach for the 1983 Baltimore Orioles.

with Jackie Robinson and Pee Wee Reese, while a player in the Dodgers organization.

His overall record as a manager in the minors was 1,175 wins to 1,186 defeats. If six of those losses had been wins, Skip would have tipped the scales. In 1991, Jimmy was honored by being inducted into the Canadian Baseball Hall of Fame.

During the 1966 season, Skip managed one of the greatest MLB catchers of all time, the Cincinnati Reds Hall of Famer Johnny Bench. He also coached in the Show for the 1975 Houston Astros. Any player or coach who had

been in the majors kept one thing on their minds: to dust off the minor leagues and get back to the majors. For Skip, that meant winning ball games. He was smart enough to give himself the best player options possible. Trying out to make Skip's club and benefit from all his baseball genius excited me. If I made his team, I would be a full-time outfielder and utility infielder. Having been in the six spot for so many years gave me defensive leverage as a player, because a shortstop can play every position on the field, except catcher and pitcher. My father told me when I was very young that if I mastered playing short and I scored runs, and then scored even more runs, I would be playing the game I loved for a long time. My experiences proved him right.

Managers search out versatile players. Ones who score runs are prized. Even though I was a premier run-scoring machine, there is always pressure to make a club in spring training—and this year the competition in camp was stiff. I competed in the outfield against a swarm of high-draft picks. It helped that my number-one fan arrived in camp with two weeks to go before the ink on the rosters was dry. Sharon came to my spring training games and cheered me on.

Only one week remained before the final cuts. Some capable ballplayers left the locker room, holding a duffle bag full of gear in one hand and their one-way ticket home in the other. Fortunately, I saw a lot of playing time, I stroked more than my share of base hits, stole bases, scored runs, and worked hard. Given the talent I was competing against, it was natural and necessary to push myself to extremes.

At the end of a grueling day—with my name still above my locker—Sharon and I decided we would go to a café and then make a series of black-and-white, human-interest, moody night photographs. I drove a green Chevy Nova with some memorable years on it. The engine was easy for me to work on. "Queen Green" purred like a kitten.

We were cruising along when a Dodge Matador blasted through a red light into the intersection. In a jarring T-bone collision, I slammed the errant vehicle so violently the driver lost control. His car jumped a curb and wound up with its front end almost through the doorway of a corner bar. Glass and debris sprayed everywhere. The drunken and dazed man emerged jolted, loud, and livid.

We had crashed in the middle of Liberty City, a poverty-stricken, disenfranchised neighborhood of Miami in the 1960s and '70s. For racial tensions, this was one of the flintiest areas in the country. Irate

night-lifers straightaway surrounded our car, screaming obscenities, rocking Queen Green and pounding on its roof.

Staying in the vehicle, full of fear, seemed a far worse option than stepping out and confronting the crisis spiraling out of control. I made the call quickly, receiving confirmation once I hit the pavement that it was the right one. Surprised I had exited, the crowd's roiling mob mentality reduced to a low-level boil. They fed off fear, but I wasn't serving up an ounce of it.

"Queen Green," the day after our car accident in Liberty City, Florida.

Fortunately, men from a church congregation were putting up a revival tent, and one called the police from a pay phone. When the cruiser arrived, the patrolman said it was next to a miracle we were still recognizable, given his past experiences in Liberty City. After I completed the accident report, Sharon and I drove back to our cabin, holding each other's hand, in an unsteady car totally out of alignment, with one headlight, a smashed front end, and a crumpled hood. Shaken, we remained standing together, unharmed, and aligned, which was all that truly mattered.

Both my hands sustained painful bruising from the collision, but I still had to play ball the next day. It turned out to be a reprehensible one at the plate as well, with three strikeouts in my first three at-bats. And then four golf carts showed up for my final trip to the dish. The pressure was on. The brass sat right there, with clipboards and stopwatches up and out, ready to chart me. I fought off two pitches and managed a dime-store single when I drove a seeing-eye-dog grounder through the middle of the infield. Directly, I stole second base. The game ended and final cuts were made that night. The following morning, CHRISTOPHER remained above my locker.

Sharon and I were elated, feeling a heartfelt attachment to South Florida, the Keys, and Miami Orioles fans. Moving back to our same apartment complex in Coconut Grove, Sharon swiftly picked up waitressing shifts again at the Coconut Grove Hotel. We both eagerly awaited the season to begin and continue to expand our art pursuits throughout Miami and beyond. For me, photographing people and the human condition has always been a driving force, beginning

in 1964 when I was 10 years old, searching out compositional winners with my father in New York City. Every image tells an important story of that moment in time, and collectively, these frames add to our visual history as a species, and without a collective history, our existence would be an unexplainable void.

For me, playing in advanced A ball for the second year in a row as a Miami Oriole was not overly exciting. My rookie season performance, I believed, deserved a spot on the AA Charlotte Orioles team in the Southern League. But the brass put me on the other side of the plate to become a switch-hitter, figuring I would be able to develop those skills better in Miami than swingin' my bat in AA.

Playing for Skip proved to be the silver lining. We developed a strong manager-player relationship, although he was exacting. When we were losing, Skip's locker-room talks would vibrate my competitive core. If his first sentence began, "I have a red ass," you could anticipate the grocery-store cart, which we used to put our dirty uniforms in, to be relocated as Skip shoved

"The Journeyman"
I found this man's wise gaze and character very compelling. My photograph below touches me as deeply today as it did when I created it in 1977, during my season in Miami, forty-six years ago.

it across the locker room. The repercussions could be as ugly whenever a player made a mental error, though such intense discussions usually unfolded privately, *mano-a-mano*. But what goes on in a baseball locker room, the dugout, on the field, on the road, and in discussions stays with the players on your team!

I started in center field and became a full-time switch-hitter, thoroughly enjoying the concept. Since cutting my wrist in 1960, I had made many switches to left-handedness. Now, my mind easily choreographed the necessary moves, and my body responded naturally to hitting from the left side of the plate.

Coming out as a runner from the that side of the batter's box gave me at least a three-tenths-of-a-second advantage running from home to first, because a right-hander has to unwind his body and then take off. A lefty already has all his momentum headed toward first from the swing of the bat, torquing his body in that direction. He comes out of the chute with after-burners blazing. Another bonus, unique to me, was having my much weaker hand on the bottom of the bat. The knob of the handle pushing against my palm improved my grip, and my top thumb had more stability to drive the pitches. When I mastered it, this would be a strategic boost to place me on base to score even more runs.

In theory it seemed a valuable offensive weapon; in reality that was not the case. Toward the end of May, I had eked out a dismal .150 average, swinging my bat as if I wore a blindfold. Unless I abandoned the Orioles' experiment, it would not be long before I was handed fuel money to drive back to Virginia. I returned as a full-time, right-handed hitter in the nick of time and hit a sizzling, league-leading .375 for the month of June, ripping the cover off the ball, raising my average to .267.

My May average, though, cost the team runs, and we needed to be victorious. To reach the postseason, we had to win one of the halves of the season to force a playoff, to next face the Northern Division winner for the league championship. This elite title would be a significant one; if successful, it would eradicate the memory of our poor 1977 playoff appearance.

Of the 11 teams in the league, ours possessed enough talent to go the distance. After the last game of the first half of the Southern Division, the Fort Myers Royals ended up on top of the mountain. Now, to have a shot at the championship in September, the temperature was intense to win the second-half crown and force a playoff against the Royals.

Sharon and I, during Tom's Miami News *feature-article interview on my season and sci-fi novel.*

I posted on both offense and defense, playing a strong outfield, and being thrown out only once stealing a base. At this level of play, each member on the team felt the heat inside the pressure cooker of pro ball to earn a postseason playoff experience.

My numbers received attention from the brass, which gave me hope. I have always sensed that living life and being a part of the human experience is a primary color in the universe's great masterpiece. What I was not aware of was that my eccentric, artistic personality was difficult for many of the upper echelon to understand or accept. A corps of Orioles execs pulled me into Skip's office in early August, to grill me face to face. I had been transported back into the middle of a boxing ring. Skip and Ralph Rowe

On June 22, 1978, Sharon and I were featured on the front page of the *Miami News* sports section. The writer Tom Archdeacon, who later in his career would earn two Sportswriter of the Year awards, penned a masterful article. It highlighted our relationship, my baseball story, and the art I created during my Miami seasons. Tom was intrigued with my paintings, drawings, and poetry scattered all around our apartment. What captivated him most of all, though, was my three-volume, fully illustrated science-fiction novel I was writing. Tom wrote: "*The Tales of the Roving Mobileans*, a story set in outer space, puts *Star Wars* to shame. There's Gatlin, the hero, a crack gunner on a spaceship, now working to help preserve nature for the mysterious Wizard of the Universe; King Fishba; wild creatures with unnerving powers; a damsel in distress; alpha-ray guns; hidden documents; scorching treks across the deserts; landslides—Christopher has included them all."

Toward the end of his lengthy story Tom quoted me: "My energy level is so high after a game that I don't unwind until about 2:30 in the morning. When I get home, I write." And Sharon added: "Scott claims it's good for him to do both. It keeps him sharp all around. He feels baseball stimulates him physically, writing mentally. You've got to use all your tools daily, or they stagnate. Together, we've opened doors for each other."

were already seated and stayed in the background. The first question asked was: "Why are you the way you are?"

It was an inappropriate question and triggered me emotionally, because for two seasons I brought everything I had and more to the diamond, every day, for my team and the Orioles organization. I was quick to answer, "Baseball is art to me, and if you do not understand that concept, you will never comprehend me as a ballplayer." Then I listed my two season stats and finished by saying, "I am an artist in a an athlete's body that wins ball games." The room's intensity remained mixed; mine was locked on high. Their grilling continued, and I countered every verbal spear with precision retorts. My edgy presentation was not appreciated by the execs. They did not have the faintest idea of how my being was designed or how it functioned. The chieftains in the ring went silent. I put my sunglasses on, and the final verbal salvo was: "What's up with the sunglasses?"

I pushed them up the bridge of my nose with my index finger and replied, "They make me Happy, very Happy." Then I opened the door and walked down the lonely hallway, back to the locker room, where my teammates were groovin' to Cat playing his air guitar and singing Warren Zevon's, "Werewolves of London." It was like he was back on stage as the lead guitarist, in his former rock and roll band, "Night

I wore my large, purple sunglasses all season. They truly made me happy.

Stack." I grabbed my good-luck rhinoceros beetle shell, which had been my locker mate since the summer of 1970. I held "Rhino" up high and joined in the fun, moving my head back and forth like a turtle going in and out of its shell. I have always tried to live my life in the present. I put my encounter with the execs behind me quickly. For me, as a ballplayer, my purpose was defined, my passion was intense, my patience was long, my priorities were nonnegotiable, my perseverance persevered, and I perceived it was all possible. I felt

comfortable with myself and confident that I possessed all I needed to move forward. I had a baseball game to play in less than two hours. Our pennant race was heating up more and more with each game that passed, especially when we dropped one.

Several days later there was an envelope from the Orioles, laying on the top of my cleats. Given the outstanding season I was posting, I hoped it would be my long-awaited invitation letter to the Baltimore Orioles Florida Instructional League. And it was! This amazing feeling of accomplishment slowly washed over my body in warm waves of elation.

The Orioles wrote, "This program is designed to shortcut the rise of a prospect to the major leagues, and it has been a highly successful program in the past because we have carefully selected players for this program."

As the wins and losses piled up into the middle of August, we sparred with the Fort Lauderdale Yankees and the Pompano Beach Cubs in a three-team dogfight to claim the second-half crown.

Most of the season I batted in the number-three slot, and that was a tribute to me as a hitter, given our team of professional ballplayers, with several high draft picks. This lineup included the Orioles

BALTIMORE ORIOLES

American League Champions 1969 and 1971
World Champions 1966 and 1970

CLYDE F. KLUTTZ
Director of Player Development

August 11, 1978

Mr. Scott Christopher
MIAMI BASEBALL CLUB
2301 N.W. 10th Avenue
Miami, FL 33127

Dear Scott:

Our Florida Winter Instructional League program will again operate at St. Petersburg, Florida, on or about September 12, 1978 and you have been selected as one of the players that we would like to have with us at that time. This program is designed to short cut the rise of a prospect to the major leagues and it has been a very highly successful program in the past only because we have carefully selected players for this program. It is not a vacation but a concentrated work program which demands a willingness to work and a dedication towards wanting to improve yourself through hard work.

1977 number-one selection, Drungo LaRue Hazewood, along with: "Big Dan" Logan, drafted at number 45; David "Antelope" Caldwell, #97; Johnny "The Galloping Bull" Denman, #201; Russ "Winner" Brett, #253; Ben "Bring It On" Lancaster, #357; Tommy "Champ" Eaton, #435; Rob "Cat" Whitfield, #532; Vernon "Hammer" Thomas, #119 (1975); Steve "Five Star" Cook, #3 (1974); Steve "Bazooka" Lake, #71 (1975); and future big league catcher Dave "Cannon" Huppert (undrafted).

The Florida State League—which was sadly disbanded in 2020 due to Covid-19, but realigned and resumed operations for the 2022 season—continues to function as a hotbed for future MLB ballplayers. We strongly believed we were the team to beat. My defense—whether at left, center, or right field—hung tough. My favorite spot, center, provided me a direct line of vision of the ball coming off the bat, so I instantaneously gauged its flight, velocity, and direction. As I computed all this, I spread my Mercury wings to track it down. This was freedom on a baseball field, at its best. My future, three-time teammate and Hall of Famer, Cal Ripken Jr., once said in a newspaper interview: "When Scotty was running the bases, I thought I was at a track meet."

A baseball on that long flight and trajectory into the outfield has many spins on it, depending on how the ball launches off the bat. It can tail to the right if the batter's hands are coming through the zone earlier than the bat head. This gives the baseball a slice, and it will fade away from you, so you sprint with all the leg power you can generate, running at the perfect angle to flag it down.

I loved to run on a baseball field, covering territory in the outfield like a soaring hawk. The entire season, I made only four errors, two of those occurring on one play. This computed into the second-highest fielding percentage on our team for outfielders, and it tied me for the

lead in assists with ten. It convinced me that being one of the best defensive outfielders in baseball was well within my grasp, especially knowing the Instructional League would provide me the games and advanced coaching needed to reach my ultimate fielding goal, setting the sights high to become a gold-glover next season.

In mid-August, playing center field against the Yankees, I turned a play at the plate when the runner rounded third, churning hard to score. He was testing my arm, and I threw a strike for an out, as a fierce collision unfolded at home plate.

It was late in the game and my arm muscles were warm and loose, so what happened next was surprising. Releasing the ball, a muscle in my throwing shoulder tore, as if a rubber band had snapped. I grabbed my shoulder and rubbed it while I trotted toward home plate to check on our catcher, Douglas "Georgia Bulldog" Nave. Bulldog had told me just the week before that he loved catching because of the bang-bang collisions he longed to be a part of. Bulldog had charged the runner and suffered a broken femur bone in his right leg. When I got to Doug, he lay on his back—close to being unconscious—with his catcher's mitt resting on his chest, cradling the ball. The umpire called the runner out, ending the inning. Emergency medics were summoned and carried Bulldog off on a stretcher and into an ambulance parked along the third base line. Doug's career was severely compromised, although that did not derail him from seeing action in nine games during the 1979 season. Always loving baseball, Bulldog became the head coach for the Georgia State-U Panthers from '83 to '86.

I did not think much about my arm until the next day, when a darting pain shot from the side of my throwing shoulder every time I lifted my arm. I had ripped a section of my rotator cuff and would need cortisone shots the rest of the season to manage this injury. Our trainer, Ronnie Hart, jammed a horse needle into my injured muscles and "rocked the boat" by moving it around in a circular motion. For the first ten seconds, he might as well have driven a long, frozen, finishing nail into my torn muscles. Then my pain would subside for the next three or four games, meeting Ronnie's medical objective, until the time would come to receive another injection. Despite the setback, our team needed my offense. I got used to the big needles; winning every game had become that important, and I pushed the hurt out of my mind, which I was used to doing.

On August 19, before a contest in our stadium against the same Yankees, Sonny Hirsch, our team's colorful general manager, who always wore orange or red hibiscus-flowered Hawaiian shirts, told me I was close to setting the Florida State League record for the highest stolen-base percentage: 37 out of 38 stolen-base attempts in a season. I had 36 out of 37 notches on my spikes, and I'd cinch the record with one more steal, for a .973 average. My one stolen-base blemish occurred early in the season when a left-handed pitcher caught me leaning toward second and picked me off.

The Yankees second baseman that night was their winter draft number-one pick, Mark "Leather" Harris. Back in the fall of 1976, I had coached Mark at U-MD and knew him as an outstanding player and person, with an astute baseball mind. Before the game, Mark ribbed me, "If you get on first base, don't try to steal, because I'll slap the tag down on you, Hawk."

"Leather," I said, "I'll see you at second—I am going to track down the record, and when the dust settles, 37 will be in my back pocket."

Our team had dropped five straight games. Skip was vibrating the locker room as our losses piled up. In this must-win game, by my third at-bat, we led by a score of 3-2. I lashed a single to left field, driving in Vernon "Hammer" Thomas. Taking a long turn rounding first, I returned to the bag, already calculating my steal. The league's all-star catcher, Pat Callahan, an eighth-round pick out of the University of Miami, and Leather both anticipated I would attempt to swipe second base, but they did not know what pitch I would choose to set the record. It was paramount that I put myself in scoring position. I had to take the bag. Skip called timeout to talk his strategy over with our next hitter, one who thrived on executing under pressure, Big Dan Logan.

Standing on first base, my thoughts flashbacked to my senior year at Maryland, to a game when our team was shut out over a twelve-inning duel. During our contest the following day, the squad was coming up short. I stood on third base late in the game, with one of the finest hitters in all of college baseball, who swung his bat as if it were a magic wand, Dini, swinging away at the plate. The scoreboard registered two outs, and Dini had two strikes. I made the decision to steal home to give our team a boost. I was 100 percent sure I would be safe. The pitcher was oblivious that I was on the hot corner. He was consumed by Dini's fierce hitting reputation.

I glanced into our dugout and signaled to Bish that I was going to steal home. Being an astute student of the game, he was stunned. If Dini had a low inside pitch to hit, I would be carried off the field by my teammates or medical personnel. Scoring a run for my team outweighed any and all consequences. When you steal home, having no eye contact with the pitcher is a given. In baseball, you never wake a sleeping dog.

Keeping the righty in my peripheral vision, I slowly walked farther down the outside of the white chalk. With his first movement, my legs went into a full sprint. I was going to dive into the dish head first, finding the plate with my left hand in a churned-up dust cloud. The baseball gods were poised on my shoulder, as the pitch was called a ball. I safely tallied a run, unscathed. Dini looked at me as he helped pull me up out of the dirt and said, "I could've killed you, Hawk." I responded with one word: "Score." Bish ran out of the dugout and gave me a smacker of a high five. The pitcher picked up the rosin bag and slammed it into the mound.

Now, in this pivotal Yankees game, second base was going to be *mine*. From the minute a pitcher starts his warm-ups and throughout the game, I would study every pickoff throw, imprinting in my mind his moves from his set position and noting the precise moment I would get my best jump. With a right-handed pitcher, the knee is the key. Left-handed pitchers are much harder to run on, because they can freeze their front leg with their right knee bent and give you a longer stare. If you break toward second too early, they halt the rotation of their body, aim their leg toward first, and fire a pickoff throw. When a southpaw freezes you leaning or flat footed, he will pick you off, and you will resemble an awkward court jester, hogtied in a baseball uniform.

Starting Yankee pitcher, left-hander Mike McLeod, a former Florida State star and nineteenth-round pick, had pitched a strong game going into the fifth inning. Mike had a quick and tough move to read over to first, keeping his delivery to the plate tight. My steal would come down to inches if Callahan put his throw on the money. When catchers have speedsters on the base paths, they want fastballs thrown up on the left side of the plate, providing the best chance to gun you down because they catch the pitch closer to the release point of their own throw.

I hoped for a breaking ball of some kind that would give me an additional half a step over a fastball. Big Dan Logan entered the batter's box. He would give me a strike unless the pitch was in his wheelhouse,

so I could get in scoring position. Big Dan, six feet, seven inches, loved to chalk up RBIs, as all cleanup hitters do. The gifted swinger aggressively tagged his pitch early in the count and drove a long fly to deep center field. I had to return to first base.

Skip relayed signs to me and the hitter. He was moving about his uniform, like a mosquito in a stiff wind, with both hands. When he touched his left wrist with his right hand, this was the key. Then he swiped the brim of his hat, giving me the steal sign on the first pitch to hitter Steve "Five Star" Cook. Five Star had quite an ascent to pro ball, having been drafted three times, two of those in the first round of the winter draft, in three years. Steve was academically focused and chose to stay in college before he had a tryout with the O's, signing in 1976.

The largest home crowd in two years, 4,014 fans, sensed I would be taking off. I had studied McLeod for this exact situation. When he went into his stretch, I waited for him to commit to his pitch, more than ready to come out of the blocks. Giving me a long look, he turned back to find his target from Callahan, and without notice fired a quick throw over to first as a warning shot across the bow not to steal.

As McLeod went back into his stretch looking for his catcher to throw down signs for what pitch to throw, he began to raise his right leg. But his head and eyes swiveled in my direction, with his gaze firmly fixed on my legs, hoping I would start my stride. McLeod's leg, up like the bent leg of a marching band's drum major, was above his waist and frozen, as if it had been cast for a bronze sculpture. If I made the slightest twitch toward second base he was coming over.

My eyes were glued to his entire body, because it was the distribution of his weight that would be my signal to run the record down. At the split second his shoulders and hips began to rotate towards home plate, my take-the-base light switched from red to green.

With a shortened lead, I threw my shoulder open toward right field and took a long cross-over step. Starting off low, I came up with my

first three strides. Many base runners make the mistake of coming up too quickly, which costs them half a step. On average, I needed two fewer strides stealing a base than most runners, and my stride was extra-long because I pushed myself out of the dirt, claiming as much real estate as I could, off and running for the record.

I could always tell, when stealing, the exact location of the ball by reading the fielder's eyes. Mark's were wide-open, and that told me the ball was almost there. If Callahan put his throw in a Dixie Cup, on the bag to Leather, my claim for the record would be determined by a matter of inches.

Mark straddled the bag, in perfect position. His glove was wide open and three feet above the ground. I threw myself into an extreme hook slide toward center field, falling into the earth to catch the back corner of the bag and be as far away from the catcher's throw as possible. Even though this measured only a six-inch difference, every inch from start to finish is important to a base stealer. Dirt flew up thick and high.

The throw was almost there. The catcher had delivered a near strike. The umpire crouched right into our mix. I thought I might be gunned down. Leather wanted to slap his tag right through my spikes before they touched the bag.

The record began leaning my way. Mark was letting the ball travel, but he had to stretch his glove out a foot in front to retrieve the throw. By having to reach for Callahan's dart, which fell 12 inches short of perfect, Leather had to bring the ball back to the far corner of the bag to slap down his tag. With the brown dust swirling in the air, I could see the umpire's arms straight out. Blue called me safe.

Skip directed a series of quick claps right at me. Mark said, "The record is yours, Hawk, nice steal." And he kicked up a flare of dirt as he returned to his position. I called time-out, pulled myself up, and brushed off my dirty uniform.

This stands as the most important stolen base I ever notched on my spikes. And I had earned the record by developing my leg strength, running 40-, 60-, 100-, 220-, and 440-yard sprints, since the age of 12. I learned early that sprinting also develops the optimum on/off firing that my leg muscles needed for speed. Running cross country—as difficult as it was for me mentally and physically, because I was built as a sprinter from head to toe—strengthened my endurance and lengthened my stride, as did racing down coach Jackson's 15-degree asphalt lane. I

systematically improved my speed one-tenth of a second at a time, over many years, covering 90 feet. This is the distance between the bases, and frequently inches determine if you are called safe or out when you steal. It was common sense that speed would give me the edge I needed to be a record-setting, human base-running laser beam.

As I worked my way back to second, the steadfast fans were energized. I wanted to hug each one of them for supporting our team's pennant race and embracing me from the stands in my glorious moment. I located Sharon standing up next to our dugout, along with her dear friend and O's loyalist, Billy Rowe. She was smiling from ear to ear, and so was I.

At the plate, Five Star, who had almost a thousand pro at-bats and thrived with pressure bearing down on his shoulder, smoked a liner into left-center field. I scored, and we won our must-win game 5-2.

Later, Sharon and I would celebrate at the chic Coconut Grove Hotel, where she worked, enjoying chocolate ice cream, cheesecake, ice-cold Coca-Cola's for me, and cappuccino coffee for her. We had lots of fun and closed the lounge, sharing our love and one of the grandest moments I had ever experienced. My heart raced: I had placed the Florida State League's stolen base King's Crown on my head. And I am wearing it today, as my golden-spikes record still stands strong. Athletes should always take time to honor their own accomplishments and be proud of themselves. I did just that.

My hook slide locked in the back corner of second base by no more than two inches. I did it. By the season's end, my winged spikes stole 41 out of 42 bases, to lead all of professional baseball with a .977 stolen-base success rate for the 1978 season. This was, and still is, an all-time record, 29 or more stolen bases, for the Baltimore Orioles organization. Wow! What a record to be extremely proud of.

To put this into perspective, if I had tried to steal 1,000 bases, my success rate would have been 977 swipes. In my final two Maryland seasons and my first two professional campaigns, I achieved an amazing 92 bases stolen in 97 attempts for an exceptional .948 average. I had only been nailed five times, and three of those were by left-handers who caught me leaning. I may have had a withered arm and handicapped right hand, but I loved to run, steal bases, and score runs—and I was very, very skillful at all three.

THE GREAT 8TH

THE DREAM MANIFESTS

With two games left in the season, we needed to win both, or there was no tomorrow, no postseason, no jousting for the ring. Each of my teammates wore the same expression: *determined*. We shared a collective mindset: *victorious*.

In the first game against the Cubs, we won 7-4, dousing their playoff hopes. Squaring off with them again in the season's finale, our "bring out the fire extinguishers" offense snuffed them early, prevailing 6-3. As third man in the lineup, I swatted three hits in five at-bats, with two runs batted in. We had done it—but would we qualify for the division title? Our fate was being played out in another stadium.

We waited for word on how the Fort Lauderdale Yankees fared. If they swept their doubleheader, we would be eliminated from a playoff berth. The Yanks lost their first game and narrowly won the back end of their twin bill, 2-1 against the West Palm Beach Expos. The Southern Division second-half title belonged to us—by a microscopic two-thousandths of a percentage point: .559 to .557! The *Miami Herald* sports section article on August 31, 1978, was titled: "Baby O's Win to Keep Their Hopes Alive." We charged into battle, giving our adversaries the best of our best. When it came down to our last three, pressure-packed games, we *had* to be triumphant—and we *were*.

For the title, we were now pitted against the gritty, first-half division champs, Fort Myers Royals, in a one-game, postseason playoff to

be staged on our home field. This was a critical game for me and my teammates. We had to send the Kansas City Royals affiliate back home, defeated. Almost all professional ballplayers have faced, at some point in their baseball lives, this must-win moment in a playoff bridge game leading to the championship series.

After six months of baseball, day in and day out, there I was, a heartbeat away from being able to play in the series for one of the most coveted trophies in all of sports, a professional baseball championship ring. My throwing muscle was seriously ripped. I rubbed it down multiple times a day with Atomic Balm. This gluey, light-orange ointment that was formulated with long-lasting petroleum bases, left me with a fire in my muscles for an hour or more. Then the inferno slowly lifted, leaving my injured muscles semi-numb, allowing me to suit up and play. For this game, I needed a large dose of cortisone, shot and rocked far into my shoulder.

As a key player on our team, I used every bit of talent and guts I could deliver, to walk off the field a winner. If the Royals catcher stood in my way to score a playoff run, I would crash into him like a wrecking ball. And if that would be my last play of the game resulting in an injury, my teammates would assist me off the diamond smiling.

Reminding myself not to project beyond a game like this; I aimed to win, at all physical and psychological costs, realizing this was the most important game of my life. There was no way to claim the ring if our team was not victorious.

Sharon and I drove to the ballpark together. We talked about the upcoming battle and listened to Elton John's *Greatest Hits* album on the 8-track. Shortly before we arrived at Miami Stadium, she said, "This is going to be a super night to watch you play. Our season is not going to end—you like pressure. How are you feeling?"

I replied, "Like I am on top of the world, Whippoorwill. I can't wait for our game to start. I am going to hit up a storm. Our team is hot, we're gonna whip 'em good."

Sharon said, "Right on," and we both started singing to Elton's music.

Skip was pitted against a strong baseball mind, Royals manager, Gene Lamont. With the tension attached to this game, Jimmy penciled me in as the number three hitter. He knew *pressure* was not in my vocabulary, and his instincts paid off. In the bottom of the third, we were losing 1-0. Their starting pitcher, Erik Hendricks, had been drafted four times before signing with the Royals in 1978. He sported

an incredible season-ending ERA of 1.89. Erik had not given up a home run all season. I had to get our offense jump-started. The Royals were spot pitching me, jamming me with fastballs and then threading the needle with breaking wrinkles. With a 2-2 count, Hendricks threw me a sharp, biting slider on the outer half of the plate. This pitch's location enabled my handicapped right hand to find its power. I crushed the ball 360 feet into the right field wall, four feet away from being a much-needed playoff home run, for a stand-up triple. Following my hefty swat, clean-up hitter Big Dan was intentionally walked.

Our next batter, with me and Dan on base, was third baseman Russ "Winner" Brett, who could have been a punter in the NFL but loved to play baseball more. He lashed a single over the shortstop's extended glove, driving me in to tie the game. I eliminated our goose egg and popped the cork for our offensive barrage. Following Winner to the batter's box was center fielder, John "Galloping Bull" Denman, who pulverized a fastball over the left field wall for a three-run homer. Hendricks would be heading to the showers soon. Our team was in for a playoff dream of a game. Starting with my run, the O's crossed home plate 11 times over the next four innings.

The *Miami News* headline the following morning read: "Miami Oriole's Big Night Has No Bounds." We came out swinging and demolished the Royals 13-2. Our seventeen-hit assault sent chills through our opponents' dugout and bullpen. Even though I was 2-4, scoring two runs and notching one RBI, I now had to find a way to dig down to give my team, and myself, a 110 percent-plus championship series.

Gene Lamont was the Detroit Tigers number-one pick in the 1965 MLB draft. He saw spot playing time in the majors as a catcher. For most of his playing career, Gene bounced around the minors. His first managing post was in 1977, leading the Fort Myers Royals.

In 1992 Gene became the Big League manager for the Chicago White Sox. In 1993 he guided the White Sox to a first-place finish in the AL Western Division, with a 94-68 record. For that season's superior managing result, Gene was honored as AL Manager of the Year. He ended his MLB managing career with a record of 553 wins against 562 losses. Then he became a coach for the Pirates, Red Sox, Astros, and Tigers until 2017.

In 2018, Lamont was hired by the Royals to be the special assistant to the general manager.

Four photographs of me were published, with the story of our victorious, winner-take-all playoff game. Above the fold on the front of the *Miami News* sports section was my favorite: a photo of me scrambling back to home plate after a fierce collision. The Royals catcher, fifth-round pick and future AAA-er, Dave Hogg, aspired to rattle my bones with a body slam into the dirt, but all those years of wrestling served me well.

Since Dave was firmly set up before I got to the plate, my only option was a direct hit. I drove my forearm into his head, sending Mr. Hogg's helmet flying and driving his left leg back a foot. As he stood up and regained balance, angry and fully stabilized, Dave had one primary objective: pound me hard into the dirt and unleash a tremor that shook home plate. Dave initiated a body slam. Instinctively, I hooked the angry catcher under his left arm and pulled him over onto the ground with me—a classic wrestling maneuver, which caught Hogg wholly off guard. The human steel block smashed me down into a pancake powdered with dirt.

I was going to be called out, but in our scuffle, with both of us being hurled into the dirt, the impact jarred the ball out of Hogg's glove. Vernon directed me to home plate to score another important playoff run. Blue threw his arms out like a horizon line, and yelled, "Safe." Mr. Hogg went ballistic with the call, going face to face with the ump and releasing a fifty-word tirade. Unable to control his anger, Dave went off the rails, forcing the umpire to toss him out of the game. My run made the tally 7-1, and the season was all but over for the Royals. Hammer and I had a bird's-eye view of the altercation. When the dust settled, I returned to the dugout rattled, to my large-eyed and joyous teammates.

Sharon had left her seat and walked down to the front row to ask me if I was hurting. I told her I was shaken up but okay. Then I winked and said, "The Royals may need an oxygen tank, especially their catcher." Skip had come to the dugout to assess my post-collision condition. He heard what I said to Sharon and commented, "Big run, Scotty." We both cracked a smile, and he walked back to his coaching box.

After the game, Gene Lamont was quoted as saying, "It could have been different, if they did not get that early homer, but what can you do? It's been a damn good season."

Skip kept our celebration low-key, as we needed to conserve every bit of energy we could to claim our RING. Excitedly I looked forward, as

I was now within striking distance of two of my lifetime baseball dreams.

We were a team of seasoned professionals, and each of us knew advancing to the championship series was in our back pocket. Ace pitcher, Larry "Engineer" Jones, pitched a four-hit complete game, to earn a win in the season's most important match to date. Engineer was ALL champion and a winner of the highest order.

```
FORT MYERS              MIAMI
           ab r h rbi              ab r h rbi
Webb 2b     2 1 1 0   Eaton 2b     5 3 2 2
Garcia lf   4 0 0 0   Thomas lf    4 1 1 1
McConn 3b   4 0 1 0   Christopher dh 4 2 2 1
Wieser rf   3 0 0 0   Logan 1b     1 1 1 2
Wooten dh   3 1 1 1   Brett 3b     5 1 2 1
Westendorf 1b 3 0 0 0 Denman cf    5 2 4 4
Hoscheldt cf 4 0 0 0  Hazewood rf  3 0 0 0
Hogg c      2 0 1 0   Whitfield ss 4 2 2 0
T.Johnson c 2 0 0 0   Lake c       5 1 3 0
Concepcion ss 2 0 0 0 Total       38 13 17 11
Total      29 2 4 1
```

```
Fort Myers              100 000 001—2
Miami                   004 331 02x—13
  E — Hendrick, Hogg, Concepcion, Webb.
DP — Fort Myers 2, Miami 2. LOB — Fort
Myers 6, Miami 14. 2B — Eaton. 3B — Chris-
topher, Eaton. HR — Wooten, Denman. S —
Christopher. SB — McConn.
                    IP   H  R ER BB SO
Hendricks (L)       3⅓   6  7  6  6  3
Lowman              1⅔   5  3  3  1  1
Prince              3     6  3  2  2  1
Jones (W)           9     4  2  2  6  5
  Balk — Hendricks. WP — Hendricks.
Prince, Jones. T — 2:30. A — 757.
```

When there is no tomorrow, champions rise to the occasion. We put on a pitching, hitting, fielding, and base running clinic in this do-or-die playoff game.

My teammates and I had all playoff cylinders firing red hot, and we were riding high, heading into the championship series. To win the professional ring, we needed to prevail in six of our last seven games. With four in a row notched on our belt, now we faced a best-of-three series against the Lakeland Tigers. Our team was two victories from the ring, that close to taking the crown.

My athletic life, its purpose and aim, came down to winning this championship. All the sweat, blood, and sacrifice had set the table for a baseball series of this caliber. Confident my body would follow my mind, I applied my ultimate level of concentration and precision. Losing in the ACC finals—and not having any hits or scoring any runs—to Clemson in 1976 still stung. That taste of defeat remained vivid, as did our playoff elimination in the 1977 season to these same Lakeland Tigers. Now it was their turn to suffer, and my teammates readied to deliver the firepower on both offense and defense to bring the championship back to the Magic City, Miami.

Beyond excited, Sharon and I exulted in reaching this proving ground. Our first two years in the minors entailed hours of hard work,

a ton of sacrifice, and also lots of memorable times. I wanted to win my championship ring for both of us, for my mother and father, for Mike, for every manager and coach, and for every teammate I had shared a baseball field with that gave the Great Game their best 100-plus percent.

I approached this ring series in the best position I could be in as an athlete, in the league the Orioles had assigned me to. I was hitting in the number-three slot, with top-notch teammates and a lineup of hitters who could turn a game around with one swing. To be a professional champion is an elite club, a golden accomplishment in all sports. I only allowed one thought in my mind: 110 percent effort to win the **RING**!

The Tigers had nine future big leaguers and the 1976 MLB Rookie of the Year and two-time All-Star pitcher on their team during the course of the season. These included a treasured fan favorite who had conversations with the baseballs before he threw them and would not allow spike marks on the mound: Mark "the Bird" Fidrych. The Bird posted a 19-9 record and led the American League pitchers with a 2.34 ERA in 1976. Mark was optioned to the Lakeland Tigers, after he recorded an opening-day win for Detroit, in an attempt to rehabilitate a torn rotator cuff he suffered on July 4, 1977, pitching against the Orioles. He never fully recovered from this injury and ended his MLB career with a 29-19 record. The Bird's last MLB appearance was on October 1, 1980, earning a victory in Toronto against the Blue Jays. The Tigers also boasted their 1978 number-one draft pick, 1984 and 1988 World Series champion, 1988 NL MVP, and 2011 NL Manager of the Year, Kirk Gibson. I felt quite proud to out-hit Kirk by 48 points in the 1978 season.

Our first contest in Miami Stadium was a thrilling, close-combat struggle. Starting the championship series was ace lefty, 11-game winner, Will "King" George. A force on the hill who had the mind and talent to always keep his team in the game, King was the 149th player chosen in the 1977 MLB draft and a masterful southpaw hurler, posting an 11-6 record with a 10th-best in the league ERA of 2.52. Pitching for Will was a spiritual pilgrimage. King got in a jam in the third inning, with the bases loaded and one out. We were losing 4-1 when Skip called on former Ohio State star pitcher, Russ "Worm Killer" Pensiero, to put the fire out. Worm Killer extinguished the flames quickly and pitched 4 1/3 scoreless frames to keep us knocking loudly on the front door.

Going into the bottom of the eighth inning, we were down 4-3. Our shortstop, Cat Whitfield, went to the plate. He battled the Tigers

pitcher, Dave Steffen, for ten pitches, taking hefty cuts, sending foul balls straight over the umpire's head into the screen behind home plate. The eleventh was a fastball that Cat drilled far into left-center field, for a two-run double. It bounced off the tip of left fielder Darrell Brown's glove, who raced a long way to track it down. Darrell missed recording an out by one inch. That shot knocked in Johnny Denman and Russ Brett to earn us a must-win victory by a 5-4 margin. One inch in baseball is like a mile at times, if that inch is not in your favor.

The Tigers ace relief pitcher, Dave Steffen, who was 9-4 on the season, with a remarkable 0.87 ERA, threw a tirade after getting the last out of the inning. Angered, he launched his glove into the dugout and stomped on his cap.

Cat's heroic at-bat, in one of the best hitter-pitcher duels I ever witnessed, proved to be fatal for the Tigers. Luis Peralta earned the win after relieving Russ, pitching 1 1/3 innings to end the game. Luis was having strike call issues with the umpire. A newspaper quoted him saying, "I'd die before I would try and change my pitch."

Kirk Gibson was the MVP in the 1984 ALCS against the Kansas City Royals. The Detroit Tigers then went on to defeat the San Diego Padres for the World Series title. In 1988 he had one of the greatest World Series at-bats in history. With two outs and his team, the LA Dodgers, one run down against the Oakland Athletics in the bottom of the ninth inning, he was put in the game to pinch hit against future Hall of Famer, relief pitcher Dennis Eckersley. Kirk had a severe leg injury and was suffering at the plate. He battled Eckersley to a full count before he launched a long, two-run homer to deep right field to win game one of the series. Kirk hobbled around the bases and is famous for his double-clutch fist pump as he rounded second base. The Dodgers went on to win the World Series championship four games to one.

Will George is celebrating his 47th year in professional baseball in 2023—the last 24 of those campaigns with the Colorado Rockies as a senior major league scout.

Russ Pensiero pitched the 1980 season for the AA Southern League champion, Charlotte Orioles. He went 9-4 with a 16th-best-in-the-league ERA of 2.67. Russ was known as the "Worm Killer" because his most effective pitch was a sinker, and the hitters grounded out, hitter after hitter, killing the worms around home plate. Worm Killer pitched in 127 games over six professional seasons. We had quite a romp as roomies on our roadies.

Rob "Cat" Whitfield breathed baseball, both on and off the field. He was born legally blind. It was determined by doctors that he could not see light as a baby. Over time, Cat went from wearing very thick glasses to wearing none at all, beginning in Little League. As a rising star in his hometown of Charleroi, Pa., Rob earned the following honors: Charleroi HS - Captain and MVP; Garrett Community College, McHenry, Md. - MVP and HOF; Anderson Broadus Univ., Phillippi, W. Va. - MVP and HOF.

One of the greatest quarterbacks in the history of the NFL, four-time Super Bowl champion and HOFer, Joe "The Comeback Kid" Montana, was a pitcher on Cat's American Legion team. Rob was selected in the 21st round (#532 overall) of the 1977 MLB draft. He went on to play for seven years in the Orioles organization. Five of those seasons were affiliated with the AA Charlotte Orioles as a player and coach.

At 6'4" and 186 lbs., Cat was a natural playing shortstop with the glove and arm to prove it, complemented by 1,593 career at-bats. Rob's 1980 AA season commanded attention, as he hit .254. His team, the Charlotte O's, won the Southern League Championship, with Cal Ripken Jr. at third base. During the season Cat was married in Weirton, W. Va., to his college sweetheart, Vicki. They were the first to leave their own wedding reception to drive back to Charlotte. With three hours of sleep, Cat suited up and played shortstop. A gifted musician, Rob could sing and rock his Les Paul electric guitar. He had a very lively personality and drove a souped-up, white 1969 Z-28, 350-cubic-inch muscle car, with two Cat-in-the-Hats painted on his rear spoiler. I felt privileged to play on three teams with Cat. His passion and purpose for baseball and life was, and still is, anchored in steel.

Now we led the series, 1-0, having won our fifth straight game. Only one or two more hung in the balance for the ring. It was our championship to seize and our crown to lose.

We played a lopsided second game in Lakeland, at Joker Marchant Stadium. The headline in the *Miami Herald* read: "Lakeland Slams Miami, Evens FSL Title Series." We lost the game 8-2, and our offense scattered only five hits. The article stated, "The Orioles scored in the second when Vern Thomas singled, stole second, and scored on Scott Christopher's triple." I was seeing the red seams of my pitches clearly in our first two championship matches, and I sautéed a 2-2 slider well into the left-center field alley. Unfortunately, the Tigers silenced our team's bats and turned them into chopsticks.

After a total of 1,533 games were played in

the 1978 Florida State League season, the premier game of the entire schedule loomed, one day away, promising to be the zenith of any pressurized contest I ever played. Envisioning my ring sitting solidly on my finger, I closed my eyes in quiet meditation and visualized my dream materializing. The mathematical odds of getting the opportunity to crush a ninth-inning homer are highly improbable, but I had been dreaming of that homer since my days in Little League, playing with a handicapped and withered right hand all my baseball life. I was going to dream super big for the next 24 hours. I would be more than ready to have the game of my life.

The Tigers manager, former professional catcher Jim "Bobcat" Leyland, won the last two years' league championships, prevailing in 9 out of 10 playoff games. With a sharp baseball intelligence, he was a fierce competitor who had eliminated the Orioles from the 1976 and 1977 postseasons. Bobcat dearly wanted his third ring. And I dearly wanted to return the agony of losing the most momentous game of the season to him and his Tigers.

So did Skip. The Orioles had not won the crown since 1972. This final-game dustup for the championship was not only between teams; it was between Jimmy Williams and Jim Leyland, two managers who possessed enough seasoning on them to put Morton's Salt out of business. Both managers loathed losing, loved competing, bled baseball, and entered this winner-take-all cockfight like two roosters poised for a barnyard brawl.

Four hours before our title bout, thunder and lightning punctuated a hard rain that lasted two hours and dumped one and a half inches of water on the field. The sandy infield

Coach Jim "Bobcat" Leyland went on later, in his 22-year MLB managing career, to take three teams to the World Series finals. His 1997 Miami Marlins won the title over the Cleveland Indians in seven games. In 2006 the Tigers lost to the St. Louis Cardinals, and in 2012 his team fell short to the San Francisco Giants. When he hung up his uniform in 2013, Bobcat had guided his clubs to tally 1,769 wins against 1,728 losses, with a playoff record of 44 and 40. Coach Leyland was voted Manager of the Year three times, in 1990, '92, and '06, in his respective leagues. This was a manager who knew how to guide a baseball team to consistently be in the hunt to compete for and win championship rings.

drained well, and the ground crew worked tirelessly to keep our game from being postponed. The first pitch was delayed by only 15 minutes, though our batting practice and infield warm-ups were canceled.

The downpour gave the Tigers an advantage, since our team had 184 stolen bases to their 120 over the season. The soggy dirt would hinder our aggressive base running. But no amount of rain would douse my athletic fire. Sixteen-plus years of competitive sports had taught me to keep that flame crackling until the first pitch ignited an inferno that scorched every cell in my body, all the way to the umpire's last call of the night.

The air was humid and thick—and so was the intensity for our game. In the locker room, Skip launched into his most important and inspiring speech of the season, beginning with spitting into a cup. One of Skip's memorable traits was that he spat a lot. He would push two fingers into the middle of his lips, and his spit would shoot out through his vee'd fingers like a cobra's venom.

Jimmy had won two professional championships as a manager: one in 1966, piloting the Leesburg Athletics, and his second in 1970, managing the Columbus Astros. In 1977 he had managed the AAA Albuquerque Dukes to a fourth-place finish in the Pacific Coast League. He keenly understood his players' abilities and, equally important, how to mold those individual strengths into championship teams. Just as we were about to take the field, he seized the moment to prepare us mentally to win. We had earned the right, he told us, to be in this game because each of us was a pro ballplayer, a champion, and we had fought all season to play for the crown. "I started playing pro ball in 1947," he said, "and what I cherish most are my championships. I want every one of you ballplayers to leave this stadium as warriors and champions."

Champions are made, not born, and I intended to make this the game, the manifestation of every dream since I started playing baseball with Dad and Mike in 1959. They, along with Mom and Mike's parents, brought my hand back, restoring my dream of winning it all. I would hit the ninth-inning homer in the final game, to walk off the field wearing my ring. That long-cherished dream flashed before me like a lightning bolt and resonated through Skip's delivery.

He concluded with his favorite, competitive line, which he had repeated all season long: "Let's get it done." When we heard those words, it was time for us to take our gear to the dugout and prepare ourselves

mentally and physically for the battle. Skip had focused us on what we had to do and how we had to do it: outmatch the Tigers with our bats, pitches, gloves, throws, base running, and most importantly, our minds and competitive must-win team spirit.

I sat by my locker with my S-2 Louisville slugger in my hands, all 34 inches and 32 ounces of it. My bat of choice was made by Hillerich & Bradsby. They burned into the end of it, in black, block letters, "CHRISTOPHER." I called my bat "Thunder." The pine tar on the handle was thick. Tapping the end of it on the concrete floor and then holding the barrel up, I said, "It is you and me tonight, Thunder. Let's rip the cover off the ball. Crush 'em with me, Thunder!"

As we left the locker room, our spikes on the concrete sounded like a hailstorm on a tin roof, echoing that long-ago thrill of being in the Orioles clubhouse at age eight. The most consequential game of the season—and of my life—was only an hour away. I could not wait to dig my spikes into the batter's box and power baseballs all over, and out of, the park.

From the dugout, the field might have been an Edward Hopper painting. The green grass and the infield's brown dirt popped under the ballpark lights. While fans started to fill the stadium, I laid my glove on the bench. I would not be playing in the outfield, as the torn muscle in my shoulder hadn't healed. I put Thunder in the bat rack and stopped by the corner of the dugout, where Sharon sat with a cluster of loyal Oriole fans, teammates' wives, and girlfriends. She blew me a kiss and crossed her wrists and flapped her hands like a flying Hawk. I gave her an air-kiss back and drew a heart with my hands; this was "*the* game" for both of us.

Heading over to the foul line to begin warming up, I jogged into center field and back, five times, all the while visualizing scoring runs. Since batting practice had been canceled, I took my rips in my mind. Swinging Thunder, I hit every mental pitch dead-center and drove the ball all over the yard. I visualized over and over again taking a tough pitch for a long ride over the fence. Thunder was a proven gamer. My teammates and I had won lots of championships since we started playing Little League as kids, on different clubs scattered around the country. And here we were, ready to play for it all. Our team—tied for the season's highest batting average in the league at .261—was the team to beat. We knew it, and so did the Tigers.

During our previous games, I had studied every Lakeland player, none more so than their outfielders. I evaluated their throwing arms and running speeds so I would be able to determine if I could stretch a single into a double, try to score a run from second base on a single, or whether to tag up on a sacrifice fly to out-run the throw to the plate.

Lakeland reserved one of their pitching aces for the final game. Not a bad chess move, by any standard. They hadn't won the last two championships by accident. The pitcher, future big leaguer Jerry Ujdur, was 5-2 on the season. We countered with a hotshot on the mound ourselves, a 1977 second-round draft pick, Tommy "Skid" Rowe, who had notched 10 wins since opening day. When Skid started strong and had command of his three pitches, you could expect him to go the distance. He was a stalwart ace hurler who pitched in 291 contests over his 11-year pro career. Skid liked my hawkish, must-score style of play and compared it to the MLB legend, Pete Rose. He once wrote to me saying, "You had and have an incredible ENERGY about you. You lifted EVERYONE up around you. You were the 'CLASSIC' CATALYST!"

Our leadoff hitter, Tommy "Champ" Eaton, a rugged player from Oklahoma, had suffered an ankle injury in game two that benched him. This represented a weighty loss for us, as "Champ" was a leader, excellent hitter, base runner, and defensive second baseman. His more than capable replacement from Kentucky, Ben "Louievulle" Lankster, would be the starter at second base. That meant I would be moving from my number-three, power-hitting slot in game two, to leadoff batter. I needed—I demanded of myself—a successful at-bat. If I jumped on their pitcher, it would give our team momentum and help shake any championship nervousness out of the dugout and my teammates.

In 1982 Jerry Ujdur was 10-10 with a 3.69 ERA, pitching in the big leagues for the Detroit Tigers. He spent five seasons in the majors, from 1980 through 1984.

In 1979 Champ Eaton, playing for the AA Charlotte Orioles, won the Rawlings Silver Glove award as the best fielding second baseman in all the minor leagues, at .991.

Jerry Ujdur warmed up in the Tigers bullpen. A fourth-round draft pick in June, he ended the regular season with a solid, highly respectable ERA of 2.39. I watched his every move and each of his pitches closely. With an ERA like that, you have to score early, because control pitchers get stronger strikes as the

game progresses. Jerry had only given up one four-bagger the entire season.

I pulled Thunder from the rack and timed my swings to Jerry's pitches outside of our dugout. Skip walked by and asked, "How do you feel, Scotty?"

"You won't have a red ass tonight, Skip," I replied. We both laughed while I simulated perfect-contact game rips.

Tommy "Skid" Rowe is the epitome of a great baseball player. Skid wanted to be handed the ball, to pitch every game of the season, if that would have been physically possible. Believe it or not, Tommy would have kept throwing until he had to bounce the ball across home plate. He chewed up the mound with his spikes, wanting to battle every hitter. Tommy was intimidating.

Drafted in the second round of the 1977 MLB January draft, Skid compiled a stellar career over 11 pro seasons on the bump (1977-1987). This included five seasons in AAA where he pitched 534 innings.

Tommy branded an exceptional career ERA of 3.72. He deservedly made the All-Star team at every level he pitched. His career accomplishments are brilliant, playing in the Orioles, Seattle Mariners, Cleveland Indians, and New York Mets organizations. In 1981, playing for the Orioles AAA Rochester Red Wings versus the Pawtucket Red Sox in Rhode Island, Skid kept the pitching charts for the first 25 innings of the longest professional baseball game ever played, at 33 innings. He pitched the following day, a very cold Easter Sunday noon game, and hurled eight shutout innings. When the game concluded, the O's had charted 41 innings of baseball in less than 24 hours (professional record), and 20 consecutive scoreless innings.

We played on four clubs together, and teammates like Skid Rowe are why I loved to play the Great Game. His admiration for baseball and the courageous intensity he brought to a team's competitive fire contributed immensely to them winning multiple professional championship rings.

At age 65, Tommy is still taking the mound in a summer league in New York for the Pelham Mets. Mixing it up with much younger players since 1989, Skid has an impressive record of 111 wins against 32 losses, with a 2.35 ERA. Having battled HOFer Reggie Jackson at the plate and dueled pitcher Ron "Louisiana Lightning" Guidry (1987: 25-3; 14 MLB seasons: 170-91) in a 1981 exhibition game versus the New York Yankees, my outstanding former teammate's legend continues to amaze! Also, I do not think another baseball player could love to play the Great Game of baseball more than Tommy "Skid" Rowe. Bravo!

Thunder felt strong and my swing sizzled. In mind and body, I had become an extension of all that baseball was for me. My earliest memories were on the diamond, and playing ball had forged a significant part of who I was. When I inhaled or exhaled, I was breathing baseball.

The announcer roused the fans, some standing, some seated, and most cheered for Lakeland. Everyone in the stadium, except a handful of Orioles loyalists and Sharon, wanted the Tigers to win their third championship in a row, pushing the debate to become a dynasty. The table was set with one of their ace hurlers on the hill. Manager Jim Leyland was a master at piloting a team. He saw me as an offensive liability—I held the best run-scoring average per at-bat for the Orioles.

The Tigers took the field, and everyone stood for the national anthem. I silenced myself in the on-deck circle, staring at the American flag behind the left-center field wall. After we sang the last line of "The Star-Spangled Banner," I picked up Thunder from the grass and took more practice swings while studying Ujdur, delivering his warm-up pitches. The pop in John Upshaw's catcher's mitt told me Ujdur was throwing hard.

Out of the Joker Marchant Stadium loud speakers I heard, "To lead off the game, now batting, Scott Christopher." I dropped the pine tar rag and spun my Louisville Slugger around so its trademark would be facing upwards. This would allow me to hit the ball on the side of the bat where the wood grains are straight and strongest. The weakest part of a bat is where the trademark label is placed. My team needed me on the bases at all costs. I had to score runs. The stadium was electric with anticipation. The intensity was mounting. I stepped into the batter's box. I was a study in determination and focus.

All the elements coalesced for a perfect night of baseball. After such a downpour, the sky became still and turned a brilliant-blue color. The chalk outlining the batter's box gleamed a shiny white. I dug in, scraping the dirt away with my spikes, tapped the far side of the plate, and held Thunder up toward the heavens. A hush fell over the stadium as the winner-take-all championship game was about to commence.

Narrowing my concentration like a laser beam, I crowded home plate and hoped Ujdur would give me a pitch on the outer half of the dish. He went into his windup and released the white horsehide baseball, nine inches in circumference and weighing five ounces. Its 108 pairs of fire-red stitches spun toward home, rotating almost 40 times. I had a split second to make contact with it.

A fastball tailed toward the inside of the plate. Blue called it a ball. With the count 1-0, I stepped out of the batter's box and gave Skip a nod in the third base coaching box.

He clapped his hands and then, as if he were holding a bat in his left hand, rolled his hand over and over, signaling it was okay to drag bunt to take first base. If his arm extended and he swung it like a bat, that meant he wanted me to rip into the pitch.

In a game of this importance, you make your way to first any way you can. Getting beaned by a pitch is as good as a base hit, so I told myself to take one for the team, at all costs, if the pitch was riding in on me. I would turn my body into the ball and hope for the best. Scoring runs was much more important than a bruise that would fade away. Being a professional baseball champion never fades away.

I gave the third baseman and future big leaguer Marty Castillo an extra-long stare to get him thinking I may be drag bunting. This would bring him in toward home plate a step or two, taking six inches away from his lateral fielding range.

I had no intention of bunting. With the count 1-0, I held a slight advantage over Jerry. Coach Leyland surely had directed him to keep me off the bases. He released a pipeline fastball, and I jumped on it. "Thunder" and I delivered a hard line drive over the shortstop's head for a single.

I rounded first base with a wide turn, looking for the left fielder to bobble the ball. Even the slightest ray of light between ball and glove would be enough to send me on my way to second. Skip clapped excitedly. I showed my teammates early that the Tigers ace pitcher was hittable. Aggressive ballplayers and teams win baseball games, particularly the crucial ones. They push opponents to be precise, eventually forcing a crack in their armor.

I wanted to steal, but Skip wanted to play it safe this early in the game, with no outs. With one out, I would have been given the green light to loot second.

Ujdur threw over to first base two times from his stretch, trying to keep me close. He attempted to confuse and alter my base-running rhythm. But he didn't know I was grabbing a king-sized, one-way lead and planned on returning to first base on his first movement from his stretch. This base-running tactic enabled my teammates and I to see his best pickoff move. I aimed to take *him* out of *his* rhythm, and it worked.

In the batter's box stood Vernon, an intimidating hitter and excellent bunter. Hammer had mastered the fundamentals of the game, and baseball encased his heart—Vernon's father, Vernon Thomas Sr., was a star player in the National Negro League, playing pro ball for the Kansas City Monarchs and Detroit Stars in the 1950s. He became a fan favorite and earned the nickname, "League." Thomas Sr. once said, "Whatever you did yesterday means nothing tomorrow, because you're facing a new pitcher." An unfortunate twist in League's career forced

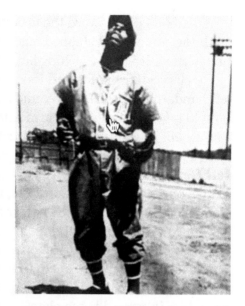

Vernon Thomas Sr. in his Detroit Stars uniform.

him to exit pro ball. He caught pneumonia and then contracted tuberculosis. The doctors told him that if he continued pushing himself physically, one of his lungs might collapse.

League taught Vernon how to play championship ball, and he educated him well. Hammer dropped down a perfect sacrifice bunt that put me on second base with one out.

I was the most feared base runner in the league. Standing on second gave me a distinct advantage to aggravate the pitcher, because it is difficult to pivot around and make an accurate pickoff throw.

Ujdur tried to ignore me, to focus on the Galloping Bull, who had been swinging a hot bat the past two weeks. My harassment worked. Jerry threw a wild pitch, and I trotted to third base. Bull grounded out on the next pitch, and I was unable to score.

Skip walked over to third base. He had an underbite, and he was biting his upper lip. With two outs, he told me to take a sizable lead and be ready to dash if the ball got away from the catcher. But my lead did not matter: Big Dan Logan, our left-handed cleanup hitter, swatted a single to right. I scored a run, and we were up 1-0. First blood was drawn, having put a tally on the scoreboard off their starter. As the leadoff hitter, I had accomplished my goal, and it also simmered

down the charged-up Tiger fans in the stands. I was a run-scoring nightmare for coach Leyland and his men—it felt magnificent.

In the second inning, the Tigers tied the score 1-1, after John Upshaw smacked a double down the left field line. His teammate Ron Martinez had gone from first to third on a wild pickoff attempt, crossing the platter for an unearned run. With the score knotted at 1-1, my second at-bat arrived in the third inning. Now we were playing a seven-inning game.

Jerry had deep-set eyes, and he liked to menace hitters with his long stares. He could do nothing to shake my concentration to drive his pitch hard. Working the count deep paid dividends for me as the game progressed. The more pitches I saw at the plate, the better. On a dancing inside slider that sawed me off, I grounded out. After I crossed first base, I pounded my fist into my left hand. I had chased one out of my zone. Every at-bat is crucial when there is no tomorrow.

Hammer batted after me and lashed a single, stole second, went to third on a balk by Ujdur, and scored on the Galloping Bull's deep fly ball to center field. We were back in the lead, 2-1. Three singles in a row drove Jerry to the showers with one out in the fourth. Coach Leyland had saved their ace for this exact situation.

Vernon "Hammer" Thomas was an exceptional athlete who signed a letter of intent to play football, as a quarterback or linebacker, for U. of Georgia Bulldogs in 1975. The "Dawgs" even recruited one of baseball's greatest players of all time, Hank Aaron, to share a Georgia football game with Vernon. The Orioles selected Hammer, an 18-year-old phenom, #119 overall in the MLB draft that same year. Fortunately for the Great Game, Vernon chose baseball over football. Playing a total of nine pro seasons, Hammer had 2,983 at-bats, 401 runs, 391 RBIs, 127 sb's, 56 homers, and a very respectable career batting average of .267. He had one Big League at-bat for the Chicago White Sox in spring training and drilled a double. He stood in center field and said to himself, "This is it, this is the Big Leagues." Hammer and I played on four teams together. He told me we were the "Go Get 'Em Duo." Vernon was one of the finest players and persons I ever played baseball with or against. Hammer is an outstanding human being and a talented pencil portrait artist. Vernon continues to promote and coach baseball with his heart, soul, passion, and premier skills, on his uncle's community baseball field in Winfield, Ga., home of the Winfield Tigers and Winfield Rangers.

Bobcat called on six-foot, one-inch, 185 pounds, right-handed ace Dave "Rocket" Cassetto. He was 6-2 on the season, finishing with the fifth-lowest ERA in the league, at 2.00 and having not served up one home run pitch.

With the bases jammed, Steve "Bazooka" Lake stood at the plate. Bazooka smoked a double-play grounder to their shortstop, extinguishing our rally. I would be the leadoff hitter in the fifth inning.

The Tiger fans began to stir. They wanted their team to start scoring. Our one-run lead in the top of the fifth inning was well within striking distance for a squad with as much offensive firepower as the Tigers. As the innings melted away, though, the scorekeeper put up goose egg after goose egg.

I was swinging a hot bat, and it got even hotter with my next at-bat. Rocket, skilled at painting the corners, reminded me of famed artist Wassily Kandinsky. His fastballs were geometric and linear, but well placed. I set myself deep in the batter's box to give me a fraction of a second longer to evaluate his pitches. With the count two balls and two strikes, I gave Skip a look. Jimmy spat through his fingers and clapped his hands. Cassetto threw me a change-up. Keeping my weight back I pulled the trigger to drive a bullet liner right up the middle for a single. I stood on first with no outs, but our inning ended with another empty oval.

Steve Lake played ten years in the big leagues. In 1987, he caught the seventh game of the World Series for the St. Louis Cardinals against the Minnesota Twins. Bazooka had one hit, driving in a run with two outs, in the classic winner-take-all game seven, one of the greatest contests in all of sports. The Twins won the world championship that night, 4-2.

We needed runs desperately when I had my fourth at-bat, in the top of the seventh. Two hits in three appearances magnified my hitting confidence. Coach Leyland had Cassetto jamming me with cut fastballs. I relished the Tigers aggressive attack. Unfortunately, their strategy worked. A four-seamer smacked into my bat below the barrel and eliminated my ability to put a jolt into the ball. I grounded out.

Lakeland started to beat the drum in the bottom of the seventh. With one out and runners on first and third, Skip relieved Skid, who had given up six hits and one unearned run in 6 1/3 innings. Like a worthy warrior, Tommy walked back to the dugout, upset that he had been yanked. Our opponent's fans awakened and were cheering and clapping for their team.

Jimmy summoned Larry "Engineer" Jones from the bullpen to extinguish the potentially lethal, game-changing threat being mounted by the Tigers. They were in a position to break the game wide open with one swing of the bat. Skip had kept our ace and one of the best pitchers in the league in his back pocket for just such a cliffhanger.

Engineer had not made a relief appearance all season, though he led the league in strikeouts with 143; 6th in strikeouts per nine innings at 7.03; 1st in complete games with 15; and 3rd in victories at 13. This was his most important call to the mound in the two years I had been his teammate and knew him as an all-capital-letters **CHAMPION**. Larry battled the first hitter he faced, Ted Dasen, and struck him out when he pulled the string with a looping curveball. Ted went fishing for it, hook, line, and sinker.

Next, he put the candle out at 60 feet 6 inches by hitting Bazooka's target perfectly, with a fastball that Darrell Brown hit a "can of corn" pop out to Ben at second base. Engineer's mastery preserved our one-run lead. We scored another run in the eighth inning when Russ "Winner" Brett opened with a single up the middle. Cat advanced him to second on a bunt, and Louievulle brought Winner home with a single to left field.

With two outs, I hoped Steve would keep the eighth alive. That would give me two runners on base, and I could put the game out of reach with an extra-base hit. I swung the leaded bat in the on-deck circle, visualizing more than a double or three-bagger. There was a tater caged in Thunder, ready to bust out. My dream homer had been germinating in every game bat I had swung since playing Little League ball. It coursed through my blood. But the inning closed as Cassetto sealed the tomb with his curveball falling off the table. Bazooka put a hefty swing on it, but his sizzling groundball to third resulted in ending the inning. I walked back into the dugout carrying Thunder over my shoulder, eager to be the leadoff hitter in the top half of the ninth inning. I knew I was going to add baseball history to my resume.

Larry Jones was drafted three times and an All-American, playing for Florida State University, where he had received a scholarship to play baseball and football as a tight end. Over his seven years in professional baseball, Engineer pitched in 207 games, compiling a record of 58 wins against 56 losses, with a rock-solid ERA of 3.67. Larry was a GREAT teammate who conquered the difficult ART of pitching. The bigger the game, the more Engineer embraced the pressure to win it.

While Larry turned the Tigers sticks into Whiffle Ball bats again in the bottom of the eighth, I never put Thunder back in the bat rack and kept taking practice swings, seeing myself crush my pitch and send it far over the outfield fence. I moved about the dugout and sat for a moment with Champ, discussing my best chances of getting on base. When I stood up, I told Tommy I was going to swing big for the fences. Champ replied, "You can do it, Scotty. I know you can!"

I was pacing back and forth and talking to Thunder as if my bat were my teammate. "I will pick the pitch and swing you with every ounce of dream I have in my body. You give me a *tater*, Thunder." My teammates were cheering on Engineer as he pitched his spots with surgical precision.

My mind had started to dial in for my upcoming at-bat. The moment had arrived. The vision was beginning to coalesce with profound clarity. This was not a time for me to question my thoughts. I had to let them pulsate, to bring me where they may. I shifted into a hitting realm of extreme concentration and focus, repeatedly seeing Thunder's violent 1/100th-of-a-second collision with a brilliant-white baseball, laced with scarlet-red threads.

Skip was spitting through his fingers as I prepared for my at-bat. The drama mounted with each breath. I put on my helmet and started taking choppy wrist swings in the corner of the dugout.

Larry delivered the Tigers a round, fat goose egg to end the eighth, although that didn't diminish their zeal for the crown. The Tigers always found a way to win—and coach Leyland, their fans, and players believed they would find the magic to steal the championship from us in the bottom of the ninth.

With our Orioles team poised just three outs away from winning the coveted title, Skip's head-to-head clash with coach Leyland hung in the balance; neither would yield a fraction of an inch. Two baseball masters strategized their final moves, and one would soon proudly declare *checkmate*. Skip held the high ground going into the top of the ninth inning of the final game, with a two-run lead. As a cushion, it was not sizable; one more run for us would change the complexion of the game dramatically.

This galvanized me to score and chalk up another 1 on the scoreboard. It was not whether I could score—I *had* to score. The intensity spiraled and tightened, but failure never perforated my mind. I utterly

loved being in the pressure cooker and wanted nothing more than to stand tall with Skip and my teammates, watching the Tigers king come crashing down.

LIVING THE DREAM

The announcer fired up the fans. The crowd was well aware that if the Tigers kept us from scoring, their team possessed the talent to find the necessary runs in the bottom of the ninth and either send this ring game into extra innings or win it.

Skip was spitting venom like a striking rattlesnake as I walked to the on-deck circle. Removing my helmet, I wiped the sweat from the inside band. Skip paused on his way to the third base coach's box. He said, "Scotty, pick your pitch and swat the hell out of it. We need you on base. We need a run. GET IT DONE."

I was so psyched up I quickly responded. His words drilled down to my core, but now it was me and Thunder and my dream. Skip always expected me to come through in the clutch. For me, there was no other option.

As one of the two non-drafted position players on our team, I had proved my critics not merely wrong, but dead wrong over my two pro seasons. Every phone call I made to scouts and letters I mailed to the major league teams touting my baseball skills and talent had been on the money, in particular those to the Orioles. Not one team drafted me in multiple selections, yet my moment had arrived. My dream perched on the brink of reality—I would pick my pitch; I would crush it right into baseball history.

Instead of swinging the leaded bat, I opted to drop the lead doughnut onto Thunder in the on-deck circle, tuning up for my colossal trip to the plate. Taking my practice cuts with another bat other than Thunder, in the ninth inning, was inconceivable. I swirled it in figure eights, chopped wood, and took full swings, all the while visualizing making contact in my wheelhouse. I put the bat behind my back, tucked into my elbows, and twisted from side to side to loosen up my hip and back muscles.

Simulating my rips, I faced Cassetto for every warm-up pitch he threw. I imprinted everything about his pitches in my previous two at-bats. The more throws you see in the course of a game, the more your odds increase in being successful as a hitter. Fifty percent or more of hitting is between your ears. Branding pitches and making the

necessary adjustments are essential for a batter to get his job done the best he can, every trip to home plate.

I took my final "long fly" warm-up cranks. Rocket brought two more focused tosses, and I studied them closely to gauge precisely how much gas his fastball burned at this stage of the game. Catcher John Upshaw, threw to second base, and the infielders sent the ball around the horn, back to Cassetto.

Sharon came up to the railing, close to me, as I swung Thunder. She was as much a part of this at-bat as I was. Sharon had fed pitching machines in the winter, traveled with me in the minors, and worked steadily to contribute to financing our dreams, celebrated with me after winning games, and supported me after losing. She lived alone when I was on the road and drove by herself to join me on away stands whenever possible. Sharon had sacrificed a lot for this at-bat. She knew it was a dream moment.

I walked over to the rail and our blue eyes locked. I said something I had never expressed to her before, "This at-bat is for you, Whippoorwill." I was breathing baseballs instead of oxygen. The Great Game and I had become one in that moment.

She was dialed in. "Hit a long one, Hawk."

I turned around and rubbed the pine tar rag into Thunder's bat handle. I picked up some dirt, spit into it, and ground that into the tar to add some grit to my grip. The crowd seemed nervous, like the thunderstorm was going to return. A section of excited fans behind home plate repeatedly yelled, "No more runs, no more runs!"

The game had passed the two-hour mark when the Tigers infielders and catcher converged on the mound, finalizing their defensive moves. I stood off to the side of the umpire, waiting for Upshaw to return to his catching position. Coach Leyland communicated to his catcher, and Upshaw gave me *the look* before he crouched down behind the plate. Catchers and pitchers will try to stare you down, but I had learned over the years to deflect any attempt to shift my confidence and focus. It was a foolish effort, because it only fueled my show-up-in-a-big-way flames to burn hotter than ever.

Baseball has a primitive element to it, unrelated to the mental and physical requirements you must possess. The constant and relentless battle between pitcher and hitter, especially, is an ever-changing reflection of life. For one, you are totally exposed in the batter's box, just

as the pitcher is on the mound. Second, you can be seriously injured, even killed, by a pitch. The stakes are high. A strikeout is a clear mark of dominance by the pitcher. A hit or home run gives the batter the insignia of being more skillful with his bat than the pitcher is with his arm.

The stage was set to live my dream. The outcome depended entirely on all my hitting skills, on everything I had been taught as a hitter from every coach since the age of eight, and on all that I had learned from my teammates along the way. Bringing my intensity into the moment, I reckoned on outsmarting Cassetto: by being patient at the plate, he would give me at least one money pitch to drive. Rocket did not want to walk me under any circumstances, so the pitch count would dictate his arsenal options and their locations in the strike zone. I had imprinted his selections in my mind with a red-hot branding iron.

I corralled my urgency to get on base and trusted that Thunder, my wooden battle axe, was ready to strike and knock the cover off the ball. But it had to be the right pitch. I narrowed my highest power zone to an eight-inch cube, wanting more than a base hit; I wanted to rock one out of the ballpark.

Taking one final glance toward Skip in the box, I felt his baseball being grounding me. Jimmy had given me the imperative to get on first at all costs, certain I would steal second base early in the count; then Hammer would advance me to third. This would leave it up to the Galloping Bull or Big Dan to drive me in for a run that would put coach Leyland's king on the chessboard, searching in the dark for one more of his coaching miracles.

The fans continued to chant, "No more runs, no more runs!" Skip squared up with second base and swung his left arm like a bat, toward the outfield fence, giving me the green light to go for the long ball to leave the yard, changing his strategy for me at the plate. He sensed something special was about to be unleashed from Number 15 and my big league battle axe, Thunder.

Jimmy and I were totally aligned. He was putting 31 years of professional baseball experience in my hands, knowing I loved the moment, sure that I could and would swing for the stadium lights. Skip put that much faith in me. For both of us, the possibility of driving the beautiful, spinning horsehide sphere out of the park was attainable. Wisdom combined with a dream can be a game-changer in the batter's box. My manager and I aimed both bat barrels at coach Leyland and his Tigers.

Dave dropped the rosin bag behind the pitcher's rubber in a blasé way, already counting me out. He wanted to move ahead in the count, so I anticipated the pitch that holds the highest strike percentage: a fastball. Because I had faced him twice, Cassetto thought I would be aggressive at the plate, like I was in my last at-bat, when his four-seamer got the best of me.

Since it was the top of the ninth inning, the batter's box and foul lines were chewed up. As baseball games play on, you have to move more dirt around in the batter's box to set your footing just right. I spit into my tattered batter's glove on my left hand. I gripped Thunder and pointed my bat, facing center field at a 45-degree angle, into the night sky, knowing I was connected to it all, and beyond.

Skip stepped in front of the coaching box, moving as close to the action as possible. In reality I know he wanted to be *in* the batter's box, swinging Thunder. And in a way, he himself was *right there*, getting set with me.

I adjusted my grip on Thunder the only way I could, which was unorthodox by baseball standards. Ideally you line up the middle knuckles so you can hold the bat in your fingers loosely. Since my right thumb was of no use whatsoever, and because my right hand remained much smaller than my left hand, this was not possible. Instead, I had to line up my big knuckles, which reduced the speed and power of my swing, as my wrists rolled over in an unconventional manner.

Nevertheless, everything at home was under lock and key. I tapped the dirt out of my cleats with my bat and dug in with my back spikes, two inches farther from the plate than usual. I balanced my weight. My plate coverage with my bat was exactly where I wanted the barrel to make contact with the baseball, right in the inside middle of the plate, six to eight inches above my belt.

A shrewd hitter studies the home plate umpire's strike and ball calls throughout the game. If the zone is expanded or shrunk, what is important is that the ump is consistent, enabling you to make the necessary adjustments. In this night match, Blue invariably called inside pitches, sometimes a bit off the black, as strikes.

I isolated Cassetto and his pitching arm in my soft-focus field of vision, erasing everything else in the stadium, including the heckling fans. I saw his exact release point and the rotations of his pitches. When he put that baseball into my .400-plus zone, I would unleash my Louisville Slugger, Thunder. With a large inhale that filled my

lungs, I let my eyes deliver an unspoken message: *Bring it on! Your best pitch is mine!*

For a brief moment, a gust of cool wind skittered across home plate and heightened my focus to optimum levels. With his toe on the rubber, Rocket went into his windup, and my eyes froze his hand and the ball at the top of his pitching arc. I narrowed my concentration on his release point to a six-inch square. His pitch would rocket out of that box, leaving me less than two tenths of a second to calculate what type of pitch was coming down the chute and determine when and where to swing. The final two-tenths of a second is when I would decide, or not, to unleash my wood through the path of the ball.

The baseball was a brilliant white with blood-red threads. At the top of Cassetto's arc, all my hitting intelligence, accumulated over the past 16 years, converged. Time shifted, and my ability to focus at the plate expanded beyond my previous four at-bats. Dave released his pitch from his six-foot-one-inch, 180-pound frame, and it catapulted from his right hand. The baseball was streaking through the air, two pairs of horseshoes sewn together, end to end, to challenge me as a hitter. Surreally, it moved into my high-percentage zone. The spin and movement on the ball of Cassetto's first pitch signaled a two-seam fastball. He was playing the odds to get ahead of me in the count. I threw Thunder's bat head right into the pitch with a slight upswing. You cannot hit such a gargantuan blast with a level swing, and I entertained no thought of being a base runner—I dialed in on a four-bagger.

I missed the pitch. Rocket had spun me around like a top. The count was 0-1. I educated myself, right then and there, that Thunder was ahead of my hips. It was crucial that I had to sit back a full tick to generate the power I needed to take one out of the park. Dave would eliminate my dream if I was not patient with my mind, body, and bat.

The Orioles bench cleared off. My teammates came up to the dugout's lip to cheer me on, keenly aware how important another run would be for us as we started to savor the taste of winning the championship. My mind functioned like a deftly programmed hitting computer. I had designed a hitting journal and charted many of the game pitches thrown to me over the season. Instead of trying to outsmart Cassetto by guessing pitches, I decided to keep my same posture in the batter's box for every pitch. Seeing the ball as clearly as I was, whatever pitch he slung my way, I determined to rip right into and pop those red threads.

He threw a purpose pitch he hoped I would chase: a low, hard slider that didn't come close to my locked-in power zone. Laying off it was easy, and I evened the count to one ball and one strike.

Dave held the rosin bag longer than usual, weighing the importance of his next pitch. If he went to two balls and one strike, the percentages in my favor would significantly increase. I kicked earth out of the batter's box like a wild bronc. The sparring was over and the gloves were off. Cassetto dropped the rosin bag and moved some dirt away from the front of the rubber with his spikes. Shaking off the first sign from Upshaw, he agreed to his next pitch call, nodding his head up and down. With his glove held high into his chest, he spun the baseball around to find the right thread placement for his next missile, thinking he would blow his best heater by me. This would even the count at 2-2. As Rocket went into his windup, he projected I would be a K-victim after one of his next two offerings, having to walk back to the dugout defeated, for the first out.

With Thunder locked into position, I distributed my weight from the front of my body to the back, coiling to bring all that force forward explosively. My back-leg thigh muscles fired and tightened. This pushed my back spikes firmly into the dirt to unleash unbridled power and energy through my bat and right into the baseball. My stride was balanced and compact, with my front shoulder turning in slightly, which gave me a fraction longer to wait on his pitch. By constraining my movement in the batter's box, I reduced the up-and-down vertical motion of my eyes, and this gave my mind-body and eye-hand coordination a boost and the ability to lean on his pitch.

I had committed to his offering: a four-seam fastball, streaking right into my wheelhouse, coming toward me in slow motion. Never had I seen a pitch so clearly. All the mind work I had done on the power of concentration and visualization crystallized in that moment. Three feet out from Cassetto's fingers, the ball stopped and my concentration seized it. It hung suspended, as if on a batting tee, for a fraction of a second. The fate of this baseball was etched on the top tier of my athletic psyche. This decision to swing was irrevocable.

The gap between my bat and ball narrowed. Round and round the luminous orb spun in its spherical rotation, its bright-red four seams swirling around the brilliant-white horsehide. I could have counted the stitches on the ball as it cut through the air toward me. I was mixing passion, spikes, and dirt as I dug in. When this tumbling,

titanium-white sphere reached 15 feet from the plate, in its final one-tenth of a second trajectory, I shifted my front shoulder inward, and my eyes aligned directly with the pitch. A perfect triangle formed in my mind: my eyes to the baseball, baseball to my bat head, bat head back to my eyes. My forearm muscles rippled. My left hand clenched Thunder like a sprung bear trap. My right hand's grip, always a challenge, was more like a spring clamp.

Keeping that visual at the forefront, timing the twist of my shoulders into the swing, I pulled the trigger for Thunder to deliver a fatal blow to the Tigers—I threw my hands downward into the path of the ball, directing my bat head to meet and crush Cassetto's pitch with as much torque as I could generate. Every ounce of energy and power I possessed to blast a baseball, I brought to the swing. This time I was patient, and my slight upswing was timed perfectly. Winding back a full tick worked. My front leg was locked, with my back leg and hip about to explode toward the ball. My left arm was fully extended and my right arm and hand remained behind the bat.

I never registered the contact. It was poetic, like a lover's kiss you never forget. Baseball and bat became one, activating the dynamic tension of two opposing forces, in direct battle and conflict of pitcher and batter, generated by two competitors who wanted completely different outcomes—and I emerged the victor. Is it possible a moment can get any better than this, in any sport?

The follow-through with Thunder was effortless. I hit the pitch on the bat's sweet spot; I saw the grain in the wood mash the horsehide. I released its head upward, allowing the continuous completion of my swing. In life's brightly colored abstract painting, I experienced a moment of quiet and isolation. Liftoff! That baseball sailed away like a meteor traveling through space, heading toward the left-center field wall, *a Ruthian blast.*

On most home runs, hitters sense the outcome as soon as the bat and ball make contact. That night, every person in that ballpark knew it. The baseball soared high into the stadium lights, on a flight pattern of a dreamer's dream that had become a reality. My body had torqued itself as far around as it could go, with my bat behind me and my chin above my right shoulder. My front spikes were on their side in the dirt from my body twisting so hard to drive Thunder through the baseball. I dropped my stick as I began to unwind. I was sure I did not need to

race out of the batter's box to leg out a base hit. A split second after I touched the baseball I knew it was gone. Three strides from home plate I saw the solitary white spec among the stars, my shot was still airborne. This dream blast was going to be a monumental home run.

Planting my cleats into the center of first base, I saw Skip in the third base box, clapping excitedly. He had signaled for me to swing for the fences, to give the at-bat my all, and I had done it. Jimmy rolled the dice and won. We both won. My shooting star landed on earth close to 400 feet away from home plate. I crushed a moon shot of a tater.

I didn't run the bases, I rounded them in my own dream to score a vital tally. The Tigers and their fans seemed motionless as I stepped on the inside corner of second base. Cassetto had turned his back on me. I was floating in my own sea of elation. The euphoria drenched me for the 360-foot circle of the bases. Skip, overwhelmed, came out of the coach's box to meet me at third base with a man's handshake, grinning uncontrollably and shaking his head, clenching my handicapped right hand. Jimmy gave me a sound slap on my back as I rounded third, heading home, and then said loudly, "Great swing, Scotty—you got it done!"

The entire team came out of the dugout and crowded around the dish. Every one of their smiles and cheers bolstered my round-tripper. Jumping, hooting and hollering, my teammates made a U-shape around home so the umpire would see me touch the plate to officially score. When my spikes landed in the center, I launched into space like I had just come out of the swing in first grade: free, so very free. I landed into the arms of my teammates, relishing this brightest moment in any athletic arena I had ever experienced, going all the way back to when I began rehabilitating my wrecked hand and withered arm. We scored another tally, forcing Bobcat to put out the hook and bring in future seven-season big leaguer Dave Rucker, who extinguished our rally flames and closed out the ninth inning.

The *Lakeland Ledger Sports* editor, Patrick Zier, said it best in his article the following day:

> . . . and then the Orioles socked the Tigers in the gut in the ninth when Scott Christopher hit a long homer to left that Darrell Brown turned and just watched sail over the wall.

I inhaled and exhaled my dream; I lived it in the most dramatic way and fulfilled it. To jack a tater in the ninth inning of the final game and

win a professional baseball championship is mathematically almost impossible—so many minute variables need to align:

- You must be a professional baseball player.
- You must be a player on a professional team that makes it to the playoffs after five months of intense games.
- Your team has to win playoff elimination games to advance to the championship ring series.
- You have to be in the starting lineup.
- The game has to go nine innings—which is a given if you are the visiting team. The score must be tied or the home team losing for them to bat in the bottom of the ninth.
- You have to get up to bat in the ninth inning.
- You have to hit a home run.
- Your team must win the game to claim the title and the ring.

But I had dreamed of doing this since I was quite young. And I dreamed of doing it as a player in the Orioles organization, and I did it. I dreamed it, believed it, perceived it, worked hard for it, achieved it—and to this day, I live with the memory of crushing that fastball and everything attached to it, including my season-after-season vision, leading up to my epic home run.

After the grand hoopla and pomp at home plate, on my way back to the bench, I spotted Sharon in the stands, and we sent an air-kiss to each other. Sharon held her arms out like hawk wings and waved them up and down. We shared this free and beautiful moment in our lives together. I walked back into the dugout with my teammates, well aware that staying focused was essential to win the game for the crown. The biggest contest of the season was far from over. We had to remain centered, but that was not easy, as my home run had uncorked the excitement and emotions of having already won the championship, and we clearly saw the hardware.

The batboy handed me Thunder, and I held the Louisville Slugger label tightly with my left hand as I pointed Thunder toward the stars once again. This was the final swing for Thunder—my magical wooden bat. I never swung Thunder in a game again, as the grain began to splinter over the winter.

The Tigers could not mount a comeback, as it was apparent in the bottom half of the frame their team was rattled, especially on the base

paths. With Lakeland's king laying flat on the board, they lost the game. Our team surged onto the field, every man a champion. None of us would have been playing for the ring that night without our collective contributions in stadiums all across Florida. We all respected each other's dedication to play as a cohesive squad, to win as a team of "Let's-Get-It-Done" players and coaches. We were one dynamite club who had the **RING** in our sights from the first pitch of the season in early April to Engineer's final out.

Our club had to have a leader that we respected and trusted. Baseball is an extremely demanding game, both mentally and physically. It is the marathon of all sports. This person had to juggle twenty-five different personalities in a positive way, motivating his players to leave everything they had on the field, for five consecutive action-packed months, both on and off the diamond, to reach the pinnacle of the Golden Summit and become pro champs. A title demands that the team comes first at all costs, each and every day of the season. Jimmy was our great leader and blazed the "Let's-Get-It-Done" confidence trail for us to believe we could win, claim, and wear the crown.

After taking the FSL League Championship, we received broad news coverage, and I enjoyed every word. On September 23, 1978, the *Sporting News*, the only news weekly of sports since 1886, published "Champs Crowned in Class-A," and the article gave Vernon Thomas and me credit for pacing and leading the offense. The piece continued

In our 1978 FSL Championship season, Tommy "Skid" Rowe pitched 199 innings, posting a career low 2.31 ERA and, not surprisingly, earned the win in our winner-take-all ring game. We were in the fall Instructional League after our crown season, and Jimmy "Skip" Williams, our manager, referred to Skid as "The Winner."

to say, "Christopher, who singled and scored the champions' first run in the opening inning, led off the ninth with a solo home run."

Giving thorough coverage of our game, *Miami News* sports section on September 5, 1978, headlined, "Two Orioles Who Couldn't –Miami Wins Florida State League Championship in Lakeland." Tom Archdeacon wrote about me and our shortstop, Cat Whitfield, who was born legally blind.

> Lakeland, Fla. – When they were young, no one thought they would function as normal human beings, much less end up as professional baseball players. Scott Christopher had all his tendons and nerves severed in his right hand when he fell on the base of a broken soda bottle. He was six years old. Doctors said he would never have use of the hand again. Last night Whitfield and Christopher led the Miami Orioles to the Florida State League Championship.

I thought back to an article in the *Falls Church Globe*, dated September 4, 1969, "Sports Career Inspired by Crippling Accident" (page 55), which ended with the question: "Where will Scott Christopher be in another nine years?" That writer surmised correctly: "It's anybody's

This quote is an excerpt from the Sporting News *article: "The workman-like offense was paced by Vern Thomas and Scott Christopher." Wow, was I lucky to have the all-star Hammer as my friend and teammate. We were one of the team's "get-it-done" duos.*

guess, but it's safe to bet, wherever he is, he'll still be fighting the "comeback" he started at age six." *Exactly nine years to the day from this quote, my comeback delivered my first professional championship.*

I feel comfortable saying Skip and coach Leyland would have presented me the MVP trophy after the championship game, if one had been awarded. I hit the single home run and led the offense by a solid margin, with six total bases from the plate. Hammer Thomas had a dynamite big game as well. We each scored two runs. No other Oriole had an extra-base hit or three hits in the game. All this—and I was the lone, undrafted free agent on the field that night. My homer is the only ninth-inning big fly in a "winner-take-all" contest, in Baltimore Orioles organizational history dating back to 1954. That is truly how substantial and rare a feat this was, is, and will always be in baseball.

FLORIDA STATE LEAGUE CHAMPIONS - 1978 MIAMI ORIOLES

BACK ROW: Mark Smith, Luis Peralta, Bob Coneys, Tom Rowe, Ben Lankster, Larry Jones, Steve Cook.
MIDDLE ROW: Ron Hart, Trainer, Carlos Arias, Clubhouse Man, Russ Brett, Will George, Drungo Hazewood, Mike Rachuba, Dan Logan, Rob Whitfield, Russ Pensiero.
Gary Nave, Greg McArthur, Marshall Fox, Executive Vice President, Sonny Hirsch, General Manager
FRONT ROW: Scott Christopher, Jorge Diaz, Vern Thomas, Tom Eaton, Jimmy Williams, Manager, Joe Alvarez, Coach, Mike Lindal, Steve Lake, John Denman.
SEATED: Batboys Lenny Harris, Andy Herman, Luis Vazquez.

Thirteen-year-old Lenny "King Pinch Hit" Harris, our bat boy, is seated on the ground, far left. He became one of the finest pinch hitters in MLB history, holding the record for most pinch hits ever in the MLB, with 212 over 18 seasons. Lenny became a world champion in 2003 while playing for the Florida Marlins. He celebrates his 40th year in pro ball in 2023, as the bench coach for the Daytona Tortugas.

For the entire season, I ended up as the ninth top hitter in the league with 300 or more at-bats, cranking a .289 average. The exceptional player and future Hall of Famer for the Montreal Expos, Tim "Rock" Raines, finished out the top-eleven hitters for the season, two notches behind me. In the MLB, Rock tallied 808 steals for an all-time ranking in fifth place. I stole 41 out of 42 bases—to Tim's 57/78 (.731)—leading the league and all professional baseball in stolen-base percentage at .977. In addition, I spanked .333 in the championship series, showing up in a spectacular way for the final ring game.

In one month I would be in camp, living in Madeira Beach, Florida, receiving intensive training that would fine-tune my baseball skills, to help me blaze a trail toward the majors. On this elite team of pros, I once again was the only undrafted outfielder/infielder free agent. I believed I had earned my ranking, and so did Clyde Kluttz, the director of player development and the grand master of a players' classification level throughout the Orioles organization. He had played nine years in the Show as a catcher and was a member of the 1946 World Championship St. Louis Cardinals.

Clyde became the most important person in my advancement to the top level of pro ball. A straight shooter with a keen baseball mind, he was a shrewd evaluator of a player's talents. Clyde had been a New York Yankees scout (1967-1975), their Director of Player Development (1971-1973), and the Scouting Director in 1974. He was a very respected baseball man who chose his words wisely. Clyde could put me in an Orioles Big League uniform.

BALTIMORE ORIOLES FLORIDA INSTRUCTIONAL LEAGUE TEAM

Sharon and I arrived in Madeira Beach, a Florida Gulf Coast barrier island, 21 miles south of Clearwater, with soft breezes and fire-tinged sunsets, prior to workouts scheduled to begin September 12, 1978. We found a bungalow on the bay side and lived like bohemian artists. I played baseball all day, and we would have the late afternoons and nights to ourselves, exploring, spending time near the turquoise-blanketed water, and creating art. Walking and talking along the sandy beaches at sunset almost every day, we made photographs, hunted seashells, and enjoyed being everything young.

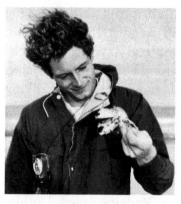

Time off the Instructional League baseball fields would be spent creating art in a variety of media. I would have moments like this, examining a stone crab I picked up while hunting photographic compositions, walking a beach with Sharon.

I made this image of Cal Ripken Sr. hitting fungoes before an Orioles spring training game in 1988.

The Instructional League offered the perfect setting. MLB clubs do not send fringe prospects there. The season would open on September 25 and close on November 15. For two months, I would compete and train with six other outfielders. Three of those were number-one draft picks: Dallas "The One" Williams, John "T-Bone" Shelby, and Drungo LaRue "Diamond" Hazewood. All three were my friends and would later play in the majors, with T-Bone winning two world titles: one for the Orioles in 1983 and one for the Los Angeles Dodgers in 1988. This super-talented array of players boasted ten or more athletes headed for the Show.

I was getting paid to play baseball with a band of exceptional teammates and one future Hall of Famer and legend, "The Iron Man," Cal Ripken Jr. Blessed with many super-human talents, Cal developed additional skills through his work ethic, desire, passion, devotion, and academic approach to the game. Rip earned every bit of his acclaim and possessed multiple areas of genius that collectively made him an admirable man and the greatest shortstop in history.

The Iron Man had been taught the fundamentals, skills, and mental toughness necessary to play baseball by a genuine master of the game, his father, Cal Ripken Sr. When Cal's father gave us a baseball talk one afternoon in the dugout, I thought I might have been in a lecture hall at the Oxford Baseball University in England.

Drungo "Diamond" Hazewood was one of the most gifted athletes I ever saw perform in any athletic arena. Drungo was offered a full scholarship to play tailback for the legendary USC Trojans football team. He was also a first-round selection by the Orioles in 1977. Diamond played seven years of pro ball, earning a shot in the Bigs in 1980. This awe-inspiring athlete and I played on four teams together. To be in his company on the field was a great honor. Drungo would smash 97 home runs in his career. One of them was estimated to be a 600-foot-plus bomb that went over the roof of a 10-story apartment building behind the left center field wall.

In 1983 Diamond retired early from baseball to take care of his mother, who was suffering from breast cancer. In 2011, Drungo, a father of seven children with his beautiful wife, Lagette, received his own cancer diagnosis. Tragically, the following year, they lost their only son, Aubrey, who passed away in 2012. I spearheaded a fundraising campaign selling my artwork and the famous photograph I made from Cal Ripken's historic #2,131 consecutive game played. Former teammates and fans purchased my offerings, with all the proceeds going to the Hazewood family to support them in this time of such great loss.

Catastrophically, Drungo's cancer resurfaced in 2013. Days before his life ended, my exceptional teammate and friend called to thank me for my efforts in 2012. Drungo's final words to me were, "I love you, Scotty," and then I said, "I love you, Drungo."

Cal "Senior" Ripken was an exceptional baseball scholar. He spent 36 years with the Orioles as a player, coach, and manager. In his seven seasons playing, primarily as a catcher in the minors, Senior had a batting average of .253. In 1987 and '88, he managed the big league club for 169 games. He was inducted into the Orioles Hall of Fame in 1996.

Cal Ripken Jr. and his brother, former big league teammate Billy, founded the Cal Ripken Sr. Foundation in 2001, which prepares at-risk youth for life's challenges by teaching them critical life skills, such as teamwork, communication, work ethic, and respect. Billy said, "Dad was a teacher, first and foremost. He had a spot for kids. He had a spot for teaching. He had a spot for turning the light bulb on." The Foundation's programs and initiatives have positively impacted millions of children and adults since its inception. Senior once said, "Baseball is just a walk of life. Everything you do in this game, you do in life. And everything you do in life, you do in this game." WOW! The Ripkens have truly made our world a better one.

One player standing in the locker room for the Baltimore Orioles in the fall Instructional League season went on to become a top-50 greatest baseball player in the history of major league baseball: Cal Ripken Jr. He would turn 19 years old on August 24, 1979.

Cal was inducted into the Baseball Hall of Fame on July 29, 2007. I was there that day, in the press pit in Cooperstown, NY, 10 feet from Rip and his fellow inductee, Tony Gwynn, of the San Diego Padres. What a great honor to experience the festivities and their acceptance speeches. It was the largest crowd ever for a players Hall of Fame induction ceremony, at 82,000 fans. The sea of Orioles orange and black honored Cal and his amazing career, playing primarily shortstop for the Orioles.

I had to hitch a ride from Va. to make it to NY, as the plane I was supposed to fly on had mechanical failure. Two fellows that I did not know gave me a lift and let me off at Grand Central Station, NY, in the middle of the night. I half-slept on a bench with my belt tightly secured through the handles of my camera bag, until the trains started running north early in the morning.

It was a celebration of baseball greatness for Rip and Tony. I was the first spectator and former teammate to shake Rip's hand after the ceremony. I said, "Congratulations, Rip, from all of your teammates!" Cal and Tony were swarmed by the press and the other 53 baseball Hall of Famers. I created a very special body of photographic images that day, and I was the last fan to leave the ceremony, as I wanted to inhale and document every bit of memory and baseball history I could ingest.

For many of those beautiful 51 days of focused baseball training, Cal Jr. and I walked off the field last, as we took turns in the batter's box late in the afternoons. One day Cal and I were going to keep hitting until the other one laid down his bat. Noted baseball man and future World Series champion, hitting instructor for the O's, Ralph "Fire Hydrant" Rowe, kept firing the pitches out of "Jugs" until he literally pulled the plug and shut down the machine saying, "You wild asses would be here until dark." All three of us laughed and walked back to the locker room together.

I felt securely anchored in Skip's talent pool, and Ralph, the Orioles minor league hitting coach, devoted a considerable amount of time working with me on switchhitting. He told me halfway through the season he had never, in 31 years of pro ball, seen a player work more intensely than I did. Ralph had been in the bigs as a third base

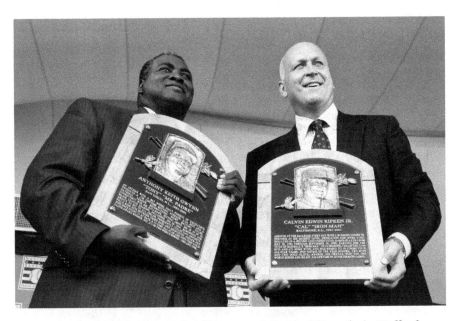

I made this photograph of Tony and Cal holding their Hall of Fame plaques moments after the grand ceremony celebrating their baseball greatness. In segments from their acceptance remarks Tony said, "If you want something and you want to compete and you want to be successful, you've got to get out there and you've got to try."

Cal stated, "The streak is marked by a number. A start has a beginning and an end. I truly believe there are no endings, just points at which we begin again."

coach for the California Angels, '72 to '75. He passed his hitting knowledge to Angel Rod Carew—a baseball Hall of Famer and one of the greatest batters in history. Ralph knew I was a hitter in the rough—and he was right. I needed his big league polish. The trainer for our Instructional League team continued rocking the boat in my shoulder with cortisone shots once a week, allowing me to do what I loved: practice and play tough, sound baseball.

During the days, I received a lot of individual training to improve my skills. My batting average hitting from the left side was steadily rising, giving our offense more runs; I played all three outfield positions like a gold-glover. I went the entire season without making an error in the outfield

Florida Instructional League

SEPT. 25 - NOV. 15
Monday - Friday at 1 p.m.
Doubleheaders at noon
MONDAY'S RESULTS
Northern Division
Cleveland Indians 2, St. Louis Cardinals 1
Philadelphia Phillies 5, Baltimore Orioles 1
Minnesota Twins 8, Toronto Blue Jays 1
Montreal Expos 7, Detroit Tigers 5
N.Y. Mets at Cincinnati Reds, not reported
TUESDAY'S RESULTS
Northern Division
Minnesota Twins 5, Cleveland Indians 2
Detroit 8, Cincinnati 1
Baltimore Orioles at N.Y. Mets, Payson Field,
 St. Petersburg, not reported
Montreal Expos 6, Philadelphia Phillies 3
Toronto 3, St. Louis 2
WEDNESDAY'S RESULTS
Northern Division
Philadlphia Phillies 5, Cleveland Indians 0
Detroit Tigers 2, St. Louis Cardinals 0
N.Y. Mets 5, Toronto Blue Jays 2
Baltimore Orioles 3, Cincinnati Reds 0
Minnesota Twins at Montreal Expos, Busch
 Field, St. Petersburg, not reported
THURSDAY'S RESULTS
Northern Division
Baltimore Orioles 4, Cleveland Indians 3
N.Y. Mets 6, Detroit Tigers 5
Minnesota Twins 8, Cincinatti Reds 7
Montreal Expos 4, St. Louis Cardinals 0
Toronto Blue Jays at Philadelphia Phillies,
 Carpenter Field, Clearwater, not reported

and posed a strong offensive threat hitting, stealing, and scoring runs.

Late one afternoon, toward the end of camp, I was the last player walking back to the clubhouse after Rip, T-Bone, and I had finished taking batting practice. Clyde Kluttz intercepted me, and we talked baseball. He said that my progress really impressed him, and if I continued to work hard, improve, and play well, I had a solid shot at playing in the majors.

"Thank you, Mr. Kluttz," I said, exhilarated. "When I am in the big leagues, I will turn the base paths into infernos as a run-scoring machine."

The words I had worked so hard to hear my entire baseball life had just been spoken. One of the most important men and major executives in the Orioles organization was now in my camp. Clyde could see me playing in the MLB one day. Though the darkest of dark horses in the entire league, I got the recognition I deserved—that of a thoroughbred.

I had Dreamed *Big*, and I had Dreamed *On*! I was closing in on playing for the Orioles in Memorial Stadium.

I'm hitting left-handed in a 1978 Baltimore Orioles Florida Instructional League game. This complex skill added potent elements to my offense. I was successfully and methodically moving forward through our 45-game schedule to master switch-hitting, elevating me even higher as a proven, run-scoring threat.

Red Threads

When the baseball released itself from the pitcher's hand,
my dream began to lift.
The brilliant red threads were spinning in slow motion.
This moment was unfolding.
Fans were silent.
The decision to swing was branded.
Humanness vanished as bat and ball crashed into each
other.
The left fielder turned and suffered the arc of my long home
run. Thunder and I had socked the Tigers in the gut.
It was over, the crown was ours to own as champions.
A dream is no longer a dream if you live it.
I planted my spikes into baseball history.
Teammates launched me into the air.
The happiest man on earth,
I had circled my—and our team's—dream.
They were cheering and I was flying
with everything I loved.

9TH INNING

GAME CALLED

Three and a half months before spring training, the brass promoted Skip to manager of the Southern League AA Charlotte Orioles. I headed in that same direction, negotiating and signing my contract to play for the Charlotte club in January 1979. My chess pieces were set in perfect order for me to show up to compete for my well-earned AA spot.

Mike managed a co-op team and a Pittsburgh-affiliated club in the minor leagues. He mastered and continues to teach players the power of a positive mental attitude in life and on the baseball field. His illustrious career in professional baseball spanned 38 years.

This Great Ambassador to baseball is a member of GWU's HOF. Mike was inducted into the Professional Baseball Scouts Hall of Fame in 2011.

Two weeks before my departure to camp, my friend Mike "Tooms" Toomey, head baseball coach at George Washington University, again allowed me to use his team's indoor batting cage and facilities to prepare for spring training. A left-hander, Tooms threw me a high, inside pitch. I bowed back on a check swing, but too late: the bright-red seams and horsehide smashed into my face like a sledgehammer. Blood, lots of blood, gushed from my nostrils. With my nose all but obliterated, broken in five places, I underwent emergency surgery right there at GWU Hospital, and the doctor reconstructed my beak. Showing up to camp with facial bruising and a metal nose guard taped to

my face so my bones would heal correctly was uncomfortable, to say the least.

Worst of all, beyond the pain of the operation and recovery, that pitch seared my psyche. I confronted a disturbing new challenge: stepping back in the batter's box against live pitching, without any fear. Mentally, I disciplined myself not to flinch, knowing I *had* to dig in or the pitchers would turn me into a whirling dervish, putting me on my heels with inside pitches. Fear had never been a part of my athletic life; I wouldn't allow it into one cell of my competitive being, as it would only ignite sure failure.

Never had I been afraid of being hit by a baseball or being hurt on a field, even though I had been slammed by pitches and stitched up on multiple occasions. Some were intentional beanings and others were not. At times, base runners came in to me at shortstop with their spikes aimed right for my knee. Each love tap delivers a different degree of pain, but as a ballplayer you expect to take those kisses in stride.

Few at the pro level have suffered two major injuries as a young child, as I had, but everyone—if they play baseball long enough—is going to deal with a range of mental and physical consequences that create the ballplayer you are to become.

Immediately I pushed the memory out of my consciousness. I had to. You cannot effectively hit a baseball with as much as a drop of fear in your mind. A situation like this demonstrates why an athlete must develop significant, battle-ready physical *and* mental strengths.

Were all my blood, sweat, stitches, broken bones, cuts, bruises, failures, and games lost *worth* it? Absolutely! All of it made total sense to me. I loved every second I ever spent playing baseball, at every age, on every team, on every level, and on every diamond. The Great Game allowed me to meet Sharon, it gave me my dream homer for the ring, exceptional teammates and coaches, cherished memories on and off the field, scholarships to Mercersburg and the University

of Maryland, lifelong friendships, internal and external strengths, so much fun, and more.

I met my new challenge head-on and performed solidly during spring training. The *Sporting News* highlighted our camp on the cover of their March 1979 Spring Training issue. Skip stood in the left-hand corner of the photo, with players fanned out across the field, stretching their legs and loosening up. The reason I don't appear in the image: I was in front of my teammates leading the exercises each day of training. This appointment honored my achievements, as 26 months before, I was an undrafted player, putting pushpins in a map of Florida, to try out from camp to camp, until one team signed me as a free agent.

When final teams were assigned, my name stayed firmly taped above my locker. The Orioles had given me serious notice, recognizing me as a fierce competitor and a bona fide big league prospect.

Sharon and I drove north to live in Charlotte. For the opening-night game on April 16, in Crockett Park, Jimmy slotted me as the leadoff batter and left fielder for the AA Charlotte Orioles. When we squared off with the Cleveland Indians affiliate, the Chattanooga Lookouts, I stood well within striking distance of Memorial Stadium and playing in the majors. This represented an arrival game for me, playing at a level of baseball very few ever experience.

Crockett Park, built in 1940 on Magnolia Avenue, was a baseball stadium right off a Hollywood set, as artful an arena as I had ever played in, constructed of sappy pine beams, with wooden fold-out seats painted white (box seats), red, blue, and yellow. Fans seemed to be right there in the batter's box with me. Something about the stadium's ambiance struck me as so Southern and literary and

Playing baseball in Crockett Park was living a dream for me. Visit https://www.facebook.com/charlotteosplayers/ for a history of the stadium video.

Frances and a military corps member who presented the National Anthem singer before our game.

Frances "Trailblazer" Crockett was the general manager and owner of the Charlotte Orioles, a pioneer for women in sports, and baseball in particular. She is recognized as the "First Lady of Baseball." For Frances and her family, the Orioles were "The Greatest Show in Charlotte" and quite possibly, "The Greatest Show on Our Planet." I enjoyed playing for Trailblazer. She was the first woman GM of a professional baseball team, being voted the prestigious Rawlings Sportswoman of the Year in 1980 and '85. Frances was inducted into the Southern League Hall of Fame in 2020. Next stop? Being nominated and selected for the Buck O'Neil Lifetime Achievement Award at the National Baseball Hall of Fame in Cooperstown, New York.

Frances had a lifelong background in sports promotions because her family was entrenched in professional wrestling since 1931, promoting hundreds of wrestling stars like "Andre the Giant," who stood 7 feet, 4 inches and weighed 520 pounds. In 1988 that company was sold to Turner Broadcasting Systems. Frances brought the fun factor to the fans, creating promotions at the stadium that drew crowds. Our team led the Eastern Division in attendance for the 1979 season, with 122,336 paid fans cheering us on.

One of Frances's front-office workers, Lib Shildt, truly a great baseball enthusiast, and I remained good friends for forty years , until she passed away in 2019. What a *grand and caring* woman. Her son Mike, who was the clubhouse boy over many seasons, had such a love for baseball that he never stopped clawing his way to the big leagues. Mike played college ball for UNC-Asheville Bulldogs, coached at UNC-Charlotte, was an associate scout for MLB, and managed his teams to multiple championships in the minors. He was the manager of the St. Louis Cardinals from July 2018 to the 2021 playoff elimination game lost against the LA Dodgers. It is quite evident that Mike knows how to work hard, dream, and win baseball games. Mike has an exceptional .559 (252-199) MLB winning percentage. In 2019 (91-71), he was voted NL Manager of the Year, guiding the Cards to the postseason—a monumental feat in every managerial baseball ranking. Mike repeated his playoff runs by taking the Cardinals into the 2020 and 2021 postseasons. Bravo to a baseball GENIUS, whose mother was a marvelous person. I wish Mike great success in his current role as a senior advisor with the San Diego Padres.

romantic, with the tree branches swaying in the breezes outside this majestic park. Nothing felt foreign to me when I played in Crockett. An eighteen-wheeler full of MLB players and multiple Hall of Famers had stepped into that batter's box, and now I would join them. This hallowed field was a launchpad to the Bigs.

Given that eight of the Charlotte O's had played for the Championship Miami O's the previous season, this year's crowd pulsed with anticipation and excitement. After much pre-season hoopla, 6,300 baseball fans crammed into the stadium's 5,500 seats and overflowed down both base lines—the largest paying crowd in the history of the Charlotte franchise.

The team planned to repay them with a win, to announce to our Charlotte supporters they had a squad the city could be proud of. I contributed by marking a 3-1 fastball coming out of the left hand of Chattanooga Lookouts pitcher, Rick Borchers, smokin' it for a tape-measure, two-run blast, scoring the game-winning run. One newspaper headline stated, "Homer Is Decisive," while it also called my long fly "the shot heard 'round Charlotte." We delivered an opening night story that the Queen City newspapers loved to write about:

> Give Scott Christopher an A+ in drama. [He] is up in the last of the eighth. In the fourth he's doubled and scored on Big Dan Logan's single. Now, with time running out, he's at the plate with a man on, two out, the count 3-1. He smashes a home run far over the left field wall.

The same article recapped the following: "Last week in spring training I asked Hank Aaron what the secret to hitting was," Christopher explained. "He said that it was 'concentration and a quick bat.' I'd heard it before, but hearing it from Hank made an impression. . . . Hank also told me that 'every time I swung the bat, I swung it as hard as I could.'"

"Hammerin' Hank" crushed 755 big league homers, over 23 seasons in the Bigs, to become the undisputed Home-Run King, surpassing the great slugger and baseball legend Babe "the Sultan of Swat" Ruth's long-standing, 39-year record of 714 big flies. The powerful right-handed hitter pounded dinger #715 on April 8, 1974—a game I watched on television with my parents. This was baseball history at its BEST.

My home-run ball rose high and arced into the darkness behind the left-center field light tower—a majestic shot. During my last two

appearances in an Orioles uniform, I had hit two, high-pressure, must-have home runs, proving to the brass that Clyde Kluttz and Skip were right in placing their confidence in me. And over the past three seasons, two of those home opening-night games saw me delivering the game-winning runs batted in.

Our pitcher that night against the Lookouts was the Orioles 1978 6th round pick, Mike "Professor" Boddicker, who had a stellar MLB pitching career, posting 134 wins to 116 losses, with an outstanding 3.80 ERA. Mike earned the ALCS 1983 MVP and became a world champion that same season, battling the Philadelphia Phillies for the crown. He tossed an exceptional second contest of the series, flattening the Phillies 4-1 on a three hitter. Professor hurled a grand opening night game for us, giving up only two hits.

Ultimately, Mike set the league record for strikeouts on June 7, fanning 19 Knoxville Sox hitters. Many players were proving to be winners as the season progressed, and I stood among them.

FIRST-HALF EAST DIVISION CHAMPIONS
CHARLOTTE ORIOLES 1979
Left to right, front row: Scott Christopher, Jeff Schneider, Rick Mayo, Dan Logan, Nate Snell, Russ Pensiero, Rob Whitfield, Bobby Bonner, Steven Greene.
Back row: John Buffamoyer, Bill Presley, Dallas Williams, Pete Torrez, Russ Brett, Drungo Hazewood, Larry Jones, Mike Boddicker, Vernon Thomas, Dave Huppert, coach Joe Alvarez, Manager Jimmy "Skip" Williams.

Dream snatcher, 1979

In any life, you can expect many moments of beauty and many moments of despair. Life is not a straight line. Every now and then, out of nowhere, an unexpected occurrence alters your life's path, for better or for worse, in the span of seconds. May 12, 1979, was a case in point. The man who had me in his sights as the darkest of dark horses, with a legitimate shot to make it to the Show, Clyde Kluttz, passed away suddenly at the age of 61, from kidney and heart ailments.

A large baseball presence attended the funeral, as Clyde touched many players' lives. Our team traveled to a quaint, white church in Salisbury, North Carolina. We showed up to honor him and pay our final respects, as did the New York Yankees Hall of Fame pitcher Catfish Hunter, whom I sat next to during the memorial service. I respected Clyde, and his sudden and premature passing saddened me. He, along with Skip, had put me in the Orioles pool of genuine, big league prospects.

My funeral attire jolted the Orioles brass. I chose to wear a colorful silk Hawaiian shirt and oversized, black rectangular sunglasses, in celebration of Clyde's accomplishments, to honor his life's journey and rejoice in his support and kindness to me. He and I shared the love of baseball and the pursuit of dreams.

I was serving up a strong season, steadily building my switch-hitting average. A newspaper article written in the *Charlotte News* on June 5, 1979, titled, "He Sacrifices Average to Become Switch-Hitter," reported:

> Scott Christopher hit right-handed his first three times at-bat in the Charlotte Orioles 9-6 whipping of Memphis at Crockett Park Monday night and picked up two solid doubles and a walk. His fourth time up, Christopher hit left-handed and bounced to shortstop. His night's work left him with a robust .345 right-handed batting average, while his left-side mark was a poor .187. "I am still a little bit behind, but I'm gonna be as good left-handed as I am right-handed."
>
> The win gave Charlotte, which opens a 12-game road trip in Knoxville tonight, a 30-19 record, the best mark in the Southern League. After winning 11 of 13 games, the O's are 4-1/2 games in front of Columbus in the Eastern Division.

Another article in the *Washington Post* sports section, dated June 20, 1979, stated: ". . . only a switch-hitting experiment ordered by the parent Baltimores kept the "Determination Kid" from batting well up in the .300 bracket." At the end of the article it asked: "Big time, here he comes?"

"We do consider him a prospect," a Baltimore Orioles representative replied. This bland response to the reporter's question made sense, in retrospect. The Orioles were already constructing their guillotine for me and my future as a ballplayer. My big league march stopped, stuck in time, when Clyde passed away. I went from being an important and proven player on the Orioles talent chart to a minor league journeyman—I simply didn't know it yet.

The June rains in Charlotte brought beautiful thunderstorms, beating their drums loudly, rolling the thunder across the clouds into a whisper, and then the lightning would strike. On one of those hot and humid, late afternoons the heavens opened up, with a dark-blue, gray, and charcoal-black canopy looking like the stormy skies in the 1842 painting, "Snow Storm: Steam-Boat Off a Harbours Mouth," by Britain's great painter, William Turner. Our batting and infield practices were called off due to lightning and the field being drenched.

That left two dugouts full of players chewing the fat and shooting the bull. Only a few fans lingered in the stands, taking cover under the metal roof. Skip sat in his managers office. My teammates and I began impersonating players on our team, Skip, and our coaches, when I had an idea. I went up into the press box atop the stadium. This structure looked like a slice out of famed architect, Frank Lloyd Wright's iconic home he designed, Fallingwater, built in 1939. I began announcing over the loud speakers a make-believe inning for both teams. When your club has the best record in the league, pretty much anything goes. If our team had been in the cellar, I would not have been in the press box or close to that microphone.

This structure was rectangular and narrow, and our team's broadcaster had not arrived yet. I pressed the button on the side of the long, silver microphone to amplify my voice across the stadium: "And now batting, Drungo Laruuuuuuue 'Diamond' Hazewood." I had witnessed Drungo smash home runs over five hundred feet. As I called players out of the dugout, both teams were enjoying my spoof.

A black telephone in the press box sat on a shelf that faced the field. Deciding to give Sharon a call to tell her about the current status of our game, I lifted the receiver, and before I started dialing I heard "Christopher" through the earpiece.

Skip was talking to the execs in Baltimore about Scott Christopher. A nightmare swiftly engulfed me as I comprehended the brass wanted to send me back to A-ball in Miami: "We need to get Christopher in Miami as soon as we can to help the team out. The club is not winning enough games. We need Christopher's experience down there."

Hot lead ran through my arteries directly into my heart. I went numb in disbelief. An MLB prospect the organization is serious about and committed to does not get sent down to A-ball in the middle of the season—especially when that player is moving forward with his skills and contributing heavily toward his team having the best record in the league. Skip, with decades of baseball loyalty, began to chuff like a steam engine. The pronouncement stung him too, and Jimmy attempted to keep me in Charlotte—but to no avail. His words fell on frozen, silent foul lines.

Our team ranked in first place. My personal record spoke for itself: only one error in the outfield; batting well over .300 right-handed; 8 out of 10 in stolen bases; and my switch-hitting steadily improving. I had pulled my left-handed batting average up 20 points in the last three weeks of play, closing in on a .250 batting average overall, and climbing steadily. Recently I hit a home run left-handed in Orlando, against the Twins. To request a professional player to begin switch-hitting full-time, at age 25, is unheard of—yet I was starting to master it. I had worked diligently to perfect this unique skill and sacrificed major offensive statistical numbers to give the Orioles what they wanted.

Moreover, Skip, Clyde, and Ralph had a broad vision for me: a big league leadoff hitter who would be an aggressive base runner and score runs, lots of runs. Each of us believed this was attainable. Jimmy and Clyde stood behind me 110 percent. I was a record-setting 74/80 in stolen base swipes over my career.

Tom Giordano had been immediately appointed the Director of Player Development to replace Clyde. A straight-line thinker, he didn't see me as a conventional major league player. I embodied the 1970s in a baseball uniform: I wore avant-garde sunglasses; wrote science fiction; painted abstract intuitive canvases; photographed obscure compositions;

United States Senate

WASHINGTON, D.C. 20510

May 10, 1977

Mr. Scott Christopher
Baltimore Orioles
P. O. Box 1868
Opa-Locka, Florida 33055

Dear Scott:

I call you by your first name because it seems I have known you for so many years. Your proud father has kept me informed of your amazing records in the field of sports.

I extend my heartiest congratulations to you on achieving a contract with the Baltimore Orioles. May your place in the professional world be as spectacular and successful as your endeavors leading up to this time.

With all best wishes.

Sincerely,

Hubert H. Humphrey

art magazines and newspapers published my paintings, photographs, and writings; and Sharon and I lived a Bohemian lifestyle. I corresponded with acclaimed artists and notables from around the world. One spring training I had received a letter of support and congratulations from the former Vice President of the United States, Hubert H. Humphrey, my father's friend, correspondent, and spirited supporter of his global humanitarian efforts. I may have been the farthest-out player Tom had ever encountered when it came to his vision of developing players to feed the Oriole's major league team. Not only a free agent, I was a free thinker and creative of the highest order.

The front office remained firm. They tied Skip's hands. He always gave me his best as a manager, and I always gave him my best as a player. We won a professional championship together, and we were moving in the right direction to win a second one. As I listened, I stared out across Crockett Park. The players outside the dugouts motioned for to me to continue announcing my colorful faux inning, but they seemed miles away. I was chained to reality within my own baseball horror show. I instantly felt like I had been slammed into the dirt, similar to that fateful day when I was six years old, and landed on the base of a broken soda bottle, spilling my own blood into the earth behind home plate. This time, my soul and passion were hemorrhaging reality behind another home plate, 19 years later.

The phone call ended and I smashed the receiver down, discarded and abandoned by my dream team. If Clyde Kluttz had not passed away, that call would never, ever have been placed. Tom Giordano made his first move with me as the player to be optioned out and demoted.

And the Orioles brass allowed him to design his blueprint however he determined would best serve the organization. My avant-garde chemistry was a cyclone of confusion for Tom. Our generational differences had forced this head-on collision, and there was no seat belt anywhere to be buckled up for me.

> Tom spent 71 years in professional baseball until he passed away in February 2019. He left his mark working in important capacities for various MLB teams. Tom earned an 11-game trial in the major leagues with the 1953 Philadelphia Athletics, where he batted .175, going 7 for 40. Two of his hits were homers.

But how was I the player who could be forfeited? For my two and a half seasons in the minors, I boasted a stolen-base success percentage of .925 that led all of professional baseball with 80 or more attempts. I batted over .300 from the right side of the plate in 650 at-bats. I had delivered a superior Instructional League season hitting and running the base paths, without a single error in the outfield. I played an instrumental part in our Florida State League team winning the 1978 FSL championship. I contributed significantly to the O's making it into the FSL postseason in 1977, and I ended up the seventeenth- and tenth-best hitter in the league, with 300 at-bats or more, my first two campaigns.

Above all that, I had given so much as a player, with my blood, my sweat, my grit, my determination, and my desire to blaze a trail with this team. I was one of a handful of undrafted players in the entire organization. This indignity was callous, beyond wrong, and the reason behind the question that had been directed to me, "Why are you the way you are?"

The press box transformed from a fun house to a wooden, bombed-out pillbox in a matter of minutes. I stared at the closed door, its beaten-up pinewood, and chipped paint. Gulping down labored breaths, I was so upset I wanted to throw the phone onto the field. Like a thunderbolt, the door flew open and smashed into the wall. Skip stood right in front of me, only a few feet away, so incensed his eyeballs could have bored holes through a steel vault. I looked him square in the eye.

"Were you on that <@*>#! phone?" A player is never supposed to overhear a conversation like that, when it is about them and the organization is exposing itself in a way any player would resent.

Unable to speak, I did not answer.

Louder this time, he asked again, "Were you on the <@*>#! phone?"

By not answering, I had answered. Skip stormed out of the press box and slammed the door shut. The pine boards rattled and the floor shook. Talk about having a "red ass"—Skip's was so red I needed a pair of welding goggles as I watched him charge across the field, back to our dugout.

I wished the door would have opened again and someone would have shouted, "Smile, you're on Candid Camera!" But this was no practical joke, as life had just launched me into quicksand.

Bushwhacked, I continued sitting there in disbelief, listening now to the thoughts in my head. *Welcome to the real world, number twenty-three. Baseball owes you nothing. You're lucky the Orioles gave you the opportunity to play one of the greatest sports on earth at such a high level. Thousands of players would have liked to listen to that phone call, because they would have been being paid to play professional baseball, one rung from the Bigs.*

But this thought was ice-cold comfort. My dream lay on the chopping block, and the guillotine blade would come down swiftly. I just didn't know when.

Shortly after this, our team went on the road, and we continued to hold first place. Skip gave me playing time, but we both knew he would be handing me a one-way ticket back to Miami. It came on a hot summer night in Memphis. The loud speakers had broadcast Elvis singing, aptly, "Jailhouse Rock."

Wrapping up batting practice, we soon would take our pregame fielding. Skip called me to the side of the dugout by the bat rack. Pausing and finding it difficult to speak, he said, "Scotty, I am really sorry to tell you, when we get back to Charlotte, you're being reassigned to Miami." Before Jimmy finished, I was under the nail.

My head filled with the sound of a thousand wasps; every thought came equipped with a stinger. I was emotionally tongue-tied and unable to express myself. I could barely talk, but I had nothing to say. I trotted out to center field to take my warm-up fungoes from Skip. Standing close to the pitcher's mound, he hit the first ones to Vernon in left field. Next it was my turn. An inferno churned inside me. Skip batted a grounder that I scooped up, and with as much arm strength as I could muster, I launched that baseball from short center field, over the press box, and out of the Memphis Chicks ballpark. Then I took my glove off and pounded it into the outfield grass.

My coach stonily followed the trajectory of the baseball's flight out of the stadium. He had never seen an act of defiance this extreme. Even my teammates and the fans were shocked by my high-arced throw.

Skip boiled over. He aimed the fungo bat at me like a rifle, took a half swing, and pointed it toward the dugout: leave the field and leave it instantly. I did, with a cannonball of anger detonating within my soul.

Of course, I was benched for the game. As I sat on the pine, I kept hearing the conversations of that fateful phone call in my mind. I remembered throwing the ball out of the stadium, using a throwing hand that was unable to pick up a baseball. I replayed Mike and me playing ball with my dad. Through this heartache, I would go into Memphis after our team bus dropped us off at the hotel and find a gritty honky-tonk, country dive-bar close to the Beale Street district, known as the "Home of the Blues." In the 1970s, this area of Memphis had become a ghost town, which was of no concern to me. In a short period, one of the weathered watering holes that had survived the desertion of patrons called out. I put my meal money in the Wurlitzer 1050 model jukebox—named "The Nostalgia," with a large silver mustang horse running free attached to the top of it—a dime at a time, listening to the blues and Elvis all night long, throwing down Kentucky Jim Beam whiskey, one straight-up shot after another.

I did not care about our team curfew; I did not care about our winning season. For the first time in my life, I did not care about *baseball*. I would go swimming in a sea of dark whiskey to forget it all. My heart ached that much, and logical thinking had landed outside the stadium of rational thought with that upset and angry, errant throw I launched.

The only responsibility I felt was to call Sharon from a pay phone and tell her the guillotine blade had been released. Although sad and supportive, she remained grounded. Our heart-to-heart was honest, consoling, and loving. I told Sharon I found the "Maybe, Maybe Not," bar to douse my baseball reality. She understood my pain so well. We finished our conversation by saying to each other, "I love you."

My roommate on the road, Russ "Worm Killer" Pensiero, one super-talented pitcher, shadowed me through the night. He and other teammates worried about me getting into trouble. I had not drunk a drop of alcohol in over five months.

The "Maybe, Maybe Not" had a red-and-black, square-tiled linoleum floor, rockin' blues music cutting through the lingering smoke, a pool

table, pinball machine, twirling ceiling fans, and men and women trying to understand the reason *why* as they told stories to shot glasses, beer bottles, pool balls, cigarettes, and each other. Of course tomorrow mattered, but it was very distant and difficult to process.

I began my descent by cueing up the jukebox with the King's "Hound Dog." For hours I presided over a one-man, rock-and-blues concert, all the while pounding back whiskey shots. When it came time for us to head back to the hotel, I sent my teammates into the night without me. I had left the ball park and everything attached to it, with reason.

The smoke-filled Memphis saloon, drowning my sorrow, and pulling a major league drunk suited me just fine. My hurting reality, broken dreams, the King, whiskey, abandonment, and anonymity were plenty of company, especially when I felt like a cracked wishbone and hollow-eyed drifter.

When midnight struck, I was holding up the bar, wallowing in booze; cigarette butts in dirty amber-colored glass ashtrays, honky-tonk music, empty stories, and colored neon lights added to my confused mind. The smoke smelled like sweet perfume. I heard the cue ball knocking into pool balls. Others in the whiskey bar walked that thin line of suffering. The Miller High Life clock kept ticking, and I kept hammerin' Mr. Beam, singing the blues to nothing but empty shot glasses, a ceiling fan that wobbled, patrons that looked like impressionistic Monet brush strokes, and myself.

The crowd dwindled, and I had a very foggy idea where I was. I did know where I *wouldn't* be: the MLB.

Lost and stupid-drunk, I thought about leaving the "Maybe, Maybe Not," but I had nowhere to go and didn't want to be anywhere near my teammates in this condition. Ceiling fans stopped spinning. Pool balls settled silently in the rack. The bartender cleared cigarette butts out of the ashtrays with a wet bar towel. Reflections in the mirrors behind the bar became more and more muted. I crawled under the pinball machine, brushed away the coffin nails, some with red lipstick on them, and pushed my head between the rusty back legs and the light-blue, chipped brick wall.

Nearly passed out, curled in a fetal position, alone but not alone—I kept Sharon in my heart as I drifted into oblivion. I could not wait until our team bus turned into the dimly lit Crockett Park stadium parking lot. Sharon and I had already talked about being sent back to Miami, and she agreed that when Skip delivered the decree from the Orioles, we would head north and not south. She supported me wholly, regardless

of which direction life took us. Sharon had been an all-in, wonderful wife and friend through all our baseball experiences together, but I couldn't help feeling our dream had been stolen from both of us.

Somebody was shaking my shoulder on the floor. I rolled my head away from the wall and squinted. "Scotty, Scott, you're in bad shape, wake up, can you hear me? It's Russ." My teammate had come out into the Memphis night on a rescue mission.

Worm Killer straightened out my legs and went to the front of the pinball machine, where he grabbed both my ankles, slid me across the checkerboard linoleum tiles, and helped me to my feet. After zigzagging down the sidewalks of Memphis for 20 minutes with Russ, I found myself lying in my bed, on top of the covers, fully dressed, with the white walls spinning and the air conditioner humming on high. I felt ill. Skip never fined me or Russ for missing curfew. He understood my misery and what it meant for a player to rescue his teammate who was suffering on such an extreme level. There are many unwritten codes in baseball. One of them is never to abandon a man at risk in any situation, both on and off the field.

On the journey from Memphis back to Charlotte, I remained a speechless ice block of a man, tucked into the back corner of the bus. I did not make any drawings in my sketchbook or read one page from my book, *The Teachings of Don Juan; A Yaqui Way of Knowledge* by Carlos Castaneda. I felt hollow. When we pulled into Crockett Stadium,

Sharon was there, waiting in Queen Green, and joy surged through my veins, just seeing her again. We were on the same frequency, in love, sharing this amazing journey called life, together in entirety.

Despite feeling bushwhacked, we talked through everything for hours. The next day we drove away from

My self-portrait painting titled, "Essay of Creative Possibility" (1977).

Charlotte, North Carolina. All my baseball bats and equipment, our art supplies, books, camera gear, clothes, and small kitchen appliances were stowed in Queen Green. Images of Tom Joad, from John Steinbeck's 1939 novel *The Grapes of Wrath*, came to mind. He headed west; I was supposed to be driving south to Miami Stadium, to suit up for an Orioles A-ball game in two days. But Sharon and I were carving a trail north. I wanted to distance myself from baseball and quit the game.

It did not take the Orioles long to react to me not reporting to Miami. The front office suspended me immediately for failure to report to my assigned team. But they continued leaving my parents messages and Tom Giordano's phone number, for me to call right away.

We traveled confused, but aligned, on roads heading north, staying wherever inspired us as the days ticked by. With college degrees and additional classes taken during the offseasons, we prepared to move forward—away from baseball and toward career opportunities in the arts, finance, computer science, and medicine. Life delivered a bruising gut-punch that doubled us over, but at least we were not down for the ten count. Together we would endure, together we would dream, as we both firmly believed that one of the only constants in life is change.

Sucker punch + love + passion = Sharon and I would survive on a high level.

RECONSIDERING THE GREAT GAME OF BASEBALL

Winding up back in Virginia, I had been AWOL for almost a week. I finally returned the calls from the O's hierarchy. The brass sincerely wanted me to reconsider and play for the Miami Orioles once again. Sharon and I both felt the Orioles had delivered an out-of-the-blue curveball, but we reevaluated the pluses and minuses of returning to play pro ball.

Despite the insult to my standing in baseball, two things had not changed: I still loved the game, and playing in the Orioles system meant living the dream. Looking at various scenarios, the one that seemed most logical for us was to return and suit up, enjoy the beaches, continue to create, live, and participate in the bohemian art scene in Coconut Grove. Baseball contributed significantly to my artistic process, as my passion for each cross-pollinated in ways that added depth to everything I did. The designs of the stadiums and the fields brought

linear aspects that I drew content from and applied in many different mediums and forms. I would introduce colors that I remembered from throughout my baseball experiences to advance my paintings. I even

National Association of Professional Baseball Leagues
OFFICIAL NOTICE OF DISPOSITION OF PLAYER'S CONTRACT AND SERVICES

Juen 15, 1979
(Date)

TO PLAYER Scott D. Christopher You are hereby officially notified
of disposition of your contract as indicated in Box No. 9 below

(Club must place an "X" in box below preceding appropriate
statement and, if necessary, add required information.)

☐ (1) You are released unconditionally.

☐ (2) Your contract has this date been assign
 Club of the

☐ (3) Your contract has this date been condit
 Club of the L

☐ (4) Your contract has this date been optiona
 Club of the Le

☐ (5) Your contract has this date been returnes
 Club of the Le

☐ (6) Your contract has this date been assigned
 the League,
 Club of the L

☐ (7) Your contract has this date been recalled
 of the League.

☐ (8) The right to recall your contract has this
 Club of the League.

☒ (9) You are hereby placed upon the SUSPENDED WITHOUT PAY
 (Cross out terms not applicable) ~~TEMPORARILY INACTIVE~~
 ~~DISABLED~~

 List for a term of INDEFINITE

 REASON:
 Failure to report to Club.

☐ (10) You are hereby reinstated from the SUSPENDED
 (Cross out terms not applicable) TEMPORARILY INACTIVE
 DISABLED

 List to the ACTIVE LIST.

Miami _____ CLUB Florida State _____ LEAGUE
BY _James M. McLaugh_____ Agent _____ (TITLE)

RECEIPT: ☒ Player sent copy of this official notice by Registered or Certified Mail.
 ☐ Receipt of copy of this official notice is hereby acknowledged

(Player's signature) (Date of acknowledgment)

BALTIMORE ORIOLES
Memorial Stadium
Baltimore, Maryland 21218

CERTIFIED No. 081648 MAIL

RETURN RECEIPT REQUESTED

"SUSPENDED WITHOUT PAY" — "INDEFINITE"
for "Failure to report to Club"
(extracted verbatim, #9 above, June 15, 1979).

had a palette for sounds that impacted the intensity of my brushstrokes and color choices. With abundant clarity, I acknowledged that I needed baseball. I would devote all of my physical and mental resources to playing expertly in an effort to overcome my recent ordeal.

We decided to forget about unpacking Queen Green. After spending three nights with my parents, we turned around our six-banger to head south on I-95 to join the Miami O's. Bottom line: I could not give up baseball like I thought I could. The game was integrated into my heartbeats. On June 28, 1979, I once again parked at Miami Stadium, shaken to be back in single-A for a third campaign, yet resolved to make the most out of life and giving baseball my best efforts.

That night saw me penciled in as the starting right fielder against the Fort Lauderdale Yankees. I had contributed to the Charlotte Orioles winning the first-half title. If I played strong ball, the chances of me being recalled for the playoffs were high. Skip would bring me back to pursue another ring, if it was at all possible.

To my surprise, when I walked into the locker room and stored my equipment, I was at ease and particularly glad to see several of my teammates from previous seasons: the Galloping Bull, T-Bone, Mike "Heat Express" Rachuba, Victor "See You in the Bigs" Rodriguez, Eddie "King Tide" Hook, Cal "Rip" Ripken Jr., Will "King" George, Brooks "Good Night" Carey, Willy "Tank" Royster, and others. Cal Ripken Jr., John Shelby, and Victor Rodriguez would all become future World Series champions.

Mike Rachuba had brought it big from the left side on our 1978 team, going 11-6 with a 2.83 ERA.

I shook hands with my new manager, Lance Nichols, a former catcher in the minor leagues and future coach of the AAA Rochester Red Wings. A veteran baseball man, Lance taught the game at a high standard. We understood each other well, and being back in A-ball for a third stint meant I required minimal attention. We both knew why I was back in Miami. I was a talented and aggressive player being asked to sacrifice bunt so the team could start winning games.

As I took batting practice that first day, I couldn't deny the thrill of being back on the field. Inside me, I will always feel honored to have been a baseball player, proud to have accomplished what I did on every diamond, and gratified to have developed my injured throwing hand and arm to reach their highest level of performance possible. What I mastered was and still is inconceivable to the medical community.

The stadium seemed larger than usual, due to the small number of fans—another indication of the team's struggles. Sharon sat in the stands, and that was all that mattered. Fortunately, she and Billy Rowe cheered me on at every home game.

I was seeing the pitches spot-on and had a stand-up night at the plate. I smashed one ball that kept finding its way down the right field line, only to be run down by the right fielder on the warning track, at the wall. It was one of the longest balls I had ever hit from the left side of the plate—and to think that 96 hours previously, I had been contemplating how to sell artwork and advance my education to build a successful career.

I *loved* playing baseball, no matter what league they assigned me to—just so I was in the game. And I would play every inning of the next 71 games as a switch-hitter—except for a special home-run derby extravaganza.

The next week took our team on an eight-day road trip. The bus rides were much shorter in the Florida State League than in the Southern League. The final four games of this roady were in St. Petersburg against the Cardinals, with a Saturday night fan promotion event featuring the renowned Cleveland Indian's pitcher and Hall of Famer, "Bullet Bob" Feller. He was slated to serve up the pitches for a home-run derby between two Miami O's hitters and two St. Petersburg Cardinal hitters. Cal Ripken and I were chosen to represent the Orioles.

I was the first hitter up. The crowd was ecstatic and so was I. Bullet Bob brought it and worked the corners of the plate. The competitive fire in him that guided his Cleveland Indians team to a world championship in 1948

still burned hot. I took my three swings, but my hits were a long way from the fence. I returned to the on-deck circle and said, "Dig in, Rip. Bullet Bob is bringing it." When Cal took his rips, he walked away from the plate knowing what I meant. We watched together as Bullet Bob chewed up and spat out the Cardinal hitters. Round one ended with no home runs from either side.

I started round two and adjusted my stance for Bullet Bob's fastballs, to no avail. I did manage more lift on my hits. Cal's efforts proved fruitless, as did the swings of the Cardinal batters.

The fans loved the competition and that Bullet Bob had shut down all four of us for the first two cycles. There were a lot of passionate enthusiasts in the stadium who grew up listening on their radios to the play-by-play calls of Bob Feller's pitching. He truly was one of the great players of his era, and of all time. The crowd that night loved seeing him back on the hill, hurling away. Round three again sent 12 baseballs flying all over the field, but none that cleared the fence.

Cal and I really wanted to win the home-run derby, especially with Bullet Bob on the mound. We did not want to lose to the Cardinal hitters, either. As I started round four, I took a focused look at the 60-year-old who pitched like a 20-year-old. He returned my competitive glare, and I moved off of the plate. Bullet Bob had been jamming me. I was batting right-handed, even though he was a right-handed pitcher, because that gave me a much higher percentage to hit home-run derby taters.

Bullet Bob had only been throwing two-seam fastballs, but each one seemed to burst about 15 feet from the plate. It was not so much his velocity that was keeping this talented hitting foursome from popping at least *one* long fly, it was the location of his pitches. With my next swing, I got a hold of Bullet's two-seamer and drove a fly ball over the left field wall. It was my best swing in the derby; unfortunately, it was just foul and did not count. This excited the fans, and a section of supporters behind the plate chanted, "Bullet Bob, Bullet Bob." I finished devoid of a long fly.

When Cal came to the plate, there had been 42 swings unable to pop a homer. Bullet Bob wanted to shut him down, but you do not get the best of Rip for long. Cal has several geniuses, one of the tops is baseball, and he knows how to optimize situations, given all the variables at hand. Cal would make an adjustment at the plate or in

the field instantaneously that proved, almost always, to be the right decision. You don't play in 19 consecutive MLB All-Star games without a keen mind and extreme "Greatest of All Time" shortstop talent.

One Hall of Famer facing one future Hall of Famer. Bullet Bob tried to slip a heater past Rip. Cal had started his stride, but he kept his hands quiet and then unleashed his bat head. The future great one hit it square and popped it right out of the park, way over the left field wall.

I don't think Bullet Bob cared who won the derby, but he only wanted to allow one home-run. He dusted the final Cardinal hitters. Cal and I prevailed. At home plate, we were each awarded a voucher that entitled us to a chicken dinner at a local, fast-food restaurant in St. Petersburg. Twelve years later, in 1991, Rip would claim the MLB Home Run Derby title, held prior to the All-Star game at the Toronto Blue Jays stadium in Canada.

Bullet Bob, Cal, the two Cardinal hitters, and me gave the fans—and ourselves—a fun night to remember. For Cal, this was the first home-run derby of his professional baseball career. For me, it has remained a dear baseball memory for all of my life. What a pair of bookend memories I had: as a junior in high school, my batting average was not one, it was *zero*; nine years later, I took part in, and won, a home-run contest with two of the top-50, greatest baseball players of all time. Wow, this was an experience of how beautiful a baseball canvas could be lived!

Bob Feller never pitched an inning in the minor leagues, taking the mound and throwing his first pitch for the Cleveland Indians at the young age of 17, in 1936. His ledger posted 266 victories and 162 losses, 279 complete games, 44 shutouts, 18 big league seasons, a career ERA of 3.25, and he won a World Championship in 1948.

Bullet Bob was the first professional athlete to enlist in the armed services, just two days after Pearl Harbor was attacked on December 7, 1941. He spent four years in the Navy and was awarded several combat medals. Bullet Bob has been voted the 36th greatest major league baseball player ever by the *Sporting News*. This was quite a draw for the Cardinals, and the stadium was swarming with blue-ribbon fans. Bullet Bob was not only a big deal, Bullet Bob was the *real* deal.

Bullet Bob and Cal were paired by the Society for American Baseball Research (SABR), who voted Bullet Bob #22 and Cal #43 among the all-time greatest baseball players.

Farther into that season, we again battled the St. Petersburg Cardinals, this time in a four-game series to be played on the beautiful island of Key West, Florida, the southernmost city in the United States, only 90 miles north of Havana, Cuba. Sharon and I remembered Key West well from our visits there over my past two seasons. We made it our destination of choice for snorkeling, beaches, and bohemian counterculture mixed in among the island residents, fittingly nicknamed "Conchs." We created a library of poignant photographs, watercolor paintings, sketches, poetry, and writings in this soft-pastel-colored town surrounded by the blue-green water that lifted our imagination to those majestic, creative places far and beyond it all.

Ticket sales for our series were brisk, due in part to Brooks "Good Night" Carey, a southpaw star pitcher on our team and native Key West Conch, a local baseball legend. Good Night compiled a remarkable 33-7 record pitching for Key West High School. His dominance on the hill with 33 victories tied him for the school record with Randy Sterling. Randy was a 1st round pick (#4 overall) by the NY Mets in the 1969 MLB draft. He pitched seven seasons of pro ball and cracked the big league nut in 1974, going 1-1 in three games on the hump.

Sloppy Joe's began operations on December 5, 1933, the day alcohol prohibition was repealed in the United States. It is open 365 days a year. This classic establishment was Ernest "Papa" Hemingway's favorite haunt in Key West, where he lived as a writer from 1928 to 1940. Papa loved to fish. He once landed an astonishing 54 marlins over 115 days, hunting down the big billfish in the open seas off the Florida Keys coastline. On November 1, 2006, Sloppy Joe's—on the corner of Duval and Greene Street—was added to the U.S. National Register of Historic Places.

Brooks pitched a stopper, winning it 2-1, despite blazing island heat, for his tenth victory of the season. The mayor presented the left-hander a key to the city that day in a pregame ceremony, along with a set of keys to drive a limousine around town. In the evening, Sharon and I rode as Good Night's copilots, to celebrate and enjoy his hometown stardom. We had a limo-load of fun, especially at the world-famous establishment, Sloppy Joe's. This neon-drenched, red-brick destination for seafarers and paradise seekers was known as Hemingway's bar.

Sharon and I danced up a storm to the live rock and roll music. The Golden Left

Cuba was very intriguing to me for so many reasons. I had played with and against Cuban ball players for three seasons, and it was evident they were highly skilled, fierce competitors, and fundamentally rock solid. The first Cuban team was founded by Nemesio Guillot and his brother, Ernesto, in 1868. It was called the Habana Base Ball Club. In 1878, the Cuban Professional League was founded. The first Latin American player to play in the US major leagues was Cuban third baseman, Esteban Bellan, from 1868 to 1873. He is known as the "Father of Cuban Baseball." To this day, the Caribbean Sea island has remained one of the powerhouses of world amateur baseball and a hotbed for professional teams to scout and draft talent.

Two hundred-plus Cubans have played in the big leagues, with four of those players inducted into baseball's eternal shrine, the Hall of Fame: Tony Perez, Martin Dihigo, Jose Mendez, and Cristobal Torriente. Atlanta Braves outfielder, Cuban Jorge Soler, was a 2021 World Series champ and the MVP—.300, three HR, six RBI.

Also of great interest to me was the rich photographic content I had seen of Cuba since I was a teenager, stunning images of a culture that I would crawl for in my pursuit of artistic winners. I searched out imagery in books, magazines, museums, and films, to then canvas Cuba making photographic and sketch-book grand slams. Seeing and teaching baseball was a dream I fulfilled in 2002. Watching the Cuban National Series, sharing my baseball knowledge with players, and moving about Cuba, making thoughtful art, became one of my great life adventures.

On the outskirts of Havana, I was able to conduct a clinic with young ball players and their coach. All of my baseball experiences in Cuba, from watching games to visiting with players competing in the National Series, and my teaching the game are still very special. The Cuban fans were so passionate about baseball that it seemed like a religion for them, and the stadiums were their cathedrals.

Arm reigned as the Ace of Key West that night, and the Conchs rolled out the red carpet for him everywhere we went. But it was a slow ride through the night, in a good way, because everyone wanted to celebrate Brooks's happy fortune. We eventually had engine failure and abandoned the limo to walk our own path, having fun reliving such a special day, reaching the final destination, La Concha Hotel on Duval Street. The celebration continued with "Good Night" Carey captaining the fun ship.

An article in the *Key West Citizen* recapping our twin bill on Sunday had a segment written about our second game that afternoon:

> With no score and the bases loaded in the fourth, Oriole left fielder Scott Christopher hit a single that scored Rodriguez and Espinoso. John Denman, who was on first, moved to third on the play, while Christopher took second as the throw went home. With two outs, Chuck Ross was walked intentionally to load the bases [to set up all possible force-out options]. Then shortstop Cal Ripken singled to left to bring home Denman and Christopher.

Can you imagine intentionally walking Big Red, to load the bases for Rip, a future Hall of Famer, to take his cuts, which he successfully did, quickly adding two more runs to the scoreboard for our winning effort?

If you like numbers, there is no greater game than baseball for delivering analytical data. It is a galaxy of never-ending numerical averages and mathematical anomalies. One such anomaly is that I am most likely the only player in the history of professional baseball ever to hit two triples from different sides of the plate—one right-handed and one left-handed—in the same game, *twice* in one season. Key West was where I had my first go at this elusive offensive hitting feat.

I had hit two home runs in a game before, but spanking two triples in the same contest is mathematically much more difficult because, statistically, far fewer three-baggers are slugged in baseball than any other hit, including home runs. Add into the equation hitting one from different sides of the plate, and you are in uncharted waters to calculate the probability of what I attained. I believe I am unmatched for this record in all of modern baseball history.

I delivered my second effort against the Fort Myers Royals on the third of August. The *Miami Herald* printed an article highlighting my two-triple game that we won 4-1. Also it let fans know we would be playing along with media personalities against the Penthouse Pets before our next game. Here is my hitting excerpt:

> Christopher tripled and scored in the third and again in the fifth. Cal Ripken went three-for-four and scored Miami's other two runs.

Such moments of personal achievement are a source of pride, and they affirmed my decision to return to the game. Not only do I treasure the memories, others have found my accomplishments newsworthy. On April 10, 2014, noted baseball writer and journalist Thom "Sport Story" Loverro wrote an article, published on the front page of the *Washington Times Sports* section: "Injured Hand Didn't Keep Scott Christopher from a Life of Baseball and Art." I felt honored to have Thom think enough of me as a ballplayer and artist to research and write my story. He received the prestigious 2014 Sigma Delta Chi sports column award for excellence in journalism for his piece about me.

I was on the team playing shortstop against the Penthouse Pets, who were clad in 1970s-chic baseball attire. Our club made so many errors that the Pets kept scoring run after run, and this all-star squad of media personalities and pro ball players were outscored by a large margin. In fact, I do not think we ever scored a run. The Penthouse Pets were a team of outstanding baseball talent, both on offense and defense.

Thom interviewed Jimmy "Skip" Williams, coach Jackson, and Cal, adding award-winning content to his article. I had to laugh reading and remembering an incident that was highlighted:

> One experience [with Scott] Ripken will never forget. They were talking on the bench during a game, and the discussion came up of what it would be like to stand in the batter's box, facing the pitcher, with your eyes closed. Christopher said, "The consensus was that it was too crazy to consider."

I had already decided to give it a go. The physics behind our experiment intrigued me. Since the relationship of the distance covered from the release of the pitch to the ball hopefully smacking into the catcher's

mitt would not be registered in my mind, how would that be processed? I would hear the pop, and the umpire would either call it a ball or a strike, but I would have no visual experience attached to the pitch. The philosophical complexity to this trial was a mind-bender.

I announced I would keep my eyes closed on the first pitch of my at-bat. John "T-Bone" Shelby heard my declaration and looked like he had seen a ghost flying in the dugout. I went up to hit left-handed. Many of my teammates were on the lip of the dugout steps to see if I would actually close my eyes. This has to be the only time in professional baseball history where a hitter closed his eyes on a pitch, during a game. My philosophical findings would take a whole chapter to write.

Planting myself firmly in the batter's box, I pushed my helmet as far down as it would go on my head. I looked at my teammates; they were all staring at my eyes. The time had come. I moved my shoulders around more than usual and tucked my head as deep as I could into my right shoulder, just in case "it" happened. Taking my left hand off my bat, I made a "V" in front of my eyes and slowly pulled it down like a window shade.

I tightly squeezed my eyes closed, which created a coal-black void of total darkness. All I could do was wait, and hope to hear the ball pop in the catcher's mitt and not feel it planted somewhere in my body. Since Cal and I had germinated this real-time experiment together, I knew he was nervous and concerned about me getting drilled and hurt. For a split second, I thought one of my teammates might crack and run out of the dugout yelling, "Everyone stop, don't throw the pitch." But baseball players think a lot and are many times quiet when they are perplexed. In the next three seconds I was going to knock on Mr. Fate's door, knowing he works in unpredictable ways, regardless of who or what holds the odds in their favor.

I held my bat high. The seconds ticked off as if they were on a timepiece's hands covered in tree sap. I counted two one-thousands, and nothing but a void. I began to exhale, then *POP!* I heard the ball bang into the catcher's mitt and knew it was a fastball by the sound it made slamming into leather. I quickly opened my eyes and saw my teammates reacting as if they were in a theater watching a melodrama. Several were laughing, others' jaws had dropped, some were holding their heads in disbelief, while a select few were pale, like they were still seeing the flying ghost.

When the umpire yelled, "Strike one," I may have been the happiest hitter ever that had a no-swing strike called. I ingested the experience and reeled myself back in from my independent film footage to focus on my job: get on base and score a run.

Cal and I at Congressional Country Club, Bethesda, MD, April 9, 2019. A memorable evening was had by all 50 guests that night. Especially me!

I visited with Cal at Congressional Country Club on April 9, 2019. He was there as the guest speaker, donating his time for a fund raiser to benefit the Casey Cares Foundation. My close friend, Bob Weltchek, and his son Nolan, had purchased a table and invited me to attend. The Weltcheks are revered in Baltimore for their goodwill and philanthropy toward charitable causes over the decades. Bob and Nolan are also celebrated sports fans of the Orioles, Baltimore Ravens, and U-MD Terrapins.

Before the event began, Cal had his Senior Vice President of Ripken Baseball, Glenn Valis, work his way through the guests to find me and bring me back to a private room. Rip and I were shadow boxing each other, fifteen seconds into our reunion. Then we caught up before we walked down the hallway, into the grand dining room at Congressional. My mother had taken me to lunch at the club when I was in high school, and I really enjoyed reliving memories of that fun afternoon with her. She was dressed elegantly, and we talked about this, that, and more.

During Cal's academic and detailed talk about baseball, touching on winning the 1983 World Series, his 2,632 consecutive games streak, and what they took to accomplish, I was surprised when he spoke about his recollection of me closing my eyes at the plate. Here is what The Iron Man said:

In the summer of 1979, I was eighteen years old. We were all kind of in the same boat—that age where you're trying to figure out yourself, the game, the world. Which, when you look back after a twenty-one-year career in big league baseball, some of your best moments are those moments, at the very beginning. Everybody's the same, we're all in the minor leagues, everybody

is equal, everybody is anxious, trying really hard to succeed, and you do not know if you are going to make it or not.

So it was interesting, Scotty Christopher, one of his skills was that he was probably the fastest man in our organization. And speed, you know, many times is a value. But you cannot steal first—spoken as someone who cannot run. I devalue speed. But with Scotty, he had this sort of outlook and his view of what was going on around him. And it was different.

I remember we would talk about this all the time, and once we were talking about how fast you have to make up your mind, to hit a fastball at ninety-five miles an hour. You have less than half a second to decide what to do. It happens like that. (Cal snapped his fingers.) This one time, Scotty says, "I wonder what it would be like to get up to home plate, get ready to bat, and just as the pitcher's ready to throw, to close your eyes and wait for the sound of the ball hitting the catcher's glove.

"Scotty," I said, "what if the ball hit you?"

And he said, "I just want to know what the relationship is of the speed as it hits. Not when I am looking at it, but to just close my eyes, quiet my mind—and I am going to do it my next at-bat."

So he goes up there, and we watched him very carefully. And right when the guy gets ready to throw, Scotty closed his eyes! Afterwards, if I remember correctly, he said, "Yeah, that half a second, when your eyes are closed, seems like it takes forever for the ball to land in the glove."

So that was the way Mobilean—that's the name he gave himself— he was mobile, all over the place. But it was really interesting, his perspective, his curiosity. I, like many others, wouldn't have the courage to close my eyes with a pitcher on the mound. I don't trust them that much, because sometimes they throw at you. And that could be the one time you need to protect yourself, you need to have your eyes open. So it was interesting to all of us, but we were glad you were the one doing it! (Lots of laughs from Cal, myself, and the guests.)

Thom Loverro's article validated my athletic chemistry, skills, and accomplishments, as well as my innate artistic nature. Here are some of his well-researched gemstones:

Jimmy "Skip" Williams, Orioles 1983 World Series Champion Coach: "[Christopher] was a little different and quirky. But he worked hard all the time. He was a good guy to have on the team. When someone was in trouble on the club, he would be right there to help you out. I felt really bad when he left. If I named the top-twenty-five players I managed, Scotty would be on that list."

U-MD Coach Jackson: "Scott had a real drive about him. He had some problems with his right hand, but he didn't let it affect him and his ability to play. He compensated for the problem. He was a good player, the kind of player I was always looking for, a kid who could overcome adversity and wanted to play."

Cal Ripken: "Everyone thought it was nuts. I wouldn't have had the guts to do it. What if that one pitch gets away? You can't react to it. But there was a greater meaning to the exercise. He was curious about everything.

"We called him the 'Mobilean,'" Ripken said of his former Charlotte Orioles teammate, a name based on a science fiction novel Christopher was writing while playing ball. "He was one of the fastest guys I ever played with. He understood the joys of life beyond most of us. He was a free spirit. . . . Scott was always in tune with his experiences on the baseball field. . . ."

Thom told me that coach Jackson also said in his interview, although it was not printed: "I very rarely saw Scott without his camera. He carried it with him everywhere."

Skip's, coach Jackson's, and Cal's words about me touched and humbled me. My memories with each one them, and all of my valued teammates, will always bring a smile to my face when I think of the games, moments, victories and defeats, championships, almost-championships, and adventures—all that we shared together on and off the diamonds, in our lives, and beyond. The teammanship I experienced through the baseball seasons of my life were instrumental in shaping

my reality. Baseball requires a truly serious nature to be competitive, but along with that I experienced a whole lot of fun. My life's baseball journey was a rock solid 10+++.

Developments on and off the field

The dog days of August in Miami can be stifling. Almost all of our games were played at night unless we had a twin bill; those were few and far between. Sharon and I would regularly frequent Little Havana in the mornings. She enjoyed *cortadito* coffee, and I—who had my first cup of coffee ever, on the artist's island of Hydra, Greece, in June 2019—liked seeing and smelling the thick espressos, looking like dark-chocolate ice cream had been melted in small, white Cuban ceramic cups with tiny handles.

Early that August, Sharon had been light-headed for days. After our morning café run in Little Havana, we searched out the Dadeland Family Planning Center, as having a checkup made sense. We entered the white brick building where Sharon took a pregnancy test. When we left the clinic, our world had been delivered the most amazing gift we could imagine: Sharon was pregnant and carrying our baby! We were absolutely thrilled.

We had been married for almost three years and both loved the idea of having children together. That spring we decided on having a baby as our number-one focus, dreaming of starting our family while I was playing baseball.

We began our celebration in Queen Green as soon as we left the clinic, driving down Calle Ocho in Little Havana with the radio playing. We could not stop talking about our family to be. This was future-tripping at its best. I was 25 years old, and Sharon would turn 27 in November. Our baby was due in early March 1980. Almost a month of baseball remained in the season to ingest the bright, sunny days of Miami, walk and talk, and daydream about how our lives would be with our beautiful baby. We were beyond excited, to put it mildly.

My switch hitting continued to improve all through the season in Miami. To become more and more of a hitting machine, I needed as many at-bats as possible to keep developing my potent offensive weapon. I expected an invitation letter to play in the Florida Instructional League to be in my locker, but sadly, and to my surprise,

the day came when the top MLB prospects were notified, and I was not one of them.

This became a *coup de grâce* for me. Just one year ago, I was considered a top major league prospect. Despite feeling gutted, I would still breathe strongly for my family and myself. Sharon and I planned to live in the basement of my parents' house, substitute teaching every day. The upside of the Oriole's slight was that we could focus 110 percent-plus on her pregnancy, ready to smack one magnificent grand slam with the birth of our child.

Doing the Math

As the season moved steadily forward, our Miami O's stabilized because of player adjustments, of which I was one. Overall, the team played average baseball. Cal was promoted to AA Charlotte in mid-August, having played in 105 games after hitting a crisp .303 for the season, the 11th best in the league. Rip also ranked 6th in slugging percentage (number of bases a player records per at-bat) at .417, 9th in total bases at 164, and 1st in doubles with 28. Clearly, Cal Ripken Jr., who would turn 19 years old on August 24, was capable of commanding the varied and difficult skills necessary to become a baseball star. The brass also reassigned catcher and future big leaguer Willy "Tank" Royster to Charlotte.

My baseball hopes were to be one of the two players promoted, since I battled successfully with my teammates to win the first-half title. We tallied a league-leading 41-25 record, a .621 winning percentage. This exceptional first half guaranteed the Charlotte O's a playoff berth. But in the second half, the team hit a downward spiral with a .421 winning percentage. The O's lost the first two games of the playoffs and were eliminated by the Columbus Astros.

Excluded from the Instructional League and not being reassigned to play ball in Charlotte again forced me to question my lopsided relationship. Where was my baseball career headed? Orioles director of player development, Tom Giordano, remained unwilling to give me the 100-percent commitment I needed to remain an Oriole.

In July I wrote him a strongly worded letter, forcing a meeting in early August to address my concerns. Afterward, I received another written missive from Tom on August 10, with the last sentence stating,

"You will be given consideration to attend the Instructional League." What would it take to prove I should be given every opportunity to continue developing my skills?

In Miami I had worked hard on my switch-hitting, playing every inning of every game on the slate since my arrival, ending the season hitting .249 in 265 at-bats. This, combined with my AA average of .222, gave me a season average of .240 in 400 total trips to the plate: 310 from the left side of the dish, 90 from the right. Of my 90 right-handed appearances, I only struck out an unbelievable two times in my first season as a full-time switch-hitter.

I also tied for the lead in triples throughout the entire Oriole's organization. There was no question in my mind or baseball self that I could be a valued big league player. It was an axiom that if you were successful in the AA level, you can have success in the majors. Many seasoned professionals, positioned throughout baseball, also believed this.

My switch hitting was going to compensate for my right hand and arm challenges in a highly positive way. I had found the key to unlock my door to the Bigs. Sadly, Giordano stood on the other side of that door, systematically over time, spot welding it shut, contributing heavily to my gradual and painful demise.

Over the past three seasons, in 750-plus at-bats right-handed, I hit over .300. This season I struck out 26 times total, which equated to one strikeout for every 15.38 at-bats. This led the entire Baltimore Orioles organization with the lowest percentage of strikeouts per 100 at-bats, at 6.5 percent. My switch-hitting steadily continued to improve, proof to me that it had been the right strategic offensive move, directed by the Orioles brass, for me to undertake my entire season.

If a hitter invariably *drives* the baseball, his batting average will be above .300. I studied this, and it paid dividends for me at the plate. In addition to the traditional batting-average index, I developed a new way of evaluating hitting. I called it "contact average," using a scale of one to four to measure how I was driving the baseball. For example, if I drove a hard-liner into the alley, 350 feet from home plate, and the center fielder caught it, I would give it a four on my contact meter, even though the drive was chalked up as an out in the scorebook.

Investing considerable time and energy on this in theory and in practice throughout my first two seasons, I consistently employed it during my 1978 fall Instructional League and into the 1979 season. I charted every

pitch that was thrown to me for my 400 at-bats, manually calculating all of the data I compiled and filling in my charts and graphs after each game.

By 1980 I had published my analytical data batting manual, titled *Baseball Offensive Batting Sheets*, or "BOBS." Many of the hitting graphs you see used during games now on television and in computer models were originally my ideas. For example, the strike zones that

A page from my hitting book, Baseball Offensive Batting Sheets, for Charlotte O's opening night, April 16, 1979. I may be the father of baseball's offensive analytical, comparative data computations. (Library of Congress 3/10/1980 reference# TXU 39-321.)

show where the pitches cross home plate in the boxes, what pitches they were, where the pitches were hit, and how they were hit came right out of BOBS. Having registered the copyright for my hitting theories and graphs with the Library of Congress, I am one of the early founders of recording, mentally analyzing, interpreting, and predicting probability. I physically implemented offensive hitting numerical statistical data into my game strategies, which produced exceptional results.

On defense, my numbers were even better. Since my return in mid-season, I played the next 71 games in the outfield without an error. This, combined with only making one error for the games I played in Charlotte, gave me a defensive fielding average of .995—the highest fielding percentage for the 1979 season of any outfielder with 104 or more games played in the field in all of professional baseball, including the Bigs. I covered a substantial amount of ground in the outfield because of my speed, and I had a keen ability to get a calculated jump and angle on the baseball coming off the bat. I flagged down many fly balls and liners that would have been out of range for most outfielders. These would have been tallied as hits in the scorebook, and translated into many runs scored by our opponents, had I not zeroed in on them.

The one error I made occurred in Columbus, Georgia, against the Astros, on a hard-hit, top-spinning line drive that I could have easily laid back on, giving the hitter a one-hop single, but as always was the case, I went for making the out. I dove with my glove arm fully extended in an attempt to make a diving catch. I missed catching that liner by two inches and the ball caromed off the tip of my glove and went to my right. I immediately returned to my feet and caught up to the ball. I saw the runner make a wide turn at first base and he never let up. Running at full tilt, he churned up dirt heading to second base, taking advantage of the loose ball from my gutsy fielding attempt. I picked the ball up and threw a strike to Champ Eaton, covering second base.

The umpire was glued to the bag and in an excellent position to make the call. The play was right there, unfolding in front of me, and Blue called the runner safe, beating my throw by half a stride. That was my lone error in over 100 games played in the outfield.

Had I played the hop, the scorebook would have no record of me ever touching the baseball. In this regard, fielding averages in the outfield need statistical attention, because you only get credit when you make an out catching a fly ball, a line drive, or throwing out a base runner.

I think baseball should reconstruct the defensive metrics and record every time a player touches a ball, to compile fielding averages, because there is the possibility of making an error on defense every time you field or throw a baseball during a game.

If a player bobbles the ball and a runner advances a base, he receives an error. If a fielder fields the ball cleanly, then the scorebook records only the hit, and the fact that the outfielder had to field the ball vanishes. Such recordings should be evaluated and changed to present a clear picture of defensive abilities. That way all the players, fans, coaches, and front office would know how many touches or throws an outfielder had in the season.

My high fielding percentage qualified me as a top-five candidate for the prestigious 1979 Minor League Baseball Rawlings Silver Glove Award, for all outfielders in the minor leagues. This award from the *Sporting News* is based entirely on fielding averages. In the number-one and number-two slots were two players in rookie ball who did not make an error in 70 games played, earning .1000 fielding averages. But I was ambushed out of the number-three spot when they presented the award to another player, who had a fielding average of .993. He was a number-one pick in the 1978 June secondary draft. At the time of the awards, his brother was playing in the Show.

In baseball, numbers never lie. You either have the number or you don't. I had the number, a .995 average, and deserved my Silver Glove trophy; it was an unbalanced decision on the part of the *Sporting News*. This accomplishment was all the more impressive, as there are hundreds of professional baseball outfielders competing for this highly prestigious defensive-skill award.

I mounted an aggressive campaign toward the *Sporting News* to right this wrong, but to no avail. As in life, baseball can deliver an injustice now and then. Holes and inconsistencies filled their return correspondence. The Chairman of the Board, the highly regarded C. C. Johnson Spink, wrote in a letter to me, "I am told your average was less than an outfielder in the Mexican League." While the Mexican League is decidedly respected, I do not think its players are considered for this fielding award. Will the *Sporting News* ever make amends for their oversight and present me with my trophy? Numbers do not lie, and I won their Silver Glove trophy for outfielders fair and square. The *Sporting News* should rectify their error. I would happily receive my trophy 44 years later.

MIAMI ORIOLES, 1979
I am #3, front row, far left; Veteran Lance Nichols, an outstanding
baseball manager, is #9, front row, center. World Series champions
included: Cal Ripken Jr., #18, second row, far right; John Shelby,
#1, top row, fourth from left; and Victor Rodriguez, #2, first row,
third from right. Eddie "King Tide" Hook, #28, second row, was
a second round draft pick, lights-out pitcher, and valued friend.
King Tide pitched 500-plus innings over five seasons, posting a
commendable .370 ERA. What a GRAND Person and Spirit!

I had many super achievements in 1979, and we finished our season
with a two-game stand against the Fort Myers Royals at their stadium.
I focused on ending my campaign on a high note, but I also felt a shift
occurring within me, my tormented muscles holding me back, which
became visible in my stolen-bases average. Before I was demoted and
sent back down to Miami, I had been successful in 74 out of 80 sto-
len-base attempts, a .925 average. But after that, I stole a turtle-esque 17
bases in 25 attempts, a .680 average. Although in line for professional
baseball, this was a poor average for me. I couldn't deny it: that fateful
press-box phone call that crashed me into the dirt continued to cloud
my baseball passion. A shift occurred in my DNA for the Great Game.

Moreover, the phone that I waited anxiously to hear ring—the call
from Memorial Stadium inviting me to the majors—remained silent.
Ralph Rowe, my hitting instructor, had told me I might receive the call
to be added to the Orioles big league roster, as their designated runner

for the playoffs. I was excited and more than ready for that dream call, but it never came. Ralph knew how hard I had worked over the past three seasons, and he may have personally wanted to give me a boost and add something positive to my rocky season.

The Baltimore Orioles deservedly made it to the 1979 World Series. After leading the October classic three games to one, they entered the seventh and final game tied with the Pittsburgh Pirates at three wins apiece. Sitting President Jimmy Carter—whom I met with in 2010 as the Executive Director of the Christopher Foundation for the Arts, to share with him CFFTA's history beginning in 1947 and its global humanitarian art missions—threw out the first pitch. The Orioles lost a heartbreaker and the World Series championship game by a score of 4-1.

I was a helpless player, suffering over this painful seventh-game defeat, along with 53,733 Oriole fans in Memorial Stadium that night, October 17, 1979. I sat in my seat wondering, as a run-scoring machine in the O's organization, that maybe I could have helped the Orioles offensively in their last three games.

Eight years prior to this 1979 loss, the Orioles had lost to the Pirates in another final, there "ain't no tomorrow" seventh-game thriller, 2-1. From '69 to '79, the O's had been in the World Series four times, which is an indicator of a well-managed and highly crafted baseball organization. But it wasn't a positive vertical gauge for me. When a franchise is consistently making it to the World Series, which is an incredible accomplishment and so difficult to do, changes to that winning team's chemistry are rarely on the table. Despite my numbers, the decision makers couldn't be sure what my or other players' alchemical effect on their expertly crafted team would be.

As I typically did with all of my athletic challenges since I almost cut my hand off at age six, I determined I would continue to work intensely. During the offseason, I practiced nonstop and began my fourth spring training ready to be an impact player.

Having three full seasons in the minors, and an Instructional League under my belt, I was well aware of what I needed to concentrate on to improve my skills and move up the depth chart. But I lacked a 100-percent, chiseled-in-stone commitment from the Orioles. The best position I could hope for was to be offered and sign a AAA Rochester Red Wings contract going into spring training. With those canary-yellow sheets in my pocket, I would feel validated as a player. I would only be one rung away from stepping into the batter's box at Memorial Stadium.

In mid-January I received my 1980 season contract from the Orioles. I opened it with Sharon by my side and read that I was to be a player for the 1980 AA Charlotte Orioles in the Southern League. I would train hard to make the team, but given what I had experienced, I was not entirely sure what to expect from the Orioles. Would I get a chance to compete for the Red Wings? Not being invited to Instructional League, not being called up to the Charlotte team for the postseason playoffs, and receiving a AA Charlotte Orioles contract going into spring training for the third year in a row—all this kept my wound exposed, festering, and filled with salt.

My mental abrasions received a much-needed dressing after the Orioles John J. McCall, Assistant Director of Player Development, sent me a letter on March 7. In it he wrote, "Should you make the AAA Rochester Ball Club in Spring Training, your salary will be adjusted." He also stated, "Your desire and enthusiasm are most impressive." I now knew I would be seeing playing time with the Rochester Red Wings, which excited me. I was aware that going into my 1977 spring training, I was the least expected athlete to make a roster at any level, with a decent chance I would be the first player released from the Orioles organization. And here I was competing with some of the best baseball talent in the world, for a shot at making the AAA roster, putting me on the cusp of playing in the majors.

Moving forward in life, one of the constants I have learned to accept is *change*. You can't be afraid of change, because you can't avoid it. Sometimes change is delivered when you pick up a telephone handset to make a call, only to learn that your career is in peril; and we know change is going to be especially present when a father cuts his first child's umbilical cord.

Brook

Sharon and I experienced her pregnancy together in a beautiful way. We lived in the lower level of my parent's house, which worked out well. My parents felt close to Sharon, and the four of us embraced each stage of her pregnancy. In the fall of 1979, we worked again as long-term substitute teachers at Falls Church High School. I was painting in a storage space, with a small window in it, that I had converted into an art studio. Previously, my parents kept two week's of K-rations and water there for our family, in case of an enemy nuclear attack in the

1960s. Also, Sharon and I were creating photographic art all around the Washington, DC, area. A joy for writing expanded my creative reservoir, and I treasured that.

Many times I would sit in the living room looking through the four large picture windows at Mike's house and the cul-de-sac, drifting back to my childhood memories. Mike and I shared a youth filled with adventure, curiosity, and endless fun. Every day we started with the unknown, and when we split up and went home, we had nourished the appetites of our insatiable, curious minds.

The adventures and memories abounded between Sharon and me too, and I hoped that we could give our child this gift of being adventuresome, passionate, kindhearted, and bold. During the fall, with its great palette of Van Gogh colors on the trees, gardens, and in the sky, we took walks and talked about the upcoming birth of our new family member. Day by day, the red and yellow leaves of the oaks and poplars became more vibrant, and then sometimes in total stillness and with a soft breeze, they would release and dance their way to the ground to become part of nature's endless patchwork quilt.

We joyfully walked our way into winter, building fires in the fireplace as the snow blanketed the earth. When January arrived, Sharon was two months shy of her delivery date.

Planning on having our baby born at home, we attended birthing classes and studied home-birth literature. Sharon practiced breathing techniques with Betsy, an experienced, skilled midwife. On January 29, the full moon brought a cold winter night with more snow. Sharon had been tossing, turning, and crampy the past few days, though she had an ultrasound just a week before, and the results were spot-on good. Nevertheless, we made an appointment to see Betsy and discuss our concerns. When she completed her exam, our trusted midwife told us that Sharon was experiencing mild contractions. We were alerted that the intensity of these waves would escalate, with her water breaking in less than 24 hours, even though she was six weeks early. Betsy said we should call her, no matter what time of night, when conditions changed.

The moon shone bright and a thick curtain of snow was falling when, at 3:00 in the morning, Sharon's water broke. I called Betsy and she informed me that she would drive over to our house immediately. As the contractions became heavier and more frequent, still Betsy had not

arrived. My mother and I were alarmed. I had been trained over the past month how to deliver a baby in our prenatal home-birth classes. Sharon and I purchased the birthing supplies requested to make an emergency medical kit. We had converted my mom's Dobb's-of-Fifth-Avenue hat box to hold the supplies.

I began to mentally prepare my mother to assist me with the birth. Wide-eyed, she picked up the scalpel and walked slowly upstairs to boil it in the kitchen. Mom filled a pan with water and dropped the surgical instrument in, with the burner on high. Sharon lay in bed, and I held her hand during the contractions. Her mood was mixed. She could not have been more excited about bringing our baby into this world but also was anxious that our midwife had not arrived.

All of my emergency equipment was laid out on a table top when my mother came back down with the sterilized blade. Her strong Irish will had conquered any nervousness. She was ready to assist me. As we stepped up to the plate, we both were very focused. Truly, all three of us shared the batter's box, but it wasn't going to be a baseball coming down the chute. I inhaled fully—and then minutes later, we received a game delay: the doorbell rang. It was Betsy. Talk about being saved by the bell!

Assessing the situation, Betsy requested that we immediately make our way to Alexandria Hospital. Her thinking was purely defensive, eliminating the possibility of Sharon, or our newborn, having any complications. She was especially concerned about exposure to the snow and low temperatures, making it difficult to breathe the cold winter air if a trip to the hospital became necessary. I rushed outside to warm up my mother's red Ford Fairlane, so that Sharon wouldn't have to breathe the frigid air. I helped her, covered in blankets, into the backseat with Betsy. My mother rode in the front seat, and the four of us nervously began our trek in the dark of the night, riding on top of a soft, white, snowy veil.

Sharon was having intense contractions in the backseat. Betsy calmed her. She had made the call to the hospital from the house to have our back-up doctor and the delivery team ready for our arrival. Thanks to the snow and it being 4:30 in the morning, we didn't encounter much traffic. The world beyond the snowflakes swirling in our headlights appeared quiet, still, and mystical.

Sharon and I were positioned in the delivery room before we knew it. The dream moment had arrived. Sharon wanted a natural birth without any medicine or painkillers. I did my best to support her, holding her hand warmly and speaking encouragingly. I told Sharon that she was a strong and beautiful woman who was going to deliver to us, and the world, an amazing baby. We had been through everything together, from the day we started dating, four years and fifteen days ago, to now, the morning of our baby's birth.

Sharon was channeling love and nature's maternal ways when the doctor announced our baby's head was beginning to crown. I was seeing our glorious little one emerge into the world; I gave Sharon moment-by-moment updates. She was so excited that she had risen above the pain, bringing a significant amount of love, strength, vision, and wisdom to grace our birthing experience. Everything was moving quickly and efficiently. The entire delivery room seemed to sway with Sharon's contractions: loud groans, moans, shrieks, and then silence. Lurching, and then stillness. Birthing fluids mixed with love, and then our newborn miracle was being cradled in the doctor's hands.

He checked the vitals and told us we had a healthy and beautiful baby girl. When the umbilical cord stopped pulsating and went limp, I cut it with a pair of surgical scissors. Sharon lovingly held our daughter to her breast. We were spellbound, in total awe. We were the parents of this living treasure.

She weighed five pounds, two ounces, had bright blue eyes, a strong will, and radiated a vibrant, magical spirit. Sharon had created, nurtured, loved, and delivered to us our beautiful daughter. This was the moment that we had dreamed of together. She was right there, in our arms. We named her Brook so that she would be forever connected to nature and everything water.

Our journey as parents began that snowy, moonlit night in 1980. We brought Brook home the following day. To say that we were profoundly moved by the realization that we had created a human being is an immense understatement. Brook had such a shining heart that it illuminated her entire being. That was true then, and it has remained true her whole life. She has and continues to make the world a better one.

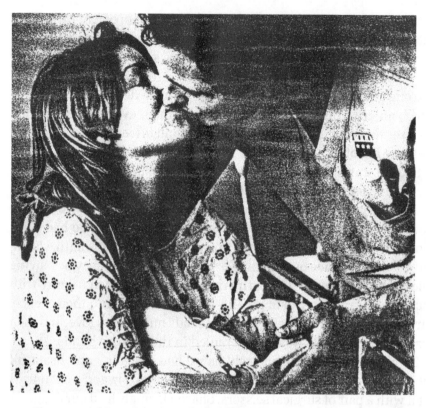

*Sharon and I embracing the birth of Brook. Our amazing baby daughter had arrived, and we were both astonished by the grandness and grandeur of it and her **ALL**. The proud parents' little girl glowed with kindness and love.*

Baby Girl Brook - Forever Loved

*The full moon shone brightly,
snowflakes dancing in the winter's wind
laid a brilliant white blanket upon the ground.
Brook, born in a snowstorm, forever loved,
A beautiful little girl,
innocent baby blue eyes opening and closing.
Tiny hands and arms reaching out, wanting to explore, to fly,
grasping for her life's miracles and dreams
of today, tomorrow, and beyond.
A magical, wise, and illuminated spirit,
filled with kindness, the All of It All, and LOVE!*

Dream Big, Dream On!

Before spring training, Sharon and I gave ourselves two extra days to get settled in Miami with our bundle of joy, Brook, adjusting naturally to the new responsibilities and awareness that all parents experience. As a husband and a new father, my perception shifted, as if I had just finished a very colorful, sizeable painting of my world that awakened slumbering feelings and illuminated corners of my sense of self. I embraced these and made them a part of my life's ongoing art-house film, one frame at a time, to be depicted day by day.

Of course, I have always seen artistic values in baseball. I would enter a dugout before a game with a blank canvas in my mind. From that moment until the final out of the game, I would paint the memories on my imaginary white-linen surface, using very bright colors. Significant moments worthy of including into my painting became a sequence of painted, abstract splashes and brushstrokes. I loved to do this. When I designed my players brick in 2014 for the entryway of the newly built Charlotte Truist Field, I had it inscribed with my name and my belief: *The Magic of Baseball Is Art.*

In a similar vein, Sharon continued writing poetry, creating photographs and drawings, all imbued with her curiosity and excitement for our future.

It's good to be a seeker,
but sooner or later
you have to be a finder.
And then it is well
to give what you have found,
a gift to the world,
for whoever will accept it.
 – Sharon's poem to me
 (April 1980)

I snapped this photo of my teammates visiting with Sharon and Brook, during a break between our games in spring training. L - R: Mark "Buffalo" Smith (see sidebar, p. 339), Vernon "Hammer" Thomas, Rob "Cat" Whitfield, Tommy "Champ" Eaton.

We both loved adventure, and playing professional baseball was always exhilarating. This time, we would be sharing our experiences with Brook. I felt indescribably fortunate that Sharon and Brook spent their days with me in spring training—it was dazzling. Seeing Brook from the practice fields in Sharon's arms, breastfeeding, grabbing the air with her tiny hands, craning to see all the unique things that made up her world was such a joy.

Each new season's camps come with fresh versions of drills designed to make you a better ballplayer, and at times present you with moments of unexpected joy. After we had broken from our lunch break, Skip came over to me, warming up down the third base line for our afternoon game. He said, "Hey, Scotty, pick up your bat and glove and head over to the Red Wings field. You're going to play center." He knew I was excited. It was not possible for me not to bust out a big grin. I felt like sprinting to the dugout, grabbing my gear, and racing over to my new AAA team. This was a very big moment. It was a dose of much-needed hope.

It became even better after my manager, Doc Edwards, went over the signs for the game with me. Fired up, I was going to start with

Vernon playing the outfield too. My second players bonus was that one of the greatest pitchers in baseball history, future Hall of Famer and three-time World Series champion, Jim "Cakes" Palmer, our starter, was about to warm up in the quasi-bullpen. Wow! I was going to cover the big pasture behind one of the all-time kings of the

Jim Palmer pitched in the big leagues for 19 seasons and won 20 games or more, eight times. His overall pitching record was a stellar 268 wins and 152 losses (.638), in 575 games, 2.86 ERA with 2,212 K's. Cakes never gave up a grand slam or had back-to-back homers hit off of him. He is the only pitcher ever to win a World Series game in three different decades: 1966 vs. LA Dodgers, 6-0; 1970 vs. Cincinnati Reds, 4-3; 1971 vs. Pittsburgh Pirates, 11-3; and 1983 vs. Philadelphia Phillies, 3-2.

In 1999 Jim was voted number 64 on the Sporting News list of the 100 greatest baseball players of all time. He was 8-3 in 12 postseason series with 90 strikeouts and an ERA of 2.61.

Mark "Buffalo" Smith was drafted #227 by the Orioles out of American University in Washington, DC, in the ninth round of the 1978 draft. He was a supreme power pitcher standing 6'2" and weighing a rock-solid 215 lbs. When Mark was on the mound, he breathed fire from his competitive intensity. Buffalo joined our 1978 team and was instrumental to our championship run, posting a 15-9 record with a 3.73 ERA. He was elevated to the Orioles AAA Rochester Red Wings before the end of our season.

Mark suffered a tough arm injury that sidelined him until his return to the AA Charlotte Orioles in 1982. Traded to the Oakland Athletics in the summer of 1983, Buffalo courageously earned his ticket to the big leagues, where he appeared in eight games and posted a record of 1-0, his lone victory coming against the New York Yankees. Mark retired after that season. When I was playing the outfield with the big Buffalo on the mound, I felt like I was watching a film of pitching highlights. Buffalo would bring a pocketful of pennies on our road trips and toss them out the window, one at a time, when he felt inspired to do so. I asked Mark why he did this, and he said, "When people find a penny they will be happy because they can make a wish." One of Mark's hobbies was boxing, and he was very good at it. If his pitching arm had remained healthy, the sky would have been the limit for Buffalo. He was exceptional and, hey, he earned a victory against the Yankees in the Bigs!

hill throwing smoke. I walked close to the hitter's box with my bat, standing well off the plate to take in pitches before the game started. Here I was with one of my childhood baseball heroes, and we would take the field as teammates in fifteen minutes.

Cakes's nickname came from his habit of eating pancakes for breakfast on the mornings he was pitching. As he started to loosen up and unleash four-seam fastballs, I felt the intensity of his BBs. With Jim's long arms, high leg kick, and smooth, fluid release, his delivery was not only deceptive, his fastball seemed to accelerate considerably and twist the final 20 feet. Cake's pitches were on me before I knew it.

Jim also owned a very elevated baseball quotient, mindful of everything and everybody on the diamond whenever he ruled the mound. That afternoon, as I played center field, baseball's legend spun around on the hill and waved me back ten feet. Three pitches into the count, my pistons shifted into overdrive, pumping at full tilt, closing in on our left fielder, Hammer. The hitter had unleashed a mighty swing. It took all of my speed, as well as instantaneously calculating the exact angle necessary to catch up to this bomb of a fly ball and flag it down. Since there was no home-run fence, I ran free on the open pasture, without an inch to spare when I finally snared it. I had made a rare, over-the-shoulder catch, robbing the power hitter's drive for a stand-up triple, ending the inning. I flipped the ball to Vernon and he said, "You ran it down good, Scotty. Great catch!" I looked over to Sharon and she happily waved Brook's little hand. I played well and was proud of myself.

Unfortunately, as spring training progressed, it became evident that I was going to be playing for Skip and the AA Charlotte Orioles once again. My wound from being sent back to Miami the year before still oozed with that grating reality. This fresh decision by the brass was not fatal, but it ignited a creative spark in me to think outside the batter's box—and its flame impacted my passion for baseball.

The shift that came with fatherhood also heightened and gained heft, building to a volcanic hotspot where the tectonic plate of my athletic career converged with my family and artistic self. Many significant issues needed to be addressed. At the top of my list, I confronted the sacrifices Sharon, and indirectly Brook, would have to endure. Sharon, a veteran, three-season baseball player's wife, understood what it took to have her husband on the road for 70-plus days and nights during

the season. Another concern we both comprehended was that a professional athlete's job security is tied to success on the field. If you underperformed, the organization had no other option than to release you. Being released strikes like the tip of a cracked whip. Within hours of notification, your locker is an empty memory. All future pages are ripped out of your scrapbook.

I had made five of my baseball dreams come true: (1) earning a full-ride, out-of-state athletic scholarship to play shortstop for the University of Maryland; (2) playing professional baseball on a high level in the Baltimore Orioles organization; (3) hitting my home run in the ninth inning of a winner-take-all championship game to wear the ring; (4) playing, winning 110 percent baseball for my managers, coaches, and teammates; and (5) winning my pro ball crown. The baseball records I established throughout my career validate that each of us can, in every capacity of our lives, "Dream Big, Dream On!" with or without a major handicap.

Becoming a career minor leaguer never played a role in any of my visions. Clyde Kluttz, Jimmy Williams, and I were painting my dream with different brushes but on the same canvas. Tom Giordano and I were unable to share any common brushstrokes, because he lacked a brush, paint, and a canvas to create a baseball future where I was concerned.

The games rolled on, and I kept my skills above the foul lines. A week before camp ended, in the locker room between practices, I passed a rough and tough foxhole catcher drafted in the second round. He still wore his catcher's shin guards, but his eyes were dazed and dimmed. My teammate's name had been peeled off his locker and his dream came to a screeching halt. I wanted to support him, but in baseball this is a private and personal moment. You stay in your own lane. I went to take some rips in the batting cage so he could be alone. When I returned, his locker was a lifeless wood and wire tomb. With almost 1,200 professional at-bats, it was time to punch out his ticket home.

Surprises in life, as in baseball, cannot be denied. Some can change the color of paint on your life's palette immediately. I saw this happen time and time again over the seasons and in my personal life. One day, for every player, regardless of the level they have achieved, their name is going to be removed from above the locker and come out of the scorebook for good. Baseball stands still for no one—not for ballplayers,

managers, coaches, or fans. It continues to move forward as one of the preeminent sports on the planet. It truly is timeless.

The rhythm of baseball creates a personal bond, but my own attachment was becoming molten and unstable. I sensed an emerging eruption from the game. Sharon and I discussed it, and I realized a gradual erosion in my passion had begun that day I overheard Skip on the phone with the top-tier Baltimore echelon. Like a volatile reality, it seeped into the crevices of my baseball soul, fracturing my zeal.

Maybe it wasn't the game; maybe it was just the Orioles organization. I did not want to be in a system that didn't respect my relentless desire, dedication, records, playing banged up, and aggressive play: getting base knocks, stealing bases, excelling on defense, scoring runs, and winning games. Throughout three full seasons, my teams had won three division titles to make it to the playoffs each year, winning one professional championship. I contributed a lot to those three postseason berths—they were quite an accomplishment for me, my teammates, my coaches, and the Orioles franchise.

Why did they want to cast me aside? Too avant-garde? Quirky? Odd? Different? Counterculture? Unpredictable? Couldn't they tolerate a player with a creative soul, outwardly passionate about creating art? Possibly all of these reasons and more—or none of them at all. Regardless, the Orioles had stung me with a sharp stinger.

Now, in this fourth season, I began to see that the organization loves to have someone like me in its minor league system, to expose gifted and highly touted younger players to learn what it takes to be a winner on a professional level and move forward into the majors to ultimately compete in the World Series. And this makes sense, as talent has to be developed to advance their mental and physical skills for the Show. The chemistry necessary for a championship team goes well beyond the 60—of the 118 elements of the periodic table—that compose our physical being. Blending players to form a winning team is extremely complicated and is based on individual personalities and skills of both players and coaches. Every team in any sport requires a unique formula to be successful. Tom Giordano and the brass must have known what they were doing as they masterfully engineered the big league club, because in 1983 the Orioles won the World Series, dominating the Philadelphia Phillies, four games to one, to become world champions.

Rip, T-Bone, and Mike Boddicker were three stars on the team. They and many of the players making up this World Series championship club patiently learned the standards necessary to claim one of sport's most coveted crowns. The "Oriole Way" was considered the finest minor league player development system in all of professional baseball during the 1970s and up to the final out of the 1983 October Classic. T-Bone went on to claim another World Series with the Los Angeles Dodgers in 1988, when they defeated the Oakland Athletics in five games. Both Cal and T-Bone remain engaged in pro baseball, 45 years after their first professional at-bats.

And Rip? Well, I would have to write another book on *his* career and still would only skim the surface of his expertise, on and off the

My historic photograph that I created from atop the Orioles dugout, on September 6, 1995. This depicts a swing in one of the most significant contests in baseball history: Cal "The Iron Man" Ripken Jr.'s 2,131st consecutive game played, breaking Lou "The Iron Horse" Gehrig's record of 2,130 games, set on April 30, 1939. He took a hefty rip on this pitch but popped out. The Iron Man had homered his previous at-bat and would single on his next trip to the plate. Cal added another 501 games to end his never-to-be-broken record at 2,632 consecutive games played. Rip's amazing streak began on June 5, 1982, and ended September 19, 1998. It will forever remain as one of the all-time greatest records in all of sports.

field. "The Iron Man" has been, and continues to be, one of the most honored players in the annals of baseball. He earned each and every one of those accolades. Way beyond the diamonds, Cal has contributed immeasurably to making our world a better one. Rip is a Hall of Famer on multiple fronts and the Greatest Shortstop in History!

With only four days left in spring training, I felt confident of making the team and traveling north with the squad. One day during practice, with the organization's gatekeepers very present, completing their evaluations to fill the final rosters, I prepared to step into the batter's box. I noticed the brass, Skip, and the general manager of an independent team, all in a group talking behind the chain-link backstop. Skip was spitting, using two fingers pushed against his lips. That meant either he felt mildly upset or he was thinking about the strategic pros and cons of making a decision. Or both.

I caught a word every now and then, sensing my loyal coach was fighting for me once again. I thought the discussion was possibly about me being optioned out to an independent team. The stitches from last season's send-down wound were being ripped out, one by one, with the Orioles executives heaping an entire mountain of salt on my oozing, injured psyche. These perceptions may have been wrong, but nonetheless my feelings activated real emotional pain.

As I finished my at-bat, a range of emotions surfaced from the magma chamber created shortly after I went AWOL in '79. Regrettably, I was on a depth chart with **"JOURNEYMAN"** printed across the top in big block letters. The reality of my baseball future hurt, and it tormented me. Advancing to 110 percent takes years of tenacity, confidence, and guts. Cascading down into the shadows of a below-100 percent ballplayer made me restless, anchorless, vacant, a traitor, and an impostor to the Great Game. The volcano in my being rumbled menacingly, temporarily held in check by the fact that I had made the final roster and would be in the starting lineup for our opening game on April 11.

HASHING IT OUT

Sharon, Brook, and I headed into Little Havana that night. We talked husband to wife, man to woman, father to mother about our emotional states and what would be in our family's best interest. I slowly dined

on my *arroz con pollo* as we discussed options. Sharon always helped me make sense of things, to sort them out, and to understand why and what I was feeling.

I remained in the game; the possibility I would be playing in Memorial Stadium in Baltimore was very real—or was it? If the Orioles kept me on the back burner, how could I expect my family to endure the hardships of being in the minor leagues? Yet, if they would reciprocate the 110-percent commitment I delivered to them—from the day I signed my first contract to the *phone call*—then all the sacrifices would be more than worth it. Clyde had held, and Skip continued to hold, me solidly on the front burner, but Clyde had passed away and Skip didn't have the final say when it came to a player's vertical advancement. Tom Giordano was holding every card in the deck.

Opening night loomed four days away. My ace in the hole was that Skip saw me as a winner, because I had proven that to him; he would fight for me to be on his team. He needed to win games to get back in the MLB as a coach or manager, and I was minted and stamped as a player who could help his vision become reality. Skip was back in the big leagues for the Orioles 1981 season, and he deserved to be back in the Show. His teams had won two league championships in his three seasons managing in the minors for the Orioles—and I played on all three of those teams.

There are so many factors that go into being a ballplayer, and the higher you go, the more puzzle pieces there are. First, you are born with a set of physical gifts; very few athletes, even exceptional ones in other sports, could ever play the game of baseball on a professional level. Then, you must have a competitive inferno that burns intensely your entire career. As the competition improves at the different levels you play, that fire has to maintain its ferocity. If the flames develop the slightest sputter, you become your own fire extinguisher and are in peril.

To move up the ladder, your skill set has to parallel your competition. As the pitching improves—usually not in velocity of the pitches but in location, knowledge, and command—you have to advance with them in knowing how to make the proper adjustments at the plate. If you do not make those tweaks, your name will not be above your locker much longer, as your batting average will spiral downward, forcing the organization to release you.

You must maintain a very strong emotional will. When you are struggling on the field, you have to put it behind you. Learning to play through injuries and knowing when to alert the team's trainer that you are not able to contribute 110 percent is important. Players can push an injury to a point where it is so counterproductive, they end up forging their own trail home, walking right out of the ballpark for good.

And finally, there is your age. Every player progresses mentally and physically at a different rate. Your brain is an organ, like the muscles that make up your body, and both have a life cycle of peak abilities and performance. So many younger and talented players are stacked up right on your heels. When deciding between keeping a rookie or a veteran, many times management will project where a younger player's talent will be at an older player's age, even given that the seasoned player is more skilled in the present—and the organization will release the veteran. Baseball maintains a narrow timeline encased in an allowed number of players on each roster. From the perspective of all pro teams, there is always a chance that your replacement may be better than you, both in the present and future.

So, giving 100 percent is essential; 99 percent won't cut it. Your numbers will be reflective, in a negative way, if you start to rewind your skills. When your stats dip week after week, the slippage has begun. That razor-sharp competitor's edge is beginning to dull, one pitch at a time. If this is the case as a ballplayer, or as an athlete in any sport, you will be balancing on a high tightrope under the big tent, in the dark, with no net to catch you as you fall through the air.

I wanted to ascend the ladder, but I was operating at 99 percent, at best. I admitted that to myself and to Sharon. Yet I couldn't make the call to walk away—after all the years of sacrifice, blood, sweat, wins, losses, successes, failures, just all of it—without giving my competitive soul and being a chance to surge back to 100-plus percent.

Perhaps worst of all: my dream of playing in the MLB leagues was wavering. And if I lost sight of that, my passion, purpose, and talent would vanish with it—then I would have to find the courage to abandon the game. If I couldn't perceive it, I could not possibly achieve it.

Sharon agreed with me, and we returned to our cinderblock cube under the palm trees, allowing the refreshing ocean breezes to bathe our three souls. Camp broke, and we drove the long, 725-mile stretch from Miami to Charlotte in our dated but always reliable "Queen Green,"

talking excitedly about our new family. Given the current state of affairs, I made one priority very clear to Sharon: I owed her and Brook nothing less than 110 percent every time I stepped onto a field. If I stayed stuck, unable to reclaim my passion, we would be packing up to move forward. Both of us were fully committed to continuing our family's journey into that unknown and amazing frontier we call life.

THE SEASON BEGINS

Upon arriving, we did not think it was the time to search out a rental for the season. It made sense to situate ourselves in a hotel, knowing it would be eight days before we would be together again.

I found it very difficult to say goodbye to Sharon and Brook. The three of us had been sharing every day as a family since Brook was

1980 Charlotte O's Roster

No.	Player	Age	Pos.	Ht.	Wt.	Bat	Thr.	'79 Club
18	Russ Brett	25	3B	6-1	195	R	R	Charlotte
3	*-John Buffamoyer	24	C	6-0	195	R	R	Charlotte
15	Scott Christopher	25	OF	6-0	175	R	R	Charlotte
17	John Denman	24	OF	6-1	200	R	R	Miami
4	Tommy Eaton	26	2B	5-11	170	R	R	Charlotte
11	Kurt Fabrizio	21	1B	6-0	195	L	L	Miami
14	Drungo Hazewood	20	OF	6-3	205	R	R	Charlotte
19	Dave Huppert	23	C	6-1	200	R	R	Charlotte
26	Earl Neal	21	OF	6-6	200	R	R	Spartanburg
16	Cal Ripken	19	3B	6-3	185	R	R	Charlotte
13	Willie Royster	25	C-OF	5-11	180	R	R	Charlotte
1	John Shelby	22	OF	6-1	175	R	R	Miami
6	'Cat' Whitfield	23	SS	6-3	180	R	R	Charlotte

Pitchers

No.	Player	Age		Ht.	Wt.	Bat	Thr.	'79 Club
21	Brooks Carey	24		6-1	185	R	L	Miami-Char.
31	Will George	21		6-1	185	L	L	Miami-Char.
25	Julian Gonzalez	19		5-11	190	L	L	Miami
20	Greg McArthur	21		6-3	200	R	R	Miami-Char.
22	Russ Pensiero	25		6-3	190	R-L	R	Charlotte
9	Luis Peralta	22		6-½	163	R	R	Miami
27	Luis Quintana	28		6-2	183	L	L	Did Not Play
24	Dan Ramirez	22		5-10	190	R	R	Miami
30	Don Welchel	23		6-4	205	R	R	Miami-Char.

Manager: Jimmy Williams (No. 7); **Coach:** Minnie Mendoza (No. 10).
*—On 10-day disabled list.

My age should have been listed as 26, and I was a full-time switch-hitter at this point in my career.

born. The next day, I watched from the window in the back of the bus, as Sharon and Brook faded away. I ached.

On the road, I read an article from the sports section of the April 9, 1980, *Charlotte Observer*, "Charlotte O's Show Pennant Potential." This writer gave a brief summary of the players on our team. All were quite positive, except mine.

> Outfielder Scott Christopher . . . junked switch-hitting at the start of spring, which O's thought was a good idea, then picked it up again last week." [Said] Giordano: "It's *his* career."

Clearly, Tom and I stood on a very rocky slope with each other. His quote confirms that the complete focus I needed to excel on the diamond had become blurry for me, and for a gripping reason.

Our season opener was scheduled in Jacksonville, Florida, against the Royals on April 11—a 400-mile bus trip for a four-night stand in their stadium. Then we were slated to drive 145 miles south to play the Orlando Twins in another four-game series. Once that set finished, we would rewind the blacktops on the other side of the interstate, back to Charlotte, arriving around sunup on Saturday, April 19. The first pitch of our home opener against the Jacksonville Royals was to cross the plate at 7:30 p.m. that same day.

Home openers bring a long-awaited pulse back into a city and its fans. Every team in the league is a playoff contender, and the possibilities are boundless. Fans mark the days off their calendars from their team's last game in September to opening night the next season. Baseball has a tendency to cleanse and refresh itself this way. It is the ultimate dreamer's sport.

As a ballplayer, I was always razor sharp when a season began. I anticipated a strong showing in Jacksonville. I liked the stadium and had crushed a left-handed homer there in '79. When I came into the dugout, I inhaled the beauty of baseball and all that it meant for me. The taste of possibility hung thick in the air. Our fresh wood waited in the bat rack, helmets gleamed with a new coat of paint, and fans piled into the stadium. The crack of the bats echoed across the pristine field as new baseballs jetted all over the park. The bases shone brilliant white, the infield dirt was perfectly raked and pebble free, and the radiant Kelly-green grass stretched out into a sea of dreams. What was not to love about opening night of a new season?

In the outfield, my teammates and I loosened up our legs, jogged, and played catch. Game conditions were excellent: a cool crispness touched the windless air, and hitting conditions could not have been better.

When I came off the field to take my rips, I read the lineup card taped to the block wall in the dugout. No stitches remained in my gaping wound. I was as far from the leadoff hitter as you could be, ninth in the batting order. I had never hit ninth in my life.

Then I cringed a second time, seeing "DH" by my name. As the designated hitter, I would not play the field. Again, I reeled. How could that be? In my 1979 season, I only made one error in over 100 games; I did not make any in my entire '78 Instructional League season; and I had done very well outfielding in spring training. My '79 campaign sustained a higher fielding percentage than the top-three major league Gold Glove winners—Sixto Lezcano of the Milwaukee Brewers, .986; Fred Lynn of the Boston Red Sox, .987; and Dwight Evans of the Boston Red Sox, .988—and I was riding the pine on defense? Pain, pure pain!

Skip knew I covered as much, or more, pasture than anybody in the outfield. If it were up to him, I know he would have positioned me on defense. The only explanation seemed to be that I was older than my fellow pasture gallopers. I was 26, and organizations place more importance on developing younger players to compete for a World Series title. The hierarchy's blueprint for their future MLB players was quite evident. The architectural drawing did not include me in their grand design. Unfocused dreamers can be naive, and I was not dreaming clearly anymore.

Jolted, the cacophony on the field became muted, as if under water. My king shifted from being blurry to a foundationless, dark and narrow stanchion. Seeing my teammates playing the outfield and waiting for all of them to bat before me confused me even more, one pitch at a time. It was harrowing. As I dug in to take my swings with my weighted bat in the on-deck circle, I hoped everything might shift once I heard, "Now batting, designated hitter, Scott Christopher" over the loud speakers—just minutes away, with thousands of fans in their seats. When it became time to tap the far end of the platter, my season would commence.

Gazing out across the field, I perceived everything baseball is about. But its beauty barely moved the needle on my competitive meter. The problem, a considerable one, was my flame was flickering. I went 0-3

with one stolen base as we dropped our away opener 6-5. My trips to the plate remained anemic. They lacked that anything-is-possible spirit all proficient hitters demand, and I sensed the 5,335 sets of eyes saw me faltering.

For our next game, the lineup card read the same for me. I desperately tried to fan my flickering flame into a blazing inferno, but to no avail. Hitting number nine and riding the pine at age 26 was like being doused by a bucket of Elmer's Glue. As it slowly hardened, I became stuck in my dark reality, unable to escape. We won 6-1, and I was the only player to score two runs, but I was hitless again, going 0-2. This time my bat was a toothpick. It had no Boom.

In game three, I was an offensive phantom, haunted at the plate. My keen ability to pick up the pitcher's release point had died. That's what happens when you play baseball at 99 percent. We won the game 9-2, but I put up another goose egg, going 0-4. After our first three games, I was 0-9 at the plate. Wow! This was a buzz saw spinning inside and outside my gut and turning my bat into sawdust at the plate—excruciating!

In game four, the Royals started their 1977 number-one pick, left-hander Mike Jones, which I took as a slump-ending opportunity. I had had skillful plate appearances against Mike over the past two seasons. He eventually pitched in the majors later that season, after recording a 13-6 record for Jacksonville. Also in my favor: I had only struck out twice, right-handed, in 90 trips to the dish during my 1979 season against left-handed pitching. My confidence jumped as I dug in to swing.

I was always able to focus very well on Mike's release point, at least in the past. But he turned me around like an unbalanced gyroscope. By the time I swung, the ball was already popping in the catcher's mitt. I struck out my first two right-handed at-bats. My fuse had blown; the lights were out. I felt humiliated—a chagrin to my teammates, to the O's organization, and to pro ball. My bat had been hollowed by termites. Had the ball been the size of a grapefruit on a golf tee, I would not have made contact. I finally resorted to drag bunting and slid one past the pitcher for my first hit. This broke the ice, and I hoped it to be the beginning to end my fatal nosedive.

I could not have been more wrong. I froze at 1-12, and we lost 13-10. Skip benched me for games five and six against the Orlando Twins, hoping that I would regain my footing. He understood my struggles.

It was frustrating to tolerate hitting .083, 26 years old, and riding the pine with my wife and new-born daughter living out of a suitcase in a hotel, drenched in reflections of neon lights at night. I was packing plugs of Red Man in my mouth and spitting away. I walked from wall to wall in the dugout, like a tormented circus performer, spiraling down to 98 percent, knowing I was sinking into a bottomless well, haunted by the memory that nine years before, I paced the dugout as a junior in high school with a zero batting average.

Jimmy reinserted me back into the number nine slot for games seven and eight. But by the end of the road trip, I may have set another Orioles organizational record, one that brings a ballplayer nightmares. I had started off the season 1 for 19, with six strikeouts, three runs scored, two stolen bases, and one run batted in. Last season in AA, I struck out one in every 12 at-bats; this season I was averaging one K for every 3.2. I was my own voodoo doll effigy that I had driven 18 wooden pins into.

Forget about 99 percent—my performance was more like 9.9 percent. Sheer torture. I called Sharon every night after the games, and I must have sounded like a broken record: zero for this and zero for that.

Sharon stayed in a hotel eating at restaurants and diners day after day, all the while breastfeeding Brook. I was grateful she had the company of her mother, Marilyn. What did I contribute? This woman, my wife, our daughter's mother, an academic and creative—and all I could show her was to swing the bat like my late, concert-pianist grandmother. I imagined my great-great-uncle, a two-time World Series manager and baseball Hall of Famer, Wilbert Robinson, gyrating in his grave.

Reuniting with Sharon and Brook pulled on me like a tidal current, and we counted the hours before the team bus would roll back into Charlotte. I told her to put the brakes on researching apartment

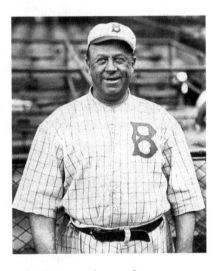

A vintage photo of my great-great-uncle while managing for the Brooklyn Dodgers. Uncle Robbie appeared on the cover of Time Magazine, *August 25, 1930.*

rentals; together we would reassess our family's future in baseball as soon as I returned.

When the bus hit Interstate 95, I was hitting a crippling, where-is-the-oxygen-tank .053. Except for my .000 average in high school, I had never been faintly close to this bus-ticket-home batting average. Desperately I hoped I would find my swing in Charlotte, with Sharon and Brook in the stands.

This became one of the longest bus rides of my life. After eight hours on the road, which seemed like twenty, I saw Sharon and Brook. My family reunited, and I was home. I tried to forget about my batting average and my vanishing dream. I just wanted to embrace the wonder of being with my wife and daughter. They held the center of my life; my future decision regarding baseball involved all three of us, not just me.

HOME GAMES

I had departed Charlotte still believing my call to the Show might come one day. I returned to Charlotte thinking I might say farewell to the game. I was in a state of mild shock. Sharon and I continued discussing my career, and it was quite apparent to both of us that I was not on the Orioles big league radar in any way, shape, or form. But neither of us felt willing to throw in the towel until I had played at least the two games over the weekend in Crockett Park. It just made sense. If my focus sharpened, then we would reevaluate.

Our first game was slated to begin at 7:30 Saturday night. A crispness remained in the air, and the Southern humidity had not had the heat necessary to build its thick, dense wall. The charged-up Charlotte fans, all 5,182 of them, filled the stands to cheer us on to victory.

I enjoyed home openers in a gigantic way. In last season's first game, I blasted "the-shot-heard-'round-Charlotte" home run in the bottom of the eighth, to win the game, 3-2. This season, I was stepping up to the plate leading the league with the lowest batting average, at .053, one drag-bunt single in 19 at-bats. I had to find my swing, I just had to.

I hoped it would be a memorable night for Sharon, her mother, Brook, and me. We all arrived at the park early so we could stroll around the stadium with our baby girl, to make opening night as special as we could. It was shaping up to be a fine Saturday evening. I yearned—in less than 24 hours, after I had played two more games—to be back at 100-plus percent.

A baseball field and the games played upon it are like works of art. Whether you are in a uniform or in the stands, you will become absorbed in the beauty of your personal baseball composition, from the first pitch of the game to the final out. Each and every canvas is different from game to game, season to season, person to person. That day, home fans had a lot to be excited about. Baseball writers were already billing our team as serious Southern League pennant contenders.

Sharon and I tried to slow the clock down, sitting behind the dugout with Marilyn and Brook until it was time to head into the locker room. We walked onto the field together, and I gave Sharon a hug and a kiss, with Brook between us. It was time to either have a "I-have-returned" breakout game, and drive the baseball all over the park, or continue my dreamless spiral into a dungeon of complete and utter darkness. My eyes followed Sharon as she carried Brook into the stands to sit with her mother. I knew Whippoorwill was as perplexed about our future as I was. I tried to shake it off. Confusion on a baseball field—and in life—is a toxic potion for certain failure.

I walked to my locker, surrounded by strongly talented teammates—14 future big league players and one Hall of Famer—due in no small part to Skip. Did I still belong among them? The crisis playing out between my ears did not relent, but it would calm down once I walked out onto the field. It was essential to get myself out of my head and stop thinking so much. I took my time putting on my home opening uniform. I liked wearing number 15 very much, because it was the same number I wore during my 1978 championship season. And I hoped those special memories would help me halt the cavernous baseball free-fall I ever experienced. I needed a parachute but was unable to find one anywhere.

All the hitters in the locker room had been in slumps before at the plate. In baseball, when a player is struggling, your teammates leave you alone to work your way out of the funk. They know it is agony, and I knew they were rooting for me. When I put my spikes on and laced them up, it was time to walk into the dugout, put my bats in the rack, jog to the outfield to warm up—one AAA-rung from the Show.

Next to my bats, I scanned the lineup card taped to the cement wall. Skip had penciled "DH" after my name again—my seventh game in a row bolted the bench, a specter on defense. Though immersed in a passionless hell, I struggled to maintain my resolve. I loved to run in the outfield and chase down long fly balls, make shoestring catches,

and throw runners out on the base paths. Instead, I would be relegated to observing from the bench again as my teammates galloped the expansive, green pastures laid out in front of me. Jimmy was doing the best he could to keep me bleeding baseball, by playing me. He did not know my baseball psychic wound, which had been delivered by the Orioles and self-inflicted by me, was beyond stitching up.

Warming up, I roamed the green pasture, to be as prepared as I could be, should I be summoned to play "D." I loosened up my arm and indulged in the exhilaration of everything heavenly attached to playing the outfield. The field was and will always be a spiritual mecca for my soul.

I took batting practice swings and sprayed liners all over the outfield. I drilled a gapper from the right side of the plate for my last swing and sprinted to first. Mike "Southpaw" Jones, at six feet, six inches, 215 pounds, was slated to throw the Sun's first pitch. I had stung him hard for a bases-loaded triple the season before, in this same stadium, but just five days ago Southpaw had chomped down on me and spit me out like spent tobacco juice. I desperately needed a breakout game that took me from cellar dweller to stellar.

By 7:30 thousands of enthusiastic fans had filled the stadium, and it was time for the guest vocalist to lead the National Anthem. Soon after the singing concluded, the ump circled our catcher, Dave "Cannon" Huppert.

Blue swept off home plate with his whiskbroom, set up behind Cannon, pulled his mask down, and yelled, "Play ball!" Twenty-two deserving professional baseball players made it onto the field to play that night. The twenty-third, number 15, brought another goose egg to the box score. It was a stifling reality to feel, for the first time ever, that I did not deserve to be on the diamond with the other players. I had pulled myself into a lobster pot of boiling water and despair. One more rung to climb to the MLB, and I was self-destructing right in front of Charlotte's finest, loyal fans and both teams.

In the sixth inning we were down 2-0, being held to two hits. We were about to begin our at-bats. Frances Crockett had hired the original San Diego Chicken to entertain the fans, and the Chicken approached the plate umpire and scattered dollar bills at his feet. The ump picked up the bills and put them in his pocket, as if he had been bribed. The ruse worked, as our next five batters scored four runs.

Red-hot Cal Ripken, who came into the game hitting .407, ripped a single through the middle; our power hitter, Drungo "Diamond" Hazewood, drilled one over the shortstop's head that made its way to the outfield fence on three bounces for a triple; that shot knocked in Rip with the eventual winning run, keeping us in first place. Worm Killer picked up a 4-2 win.

Heading back to our neon-drenched hotel after the game, I carried the knowing that my league-leading, worst-batting average had nosedived to .045. Now I was 1-22 at the plate. In this agonizing reality, time stood still. When a dream dies, part of your being dissolves into thin air, right before your eyes. I felt like a mime in Paris, performing in the middle of the Pont Neuf bridge, moving my hands in white batting gloves, searching for something that no longer existed. I was lost above a still and lonely river of fractured thoughts. There was only a flicker of hope left in the batter's box. Taking my swings was the only way possible to reignite my flame.

With the moon shining down and all the glow from the streetlights bouncing off the windows and buildings, it was a long and restless night. I felt weak and my appetite all but vanished. I was suffering. I imagined myself on the album cover of a country-music, down-and-outter titled, "Your Baseball Bat Is Filled with Lead, Gopher Holes, and Memories." My only solace, sleeping next to me, was my family—Sharon and Brook.

Cold waves slowly washed over me, one after the other, starting at my feet and exploding out the top of my head. I had to begin making sense of it all and accept the fact that my first 22 at-bats on the baseball field were a charade. I tossed and turned all night, and woke Sharon up around 3:30 a.m. when I clutched the top cover and pulled it across the bed. She asked if she could do anything to help settle me down, and I

Dave Huppert played on two big league teams, the Baltimore Orioles (1983) and the Milwaukee Brewers (1985). He also was the catcher in the longest professional game ever played, a 33-inning contest that lasted eight hours and 25 minutes. Cannon caught the first 31 innings, an all-time professional record for one game. Dave logged in 29 seasons managing in the minors. His final ledger showed 1,986 wins against 1,888 losses (.513).

In 2005, Cannon was the third base coach for the major league Washington Nationals. Dave was a gifted leader on the field and elevated the Great Game his entire baseball career.

said, with little conviction, "No, I'm praying my swing will come back tomorrow when I step up to the plate."

REALITY BECAME LOUDER AND LOUDER

On Sunday, April 20, 1980, game time was set for 3:00. I loved playing day games. The dance of light from moment to moment would change the way I perceived the game, stadium, and fans. The bright-red stitches on the baseball, spinning through the air, seemed more radiant in the daylight. The glistening, green grass and the buckskin-brown dirt called to me. Everything was enhanced and alive in the Queen City's classic baseball theater. Sharon, Brook, and I were among the first to pull into the stadium parking lot. Marilyn had left in the morning to return home. I had stabilized my dark tailspin as best I could, but the baseball structure of my DNA was drained and weakened.

We wanted to soak in as much baseball as possible on this beautiful afternoon. From the stands we watched as the ground crew prepared the field for batting practice. In three hours, I would be standing in the batter's box of this majestic structure of baseball art, Crockett Park. When the time came for me to walk to the locker room, I told Sharon I had to score at least one run for Brook. "Make sure Brook sees all my at-bats." They were seated in the white box seats, to the right of home plate, three rows up from the rail. "I want to be able to see you both when I score Brook's run." Sharon smiled and took Brook's baby hand and waved it as I slowly walked into a peeling fresco of a confused locker room.

Now it was all on the line for me and my family: either I delivered, or we took to the country roads, heading north, back home to Virginia. While putting on my uniform, I experienced the peculiar impression of being on the far edge of my team, like a spectator looking in. My first at-bat had to be at 100 percent, or I was going to play another torturous game. A shiver of sharks fed on my nerves while my teammates were having fun. We were in first place, so they deserved to celebrate. But me? The rhinoceros beetle was listless in my locker; the good-luck totem brought no joy. Rhino beetle was a fossil of my past glory days.

I would be batting in the ninth slot again. But at this point, I felt lucky even to be penciled in on the lineup card. Skip had such faith in me that

I think he would have started me even if I was hitting .000, because I continued to score runs from getting on base with walks, fielder's choices, and errors. Despite my collapse as a former, entirely capable, passionate ballplayer, my intensity to score runs never wavered. As my hitter's mind became more and more fragmented, crossing home plate remained rock solid—even more so tonight, as I was determined at all costs to score a run for Brook.

Skip always had me take my outfield pregame in center field. I ran my warm-up sprints with strong legs. Unfortunately, from the waist up, my body was tense and twisted, as in the throes of an excruciating nightmare. I warmed up my arm playing long toss with Drungo, but my silver glove would continue to cradle dust, as I was again the DH. Jogging off the field, I knew my first trip to the plate would be a reality barometer for it all, encasing me in a pressure cooker.

The clock ticked away the minutes until I stepped up. When your name is on a baseball lineup card, there is nowhere to hide. You have to take your rips when the stadium announcer calls you to the plate. The Charlotte O's were on an offensive tear as the game began, chasing Jacksonville's starter, Rick Dubee, to the showers as T-Bone tripled, Champ doubled, Rip walked, and Kurt "Sweet Swing" Fabrizio doubled. By the time I came to the plate with two outs and four runs scored, Dubee had been relieved by Erik Hendricks—the same pitcher I had crushed a triple off of in our 1978 playoff game to help advance our team to the championship series. I observed my teammates riding on a carnival merry-go-round, the way they were scoring runs: round and round they circled the bases, crossing home plate as baseballs flew all over the ballpark. Maybe, just maybe, I could join the ride. But that was not going to be the case.

Trouble showed up first in the on-deck circle. After swinging my weighted bat, I removed the lead doughnut and took three cuts with my gamer. My swings were heavy and not fluid. Could I find the passion that had graced me since my first game with the Little League Coyotes at age eight? Please, baseball spirits, somehow return to me in the batter's box as a fierce hitter, PLEASE!

"And now batting, the designated hitter, Scott Christopher," echoed across the park. I dug in deep on the left side of the platter. Willy "Tank" Royster had knocked in Sweet Swing and immediately chose the perfect pitch, a low, inside fastball, to steal second base, putting him in scoring

position. Tank was clapping and cheering me on. One sharp shot would double my batting average and put our team up 5-0. This at-bat could start my return ascent to 100-plus. Sadly, 99 percent and below was locked into my baseball destiny. After four pitches, my comeback hopes were slithering away. The Hawk's focus meter was covered with frost. My ability to read the pitch from the critical release point was myopic.

I was wrapped in chains of mental mayhem. Stepping out of the box, I told myself to snap the hell out of it. The loyal Orioles fans rooted for me; I felt and heard them, but nothing, absolutely nothing, worked. I fished for the fifth pitch, a low and sharp breaking slider, ending the rally and inning with my seventh strikeout in 23 at-bats. Disgusted, I wanted to launch my bat into a state fair fun-house mirror and shatter this horror show.

I walked back to the dugout, a disgrace to baseball, bogged down by the grim awareness that I only had three or four more at-bats before the sentence that had been slowly saturating my baseball passion and DNA, since the fateful phone call, would be pronounced: "It is time to lay down your bat—your extraordinary baseball journey as a player is over!" My mind and body were filled with fire ants, stinging me every-where. I had not struck out three times in a game my entire college or pro career. A fan yelled from the stands, "No wonder you're hitting ninth." I could not possibly let this game be the one that delivered me my first K hat trick.

As I approached the plate for my second appearance, it was evident that the fan was right. The way I was swinging the bat, I had earned being in the number nine slot. My thoughts were so intensely scattered I had to let my physical self take the helm. This strategy partially stabilized my dreadful collapse. Slightly improving my focus in the box, I put my athletic motor memory on auto pilot. I drew a five-pitch walk, only to remain stranded at first as T-Bone Shelby drove a long fly to right fielder Raul Tovar, ending the frame. If our game did not go into extra innings, I would have at least two more at-bats. The odds of scoring Brook's run were becoming narrower as the innings mounted.

Each time I walked to the plate I would look at Sharon and Brook in the stands, but it seemed each stride took me farther from my base-ball future as I continued performing at the lowest level ever. With my third at-bat, the Royals sensed I was crumbling exponentially as a hitter, and they were going to capitalize on my collapse by pounding me

with inside fastballs. With the count 1-1, Hendricks sent me a heater. I made sound contact and drilled a sizzling grounder to the shortstop, who threw a dart to first for the out. After Jacksonville had ripped the cover off the ball, all across and out of the park in the top of the seventh inning, they finished their at-bats, flaunting a commanding 16-7 lead. Twenty-three runs in this slugfest so far, and not one of them had been scored by number 15.

PERSONAL TRIUMPH: SCORING BROOK'S RUN

The red sun etched the clouds across the horizon. What could possibly be my last official at-bat of the game approached, and I remained hitless. Adding to my demise was the imperative to score a run for Brook before the rockslide that would forever close the entrance to my baseball world. Yet mercifully, that pressure provided a microscopic ray of light for me to have my final at-bat with a pulse of passion for the Great Game running through my bat.

I approached the on-deck circle anxious and disoriented, like the agonized person on the bridge in Edvard Munch's four-paintings series titled, "The Scream." My soul plummeted in a free-fall and my breathing was shallow. I carried my lifeless, 1-24, .042 season batting average like a prisoner's ball and chain. My own mind had lost the key that would free me from these shackles, allowing me to reclaim my 110-percent baseball existence. My bat was a wooden anchor, tethering me to a terrifying reality, sinking me further and further into my dismal self, one swing at a time as I lived an athlete's nightmare.

Emerging from behind heavy clouds, the sun hovered over the right-field line from home plate. Surprisingly and thankfully, something within shifted. I became aware of a pulse in my stick to drive a pitch. My gradual downfall—starting ten months prior when I picked up the telephone in the press box—terminated with a thump in my heart.

A memory flashed in my mind of when I was a young teenager and had fallen through the winter's ice on a pond. Fully submerged—in a freezing, dark-gray, desolate world—I never panicked. I found the opening in the broken ice by the way the light refracted in the water, and I slowly pulled myself safely back onto the ice and inched my way to the snowy, frozen bank. That memory whispered to me now: *There's only one way out: to find the light in your thoughts and own the batter's box.*

I had worked strenuously for so many years to become the athlete that I was; the accumulated power of all that verve rose in me, buoying me to the surface. I rolled the leaded bat to warm up my wrists. I simulated a swing, but I stopped it right where I wanted to make impact with one of the pitches I was about to see. Right there, right on the sweet spot of the barrel, I would sting it. I smashed my bat into the ground and the lead doughnut hit the dirt with a heavy thud. I was ready to dig in at the box, get on base, and score Brook's run at all costs. I made up my mind that I would not move out of the way of a pitch if it was going to hit me. I absolutely had to get on first base and that was all that mattered.

The volcano inside quieted as I entered the box. I had reached my breaking point, and I beheld the breathtaking, new vista before me: tomorrow would be a new day, and I was almost positive I would no longer be a baseball player.

I glanced at Sharon in the stands. She had turned Brook around so our beautiful baby girl faced her father in the batter's box. I was batting left-handed, with Tank on second, Cat Whitfield on first, and no outs. The Galloping Bull had started the bottom of the seventh inning off with a homer. We needed eight more runs to tie the game.

Following the path of the sun as it set, I walked directly into the red orb hovering between first base and the end of the horseshoe-shaped stands swarming with Charlotte's finest. Emotions flooded me. Simultaneous movie screens in my mind played momentous baseball clips of the past. I had to find an exit from my searing sorrow. I drilled down to focus on my team's comeback rally and summon the complete concentration necessary to drive the pitch. I stepped out of the box to compose myself, fully knowing that to successfully hit a ball requires being 100 percent present. The fans must have thought I had a gnat in one of my eyes, but I was really shaking off my sadness and stalling to center my at-bat; this could be the last time I ever stepped up to the plate. I had to score Brook's run!

I looked at Skip in the third base coaches box. He wanted me to break my hitting slump and put a dent in the baseball as much as I did. What a stupendous coach. Skip always believed in me. I was 1 for 24, and Skip had not put me on the pine. He clapped his hands and ran through a series of signs. I positioned my spikes in the tawny, clay-laden Southern dirt and cocked my bat high and strong, summoning

passion out of the dusk. If this were, indeed, my last at-bat, I was not going to cheat baseball.

With 325 professional games behind me, 1,236 plate appearances, and 1,109 official at-bats, I had walked 100 times and scored 169 runs, with 87 runs batted in. Now I had to score one more time, at all costs. I remembered my father's encouragement: "Give me your best swing, give me your best swing!" I could picture my beautiful mother in the stands. I heard Sharon cheering, "Get a hit, Hawk!"

I created my highest-percentage hit grid in my mind and worked the pitcher to a two-balls, one-strike count. I dug in solidly and tightened up my swing for his fourth pitch. He threw a hook curve that could have landed a dancing billfish as it approached the plate. This was an average-percentage pitch for me to drive the ball with a quick, compact swing. Craving contact, I locked into the rotation of the ball and released the trigger.

My bat head came through the zone on the off-the-shelf curve, hitting it on the sweet spot. The infield had shifted slightly toward right field. My peppered grounder was on the left side of second base, a two-hopper that the shortstop, Onix Concepción, fielded cleanly. Concepción would play in the big leagues by the end of the season. The play at first, on the double-play attempt, was going to be close. I fired both afterburners, running right into the setting sun, lengthening my strides as much as possible, with my spikes kicking up dirt along the inside of the beaten-up, powdered-chalk foul line.

Second baseman Dennis Webb made his pivot to complete the DP, throwing a pea to the first baseman, who stretched out as far as his legs and glove would take him. He looked like a gymnast with a baseball glove doing a front split. I beat the throw by a solid step.

I always beat the throw on the backside of a double play. Vernon once said, "We [teammates] used to say that your feet never touched the ground when you were running." I made it to first base on a fielder's choice. Tank stood on third. Somehow I had to get to second base so I would be in scoring position. My legs were on fire but they were hog-tied; to swipe a bag was not an option, as we were getting routed, 16-8.

T-Bone came up to the dish with one out. He hit a one-hop come-backer to the third base side of the pitcher. Facing Tank when he fielded the grounder, Hendricks froze him on third, with me running flat out to second. He wheeled around and threw T-Bone out at first. I stood

on second base, staring down the faintly beating white baseball heart, home plate, 180 long feet away.

Champ set himself up at the plate for his at-bat. Hendricks could not pitch around Tommy, because the hottest hitter in the league, 19-year-old phenom Cal Ripken Jr.—pulverizing pitchers with a .400-plus average—occupied the on-deck circle.

Neither Champ nor Cal could imagine what was at stake for me: at 26 years old, hitting .040, and having lost my 100-plus edge, I *had* to score. Within striking distance, I could taste the dirt on home plate. I began calculating the angle that would require the fewest strides to round third on a hit. I imagined running a string straight from the center of second base to the center of third base. If Champ sent that sphere through the infield, I was going for the plate hell-bent, running two steps on the outfield side of the string. Being well behind second gave me the optimum angle to the inside corner of third. With a deep tilt toward the earth, I would push mightily off the bag with my right spikes. From that point on, for the remaining ninety feet, my cleats would sprout wings.

This might be my final chance to be in scoring position on the base paths. Oddly, I stayed focused and my will was strong. My pain was lifting. I was free of the batter's box misery and liberated on the base paths. As soon as the pitcher committed to throwing his pitch, I would take several crow hops toward third, reducing the distance to home plate. The strengths and weaknesses of the outfielder's arm didn't matter to me. If the catcher, Duane Gustavson, blocked the plate, I would be a one-man demolition derby, inflicting the most shattering collision he ever experienced defending the dish in his effort to keep me from scoring Brook's run. And if that resulted in a fistfight, I would throw punches, round after round, until someone knocked me to the ground and I could not get up. If necessary, this truly would be the "shot heard 'round Charlotte"!

I would leave baseball having scored a run, at all costs. I yelled to Champ, "Get on it, drive the rock, you can do it, Tommy, come on, Champ!" Hendricks did not pay much attention to me, with his team winning by such a solid margin. He tried to get Tommy to go fishing on his first two offerings, but Champ hung steadfast to his high-percentage hitting zone. When the third pitch was delivered, a belt-high outside slider, Tommy stung it and drove a liner, just past the outstretched glove of their second baseman, into right field. I had an excellent lead when

he made contact. I pivoted on my right leg, balled up my fists, threw my right shoulder hard toward left field, and blasted off, wings and all.

Skip, standing down the third base line, raised both his leathered palms up, face high, signaling me to make my turn, but to stay tight at third. This was his brakes-on, red double-stop sign. One run for us was incidental when you are hunting a come-from-behind rally. It would be a major base-running error if I were gunned down at the plate.

My instincts on the base paths ranked second to none in the Orioles organization, and I was going for the score. Skip looked right into the intensity of my eyes as I rounded third base. I hit the inside corner of the bag perfectly, at full tilt, thrusting off with my right foot. He saw the fire in my spirit, as he had many times before. Jimmy knew I was not about to settle for third base. I pulled myself back into the base line and became a sprinting bolt of lightning in a baseball uniform, zeroing in on my bullseye, home plate.

My spikes ground far into the dirt and threw it into the air, like a cheetah in pursuit of its prey. It all came down to this: scoring a run for Brook. Forty-five feet out, I saw the catcher setting up in front of home base. The swat was a frozen rope, and the odds were that the right fielder had a solid chance of throwing me out with a strong and accurate throw. It did not matter. Nothing mattered other than giving everything I had and more in this moment, possibly my grande finale.

Twenty feet out, and it was going to be a catcher's nightmare if he attempted to block me from scoring my final run. All my baseball memories, all the blood I had spilled, all the sacrifices I had made along the way, joined to make me a human, 175-pound speeding, target-focused cannonball.

Fifteen feet out, the catcher's posture and the angle of his eyes signaled the ball was coming wide of its intended mark. He left the plate to move down the third base side of the field to backup the pitcher, who ran to intercept a strong, top-spinning, short-hop throw. The umpire and Rip, our next hitter, moved away from the scarred-up white platter. Home plate was undefended; I would make it mine, all mine, for one last time.

A full stride out, I went airborne with my cleats high. I had just left the swing in first grade, with Cal standing there to see me crash-land instead of Mike. I flew like a hawk. Touching down hard, my spikes cut a swath through the earth, into and across the heart of home plate, throwing a plume of dirt and dust into the air.

I was safe! My run for Brook was marked in the scorebook. The fans cheered, sensing a comeback rally for their O's was possible.

It all came down to an off-the-mark throw, pitted against a runner who never played it safe on the bases. The imperfections attached to baseball games make it one of the truest of all sports. It forces excellence from players and coaches, pitch after pitch, out after out, inning after inning, game after game, month after month, all season long, in pursuit of a coveted championship ring.

When I pulled myself up and the dust settled, I singled out my family in the crowd of fans, 35 feet from me. Sharon and I beamed at each other. She knew how much I wanted to score a run for Brook. I trudged by our next hitter, baseball's future legend, Cal, and said, "Keep it going, Rip." Walking back to the dugout, covered in dirt and memories, relief washed over me. I glanced at Skip. He gave me a handclap but was tight-lipped, as I had run through his red double-stop signs. Jimmy would understand my decision to go for scoring Brook's run before the game was over.

At the edge of the dugout, a band of my teammates greeted me. Almost all base runners would have remained at third. It was a gutsy decision on my part. Baseball players love it when a teammate beats the odds, especially when scoring a run. At the end of the seventh inning we added five runs, bringing the score to 16-12 in favor of the Suns.

Many times people get pulled in two directions in a single moment, and it is almost always painful. This was one of those stressful junctures for me. Brook's run was in the scorebook, and I would be stepping into the batter's box one more time, either in the eighth or ninth inning.

A SEASON ENDS, A NEW ONE BEGINS

A particular thought consumed me when the inning ended: how was I going to spend my whole dollar bill on my 1,111th professional baseball at-bat? Despite my stupefied turmoil, one thing remained clear—this game was far from over. The O's still had a chance. Our squad comprised outstanding talent and fielded multiple future big leaguers and world champions.

Hendricks had struggled to find his pitching spots in the seventh inning, being relieved by Jeff Cornell. Cornell was a 5' 11" right-hander who had been drafted in the eighth round of the 1978 MLB draft. He came

at hitters aggressively with fastballs. This competitive fire would eventually earn him a spot in the Show on the 1984 San Francisco Giants.

I had five batters ahead of me before I would dig in for my swings—enough time to study Cornell and develop my left-handed hitting strategy. Being the least-feared hitter in the league possibly had the Royals thinking I should consider becoming a flying trapeze artist in a dirt circus. I was a dreadful 1 for 25 with an appalling batting average sitting at .040. A fastball fiesta lay in my immediate future, regardless of the count.

In the bottom of the eighth with two outs, Galloping Bull and Cat stood on first and second. I had had over four hundred left-handed at-bats in my pro career, with a share of those trips to the plate resulting in extra-base hits, including one long homer against this same club in 1979. If I got a hold of one of Cornell's four-seamed heaters and drove it, one or more runs would score. We would be that much closer to a momentous come-from-behind victory. A drag bunt was not on the menu for me. We had four outs left to score four runs to take the game into extra innings. The Charlotte Orioles fans were very loyal. Nobody was leaving the park. In fact, they were loudly cheering for us as our rally gained steam.

With the first three batters, I perched on the lip of the dugout, glued to Cornell, attempting to prepare my mind to react to the velocity, location, and movement of his pitches. A critical problem remained, though: despite scoring Brook's run, my abilities remained below 100-plus percent. The dust I had kicked up at home plate still swirled around in my thoughts, clouding my already compromised perceptions.

Surprisingly, when I picked up the leaded bat and started swinging it in the on-deck circle, a voice in my head said, "You are a professional baseball champion, and champions never *not* give their teammates everything they have in them to win." That did the trick. Right there, the tormenting chatter in my mind went silent. The athlete in me would be able to zero in on and pick up Cornell's release point and pitches. I would give my final baseball at-bat everything I had in me and leave it all on the field.

The rally was underway, even with two outs. I was in position to bring the fans to their feet. Sharon and I made contact. She smiled brightly, with Brook all cuddly and propped up in her lap. I took a fierce swing for her, and she knew what that meant. I was going to spend my

last buck on my 1,111th official at-bat and drive the horsehide as best I could. Sharon held Brook's tiny baby hands and they clapped together. The announcer called out across the stadium, "And now batting, Scott Christopher." When I looked at Skip in the third base coaches box, as I was digging in deep, he gave me his trademarked, one-of-a-kind, V shaped two fingers over his lips, tobacco spit, and yelled out, "Bring 'em 'round Scotty, hit your pitch." The fans amplified their cheering.

That this was going to be my final at-bat was a reality I managed to put outside of my athletic self. I had a job to do: to give 110 percent of what I was capable of in that moment, even though my skills and mental approach to the game had left the ballpark. I was exactly on my career run-production metric, which was one run per every 6.5 at-bats. With my senses heightened, I planned to sit as far back as I could in the box and give the first pitch I chose to go after the best home-run swing I had in me from the left side.

As I surmised, Jeff intended to make me prove to him that his fastball did not own me. He fired a smoker right into the inside half of the plate, belt high. I decided to uncork a savage tater swing and invest it all right there on his first pitch. His release point was crystal clear. I picked up the rotation of the red-laced baseball far enough out to seat myself low and anchored. Since the trajectory of the pitch was going to end up in my wheelhouse, a green light appeared and I freed up my swing.

When ball and bat met, I could see I was going to drive the baseball. The crack of the bat silenced the fans for a moment. I stung a liner right down the first base line. It wouldn't be a homer, but I thought it would clear first baseman Phil Westendorf's mitt. He had been shading me towards the foul line to reduce the odds of an extra-base hit. Phil timed my frozen rope perfectly. Standing 6' 7" tall, the human windmill took a long stride to his left and snagged my liner with his outstretched lobster-claw glove for the third out of the inning, completing an exceptional defensive play. I had sprinted halfway down the base line before I put the brakes on. My laser dart extinguished our run rally hopes. Four more inches to his right and there was a good chance I may have been legging out a triple.

I quickly turned around to return to the dugout with my shameful, 1 for 26, .038 batting average. As I trotted straight down the base line headed for home plate, intending to plant my spikes squarely into the dish one last time, the anguishing chatter in my mind returned. My

life in that moment represented a complex mosaic of emotions and sensations. This was the first time during a game I had ever approached the dish from the opposite direction down the first base line, as it is customary to angle your way back to the dugout, trotting by the pitcher's mound. And into the home of all my baseball dreams, a white house with a black walkway around it, my spikes landed for the last time. In a roundabout way, I was scoring my own final run, returning home to my 100-plus percent existence that my soul and spirit demanded.

Three steps after I touched home on my way to the dugout, I passed our catcher, Willy "Tank" Royster, about to take the warm-up pitches from our pitcher, Luis Quintana. I said to him, "Shut 'em down, Tank." With the eighth in the scorebook, the score still stood at 16-12 in favor of Jacksonville.

The ninth inning brought the moment I dreaded most. I was pacing inside the dugout, agonizing over what I knew had to be done. Skip was evaluating the lineup card, hoping our team could pull at least four or more runs out of their bats in the bottom of the ninth, to tie the game at 16 runs each, forcing extra innings or winning it right there with five tallies.

I stood at the top of our dugout steps, facing the baseball field as a player, for the last time. The lone person in the entire stadium who understood the insurmountable odds I had conquered to be wearing a Charlotte O's uniform was Sharon. There would be no applause, no standing ovation, and no curtain call from the fans for number 15. I stretched my arms out like a gliding hawk. Then I painfully said to myself, "Goodbye, Baseball, I will always love you!" I felt oddly emancipated in that moment.

As I lowered my wings, Sharon and I shared the moment. Whippoorwill knew, too, our baseball dream had ended. My wife was the only person standing in Crockett Park who was focused on me. She held our baby daughter, Brook, clapping out of love and respect. Sharon appreciated the courage it took for me to give 110 percent, with a throwing hand that, since age six, was too handicapped to pick up a baseball. I returned a clap to her, in honor of my love, the wholehearted sacrifices Whippoorwill had made, and the commitment, support, and loyalty she had shared with me and for me over the last four seasons.

I was free from the torture of not being able to give 100 percent to my teammates, Skip, baseball, its fans, and all the people connected

to me, including my family and myself. I had made the right and only decision possible, given that my baseball spirit, my mind, my journey—my everything—would not allow a 99-percent existence. I have always believed my human experience deserves all that I can give it, each and every stride along the way.

I picked up my Rawlings XPG 3-P glove from the splintered wooden bench, inscribed with the words, "For the Professional Player." On the outside of this high-grade piece of leather, I had inked during my 1977 season a scene of mountains and a rising sun—a symbol of freedom for me—two skyward arrows emerging from the earth, representing exploring the universe's vast creative frontiers, and two flying hawks soaring the wide-open skies together, a fitting emblem for the glove that had only made one error in its last 150-plus games played in the outfield. Chasing down long fly balls in the power alleys was another pure freedom for me. I am holding it in my hands right now as I write, and through the years, every now and then, I will throw a baseball into it, loving the *pop* my glove makes when the ball hits the pocket just right. I cherish the baseball memories my glove brings back to me.

Our game had passed the three-hour mark. Carrying my mitt, I walked over to Jimmy, paused for a moment and winced, and then delivered the final brushstroke to end my dream. "Skip, my best game is behind me. Thanks for having such faith in me as a ballplayer. I know the Orioles do not share my vision, and the time has come to be with my family and experience life as an artist. I'm turning in my uniform." Baseball players do not say a lot when that day comes to hang up their spikes.

Although stunned, Jimmy did not try to talk me out of it. Seasoned veterans like Skip, who spend a considerable part of their lives in a baseball uniform, have seen most everything that can happen to players, both on and off the field. This man of profound wisdom and kindness said simply, "Are you sure, Scotty?"

He was genuinely concerned about me and my family. We had shared one heck of a run together. Over four teams as manager and player, Skip became an inspiration to me as a man. And I would find out later, through his newspaper interviews about our manager/player relationship, that I had inspired him as well.

"Skip, you're a baseball player until you are not. I'm unable to give you or my teammates one hundred percent. I have lived my baseball

dreams, so they are not dreams anymore. I am sure, and I am turning in my uniform."

We shook each other's hand firmly. As my hand separated from Jimmy's, my life as a baseball player stopped in that instant. The sadness in his eyes pained me, but the worst decision is always no decision. For me, my verdict was chiseled in stone. With our eyes locked on each other's, I said, "Skip, you are a great baseball man, and thank you for it ALL!"

Reaching down into my guts for any strength I could find, I said goodbye to my teammates on the bench, pulled my bats out of the rack, tucked my glove under my arm, and clickety-clacked across the concrete to the locker room. My legs were two anchors; they did not want to leave the field. But with a sense of certainty, my mind and soul knew that the dreams and passions I carried with me would shape my future. I gutted my wooden shell of a locker to the dead silence of an empty room that seemed foreign. I did not belong there anymore.

> I achieved more, even to this day, than any professional baseball player in the history of the Great Game who had sustained an injury to his throwing hand and arm, as crippling as mine. My record of achievements that I accomplished, given my extreme handicap, will hopefully inspire all who know my story to latch on to their own beautiful dreams and truly DREAM BIG, DREAM ON!

I piled my baseball gear into my black vinyl Orioles equipment bag with my name, printed in orange, on it. I placed my Rawlings glove on top and zipped it up. To this day, except for my one glove, everything is still in my road-trip travel bag, saddle soap and all, just as it was that

This is my Rawlings Glove that helped make many outstanding plays and catches in the outfield over my pro career.

early Sunday evening I walked away from one of the greatest sports in the world, baseball.

I exited the locker room as the game ended. We lost, 16-13. Every player in the lineup on my team scored a run, and the two teams combined to score a total of twenty-nine runs. These were both firsts for me in pro ball. It was an offensive barrage for all of my teammates except one. I was the only player that did not have at least one hit. And with another goose egg at the plate, I would depart the stadium with my season stat sheet showing an appalling one hit in twenty-six at-bats, which translated into an anemic .038 batting average. Two months later, my prior star-studded team won the first-half division title, and in September, the Charlotte Orioles dominated the playoffs, winning six of seven games to claim the coveted Southern League Championship ring.

Sharon and I met in the players parking lot before anyone else was there, at the most quiet time of the day, where the magic and beauty of it all play out before your eyes, in those brief moments between daylight and twilight. We embraced, and I gave Brook a kiss on the top of her head. I told our amazing baby girl, "My last run I will ever score was for you, Brook." I didn't need to say more. Sharon and I were totally aligned in knowing that our love, passions, purpose, and dreams would deliver us a life brimming with wonders.

We fired up Queen Green and drove slowly away from Crockett Park. My breaths no longer came labored, the fire ants had disappeared, and I began to awaken from my nightmare. No tears and no sadness. The fresh air filled my lungs once again with hope. Sharon sat next to me with Brook swaddled in her arms. The stadium lights behind us became small starbursts in the rear-view mirror.

AN ILLUMINATED MANUSCRIPT

The next morning, outside a 7-11 store, I dropped coins into the newspaper stand to buy the *Charlotte News*, so I could have a box score of my final game. Thirty-one hits, eleven walks, and 29 runs were totaled in this epic slugfest, and my score, Brook's run, was the only one that was highlighted, with a photo of me sliding safely across home plate, dirt flying—and Rip standing right there to witness my last baseball moment. I showed Sharon my picture and then folded the sports page and placed it back into the newspaper. I quickly decided to leave the

paper on top of the rack. I did not want any of the memories attached to playing my final game at 99 percent or below. The game article, box score, and photograph were the final colors, as a player, of my life's baseball mural. Later I learned the *Charlotte Observer* stated two days later, "The O's roster got its first change of the season and lost a lot of speed when outfielder Scott Christopher decided to retire after a 1-26 start."

My creative and artistic soul was becoming ignited and illuminated. I realized I truly had a colossal adventure and magnificent experience with my family, friends, managers, coaches, fellow players, and opponents that left all they had on the field. I had done it: I had "Dreamed Big"; I had walked in the bright light of my Dream; I had launched my final-game, ninth-inning, RING home run, to win it all with my teammates and coaches. I will always be a professional baseball champion, the Baltimore Orioles' season-highest stolen-base-percentage king, with 29 or more stolen bases, and the only pro batter to hit two triples from different sides of the plate, in the same game, twice in one season.

In return for all the sacrifices, sweat, and blood, the game of baseball gave me as much or more as I had given it. Without baseball, I would not have become the man I am. I have absolutely no regrets. I had a phenomenal journey living my professional baseball dreams for one thousand, one hundred, ninety-six days, with Sharon by my side from day one to my final at-bat.

That very afternoon, Whippoorwill and I began to explore picturesque rural fields and new visions centered around our family. With two cameras and Brook by our sides, we made photographs as we meandered along farm pastures of North Carolina. In scenic fields such as those, and countless other settings and destinations around the globe, throughout my life, I have continued to make photographic art, paint, write, sculpt, and produce films. To date, I likely have created more artistic pieces than any professional athlete in history. And through my creative efforts, as well as the missions undertaken as the Executive Director of Christopher Foundation for the Arts, I promote peace, love, and creativity across the earth, striving to make our world a better home for all. My passions for being a creative are powered by the hope that my art, and the art of others myself and CFFTA advance, will build bridges to help heal the divides between peoples across the globe. In

my heart of hearts, I know that with all living beings, the one are many and the many are one.

Live your passions, live your dreams, listen to your heart, give yourself 100-plus percent, offer the world your love and compassion, earn your own RING and wear it proudly! You truly deserve it ALL, my friends. Together let's give it our best to make this beautiful planet we call earth and our home a gift to the universe. The distance between dreams and reality is loving what you do and genuinely living the PASSION for doing what you LOVE to make your DREAMS come TRUE!

"DREAM BIG, DREAM ON!"

• • • • • • • •

CHARLOTTE O'S

SCOTT CHRISTOPHER OF

*My 1980 player's baseball card photo was snapped two
hours before I stepped into the batter's box in my last
contest, as a professional, to swing away and score my
final run playing the Great Game of BASEBALL.*

Painter, Painting, Mural

This amazing and brightly colored artistic mural we call life
is a canvas that we paint on each and every day of our lives.
Sometimes you must change the colors for reasons important to you.
It is beautiful knowing you are the creator of your painting,
and the story it represents.
How exciting to become your own masterpiece,
A unique work of art.
Never anyone past, present, future—is like you,
living your life bathed in the illuminated light
of being true to yourself, others,
dreams, passions, the All of it All, and LOVE.

INDEX

*Numbers in **bold** refer to images.*

Moeller, Jim "Mole" 157, 159, 160, 161, 165, **166**
Molitor, Paul 183
Montana, Joe "The Comeback Kid" 262
Montreal Royals 192
Moody Blues, The 165
Morris, Mike 194
Most Valuable Player (MVP) 86, 155, 156, 195
Murray, "Steady Eddie" 240, 252
Muse's field 111

N

National Junior College Athletic Association (NJCAA) 108
National Negro League 270
Nave, Douglas "Bulldog" 249
Nave, Douglas "Georgia Bulldog" 249
New York Giants 209
New York Mets 152, 193, 267
New York World's Fair, 1964-1965 50–51
New York Yankees 19, 22, 87, 123, 209, 215, 267, 287, 301, 339
Nichols, Lance 312, 330
Niffenegger, Bob "Niff" 186, **194**
Noonan, John "High Noon" 234
Norman, Russell **58, 59**
Norris, John "Bendix" 169, 171, 175, 176, 182, **194**
Northern Virginia Sun
 "Injury Nips Young Diamond Star's Career" 14
 "Plucky Rookie Vows 'Comeback' at Age 6" 14
notice of suspension **311**
Nova Scotia, Canada 214

O

Oakland Athletics 70, 261, 339, 343
Oakley, David 27
Oakley, Peter 26–27
Obal, Dave 166
Ogden A's (Ut.) 151

Oklahoma City Dodgers 152
O'Malley, Joe 166
Orlando Twins 348, 350
Owens, William H. "WHO" 194, 207

P

Pacific Coast League 151, 264
Palmer, Jim "Cakes" 339, 340
Pampano Beach Cubs (Fla.) 236
Pappas, Gus "El Greco" 198, 201, 206
Pasqual, Camilo "Little Potato" 226, 237
Patton, Cornell "General Patton" 49
Pawtucket Red Sox 267
Pelham Mets 267
Pensiero, Russ "Worm Killer" 260, 261, **300**, 307–309, 355
Penthouse Pets 319
People Magazine 151
Peralta, Luis 261
Perez, Tony 317
Philadelphia Phillies 168, 240, 300, 339, 342
Piazza, Mike 193
Pietà (Michelangelo) **50**
Pigman, Kris 103
pinball 17, 34, 45, 144, 308, 309
Pine Spring (Va.) 5, 26, 125
Pink Floyd 165
Pittsburgh Pirates 257, 331, 339
Point Stadium 77, 78, 116, 121, 128, 129
Pompano Beach Cubs (Fla.) 247, 255
Porter, Chuck "Falcon" 158, 166, 172, 173, 187, 188
PP&K (Ford Motor Company: Punt, Pass, and Kick) 29–30, **31**
Presley, Bill "Elvis" 237, 300
Presley, Elvis "the King" 5, 114, 147–150, 165, 306–307
Prevost, John 97, 98, 101
Prince Georges (Md.) 122, 123, 124, 125
psychology of athletes

Virginia Wesleyan Marlins 85

W

Wade, Rick 166
Wake Forest University (N. Carolina) 154
Warren, Jim 65
Washington, Denzel (actor) 116
Washington Nationals (D.C.) 78, 355
Washington Post 49, 112, 114, 145, 201, 238, 302
 April 27, 1977 230
 "Baseball Player Finds a Hard Road Leads to His Life's Goal" 217
 "Christopher Turns Crippling Injury into .375 Mark"
 comeback story to inspire others 112
 "Determination Kid" 302
Washington Senators 219, 226
Washington Times xi
 "Injured Hand Didn't Keep Scott Christopher from a Life of Baseball and Art" 319
Weaver, Earl "the Earl of Baltimore" 154
Weaver, Mike 60–62
Webb, Dennis 361
Wells, Major 66, 68
Weltchek, Bob 321
Weltchek, Nolan 321
Westendorf, Phil 366
West, Jim (Univ. of Va.) 109, **184**
West Palm Beach Expos 255
Wheaton Regional Park 145
White House, the 6
Whitfield, Rob "Cat" Praise page, 246, 248, 260–261, 261, 262, 273, 285, **338**, 360, 365
Whiting, Michael (Dr.) Praise page
William & Mary College 60, 62, 106
Williams, Dallas "the One" 232, 288, 300
Williams, George Cabell III "GC"

100
Williams, Jimmy "Skip" 239, **240**, 243, 263–265, **286**, 295, **300**, 319, 323, 338–345, 353, 368–369
Williams, Ted "the Splendid Splinter 205
Wilson, Tom "Torch" 124
Winfield Rangers (Ga.) 271
Winfield Tigers (Ga.) 271
Woods, Tiger 142
Woody Woodpecker 11
World Series 20, 123, 152, 154, 168, 220, 221, 240, 260, 261, 263, 272, 290, 296, 312, 317, 321, 323, 330, 331, 339, 342, 343, 349, 351
Wright, Frank Lloyd 302
Wright, Gary (musician) 175

Y

Yastrzemski, Carl 144
YMCA 15
York Baseball Tournament (Pa.) 143
Yount, Robin 183

Z

Zanesville Pioneers (Oh.) 128
Zier, Patrick 282

Scott Christopher: "Dream Big, Dream On!"

Scott Christopher advanced further in professional baseball, with his severely handicapped throwing hand and arm, than any player in history. Featured in *Sports Illustrated* at age twelve, he became a two-time MVP playing shortstop for the University of Maryland, setting multiple records there and professionally as an undrafted free agent in the Baltimore Orioles organization.

Scott's story will take you along an amazing journey of belief, vision, passion, intention, desire, dedication, dreams, and arduous work that led to hitting his "Dream Home Run" in the ninth inning of the final ring game, to become a pro baseball champion. He delivered all of this and so much more, despite his doctors considering amputating Scott's hand following a crippling accident behind home plate at age six. His comeback from that injury was extremely challenging and included having a .000 batting average as a junior at Falls Church High School, striking out three times in four at-bats. Unable to pick up a baseball, he has to push it into his hand to establish a grip.

Most likely having created more art than any professional athlete in history, Scott's first book, penned in 1978, a futuristic and fully illustrated science fiction novel, *The Tales of the Roving Mobileans*, was declared to "put *Star Wars* to shame," by esteemed *Miami News* sports writer, Tom Archdeacon. Following this came Scott's 1980 "Baseball Offensive Batting Sheets," a highly successful book focused on using the power of the mind to process recorded, offensive analytical data to become an outstanding hitter. His concepts work, and a reissue of this must-have batting manual will be published in the future.

He formally established Christopher Foundation for the Arts as a 501c3 organization in 2005. As executive director, Scott guides CFFTA's mission to encourage the individual creative process through advocating the extraordinary cultural and global benefits of artistic expression. Cultural exchange initiatives, exhibitions, donation of photographic prints to museums, and creating art has been carried out in over thirty-five countries.

Reading his story, where every word—a brushstroke in an artistic, linguistic mural—is a launch pad for readers to become INSPIRED to give their own dreams the 110 percent effort and focus they deserve.

FORTHCOMING NOVEL:

THE TALES OF THE ROVING MOBILEANS:
TO THE ALL OF IT ALL AND BEYOND!

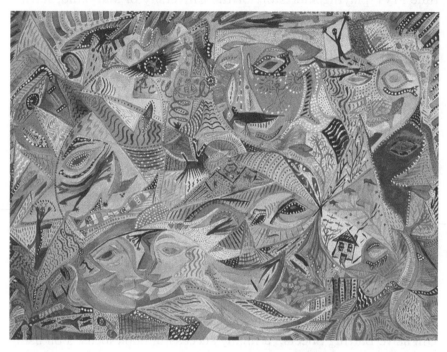

"Mosaic Lovers - Universal Underwater Library Advisory Board"

Scott's ever-evolving sequel to his 1970's sci-fi novel, *The Tales of The Roving Mobileans*, is his next literary adventure. In a 1978 feature article written by the noted journalist, Tom Archdeacon, for the *Miami News*, Tom wrote, *"The Tales of the Roving Mobileans*, a story set in outer space, puts *Star Wars* to shame."

This fully illustrated novel will begin in the Universal Underwater Library, where King Fishba and Queen Crystal Eye address the twenty-five intergalactic ambassadors of the All of It ALL and Beyond, a squadron of heart-driven, goodwill warriors. Readers will be transported in particlization energy ships, known as Melborpons, into the past and future of Destination Y. Seat belts required!

FORTHCOMING MOVIE:

THE BASEBALL ARTIST

*Scott is explaining to Rich the complex art of batting
for future reference in his writing of the screenplay.*
The Baseball Artist *is currently in development.*

Rich Henrich, Founder and Executive Director of Film4Change, has won Emmy awards as a director and producer. He is an Emmy nominated writer. His vast list of honors also include being a Telly award-winning producer. Rich is chief screenwriter of *The Baseball Artist*, a film based on the true story of Scott Christopher. Henrich, believing in the power of story and in this true-life tale, will share the magic of Dreaming Big to ignite a universe of possibilities.

Rich remarked, "From a tree both bat and paper are made, and together they spin a tale of magic and wonder for the world to see."

Printed in the USA
CPSIA information can be obtained
at www.ICGtesting.com
LVHW081938121123
763661LV00011B/497